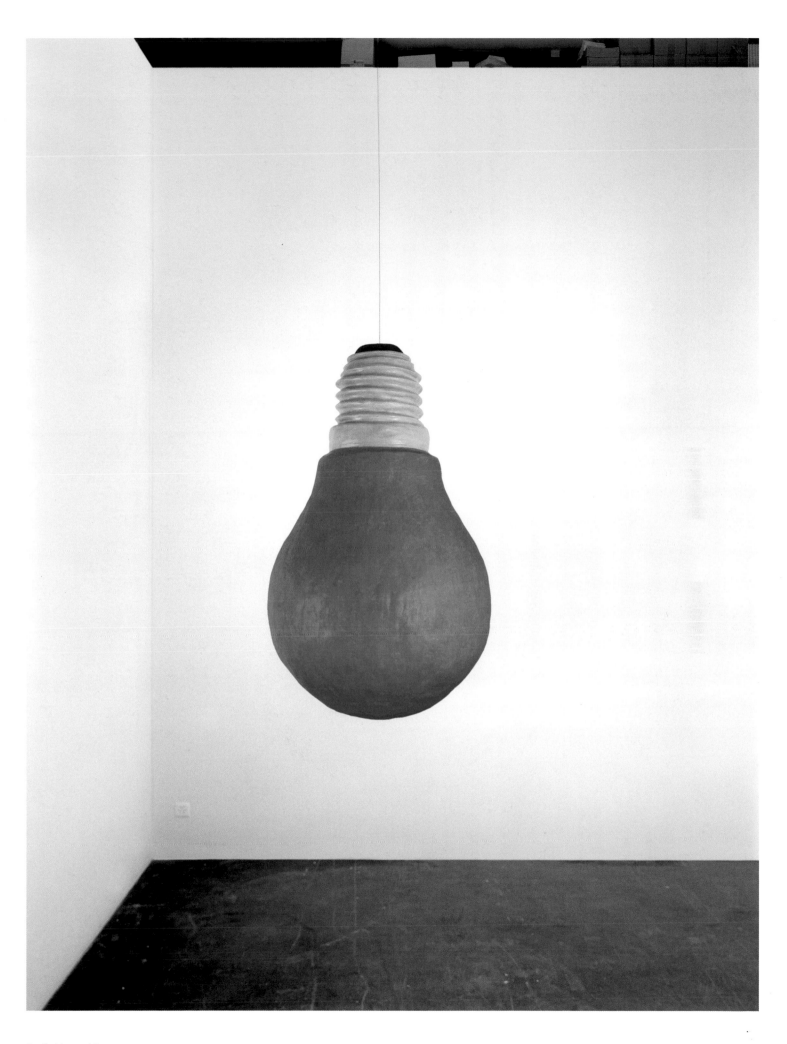

the first hour of the poem
2005, cast wax, pigments; 140 × 82 × 82 cm

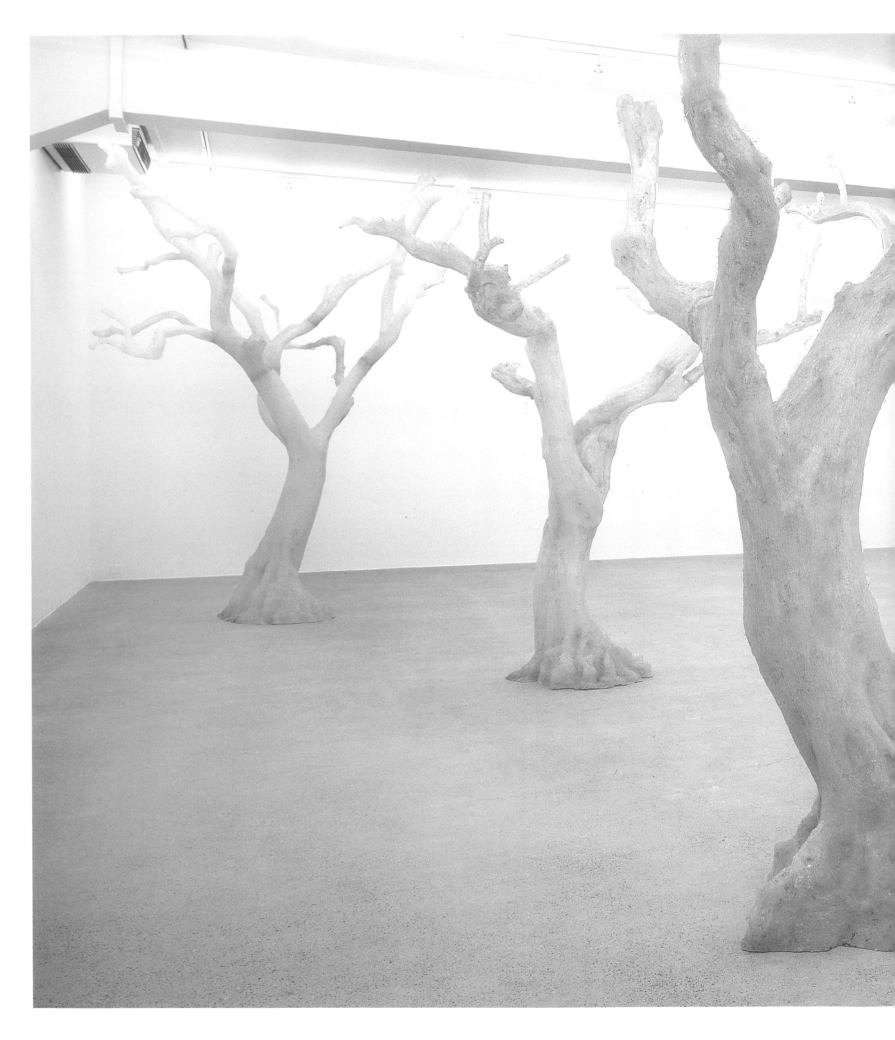

4 when the water went south for the winter it carried us down like storm driven gulls. out
of reach until it's magic we are crossing our own stony ocean. across dark stream of shooting
stars. we sail into pleasure and unload our spacious soul. everything gets lighter everyone is light.

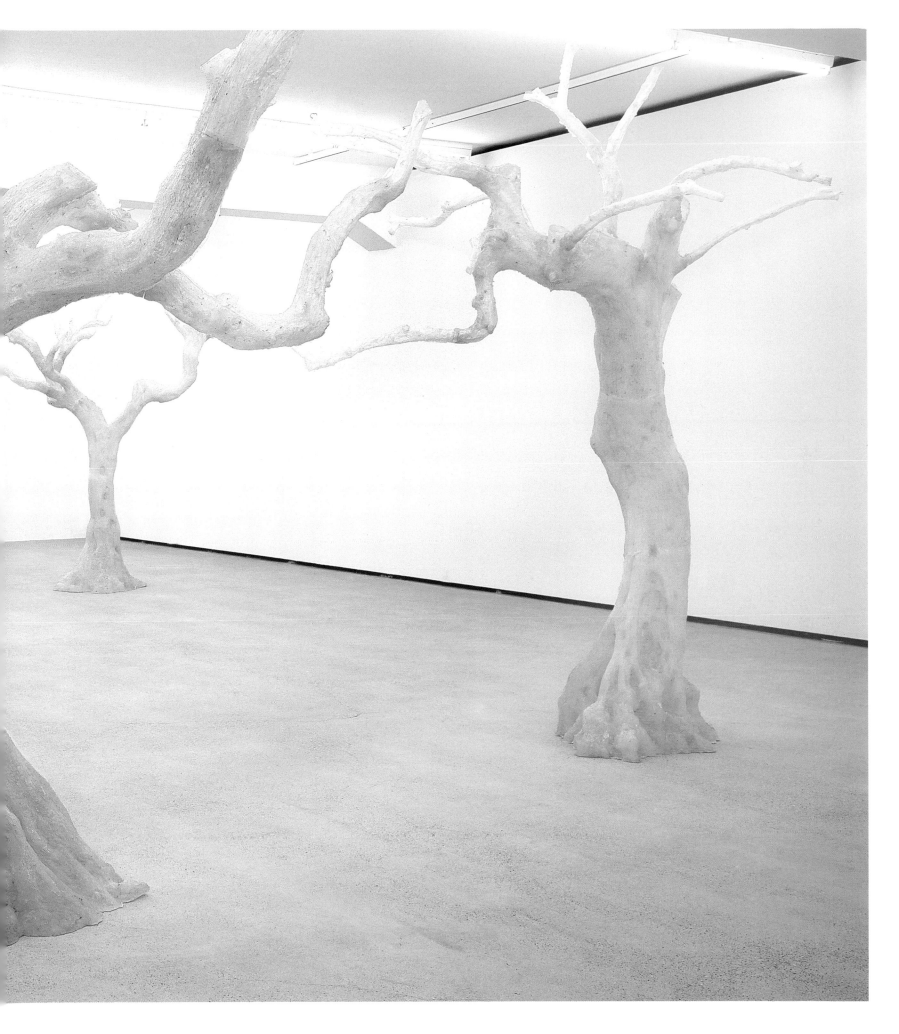

ugo rondinone
zero built a nest in my navel

whitechapel london

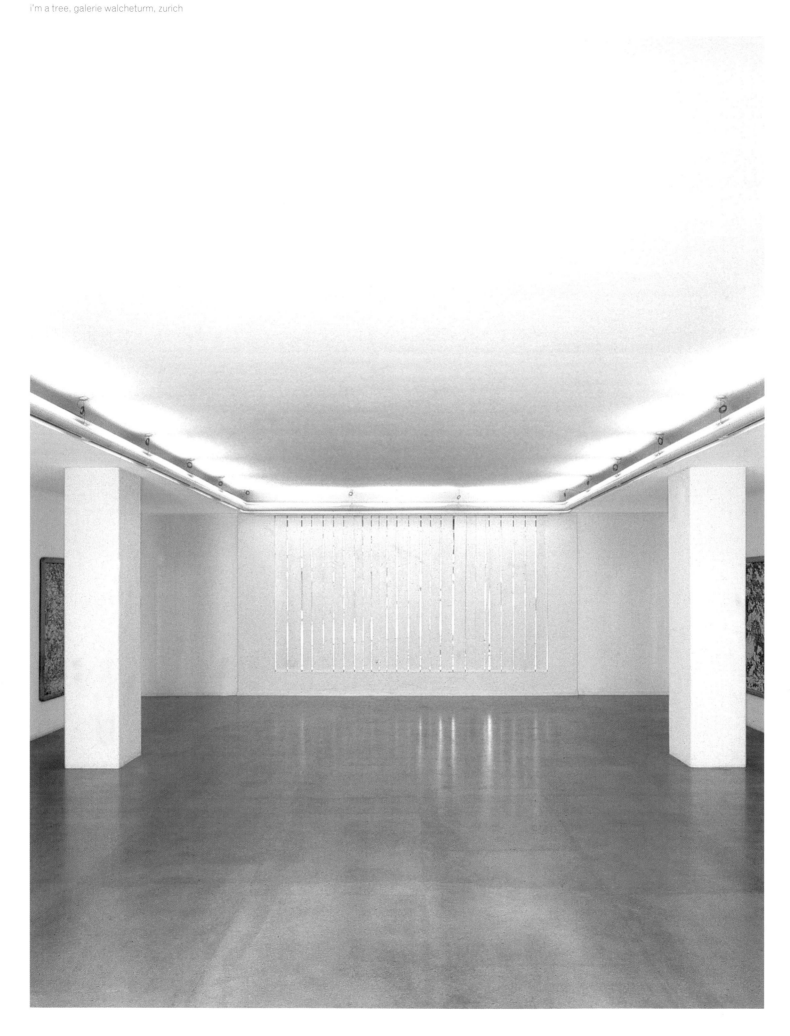

8 untitled
1991, wood, acrylic paint; dimensions variable

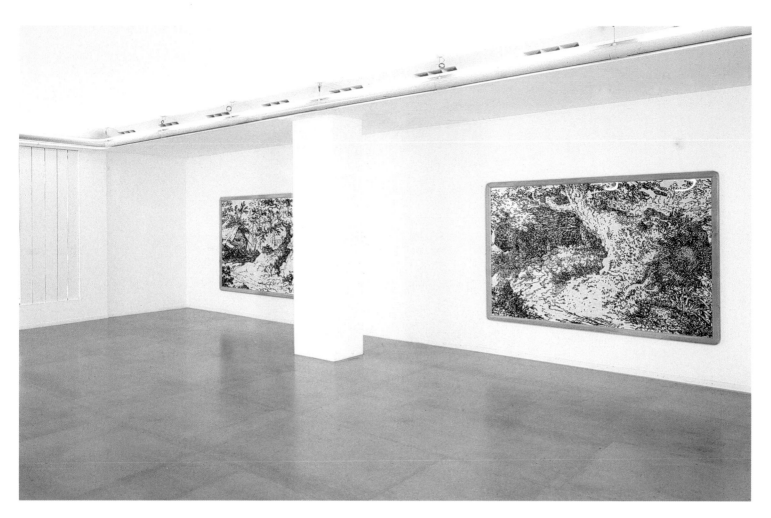

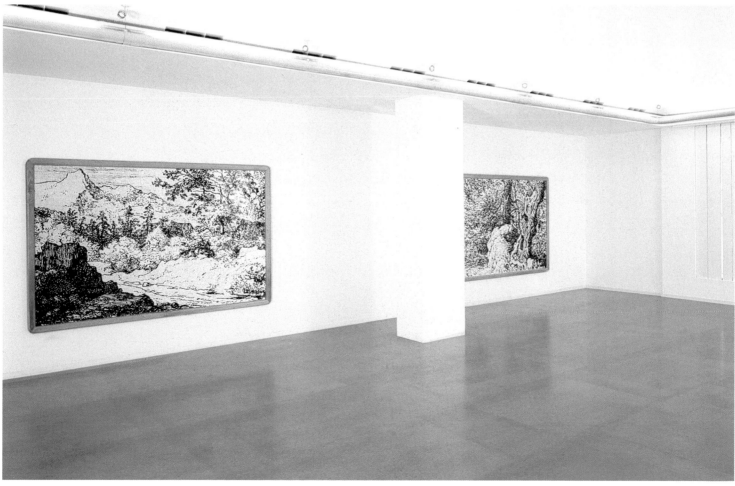

vierundzwanzigstermaineunzehnhundertneunundachtzig
1991, ink on paper, wooden frame; 180 × 260 cm

drittermärzneunzehnhundertneunundachtzig
1991, ink on paper, wooden frame; 180 × 260 cm

vierzehnteraugustneunzehnhundertneunzig
1991, ink on paper, wooden frame; 180 × 260 cm

neunzehnterjunineunzehnhundertneunundachtzig
1991, ink on paper, wooden frame; 180 × 260 cm

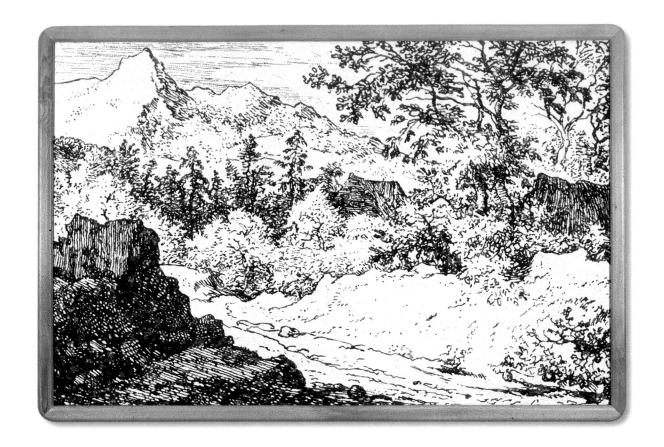

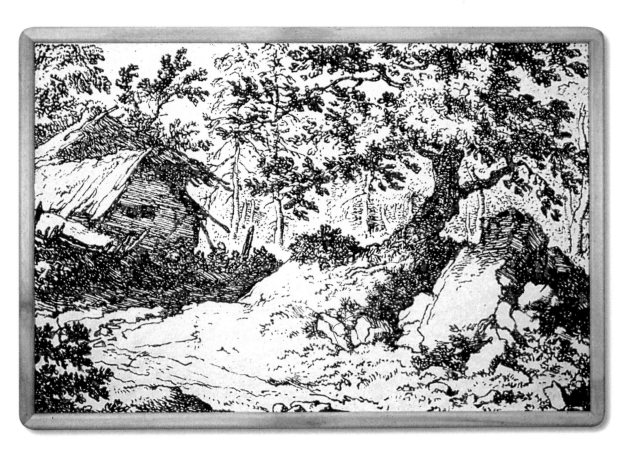

10 drittermärzneunzehnhundertneunundachtzig
1991, ink on paper, wooden frame; 180 × 260 cm

vierundzwanzigstermaineunzehnhundertneunundachtzig
1991, ink on paper, wooden frame; 180 × 260 cm

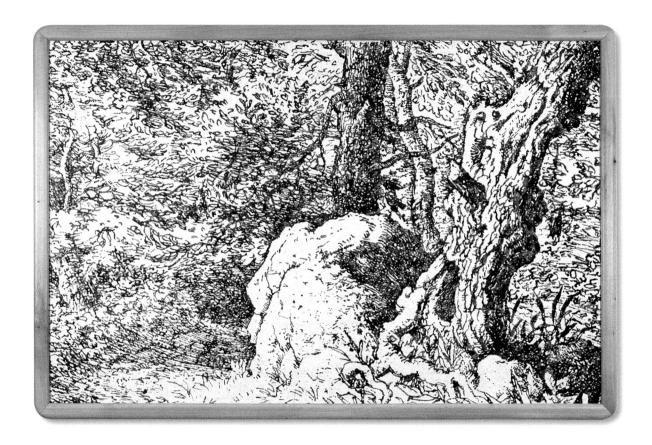

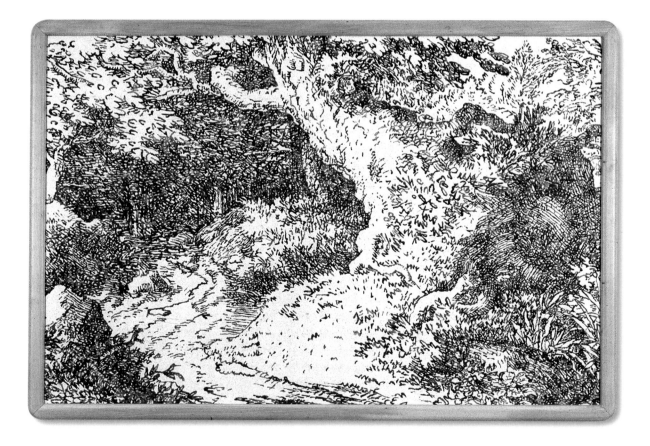

neunzehnterjunineunzehnhundertneunundachtzig
1991, ink on paper, wooden frame; 180 × 260 cm

vierzehnteraugustneunzehnhundertneunzig
1991, ink on paper, wooden frame; 180 × 260 cm

12 untitled
 1991, wood, acrylic paint;
 dimensions variable

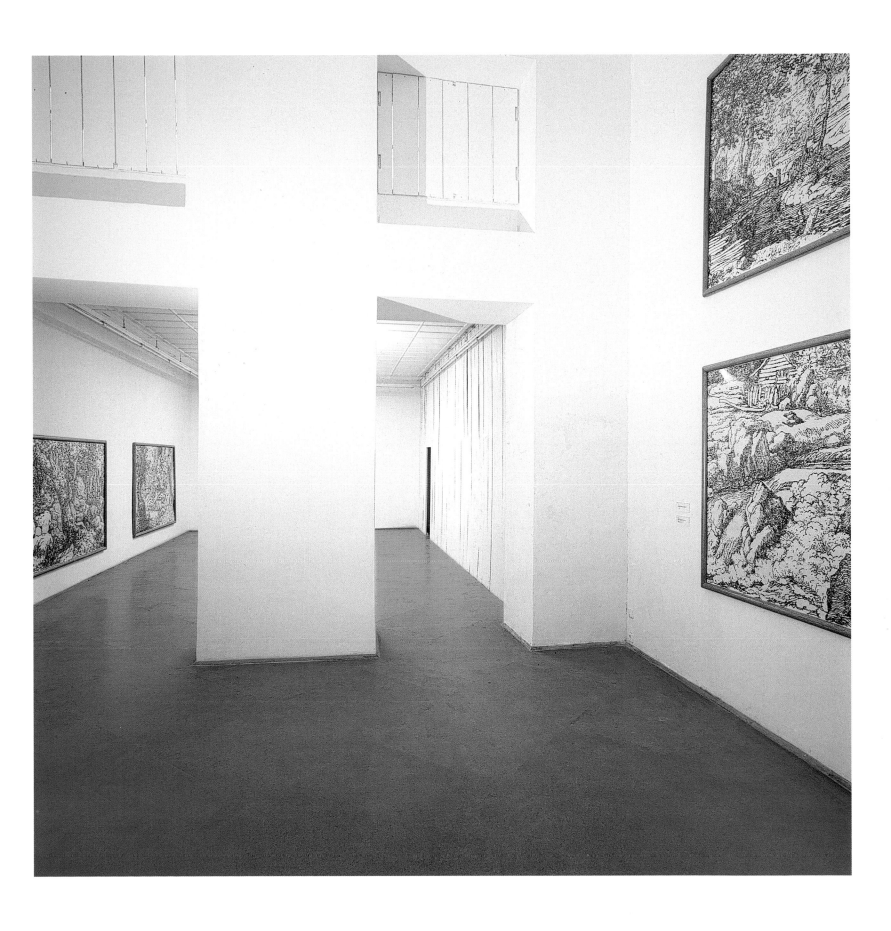

ersterjunineunzehnhundertneunzig
1991, ink on paper, wooden frame; 180 × 280 cm

siebterjunineunzehnhundertneunzig
1991, ink on paper, wooden frame; 180 × 280 cm

dritterjulineunzehnhundertneunzig
1991, ink on paper, wooden frame; 180 × 260 cm

vierterjunineunzehnhundertneunzig
1991, ink on paper, wooden frame; 180 × 260 cm

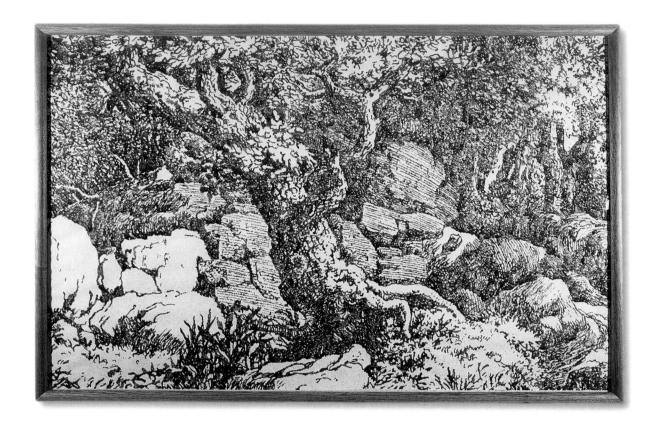

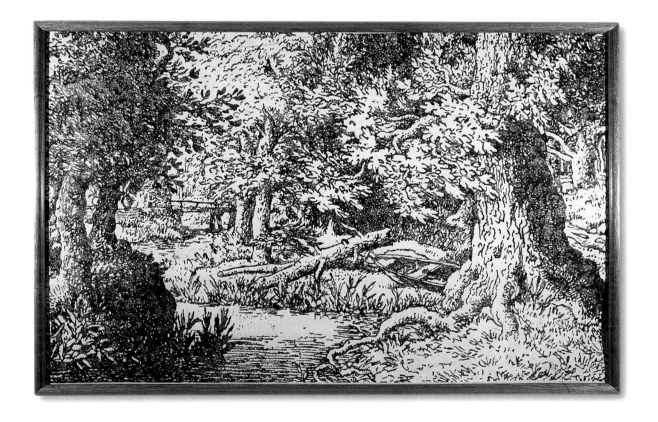

14 ersterjunineunzehnhundertneunzig
1991, ink on paper, wooden frame; 180 × 280 cm

siebterjunineunzehnhundertneunzig
1991, ink on paper, wooden frame; 180 × 280 cm

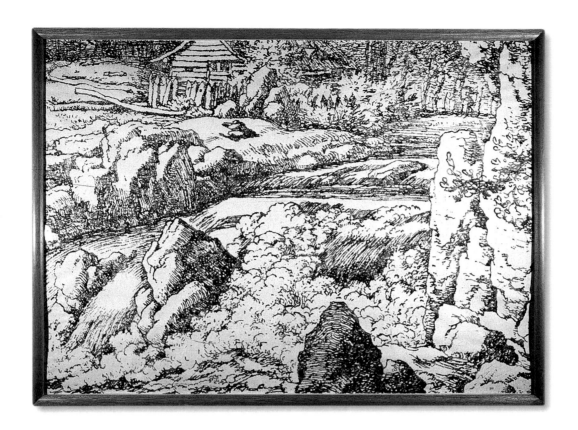

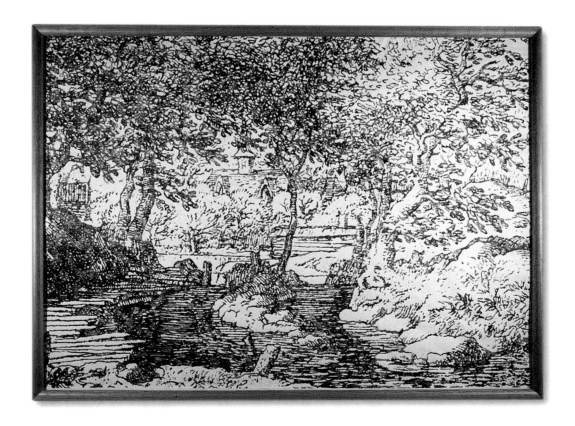

vierterjunineunzehnhundertneunzig
1991, ink on paper, wooden frame; 180 × 260 cm

dritterjulineunzehnhundertneunzig
1991, ink on paper, wooden frame; 180 × 260 cm

16 untitled
1991, wood, acrylic paint; dimensions variable

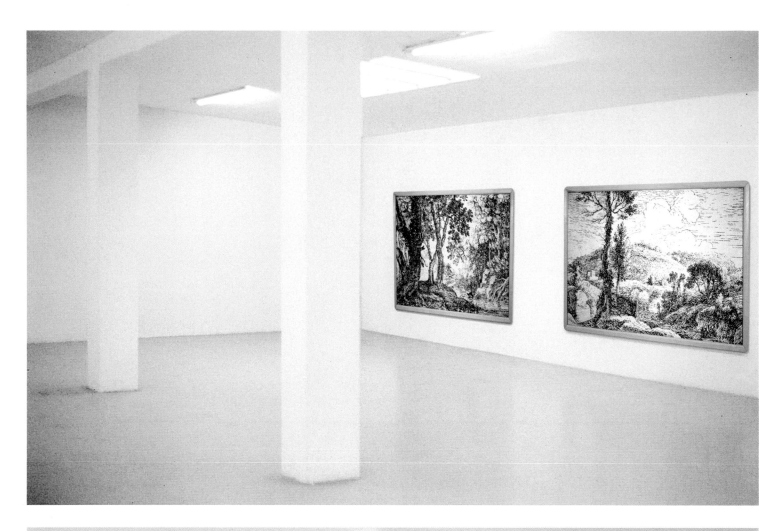

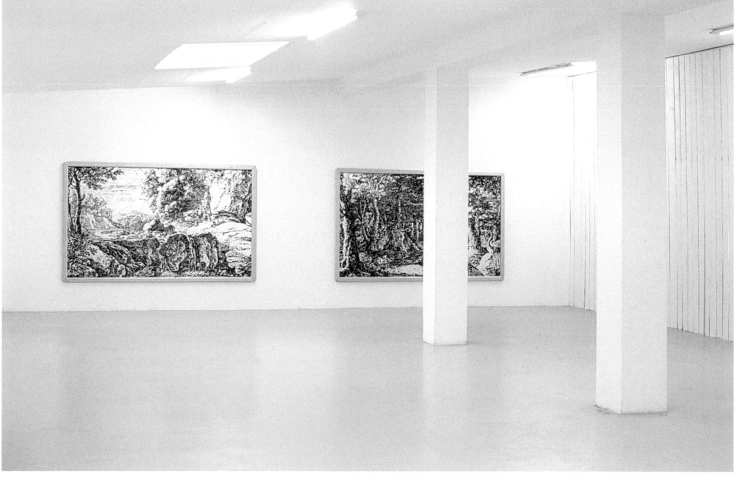

sechzehnteraprilneunzehnhundertneunzig
1991, ink on paper, wooden frame; 180 × 280 cm

neuntermärzneunzehnhundertneunzig
1991, ink on paper, wooden frame; 180 × 280 cm

siebzehntermaineunzehnhundertneunzig
1991, ink on paper, wooden frame; 180 × 280 cm

einundzwanzigstermaineunzehnhundertneunzig
1991, ink on paper, wooden frame; 180 × 280 cm

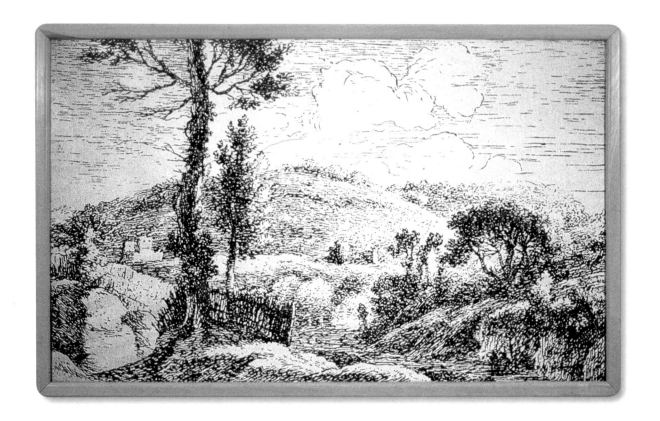

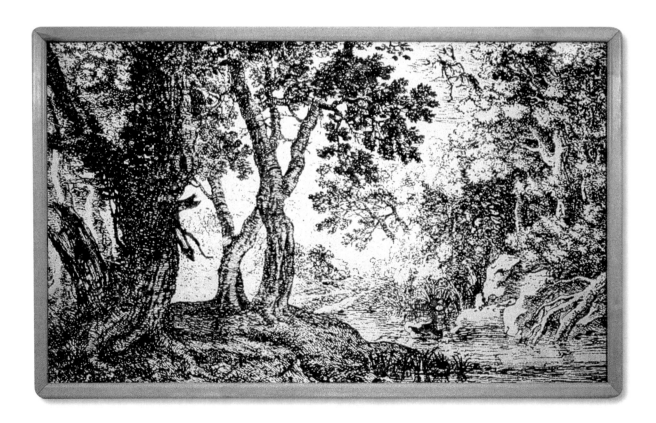

18 neuntermärzneunzehnhundertneunzig
1991, ink on paper, wooden frame; 180 × 280 cm

sechzehnteraprilneunzehnhundertneunzig
1991, ink on paper, wooden frame; 180 × 280 cm

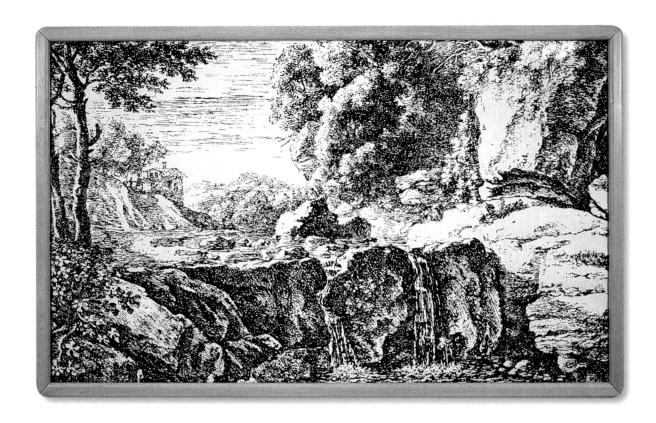

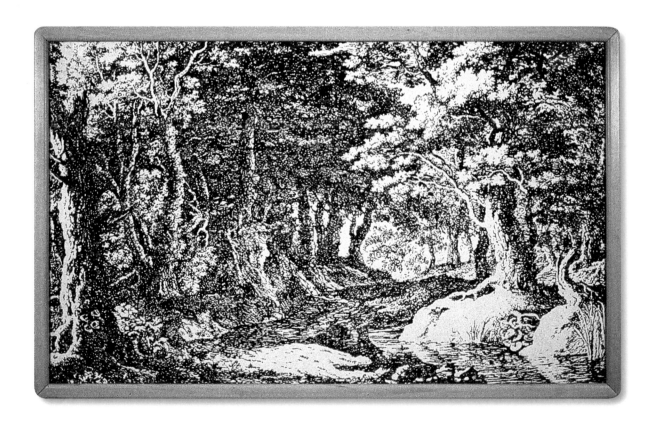

siebzehntermaineunzehnhundertneunzig
1991, ink on paper, wooden frame; 180 × 280 cm

einundzwanzigstermaineunzehnhundertneunzig
1991, ink on paper, wooden frame; 180 × 280 cm

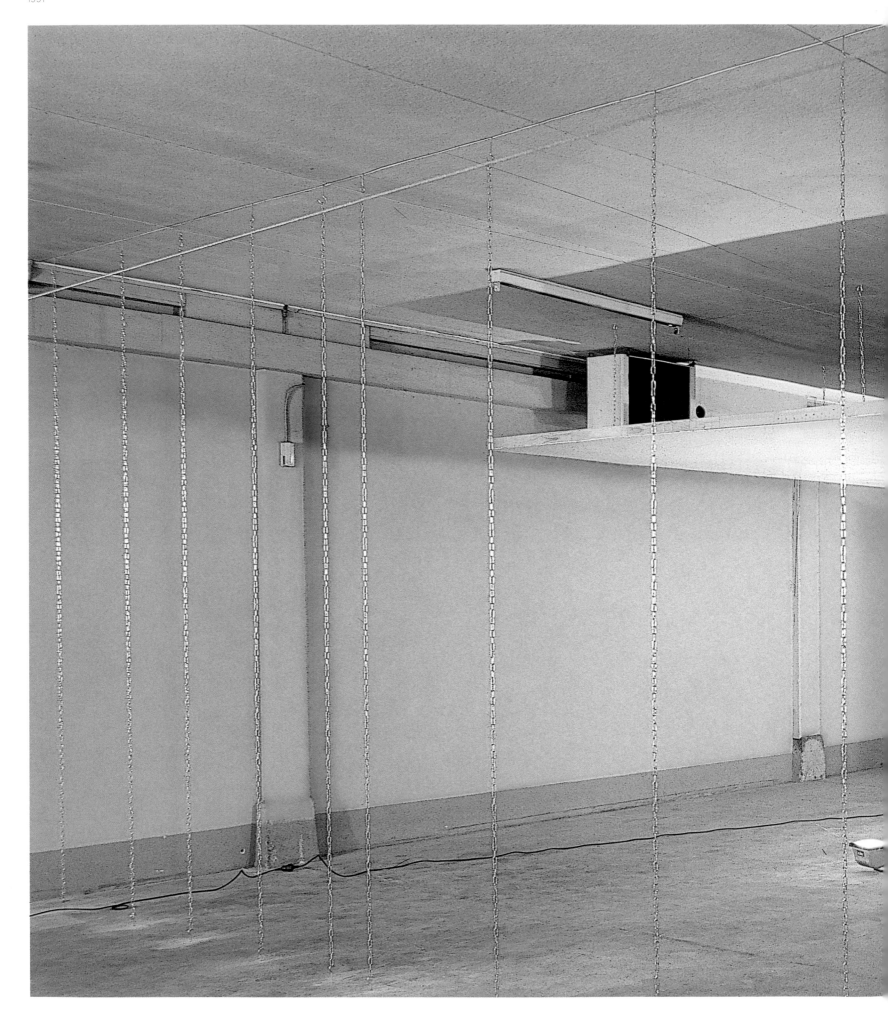

the telephone ringing three times in the dead of the night, and the voice on the other end asking for someone i was not.
1991, metallic chains, spotlights, aluminium, paint; 350 × 1200 × 1200 cm

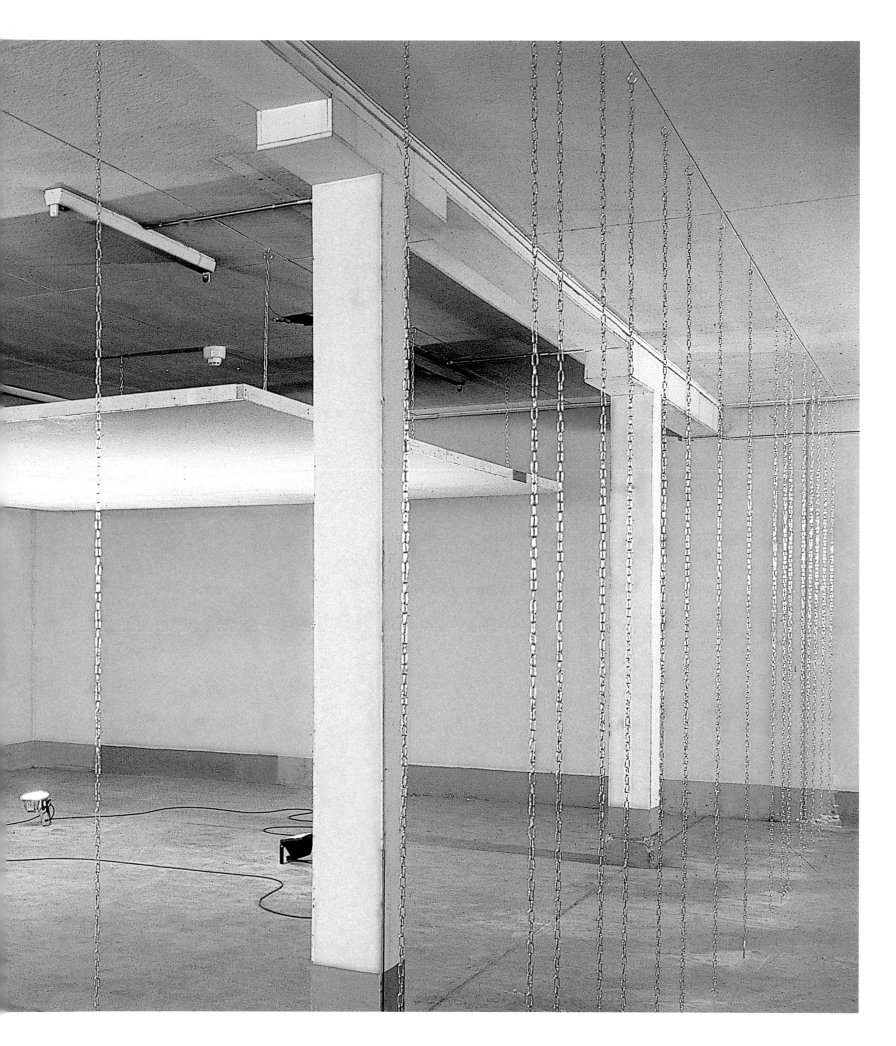

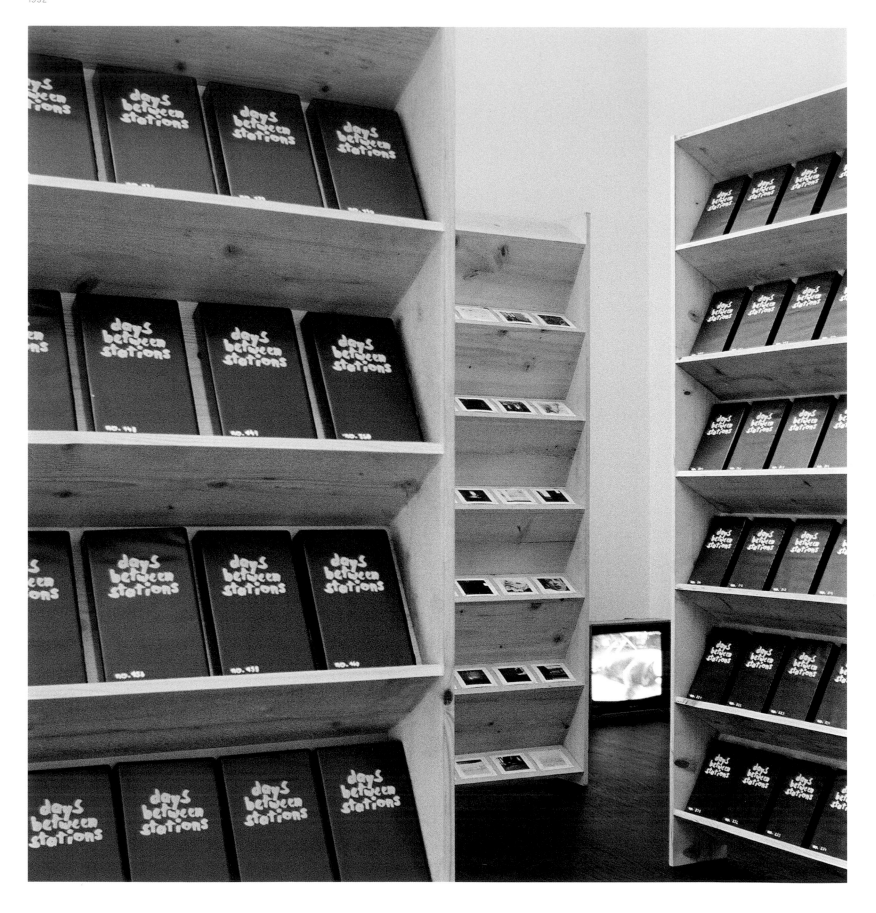

22 days between stations
1992—work in progress, 540 videotapes, 9 shelf units
made of pinewood; 203 × 167 × 20 cm each shelf

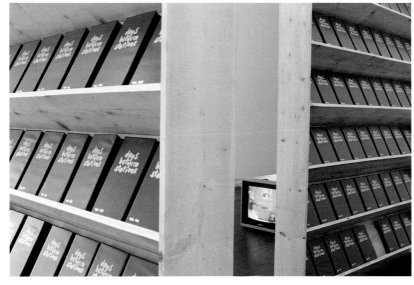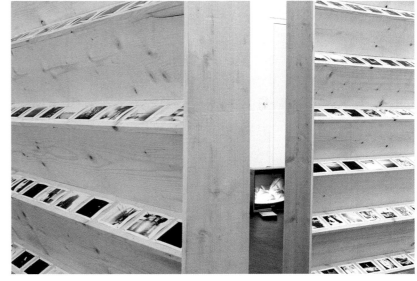

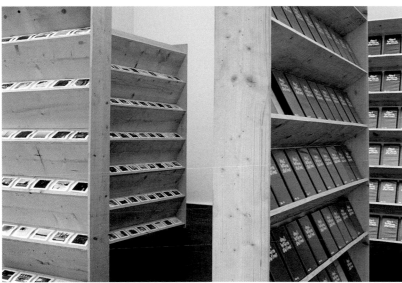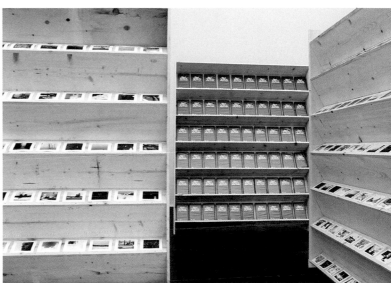

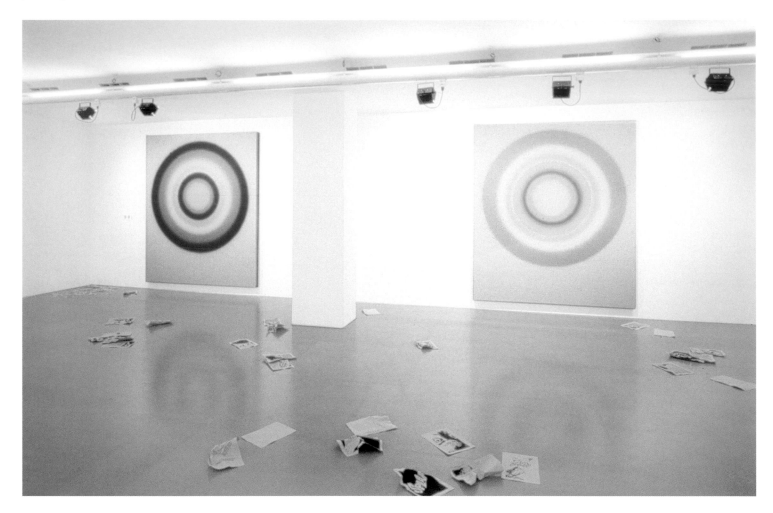

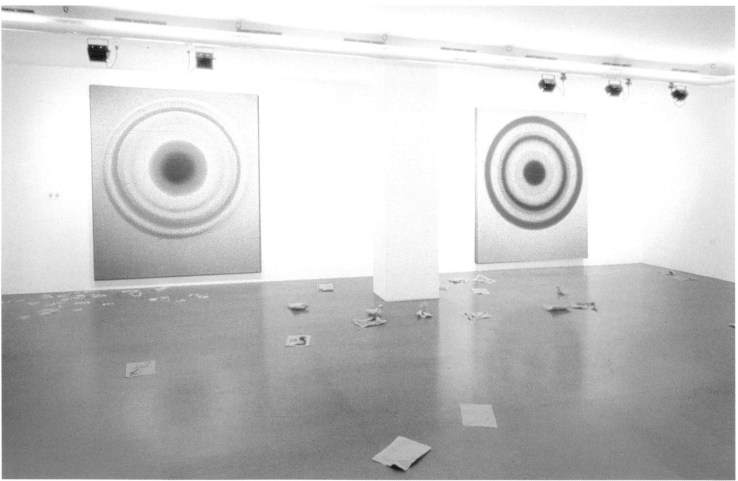

24 siebteraprilneunzehnhundertzweiundneunzig
 1992, acrylic paint on canvas; 250 × 210 cm

 neunterjulineunzehnhundertzweiundneunzig
 1992, acrylic paint on canvas; 250 × 210 cm

 siebzehntermärzneunzehnhundertzweiundneunzig
 1992, acrylic paint on canvas; 250 × 210 cm

 achterseptemberneunzehnhundertzweiundneunzig
 1992, acrylic paint on canvas; 250 × 210 cm

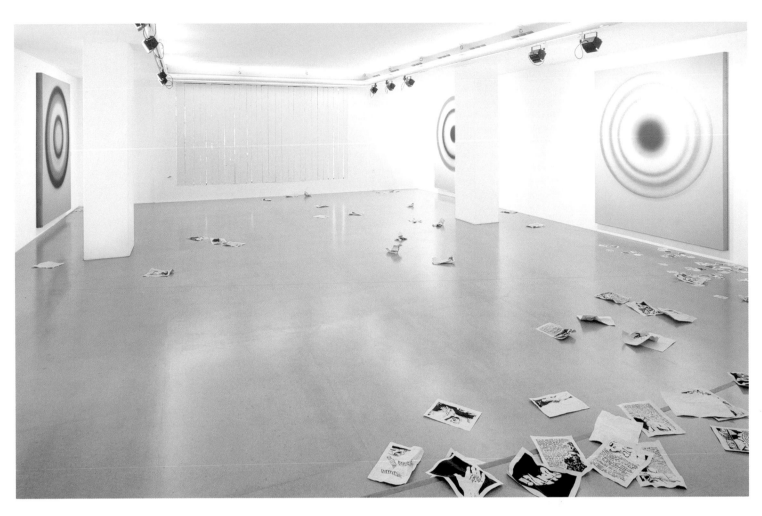

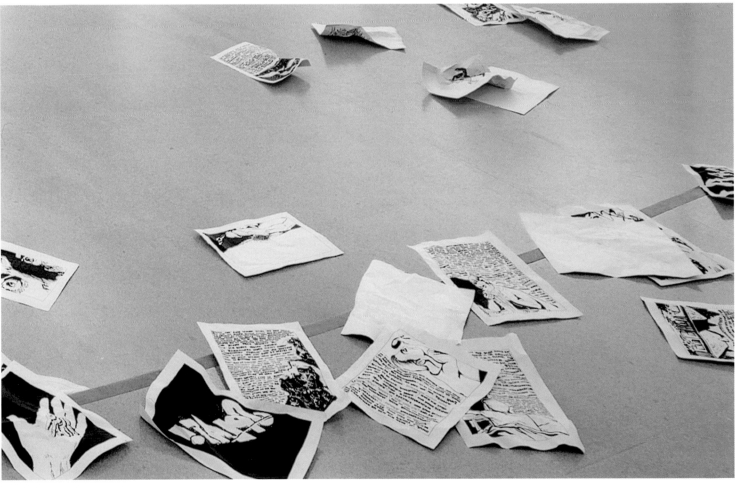

untitled
1992, wood, acrylic paint; dimension variable

1992
1992, 60 parts, ink on paper; 29.7 × 21 cm each

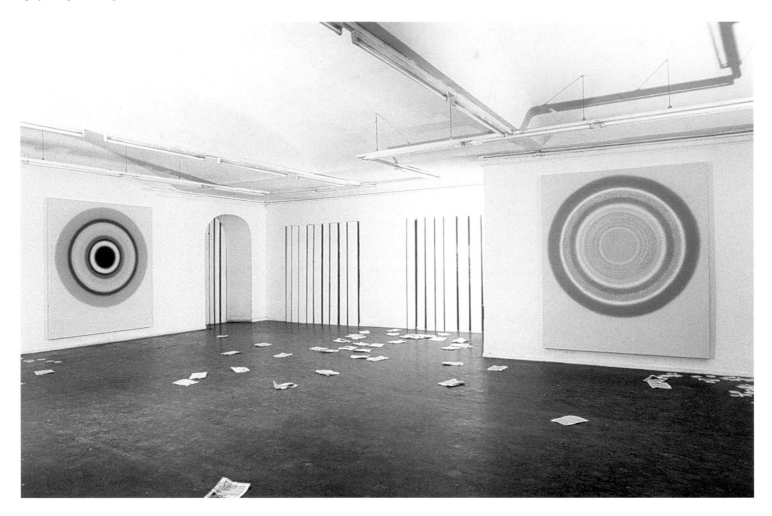

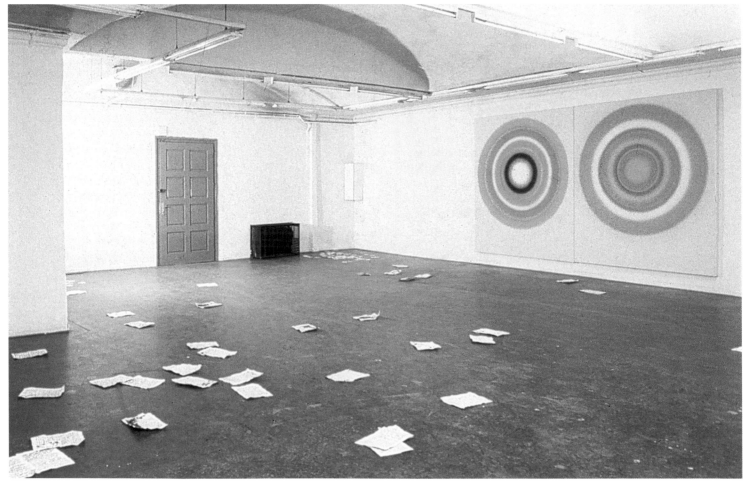

26 zweiteraprilneunzehnhundertdreiundneunzig vierzehnterjanuarneunzehnhundertdreiundneunzig untitled
 1993, acrylic paint on canvas; 250 × 210 cm 1993, acrylic paint on canvas; 250 × 210 cm 1991, wood, acrylic paint; dimensions variable

 viertermaineunzehnhundertzweiundneunzig vierteroktoberneunzehnhundertzweiundneunzig 1993
 1992, acrylic paint on canvas; 250 × 210 cm 1992, acrylic paint on canvas; 250 × 210 cm 1993, 60 parts, ink on paper; 29.7 × 21 cm each

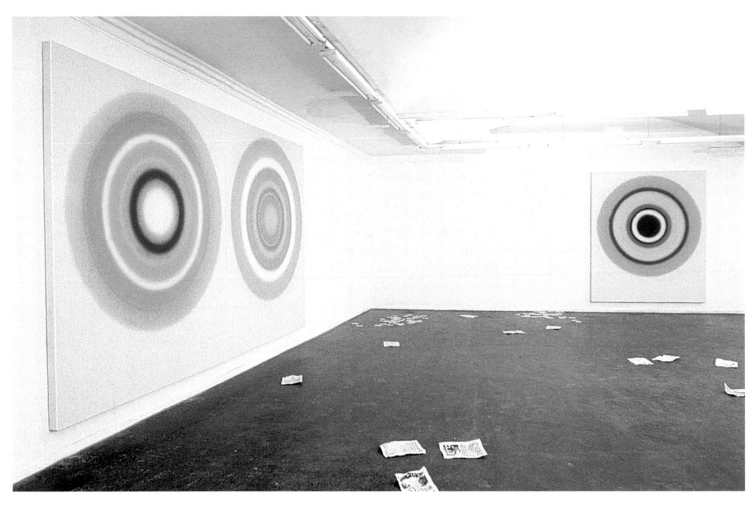

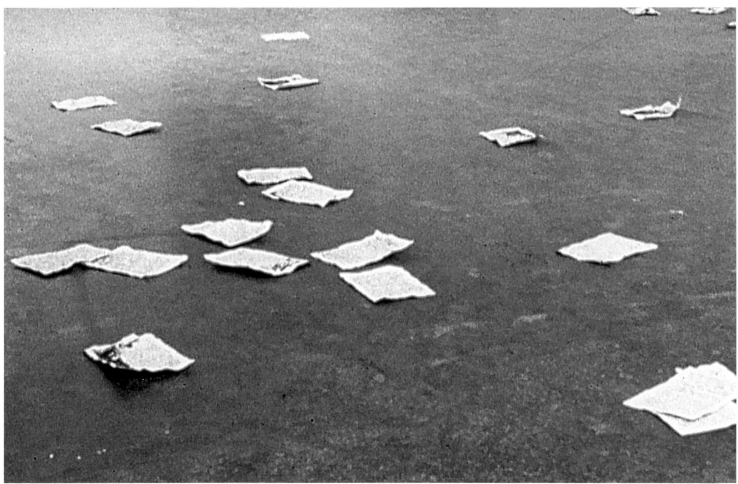

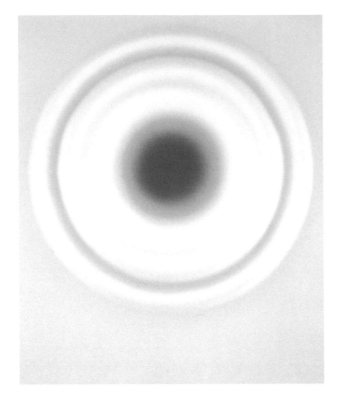

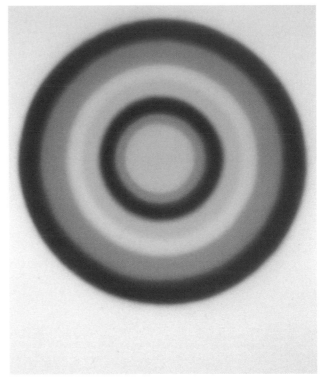

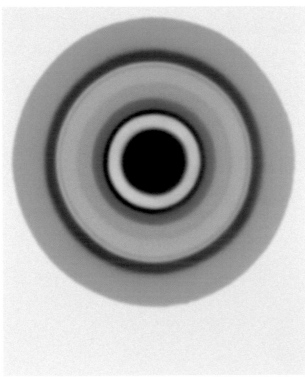

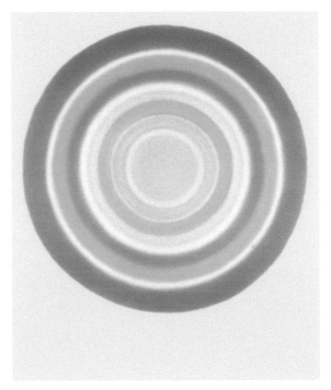

siebzehntermärzneunzehnhundertzweiundneunzig
1992, acrylic paint on canvas; 250 × 210 cm

zweiteraprilneunzehnhundertdreiundneunzig
1993, acrylic paint on canvas; 250 × 210 cm

siebteraprilneunzehnhundertzweiundneunzig
1992, acrylic paint on canvas; 250 × 210 cm

viertermaineunzehnhundertzweiundneunzig
1992, acrylic paint on canvas; 250 × 210 cm

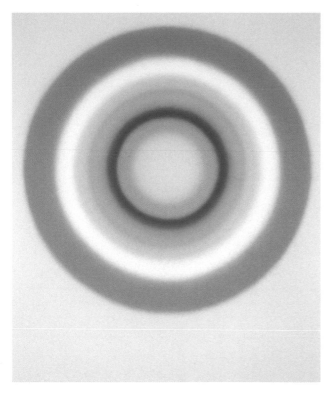

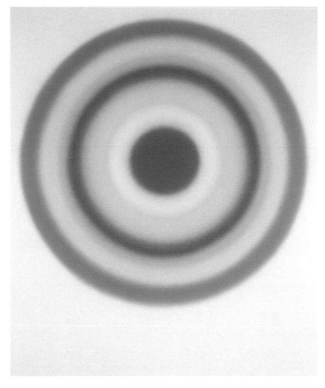

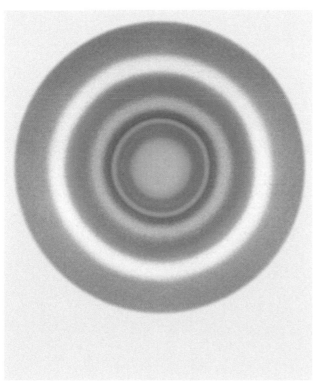

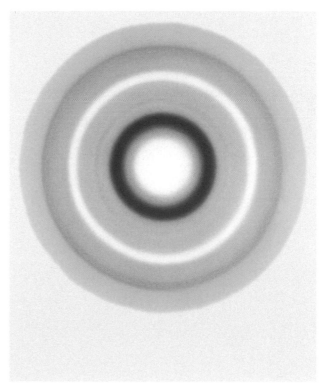

neunterjulineunzehnhundertzweiundneunzig
1992, acrylic paint on canvas; 250 × 210 cm

achterseptemberneunzehnhundertzweiundneunzig
1992, acrylic paint on canvas; 250 × 210 cm

vierteroktoberneunzehnhundertzweiundneunzig
1992, acrylic paint on canvas; 250 × 210 cm

vierzehnterjanuarneunzehnhundertdreiundneunzig
1993, acrylic paint on canvas; 250 × 210 cm

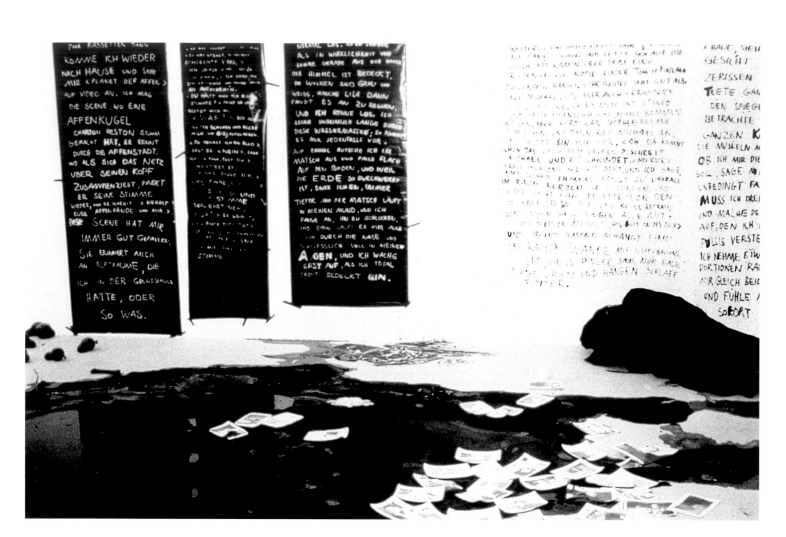

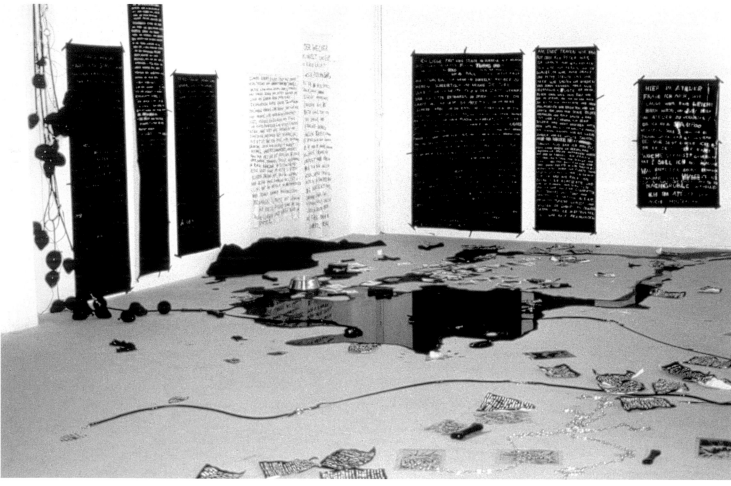

30 if
1993, steel, leather, gum, ink, cotton, photographs,
paper, electric pump; dimensions variable

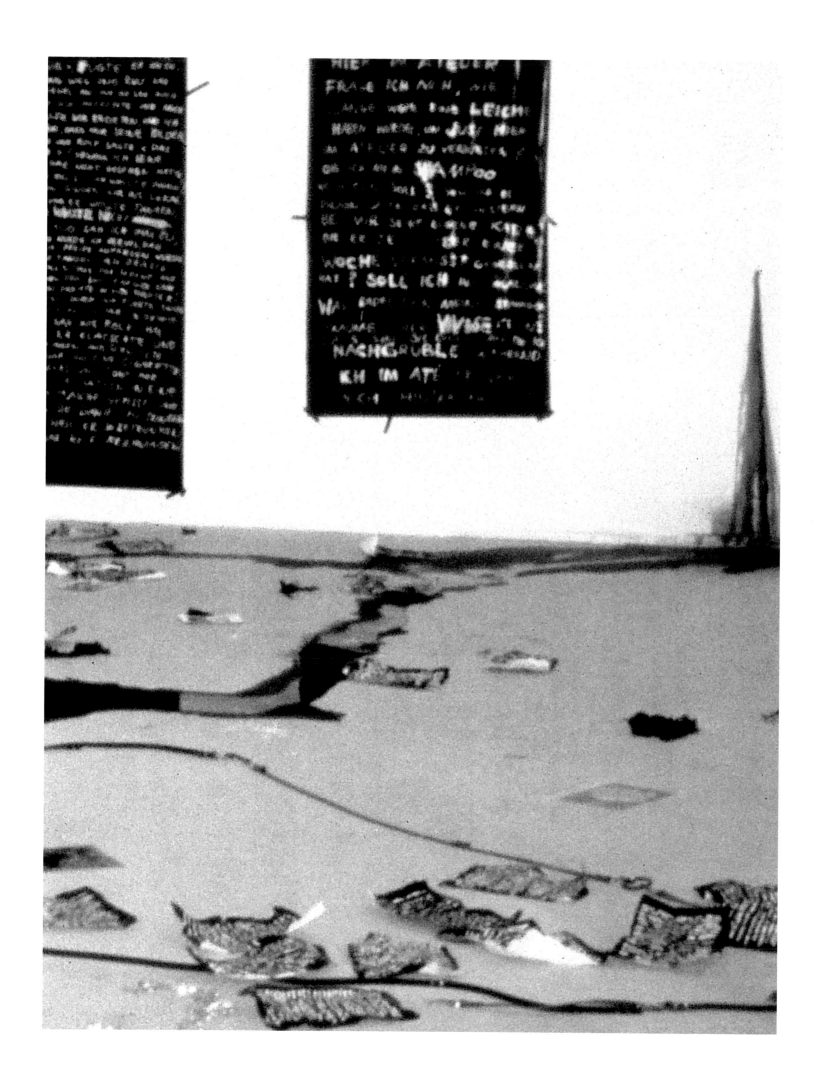

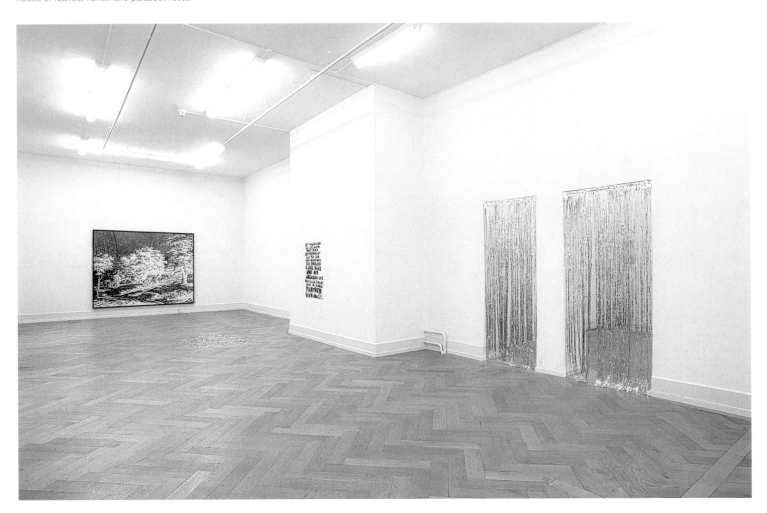

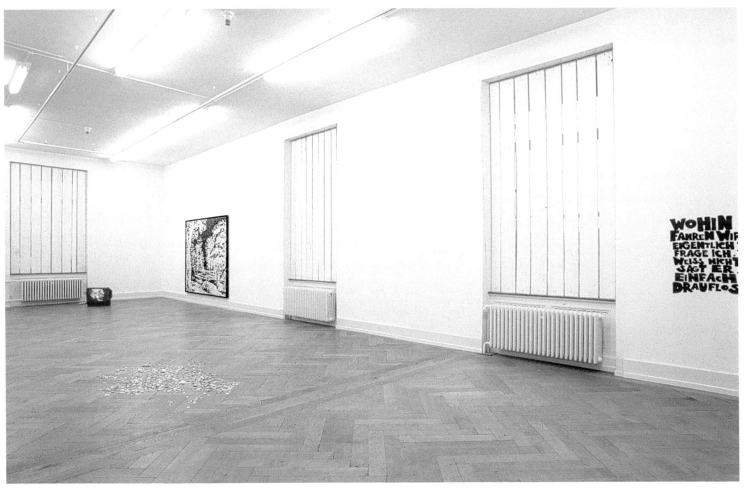

32 elftermärzneunzehnhundertdreiundneunzig rain 1991–1993, black and white photographs
 1993, ink on paper, wooden frame; 200 × 300 cm 1993, silver tinsel; dimensions variable scattered on the floor; dimensions variable

 mittwochabend, es ist schon spät… achtzehneraugustneunzehnhundertdreiundneunzig wohin fahren wir…
 1993, acrylic paint, glitter 1993, ink on paper, wooden frame; 200 × 300 cm 1993, acrylic paint, glitter

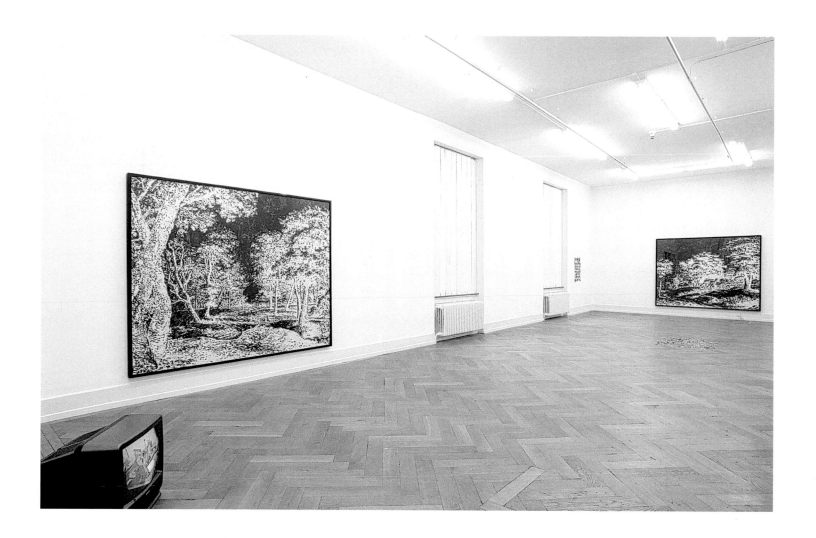

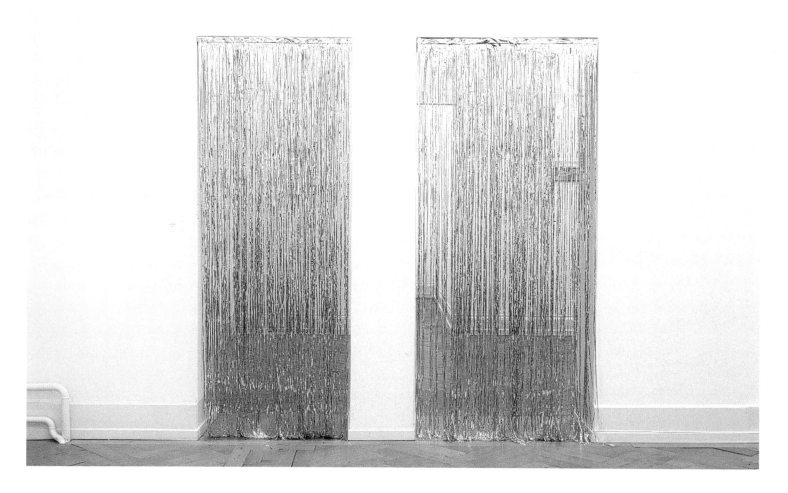

eine glühbirne…
1993, acrylic paint, glitter

days between stations
1992–work in progress, 540 videotapes,
9 shelf units made of pinewood;
203 × 167 × 20 cm each shelf

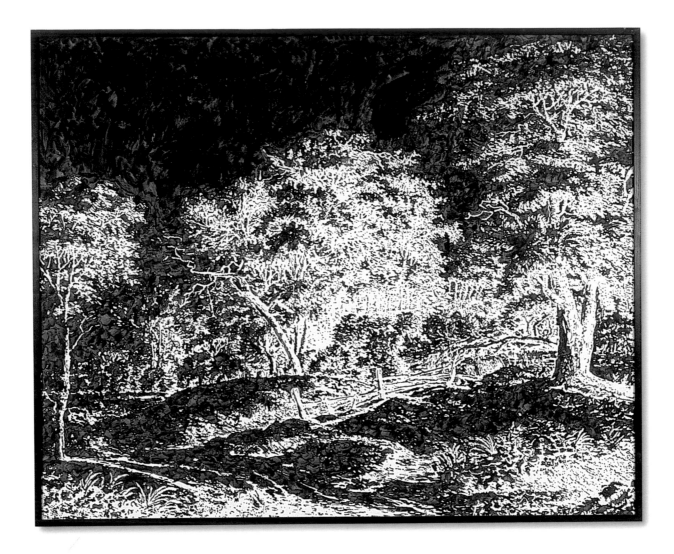

elftermärzneunzehnhundertdreiundneunzig
 1993, ink on paper, wooden frame; 200 × 300 cm

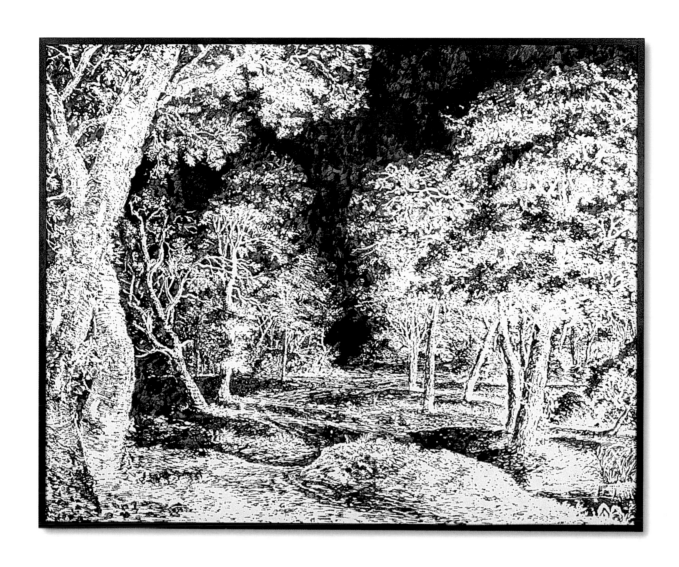

achtzehnteraugustneunzehnhundertdreiundneunzig
1993, ink on paper, wooden frame; 200 × 300 cm

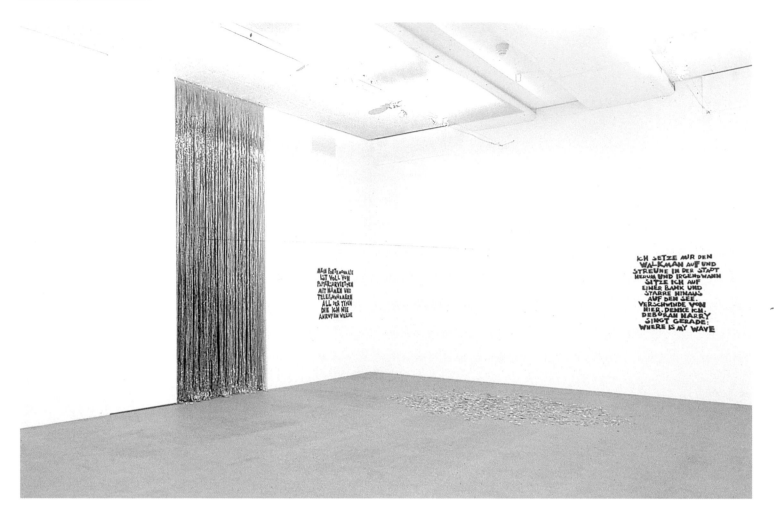

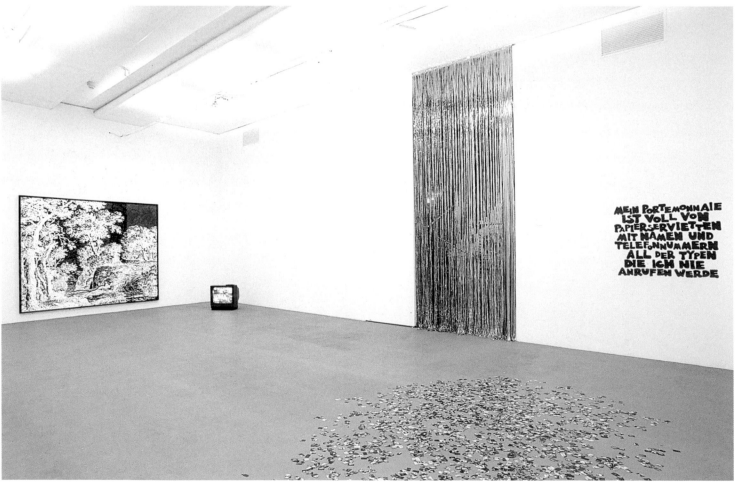

36 rain
1993, silver tinsel; dimensions variable

mein portemonnaie...
1994, acrylic paint, glitter

ich setze mich...
1994, acrylic paint, glitter

1991–1994, black and white photographs scattered
on the floor; dimensions variable

elftermärzneunzehnhundertvierundneunzig
1994, ink on paper, wooden frame; 200 × 300 cm

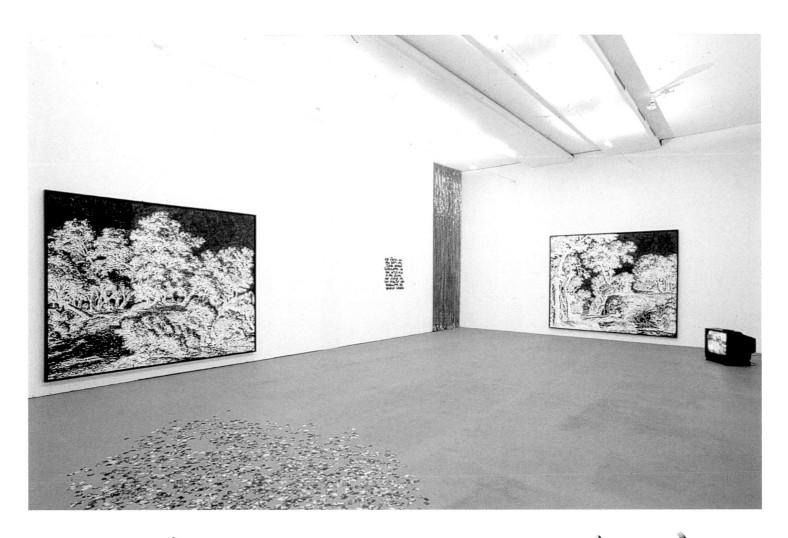

vierzehntermaineunzehnhundertvierundneunzig
1994, ink on paper, wooden frame; 200 × 300 cm

ich steige aus dem bett...
1994, acrylic paint, glitter

days between stations
1992–work in progress, 540 videotapes, 9 shelf units
made of pinewood; 203 × 167 × 20 cm each shelf

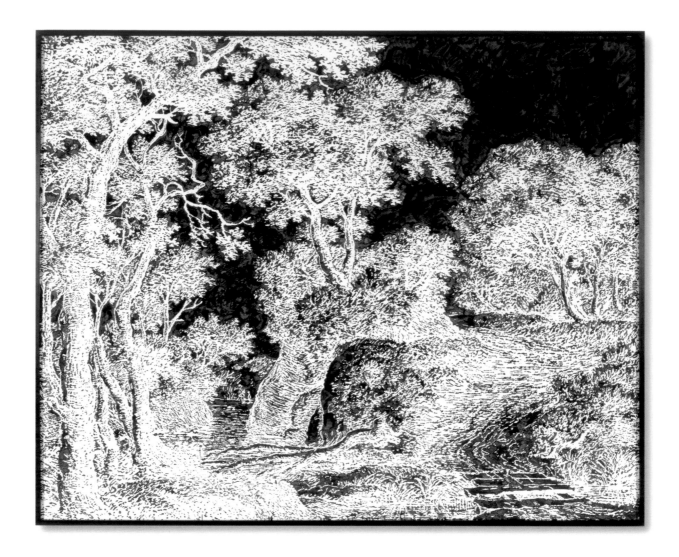

elftermärzneunzehnhundertvierundneunzig
1994, ink on paper, wooden frame; 200 × 300 cm

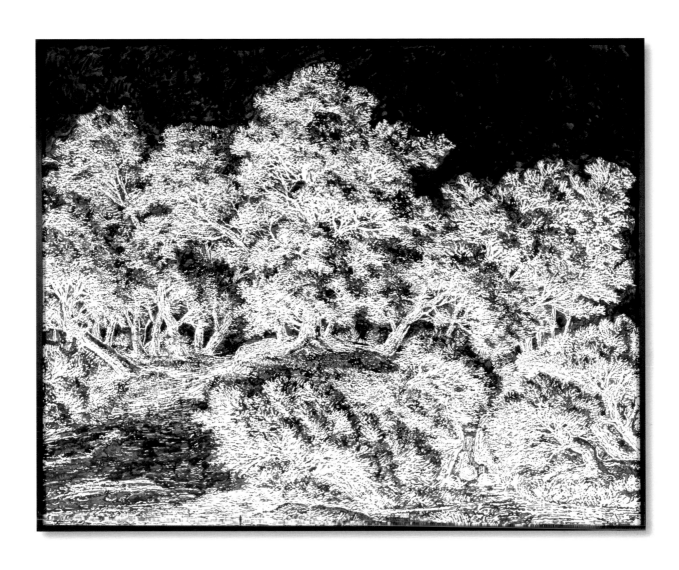

vierzehntermaineunzehnhundertvierundneunzig
1994, ink on paper, wooden frame; 200 × 300 cm

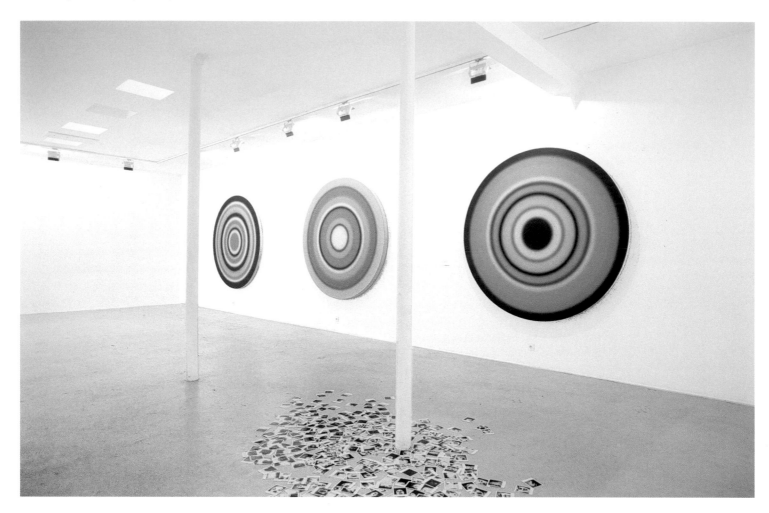

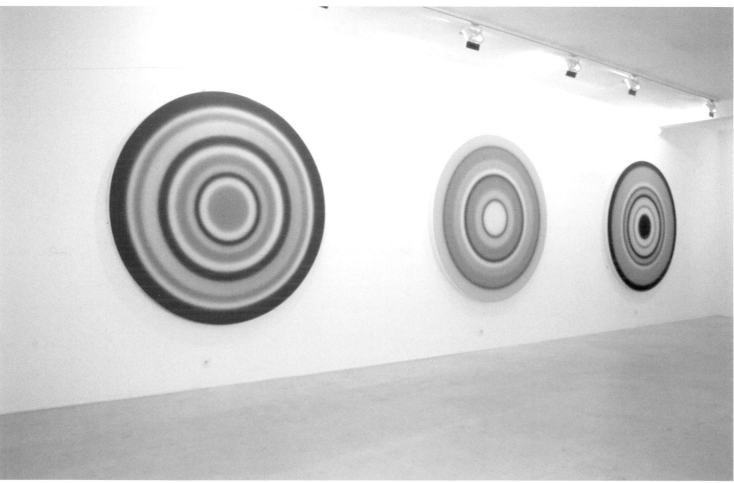

achtzehnteraprilneunzehnhundertfünfundneunzig
1995, acrylic paint on canvas; ø 220 cm

neuntermaineunzehnhundertfünfundneunzig
1995, acrylic paint on canvas; ø 220 cm

zwölftermärzneunzehnhundertfünfundneunzig
1995, acrylic paint on canvas; ø 220 cm

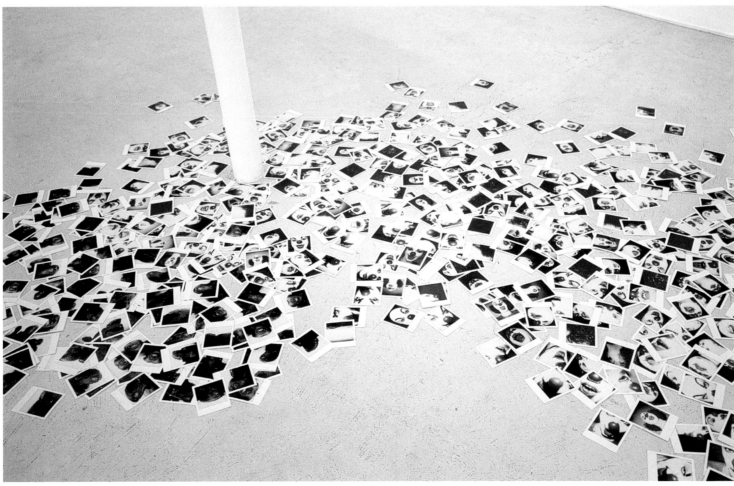

please?
1995, 60 polaroids; dimensions variable

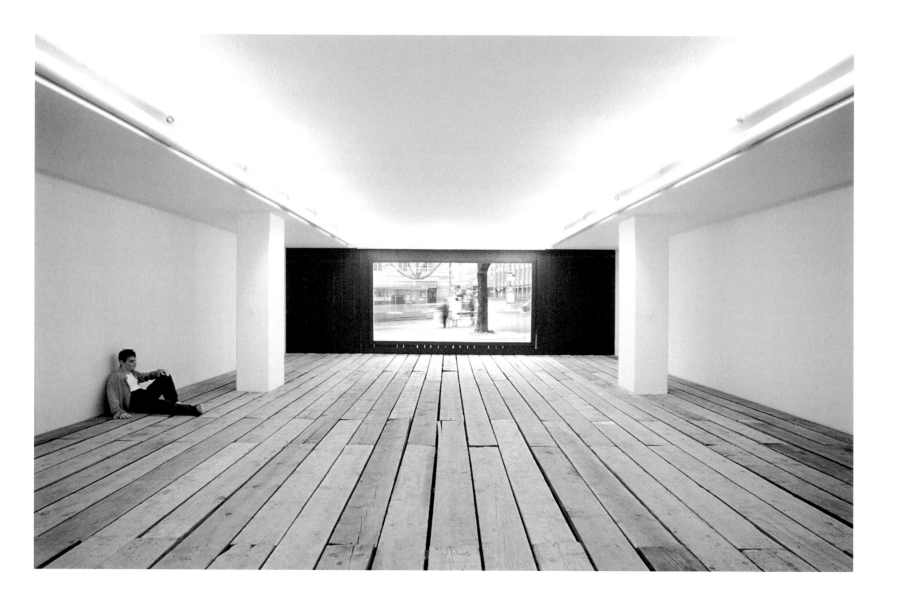

42 heyday
1995, polyester, cotton, hair, wooden floor,
wooden wall, paint, perspex; dimensions variable

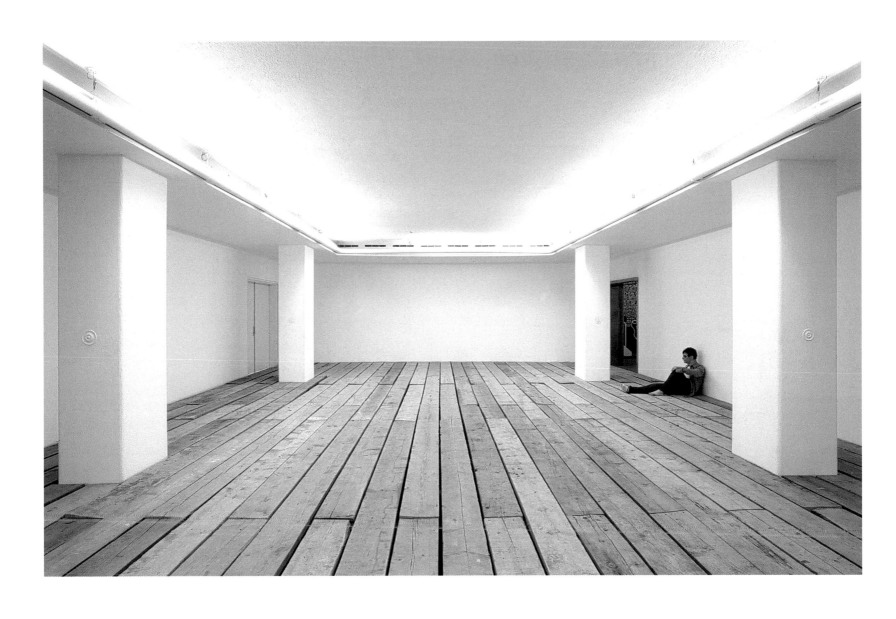

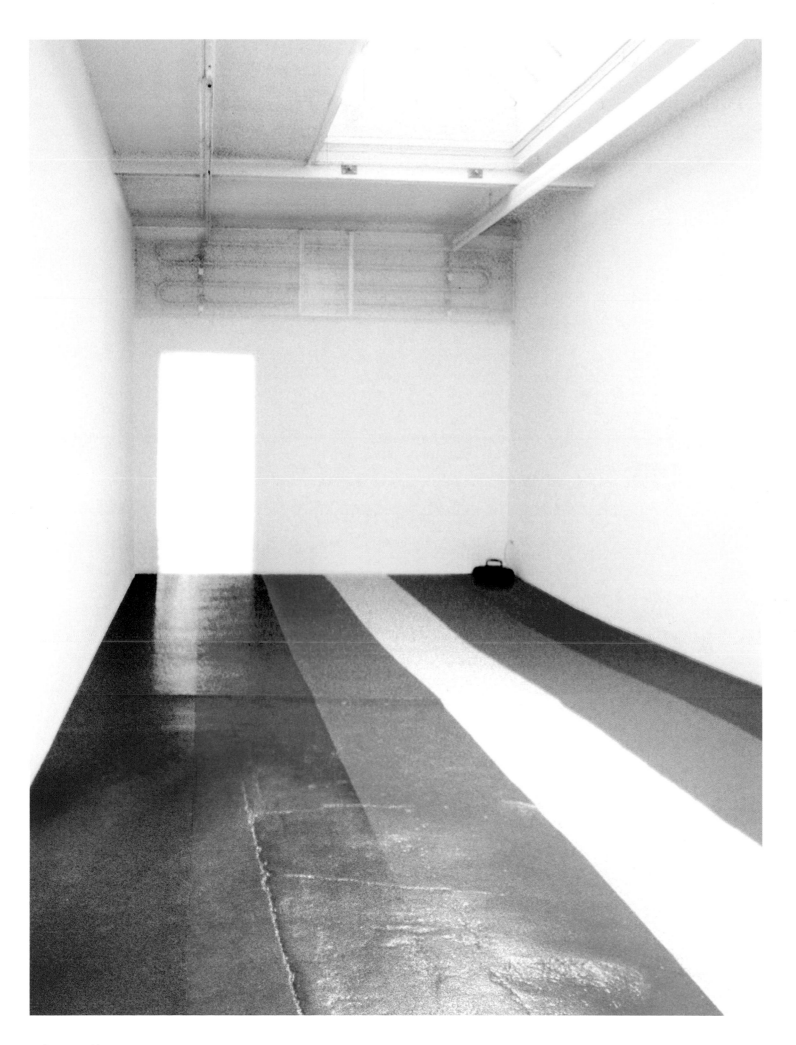

you're my sunshine
1996, floor paint, tape and tape recorder; dimensions variable

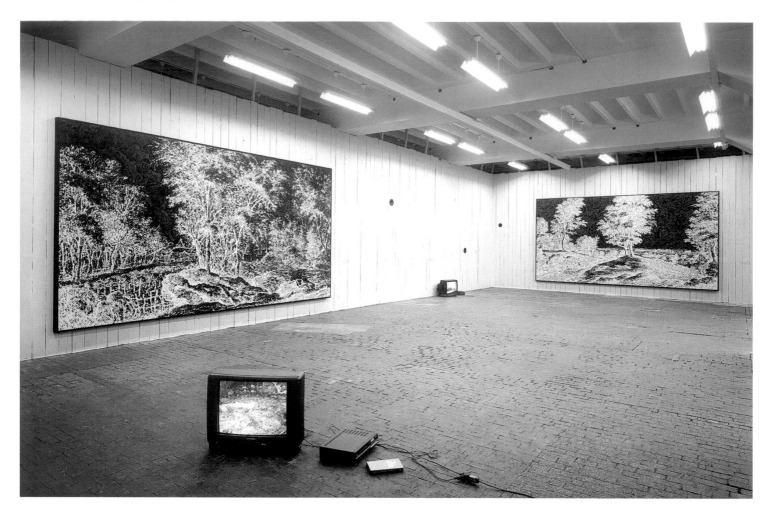

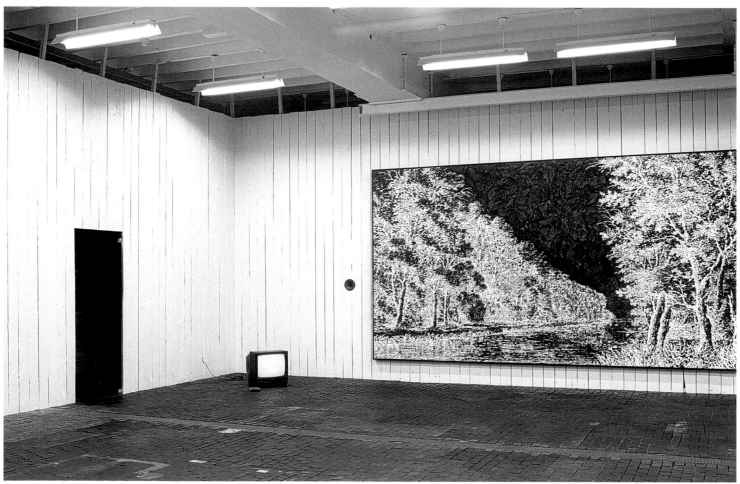

46 dritternovemberneunzehnhundertfünfundneunzig days between stations
 1996, ink on paper, wooden frame; 300 × 500 cm 1992–work in progress, 540 videotapes, 9 shelf units made of pinewood; 203 × 167 × 20 cm each shelf

 sechzehnterdezemberneunzehnhundertfünfundneunzig siebteroktoberneunzehnhundertfünfundneunzig
 1996, ink on paper, wooden frame; 300 × 500 cm 1996, ink on paper, wooden frame; 300 × 500 cm

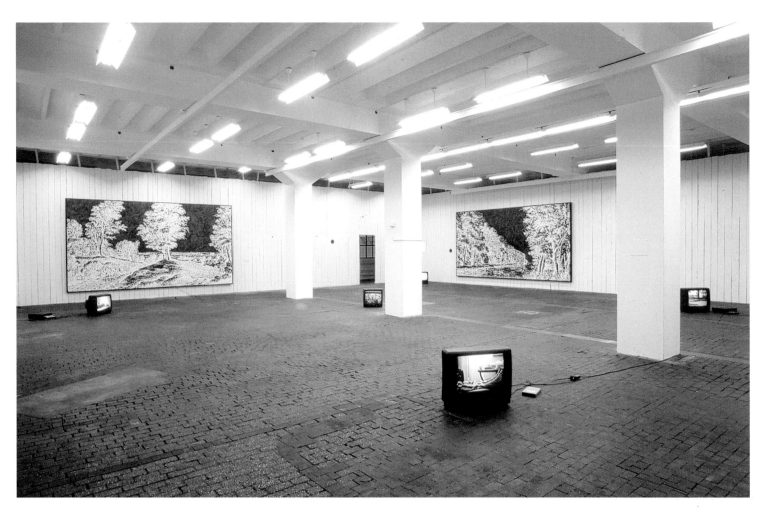

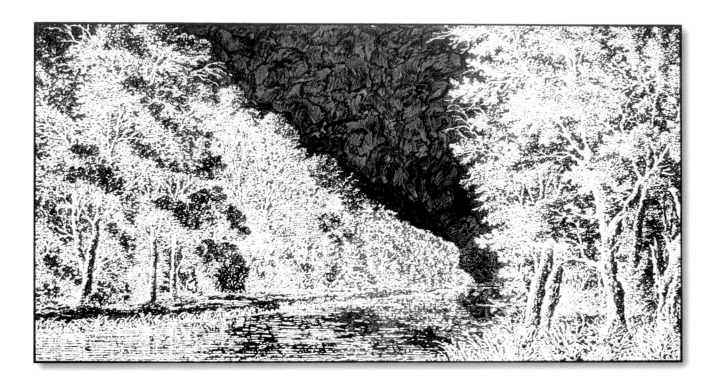

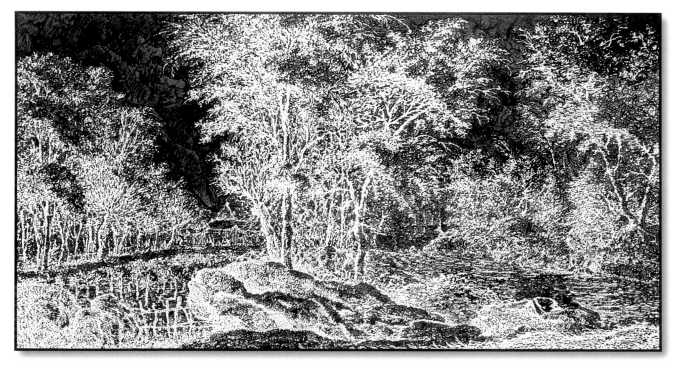

siebteroktoberneunzehnhundertfünfundneunzig
1996, ink on paper, mounted on canvas; 300 × 500 cm

dritternovemberneunzehnhundertfünfundneunzig
1996, ink on paper, mounted on canvas; 300 × 500 cm

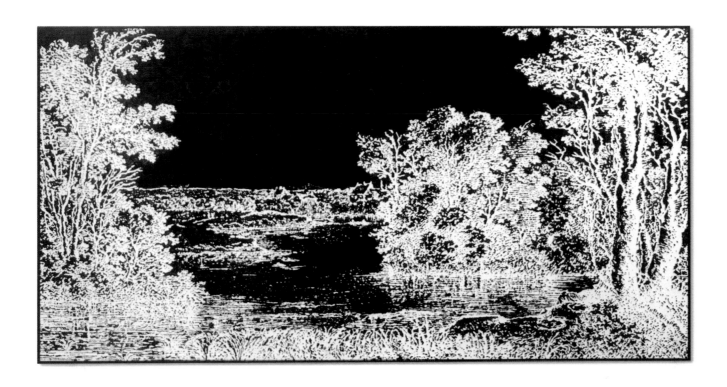

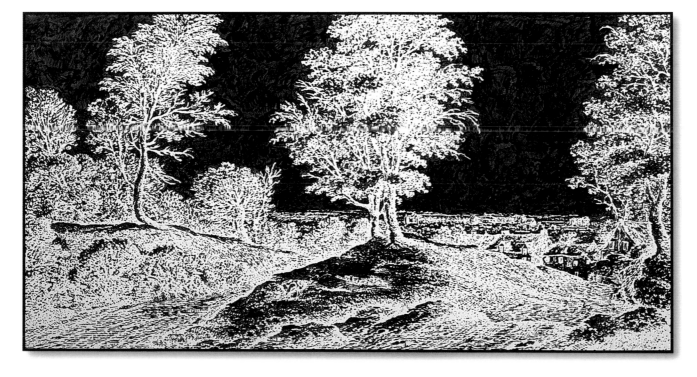

vierundzwanzigsternovemberneunzehnhundertfünfundneunzig
1996, ink on paper, mounted on canvas; 300 × 500 cm

sechzehnterdezemberneunzehnhundertfünfundneunzig
1996, ink on paper, mounted on canvas; 300 × 500 cm

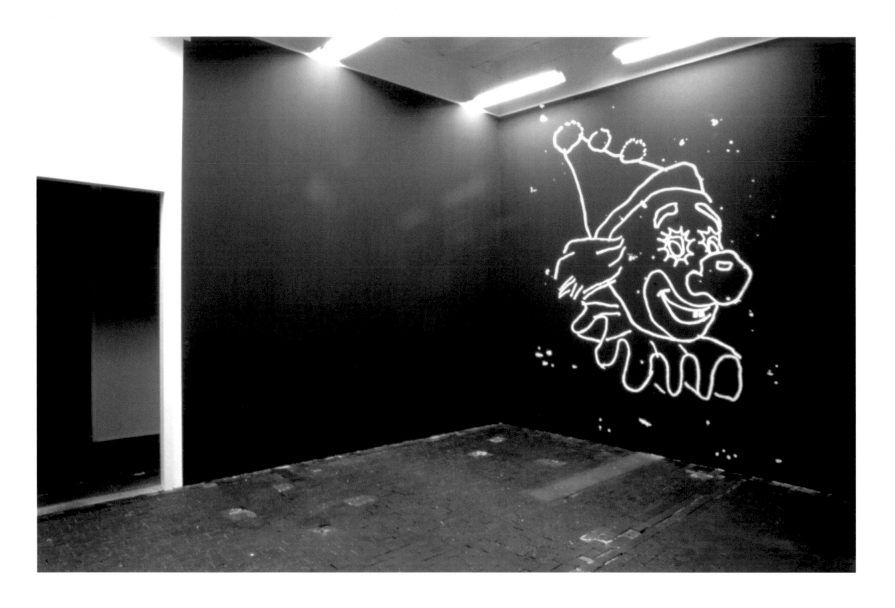

50 untitled
 1996, mural painting; dimensions variable

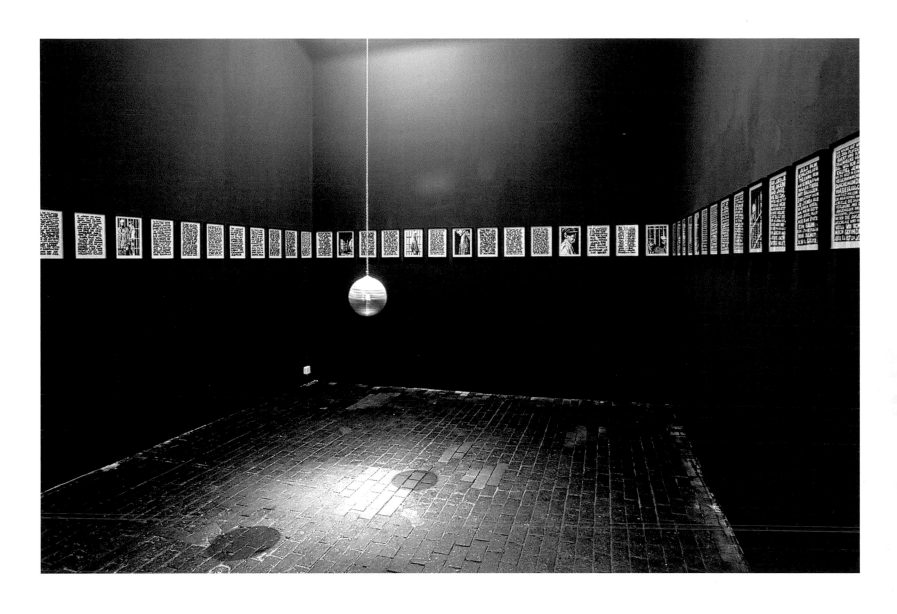

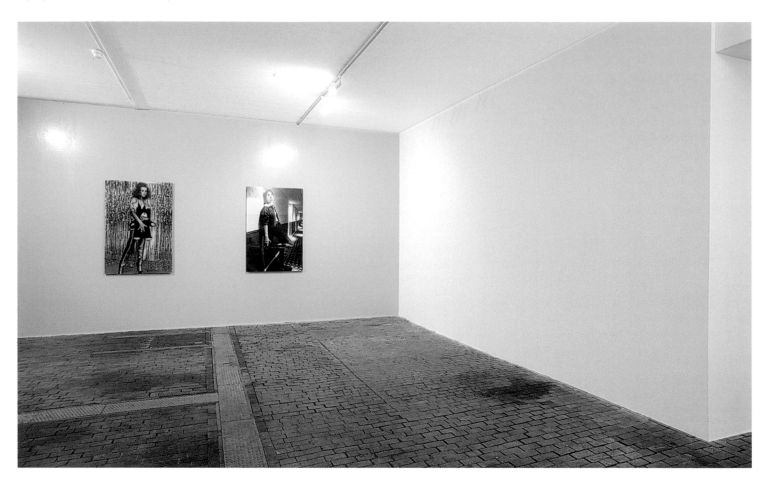

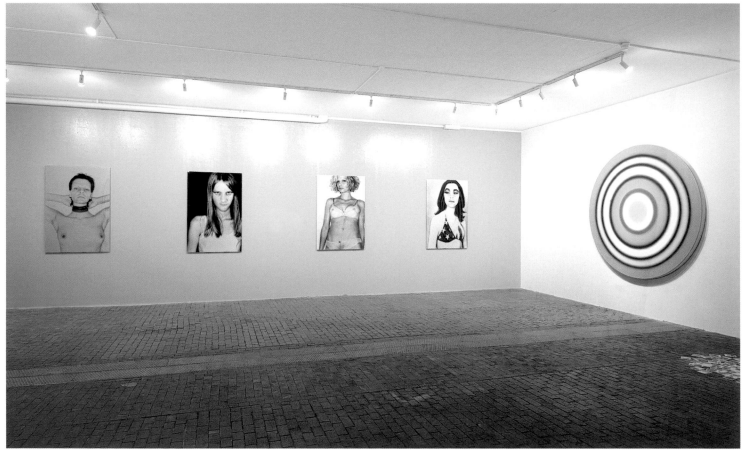

52 i don't live here anymore
1995, c-prints mounted on perspex; 150 × 100 cm each

elfteraugustneunzehnhundertfünfundneunzig
1995, acrylic paint on canvas; ø 220 cm

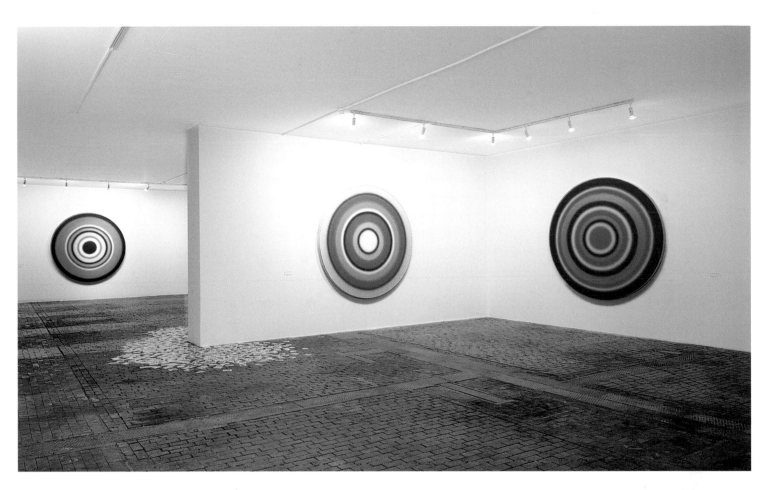

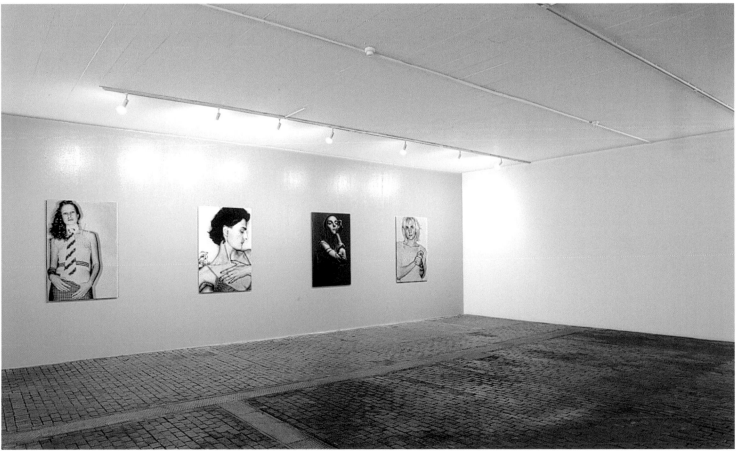

neuntermaineunzehnhundertfünfundneunzig
1995, acrylic paint on canvas; ø 220 cm

zwölftermärzneunzehnhundertfünfundneunzig
1995, acrylic paint on canvas; ø 220 cm

achtzehnteraprilneunzehnhundertfünfundneunzig
1995, acrylic paint on canvas; ø 220 cm

please?
1995, 60 polaroids; dimensions variable

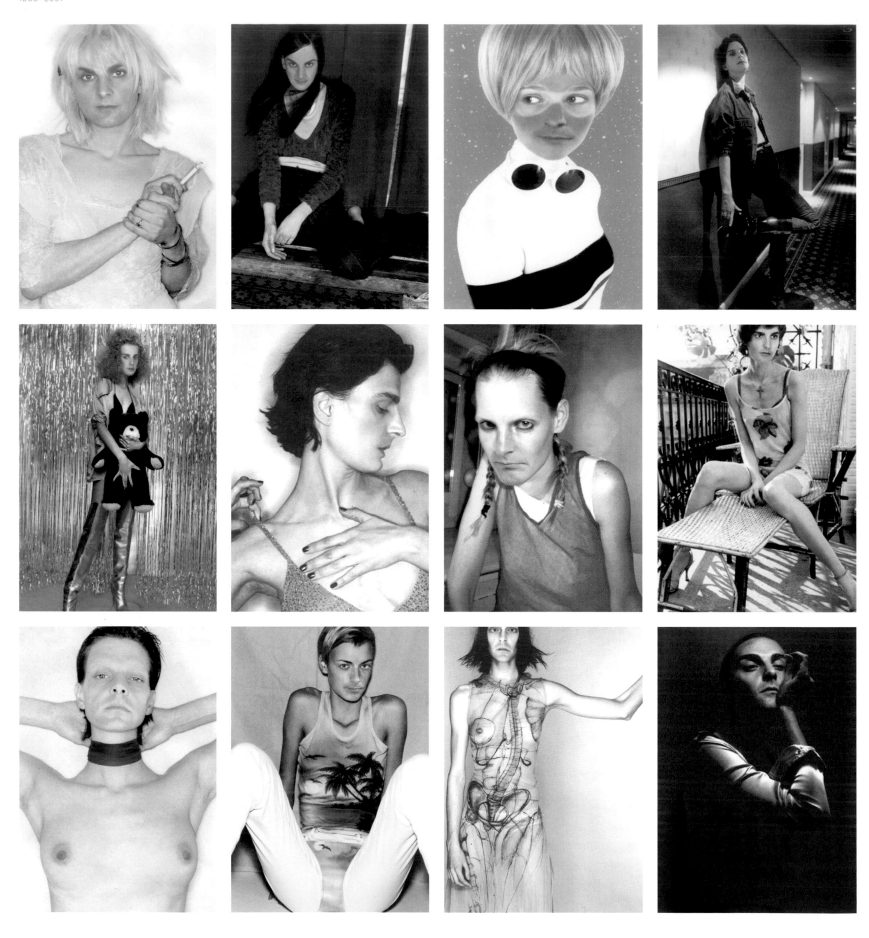

all: i don't live here anymore
1995–2001, c-prints mounted on perspex; 150 × 100 cm each

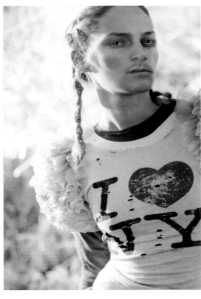
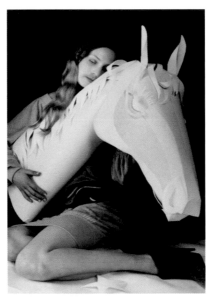
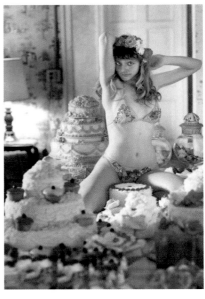
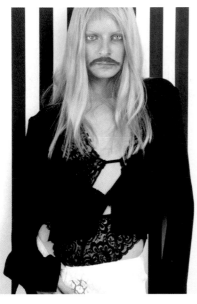
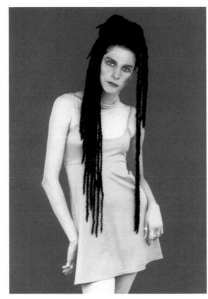
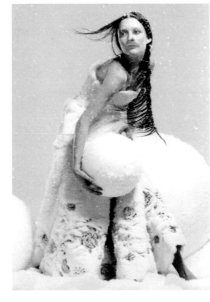
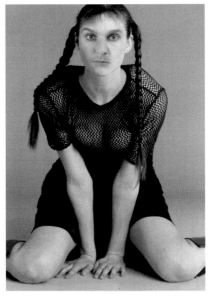
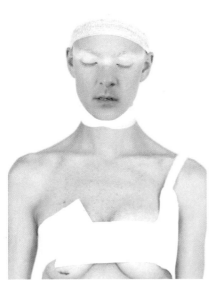
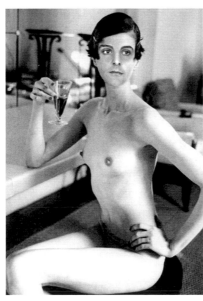
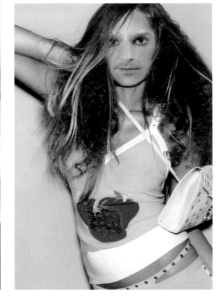
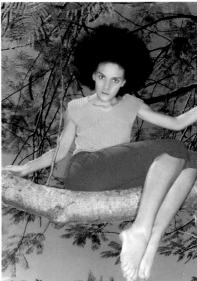

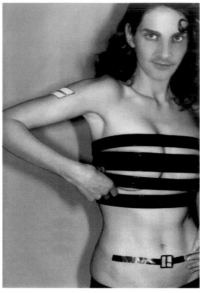
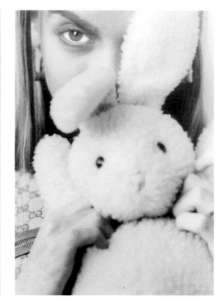
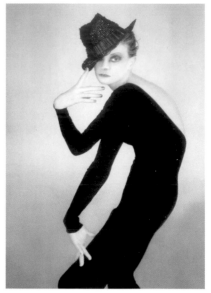
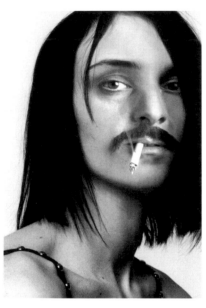
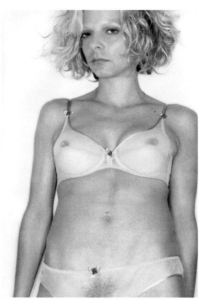
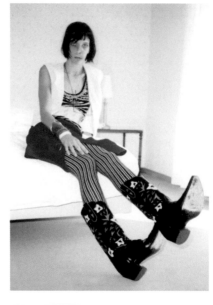
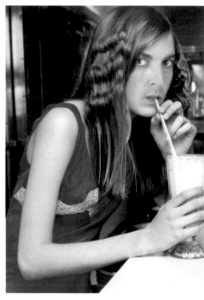
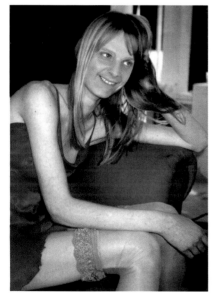
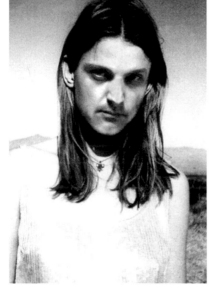
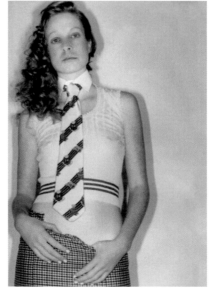
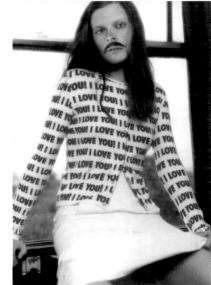

56 all: i don't live here anymore
1995–2001, c-prints mounted on perspex; 150 × 100 cm each

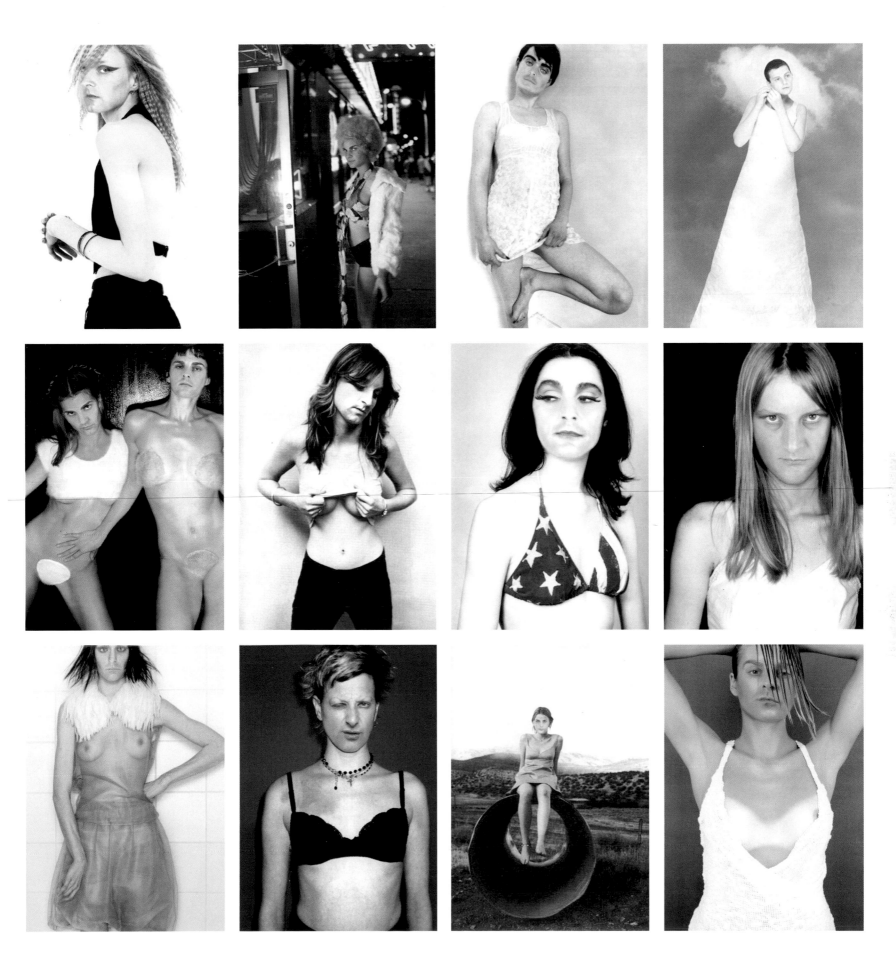

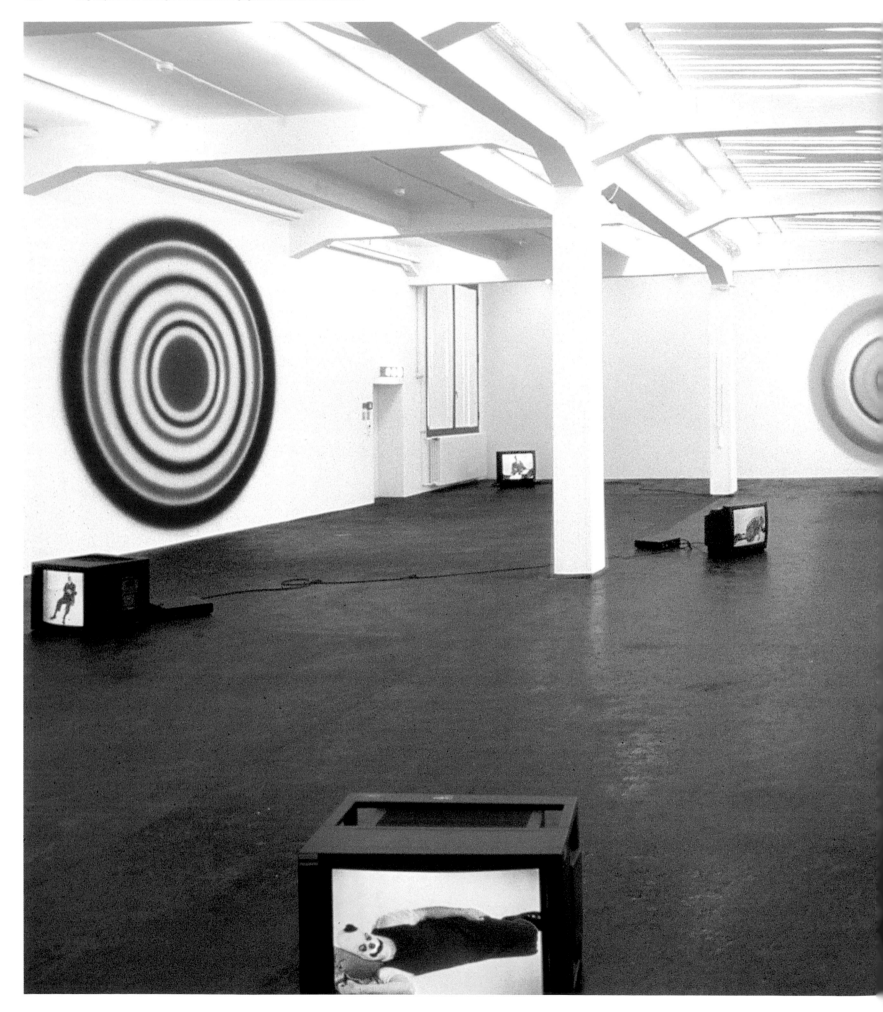

dog days are over achtzehnteraprilneunzehnhundertfünfundneunzig
 1996, 6 dvds, 12 speakers, 12 sensors, sound; 1996, acrylic mural painting; ø 400 cm
 dimensions variable

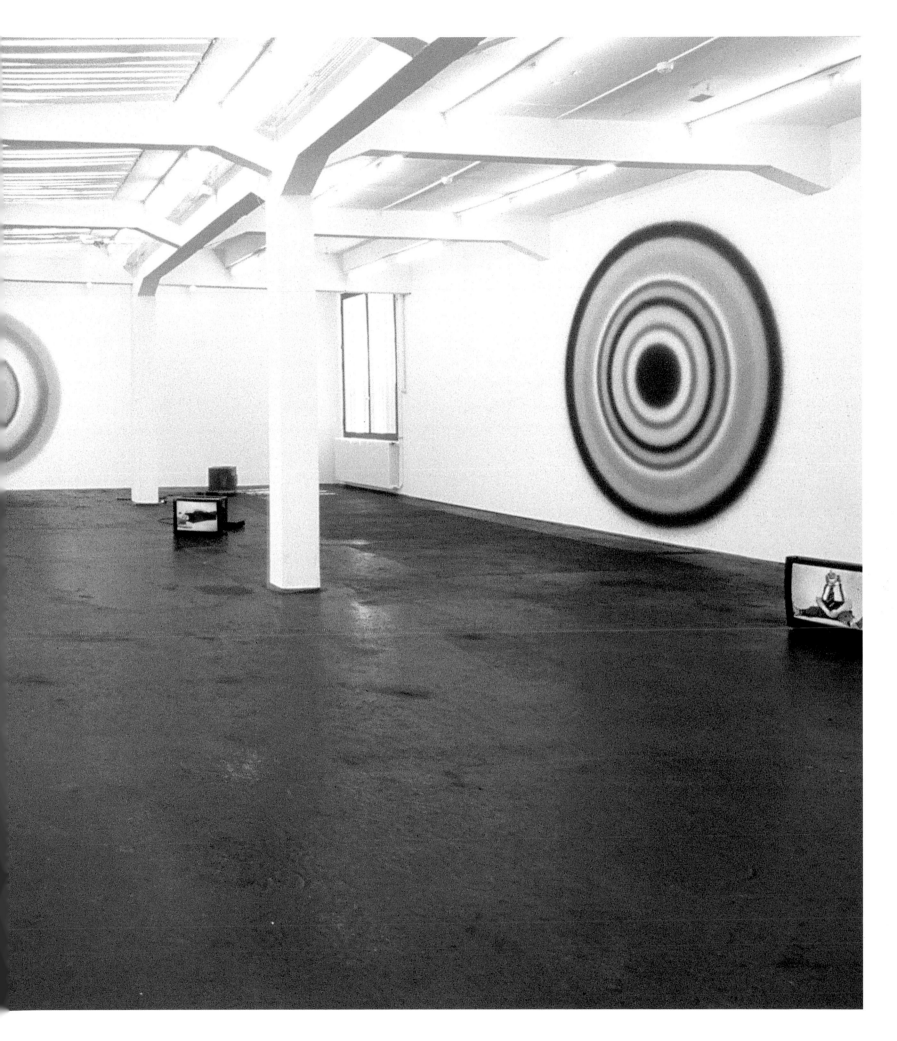

zwölftermärzneunzehnhundertfünfundneunzig
1996, acrylic mural painting; ø 400 cm

neuntermaineunzehnhundertfünfundneunzig
1996, acrylic mural painting; ø 400 cm

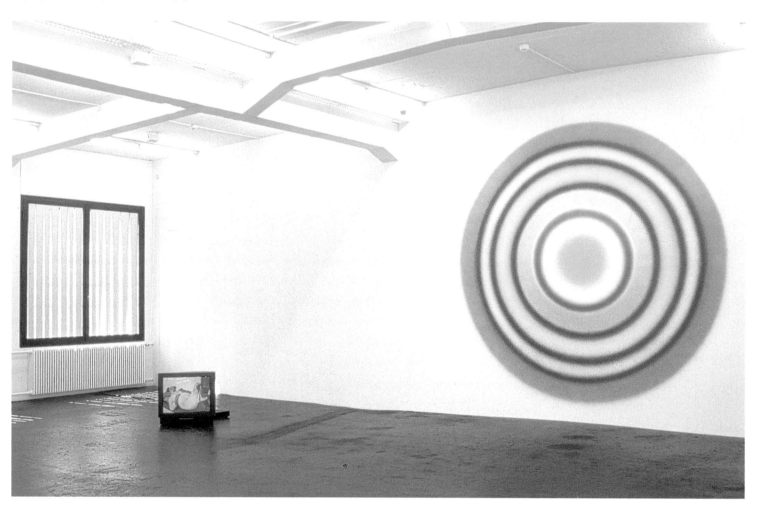

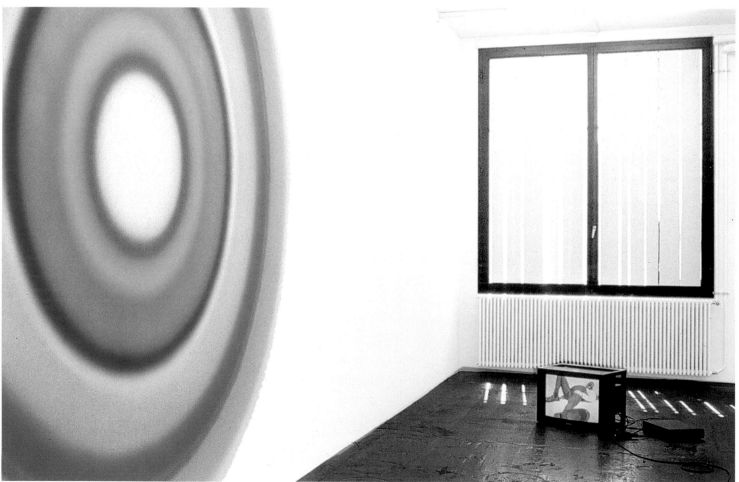

60 dog days are over
1996, 6 dvds, 12 speakers, 12 sensors, sound; dimensions variable

elfteraugustneunzehnhundertfünfundneunzig
1996, acrylic mural painting; ø 400 cm

zwölftermärzneunzehnhundertfünfundneunzig
1996, acrylic mural painting; ø 400 cm

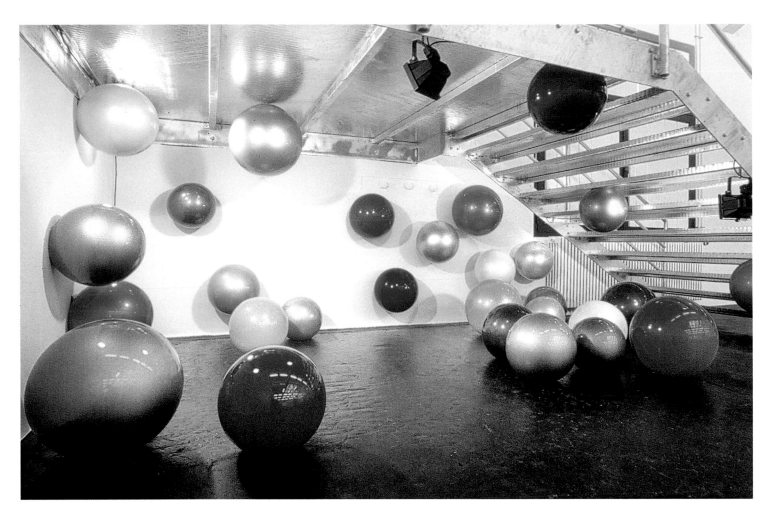

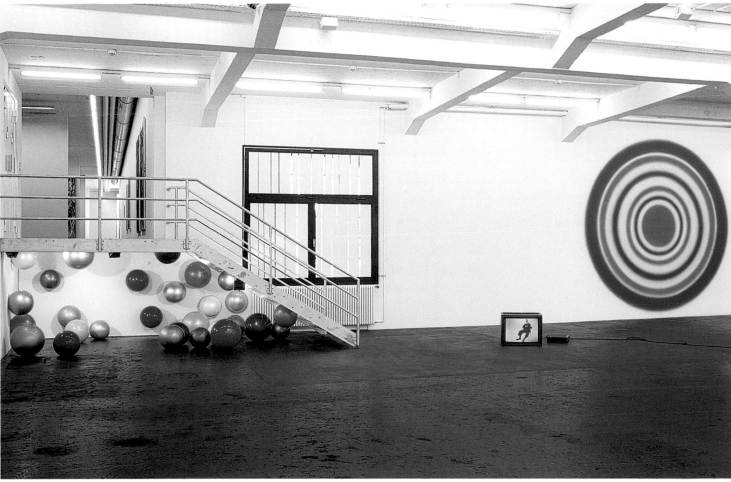

gone with the wind
1996, baked car enamel on 32 polyester spheres, sound; ø 50-70 cm each

achtzehnteraprilneunzehnhundertfünfundneunzig
1996, acrylic mural painting; ø 400 cm

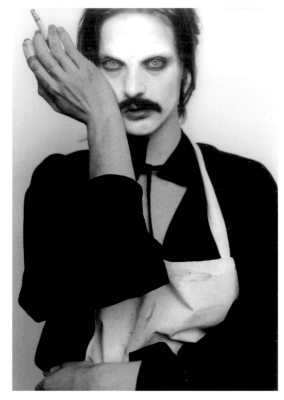
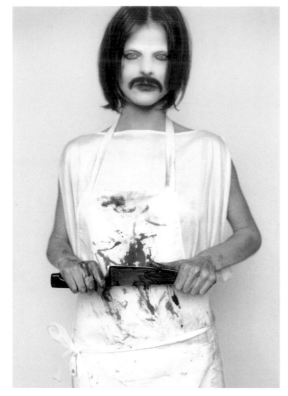
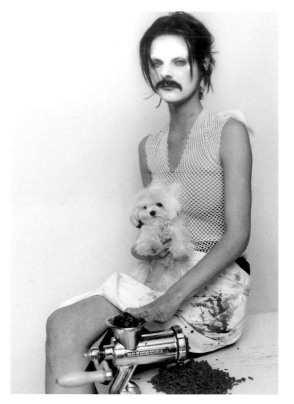
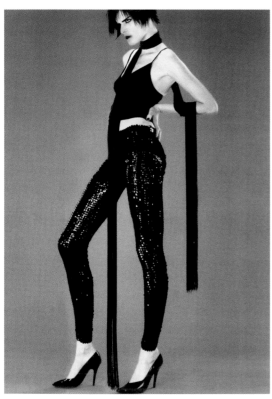
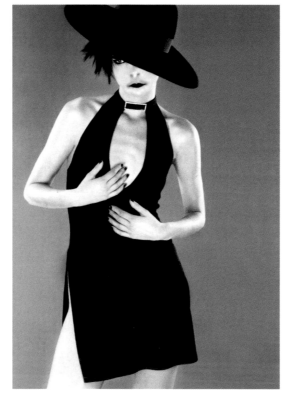
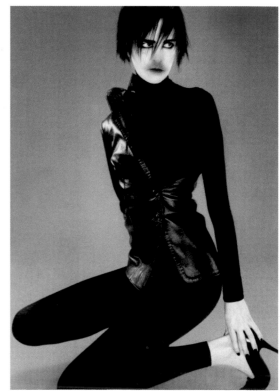

i don't live here anymore
1996, 5 parts, c-prints mounted on perspex; 150 × 100 cm each

i don't live here anymore
1996, 6 parts, c-prints mounted on perspex; 150 × 100 cm each

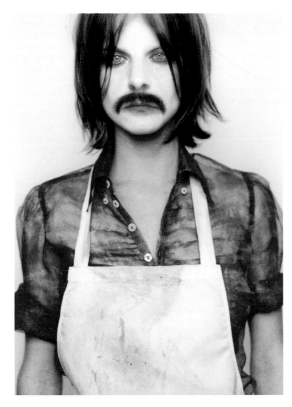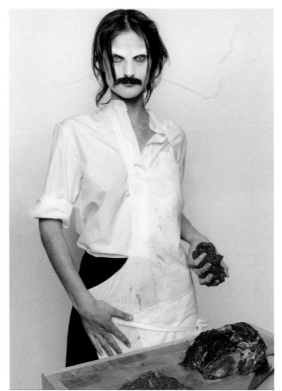

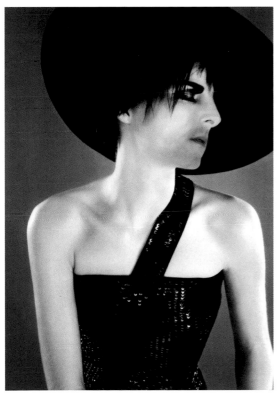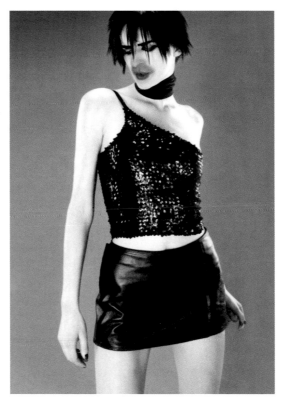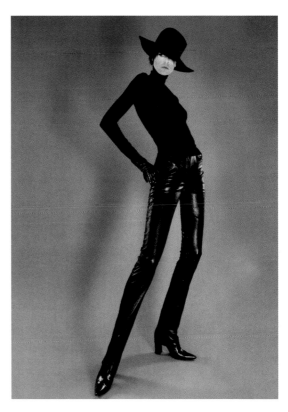

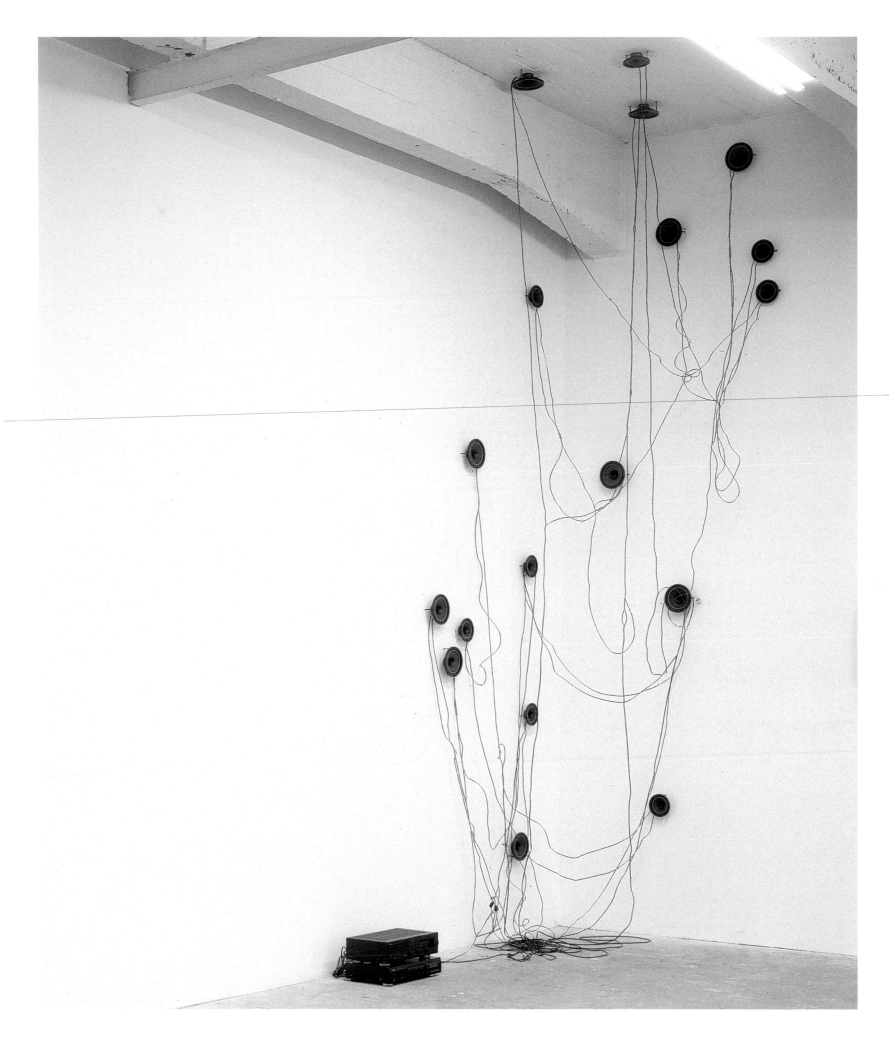

my sister is a rainmaker
1996, 18 speakers, sound

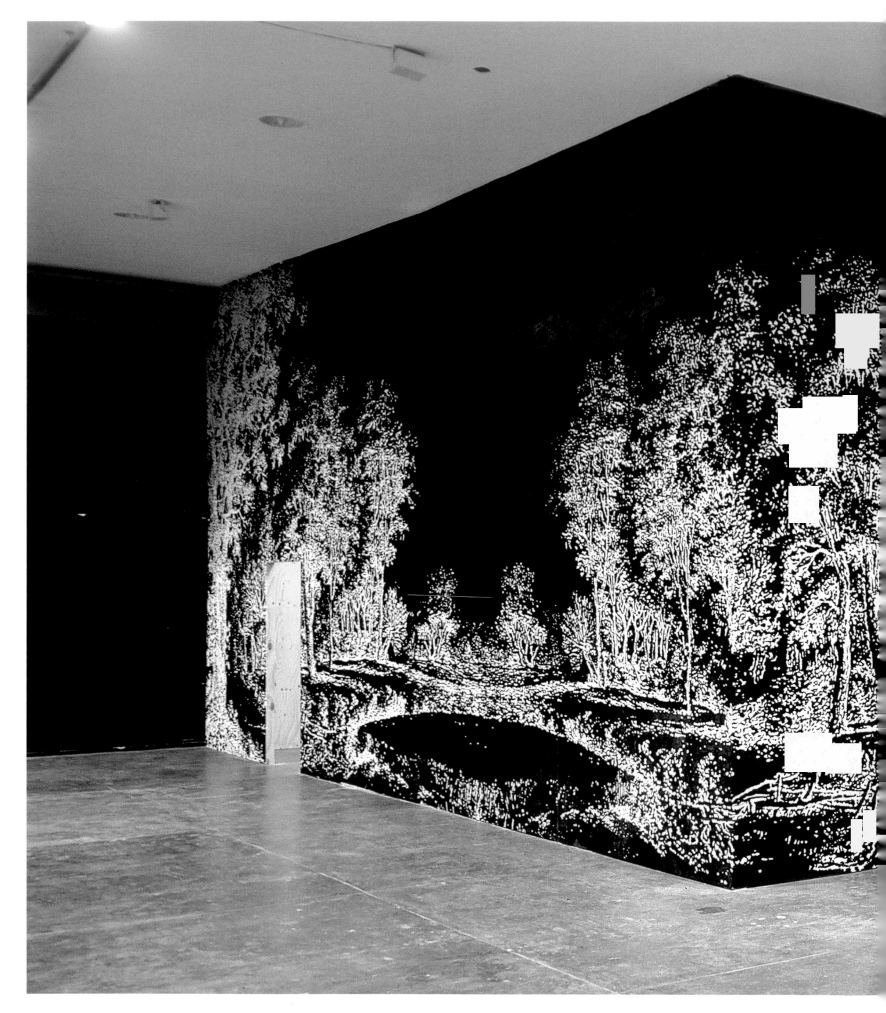

where do we go from here?
1996, ink on wall, plywood, yellow neon, 4 dvds, 4 projections; 500 × 1200 × 1000 cm

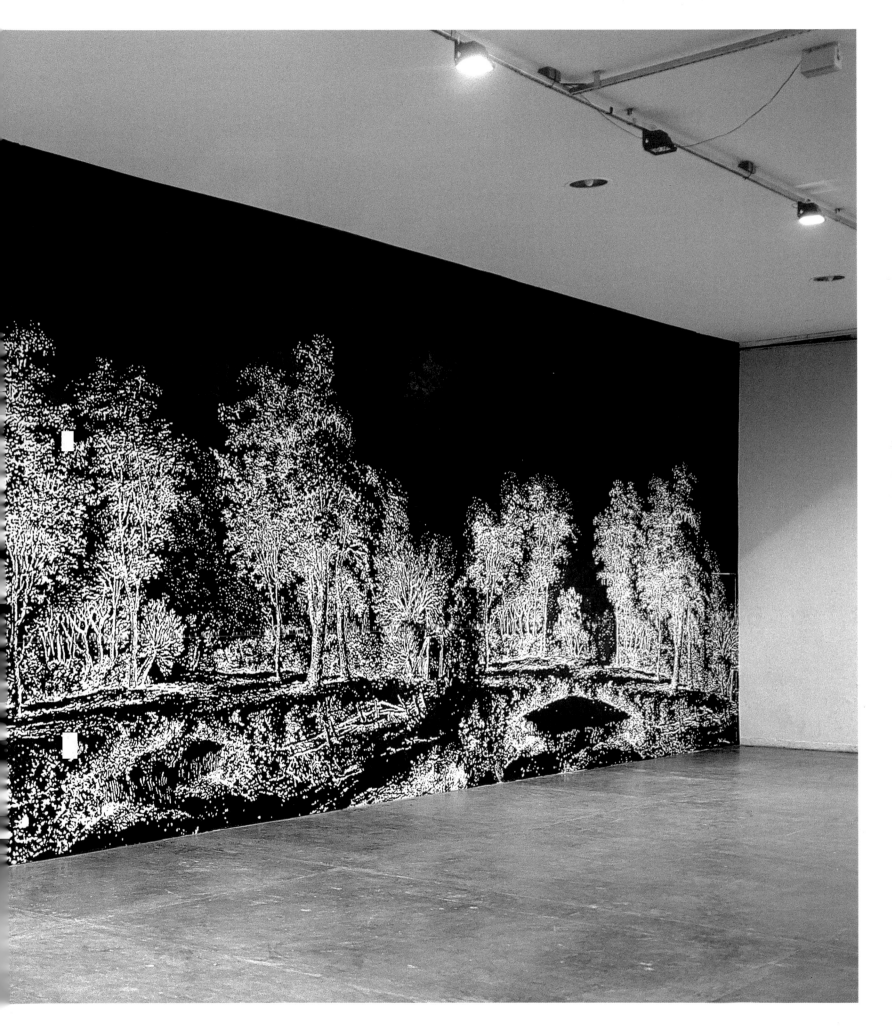

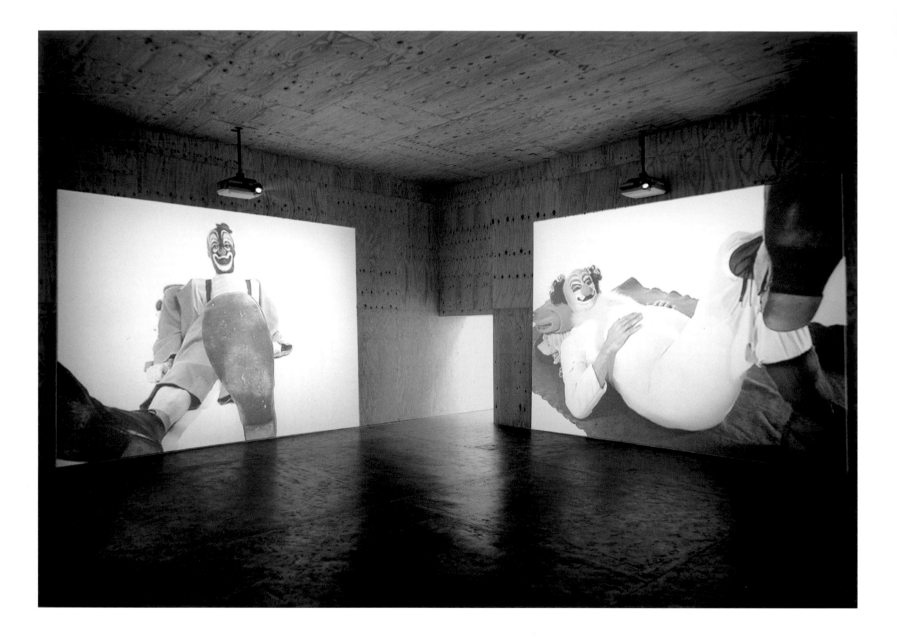

where do we go from here?
1996, ink on wall, plywood, yellow neon, 4 dvds, 4 projections; 500 × 1200 × 1000 cm

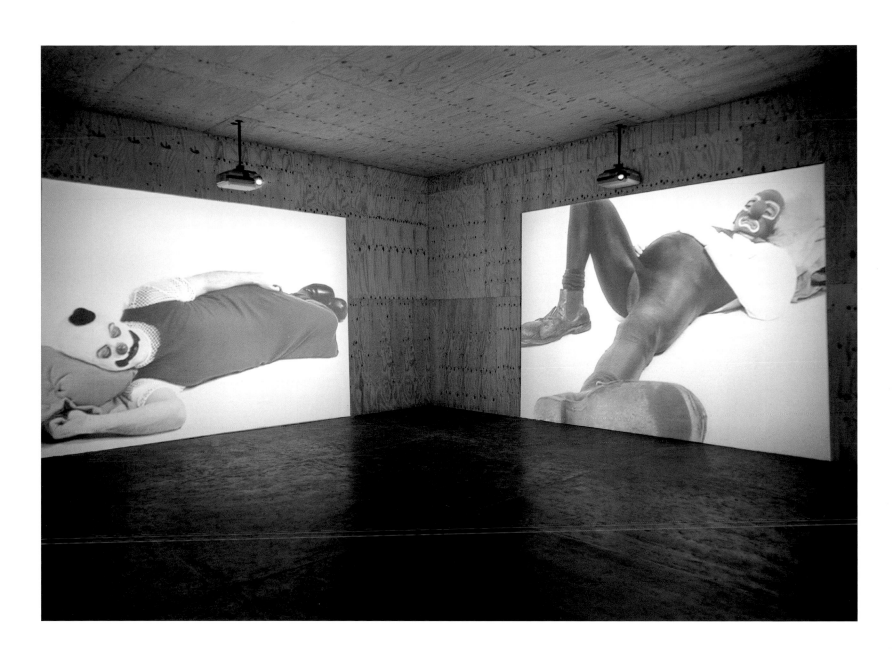

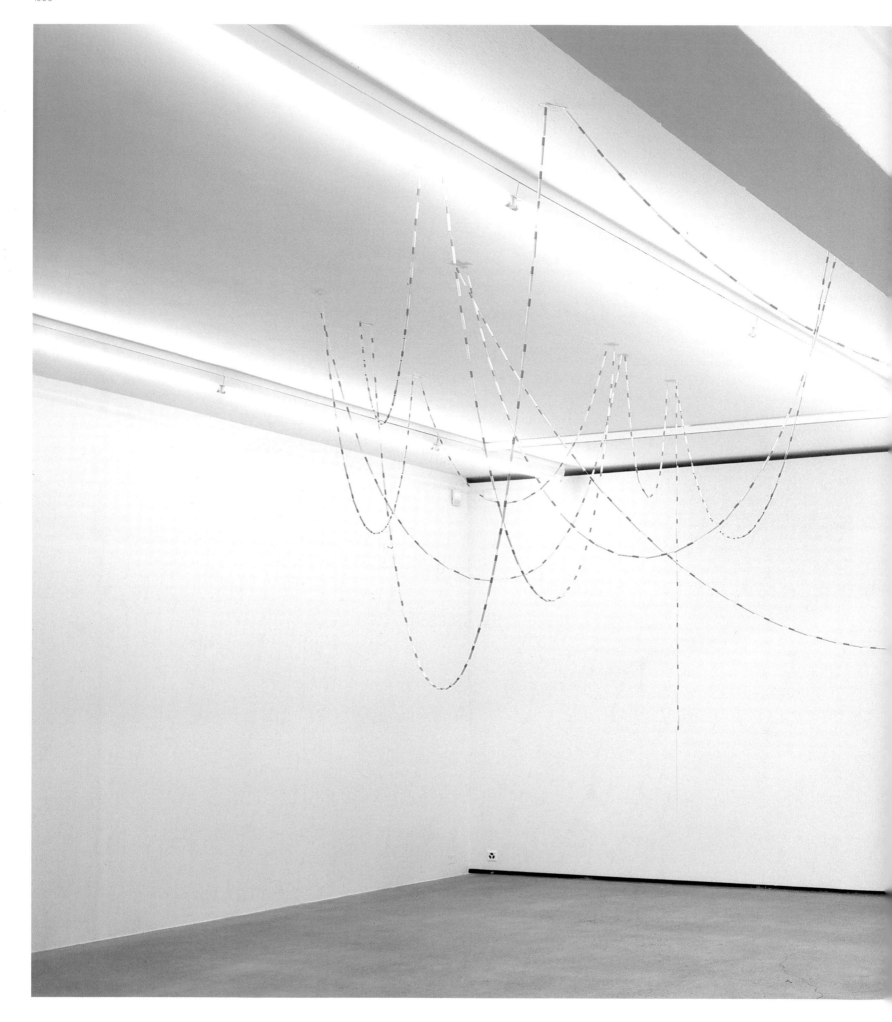

autumn harvest uprising
1996, aluminium, paint, string

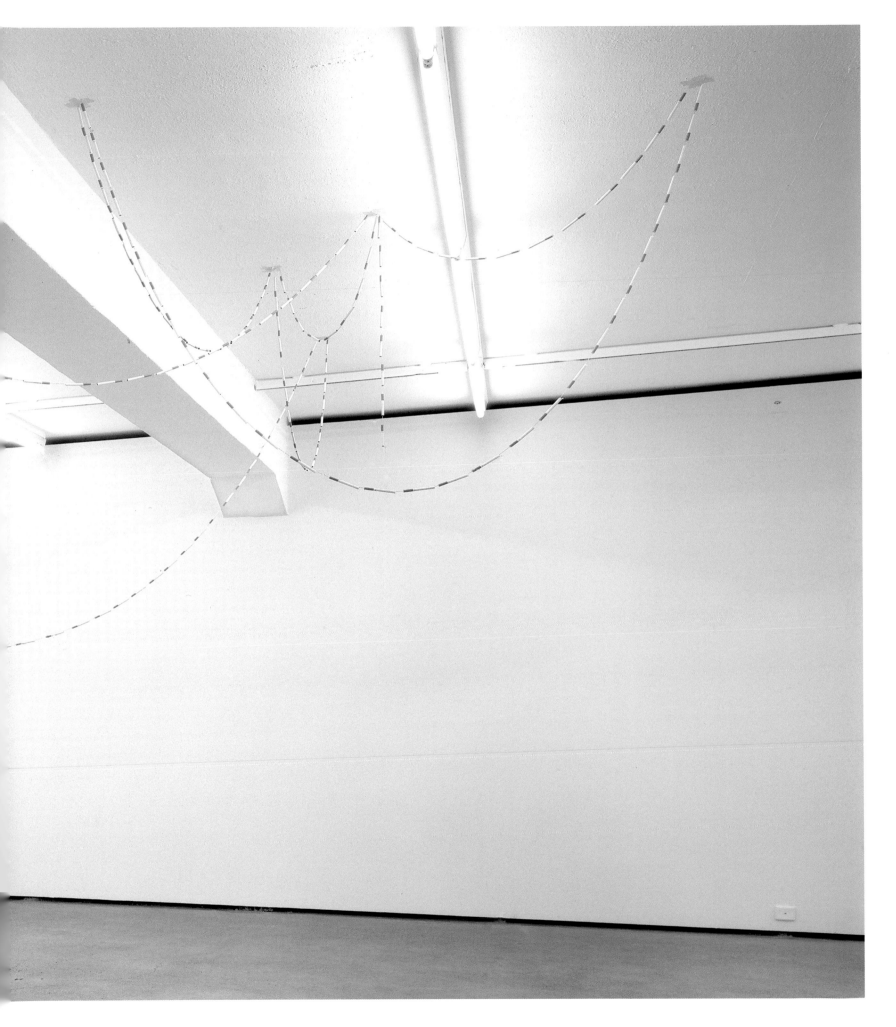

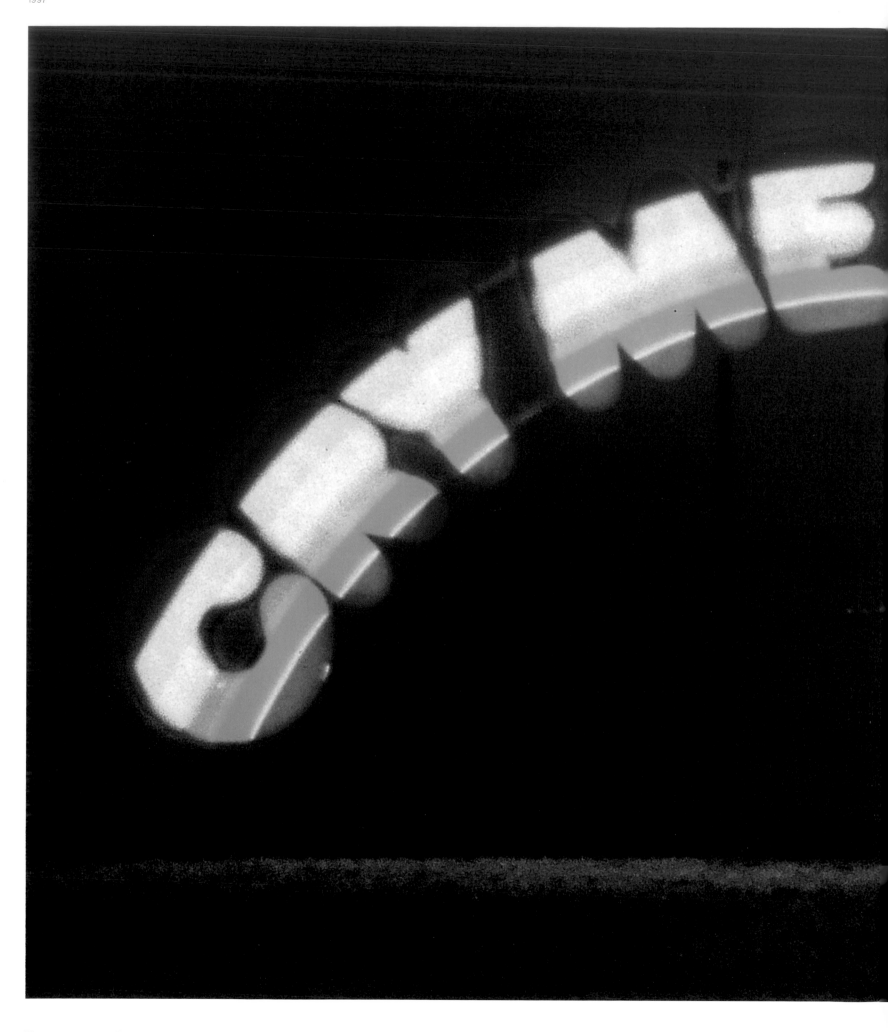

72 cry me a river
1997, neon, perspex, transluscent film, aluminium; 350 × 750 × 10 cm

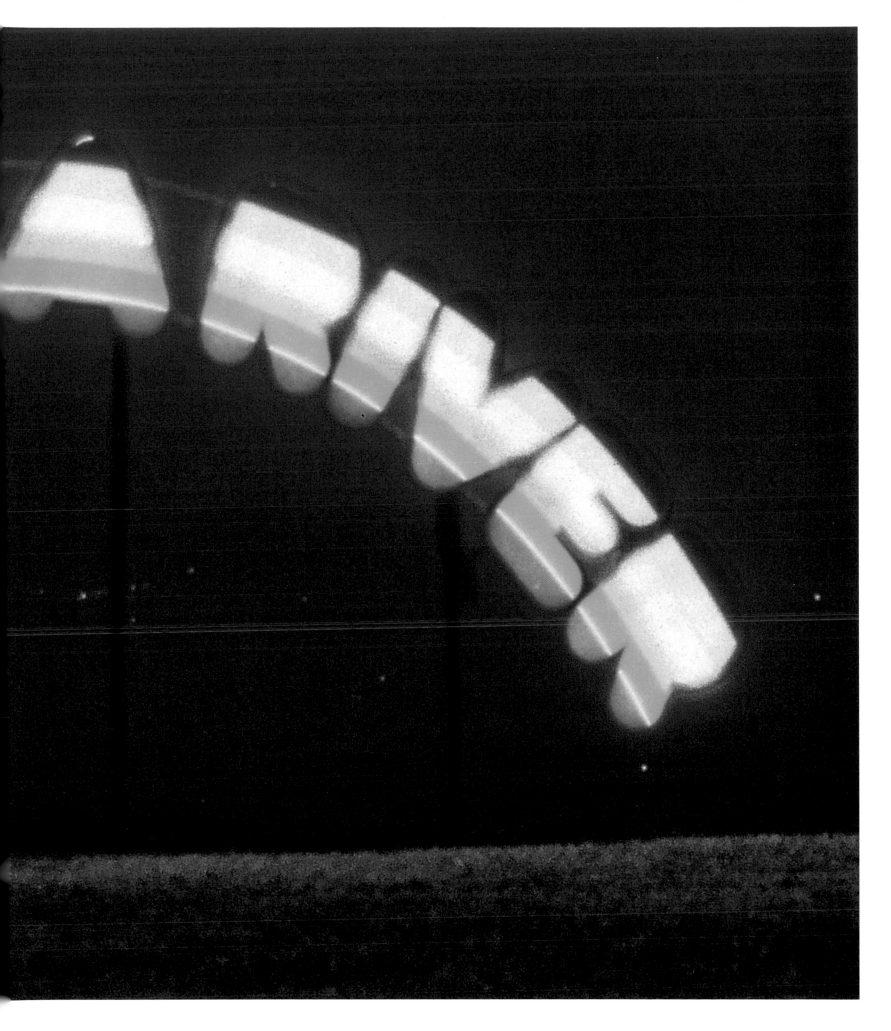

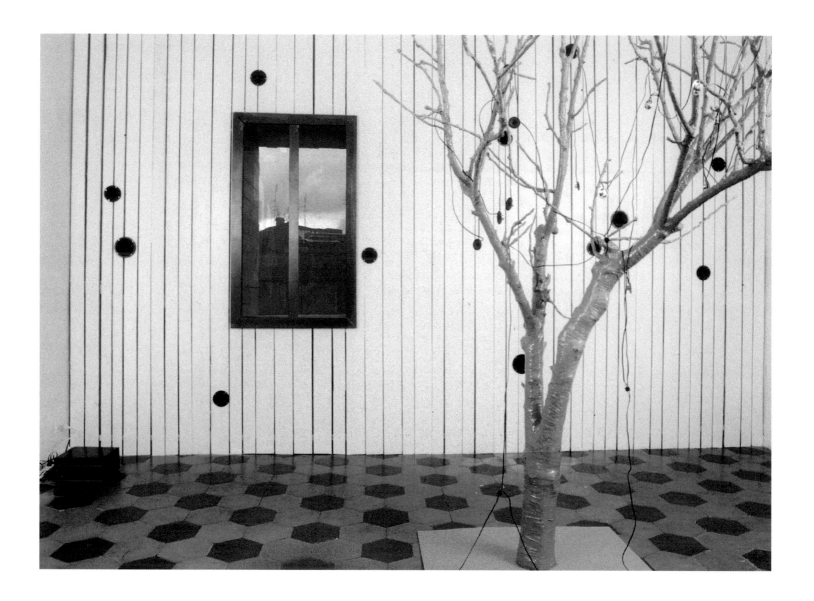

74 everyday sunshine
1997, wooden wall, perspex window, 12 speakers, sound; 300 × 600 cm

moonlight and aspirin
1997, 2 parts, polyester, rubber tape, 40 speakers, sound, text loop; 300 × 120 cm each

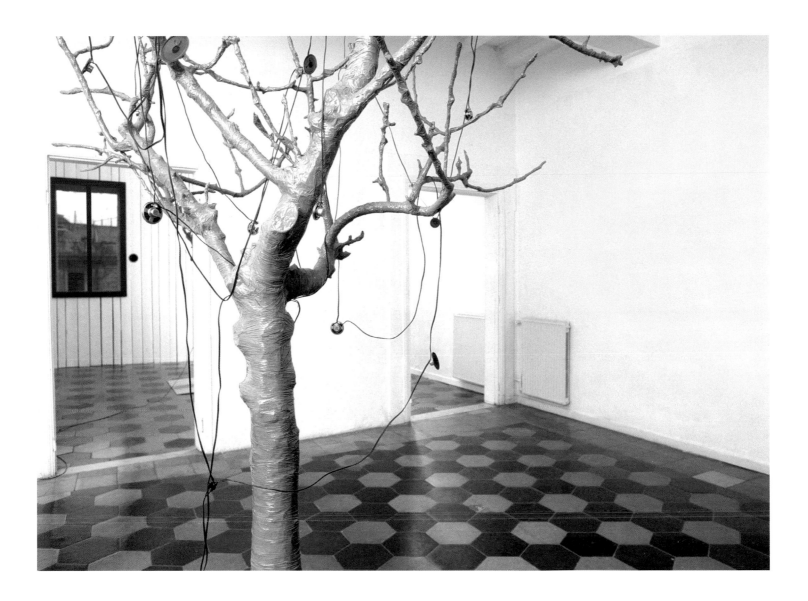

w: where are you going?
m. just gonna get a cup of coffee.
 you want something?
w. yeah, can i have a hot chocolate?
m. ok, i'll get it.
w. when are you coming back?
m. what do you mean? i'm coming
 right back.
w. i just have this feeling that
 you're not gonna come back.
m. i'm coming back in five minutes.
 i'll get your hot chocolate.

w. i really like you. i'm gonna be
 really sad if you don't come
 back. unless you tell me if
 you're not gonna come back, just
 tell me. don't lie to me. you're
 gonna come back, right?
m. if you don't want me to go, i
 won't go. all right? i won't get
 you the hot chocolate.
w. look, if you wanna coffee, go
 get a coffee. but just come back.
m. i told you i'm coming back.

w. can i get a kiss goodbye?
m. no! don't start trouble. don't
 start evil. i didn't say i'd
 give you a kiss. i said i'd get
 you a hot chocolate. ok! so, i'm
 gonna go.
w. where are you going?
m. just gonna get a cup of coffee.
 you want something?
w. yeah, can i have a hot chocolate?
m. ok, i'll get it.
...

76 all: i don't live here anymore
1997, c-prints mounted on perspex; 100 × 150 cm each

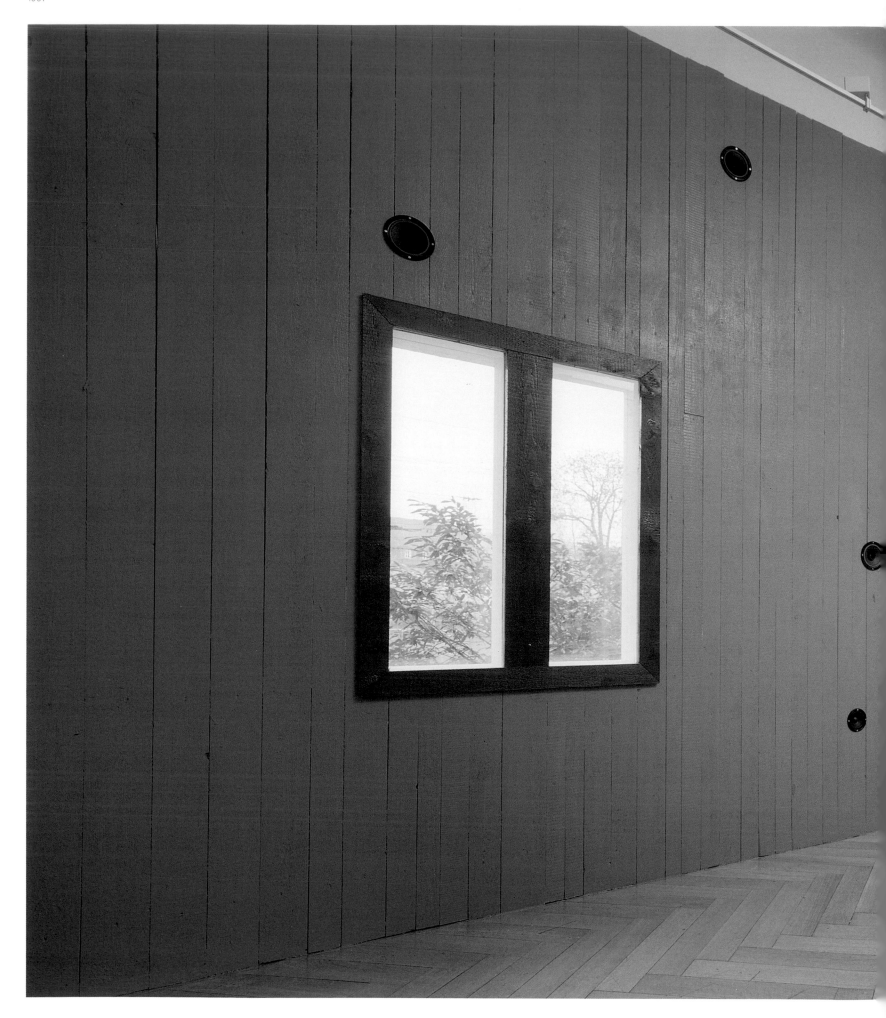

tender places come from nothing
1997, wood, yellow perspex windows, 12 speakers, sound; dimensions variable

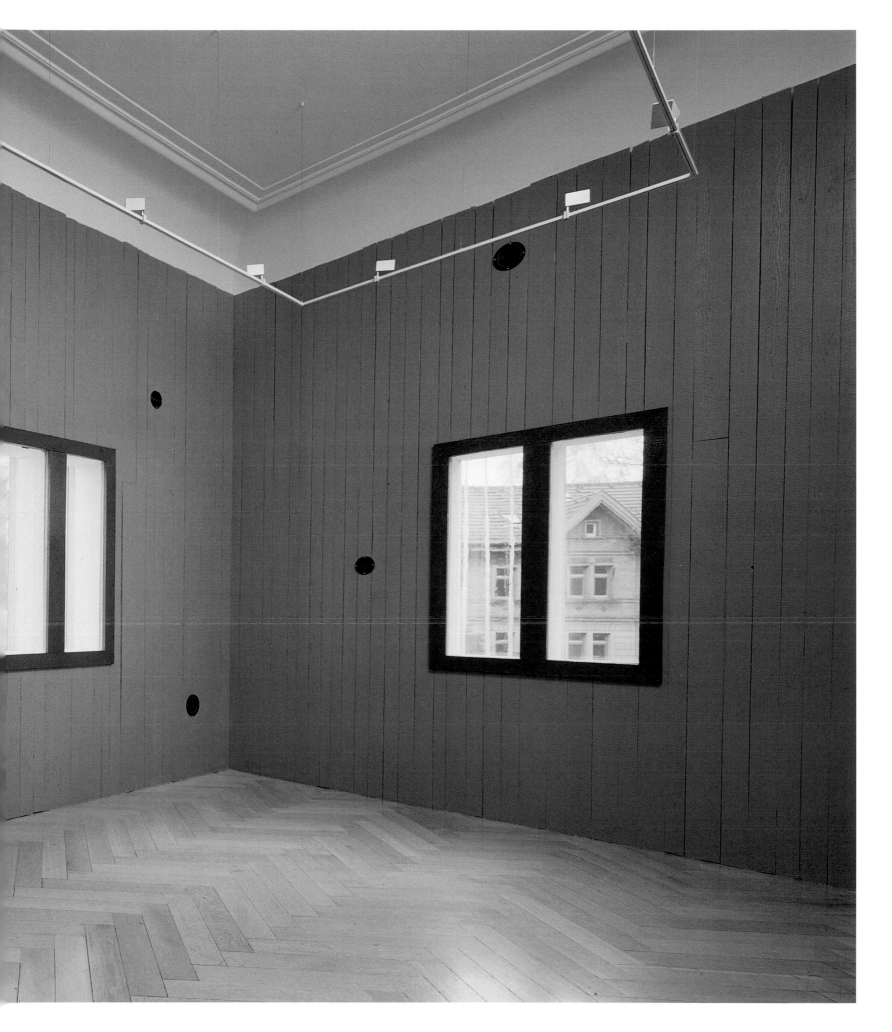

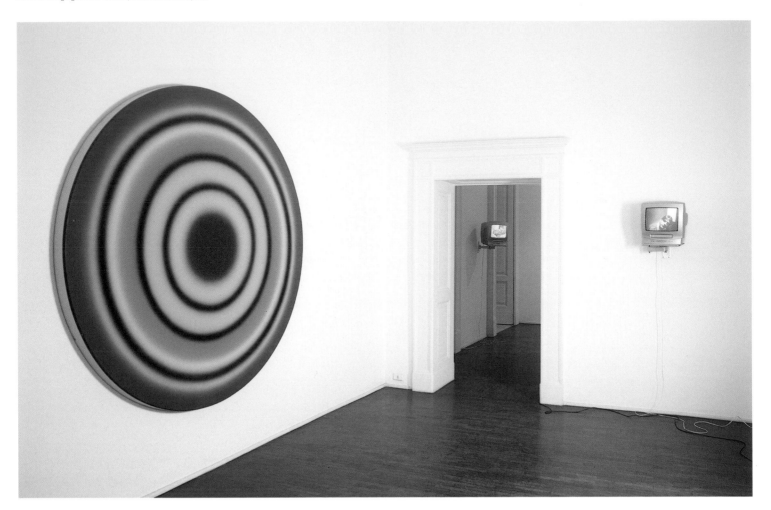

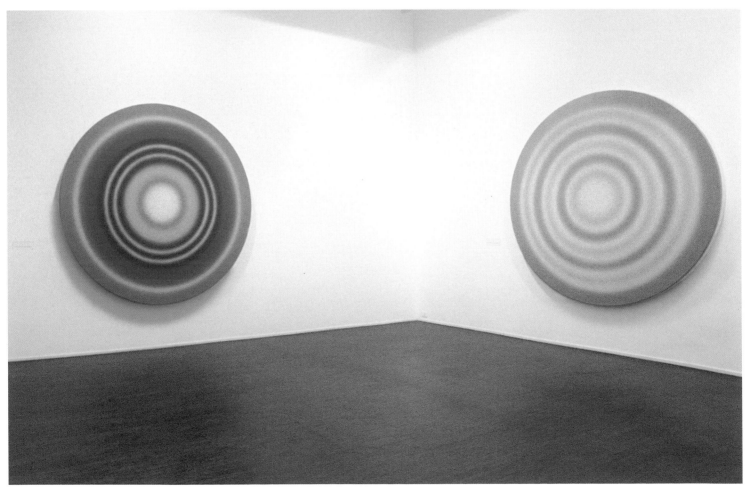

fünfzehnteraugustneunzehnhundertsiebenundneunzig
1997, acrylic paint on canvas; ø 220 cm

dritterseptemberneunzehnhundertsiebenundneunzig
1997, acrylic paint on canvas; ø 220 cm

stillsmoking part I
1997, 4 monitors, 4 dvds, speakers, sound; 200 × 350 × 40 cm

vierundzwanzigsteroktoberneunzehnhundertsiebenundneunzig
1997, acrylic paint on canvas; ø 220 cm

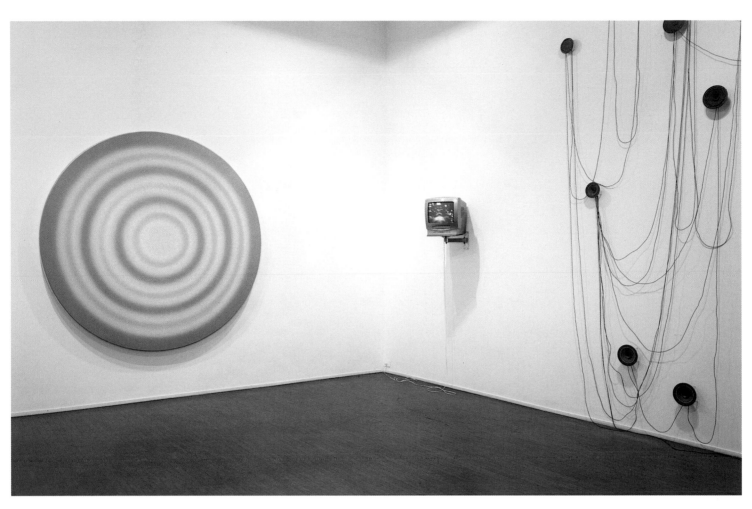

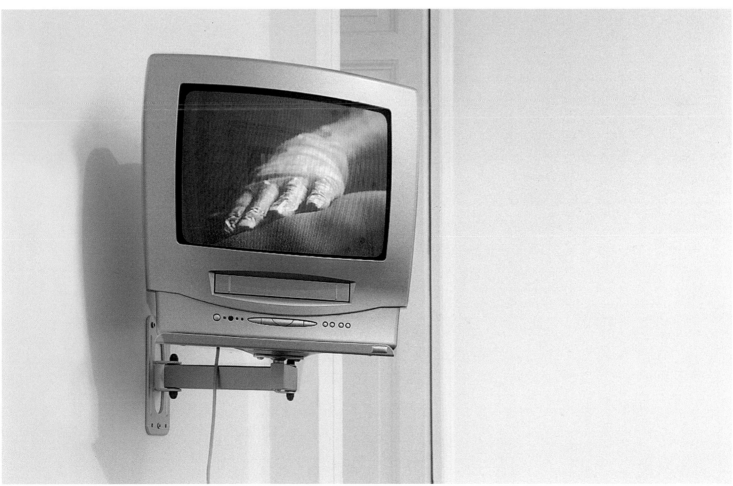

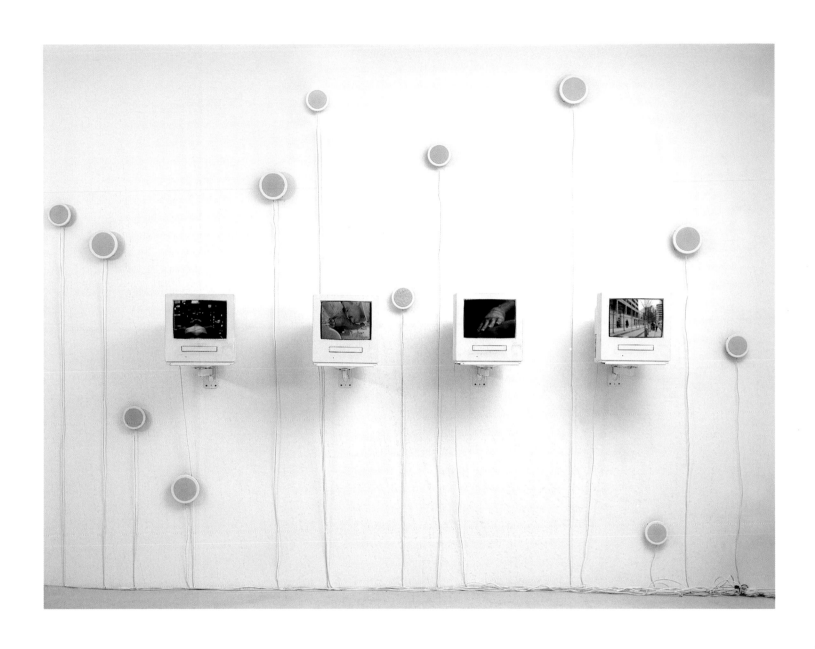

stillsmoking part I
1997, 4 monitors, 4 dvds, speakers, sound; 200 × 350 × 40 cm

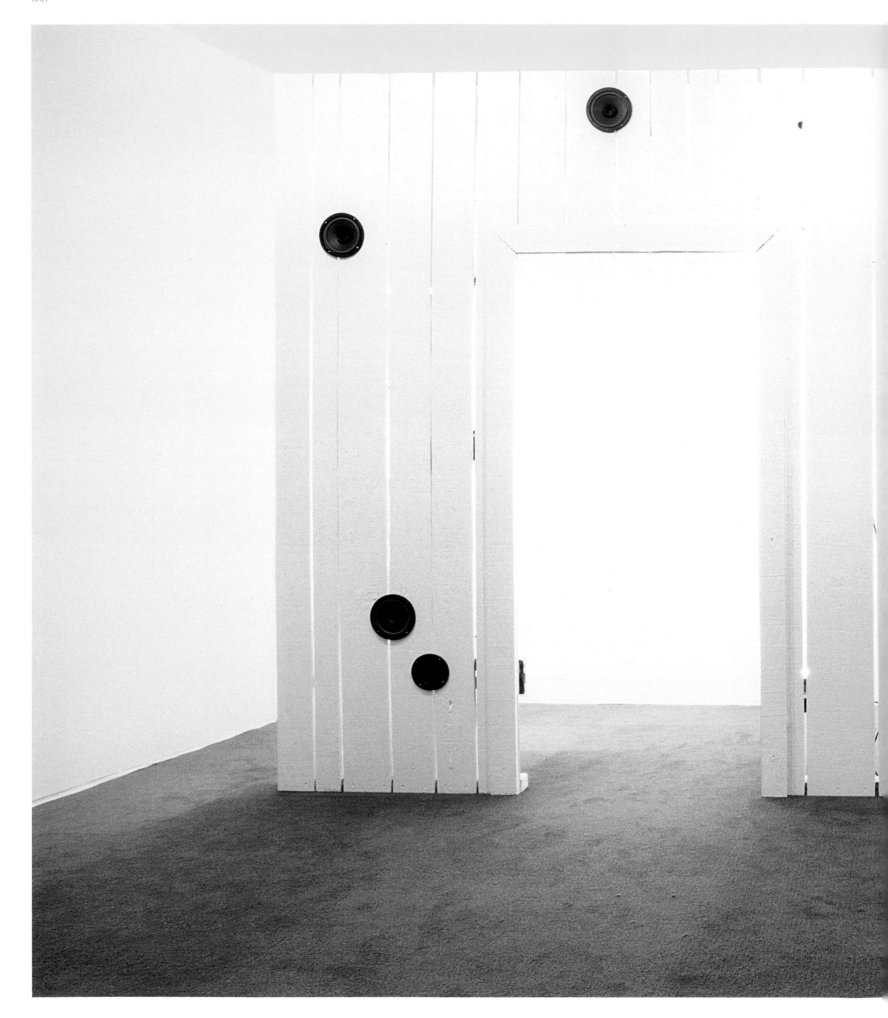

84 bonjour tristesse
1997, polyester, cotton, wood, paint, speakers, spotlights, sound; 300 × 500 × 270 cm

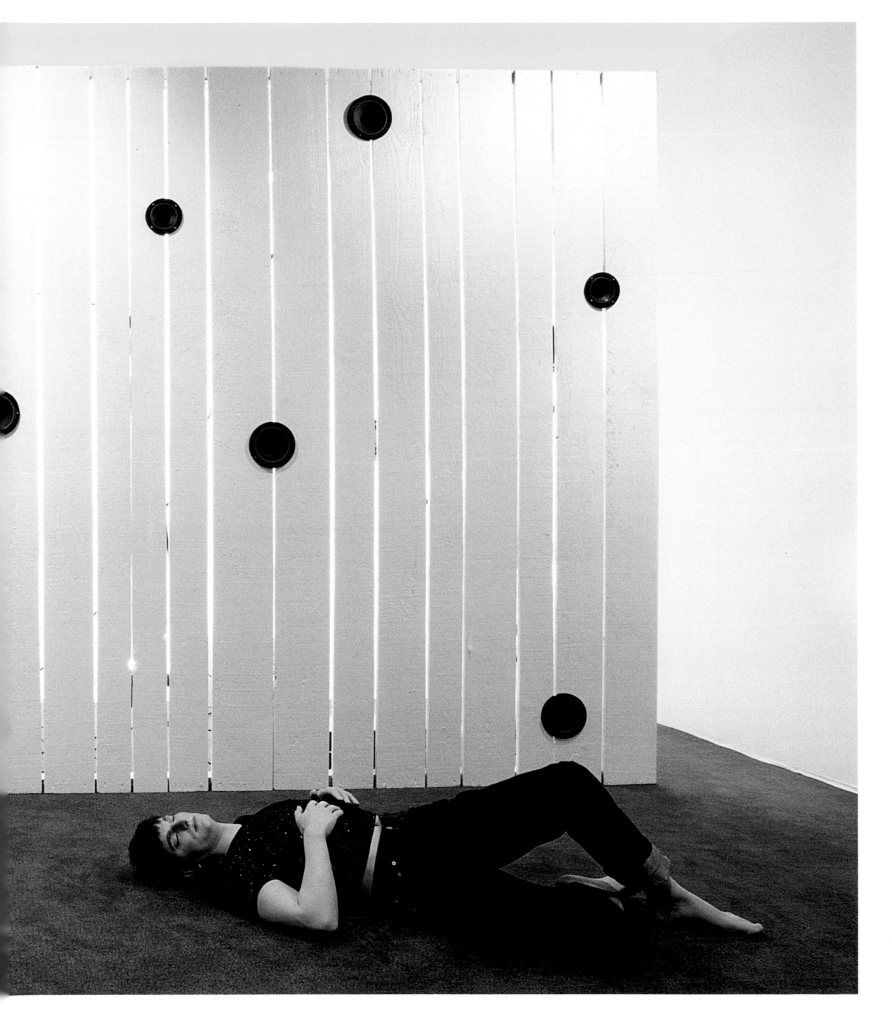

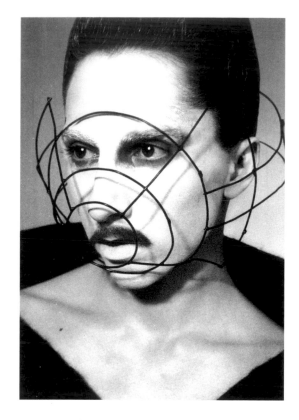
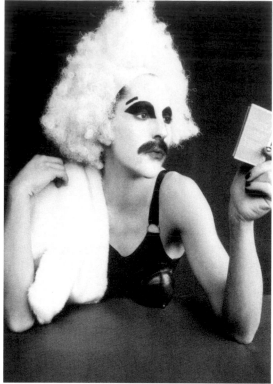
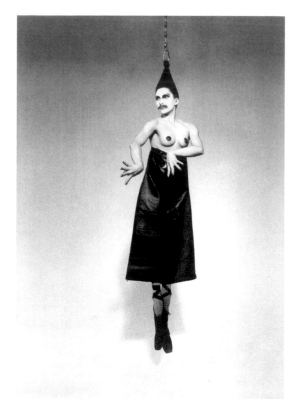
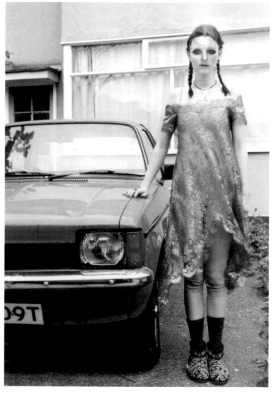
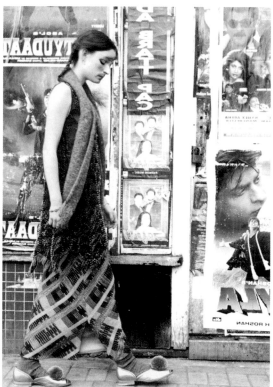
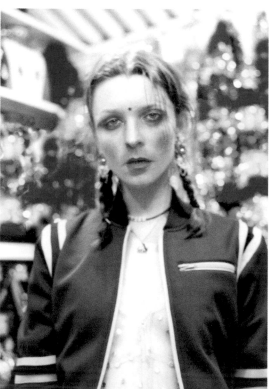

86 i don't live here anymore
 1997, 5 parts, c-prints mounted on perspex; 150 × 100 cm each

 i don't live here anymore
 1997, 5 parts, c-prints mounted on perspex; 150 × 100 cm each

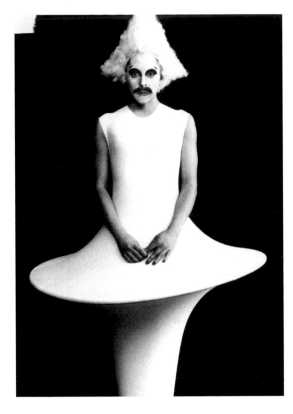

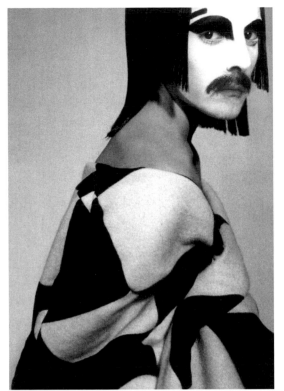

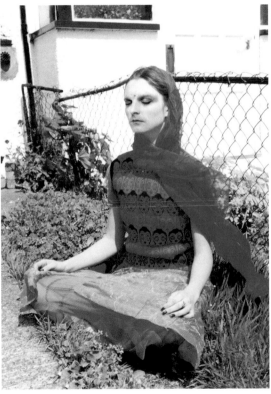

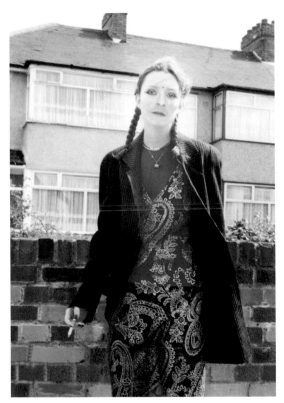

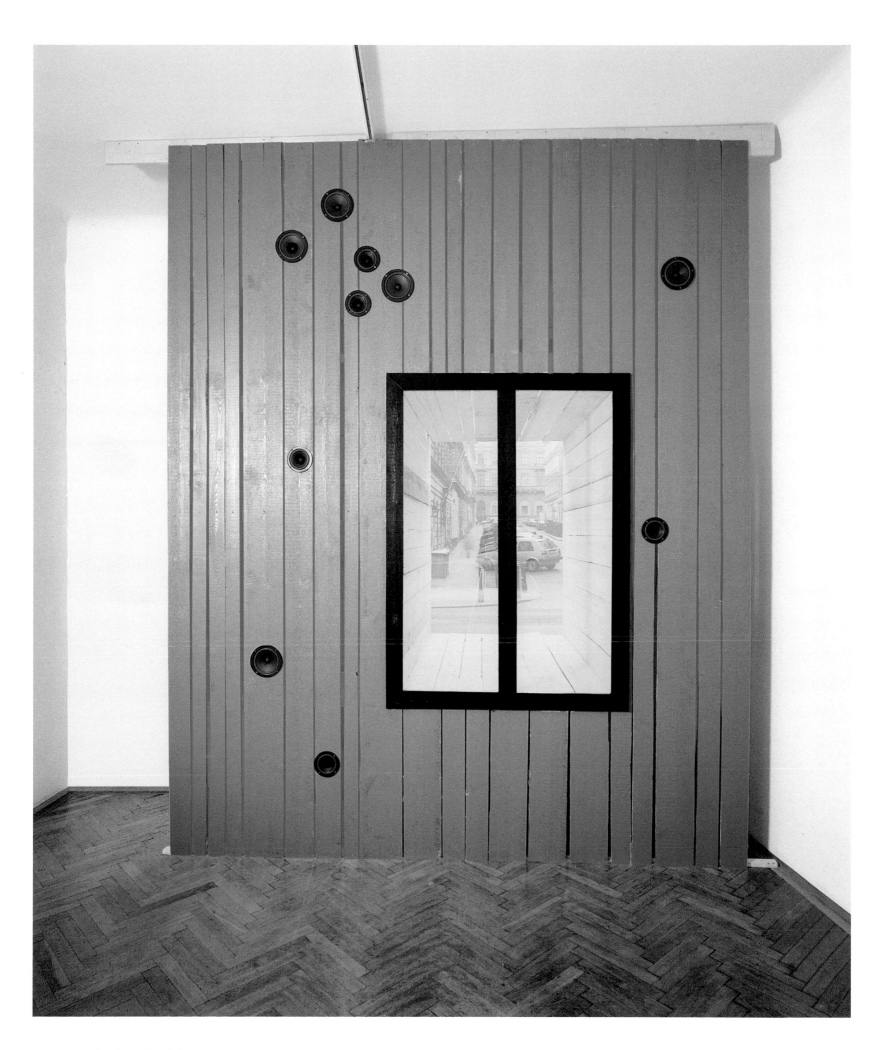

so much water so close to home
1997, wood, paint, perspex window, speakers, sound; dimensions variable

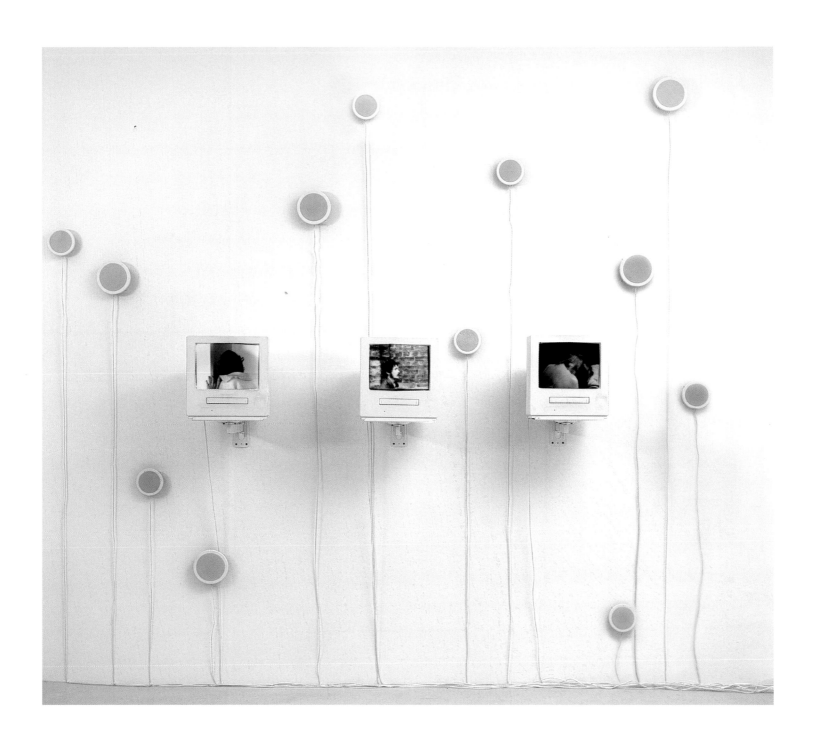

stillsmoking part II
1997, 3 monitors, 3 dvds, speakers, sound; 200 × 250 × 40 cm

92 dog days are over
1998, neon, perspex, transluscent film, aluminium; 330 × 770 × 10 cm

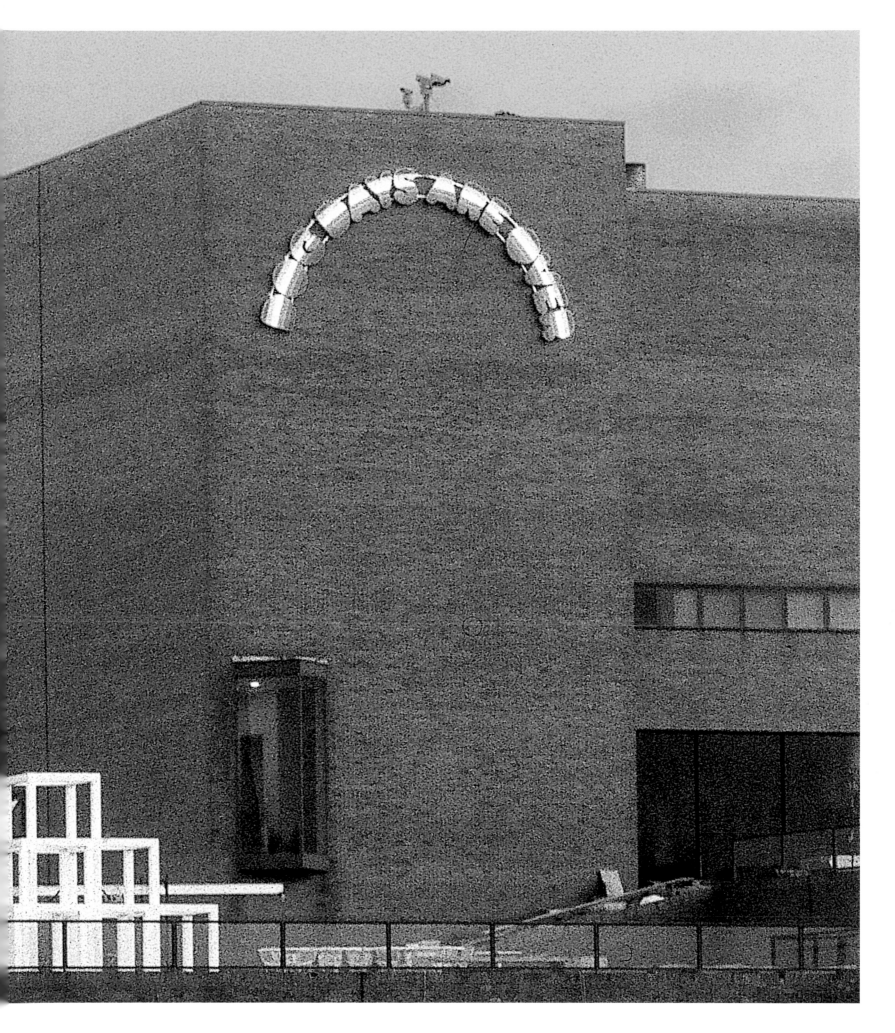

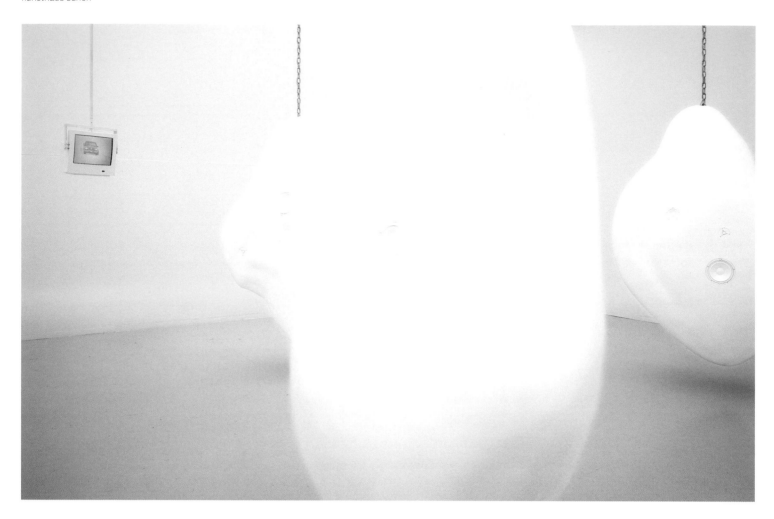

the evening passes like any other. men and women float alone through the air. they drift past my window like the weather. i close my eyes. my heart
is a moth fluttering against the walls of my chest. my brain is tangle of spiders wriggling and roaming around. a wriggling tangle of wriggling spiders.
1998, polyester, car enamel, metal chains, speakers, sound, 4 dvds, 4 monitors; dimensions variable

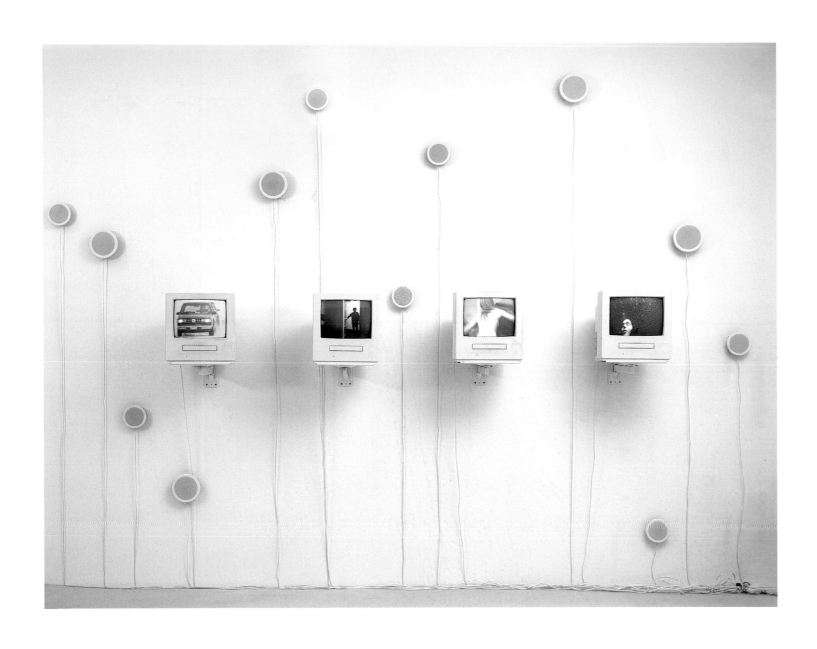

stillsmoking part IV
1997, 4 monitors, 4 dvds, speakers, sound; 200 × 350 × 40 cm

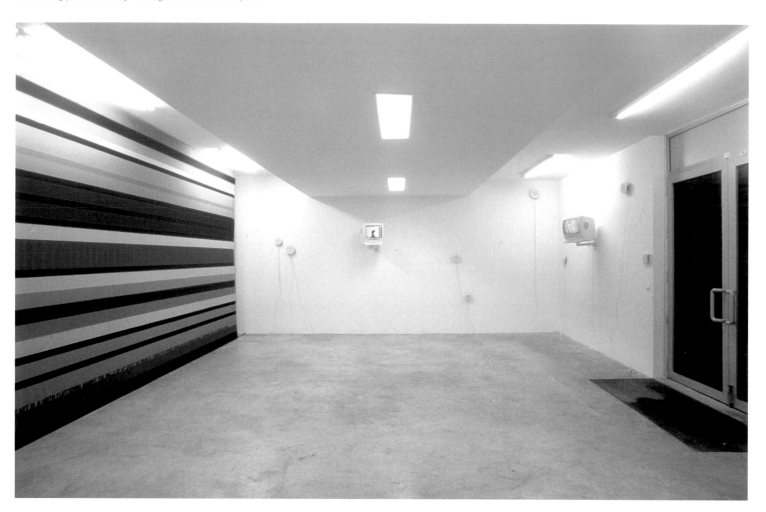

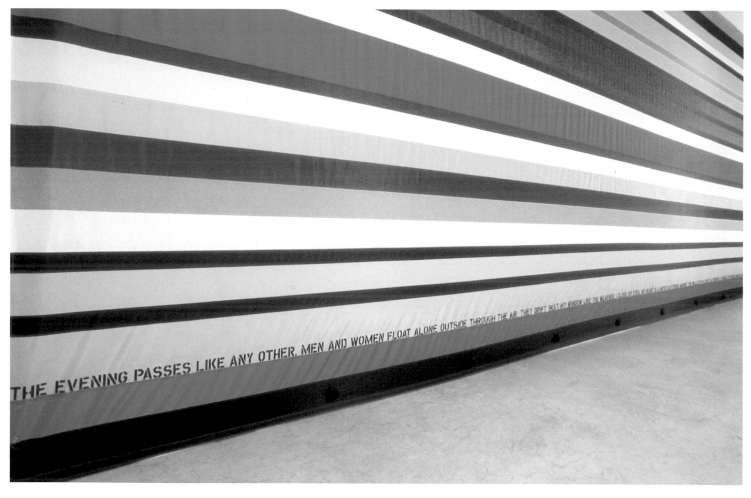

98 the evening passes like any other
 1998, nylon, 15 speakers, sound; 300 × 900 cm

 stillsmoking part III
 1997, 3 monitors, 3 dvds, speakers, sound; 200 × 250 × 40 cm

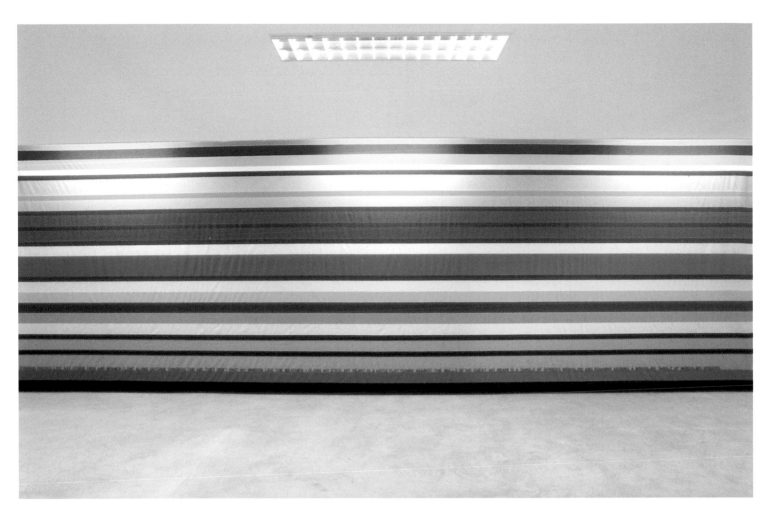

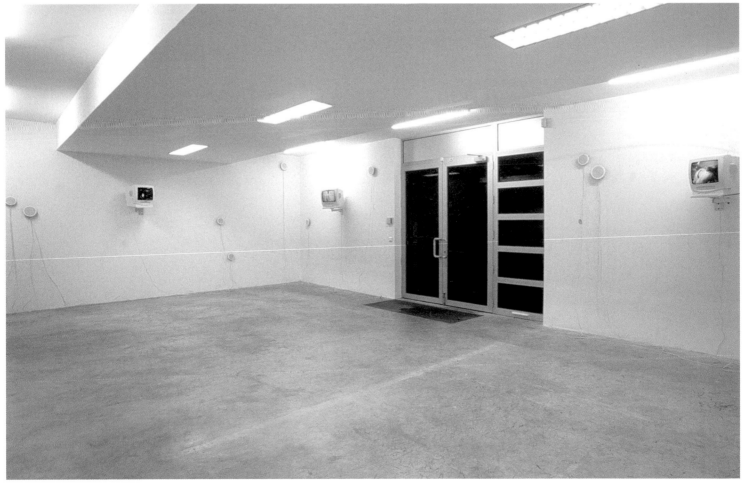

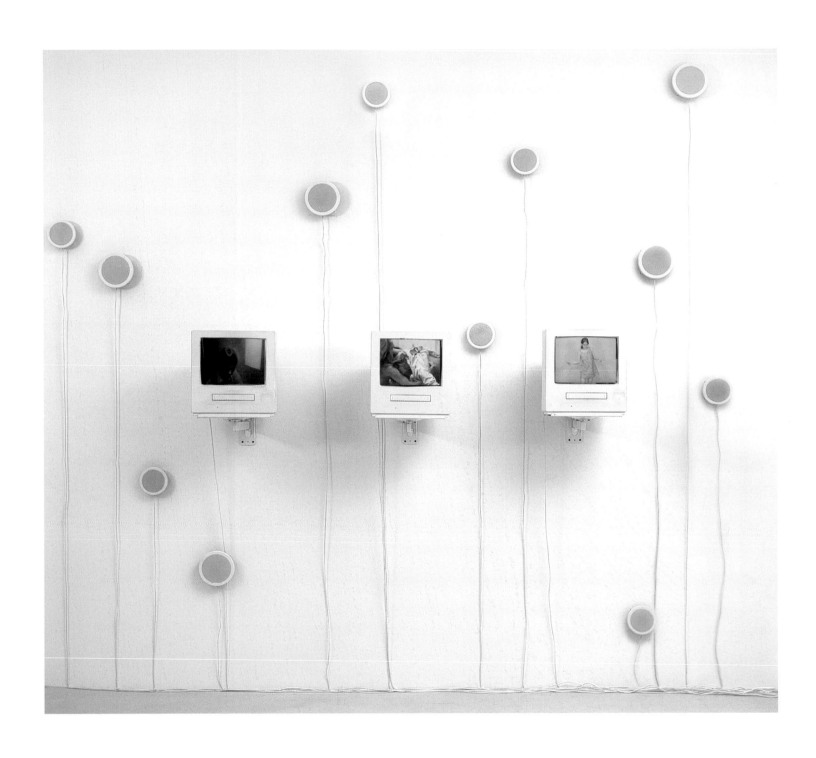

stillsmoking part III
1997, 3 monitors, 3 dvds, speakers,
sound; 200 × 250 × 40 cm

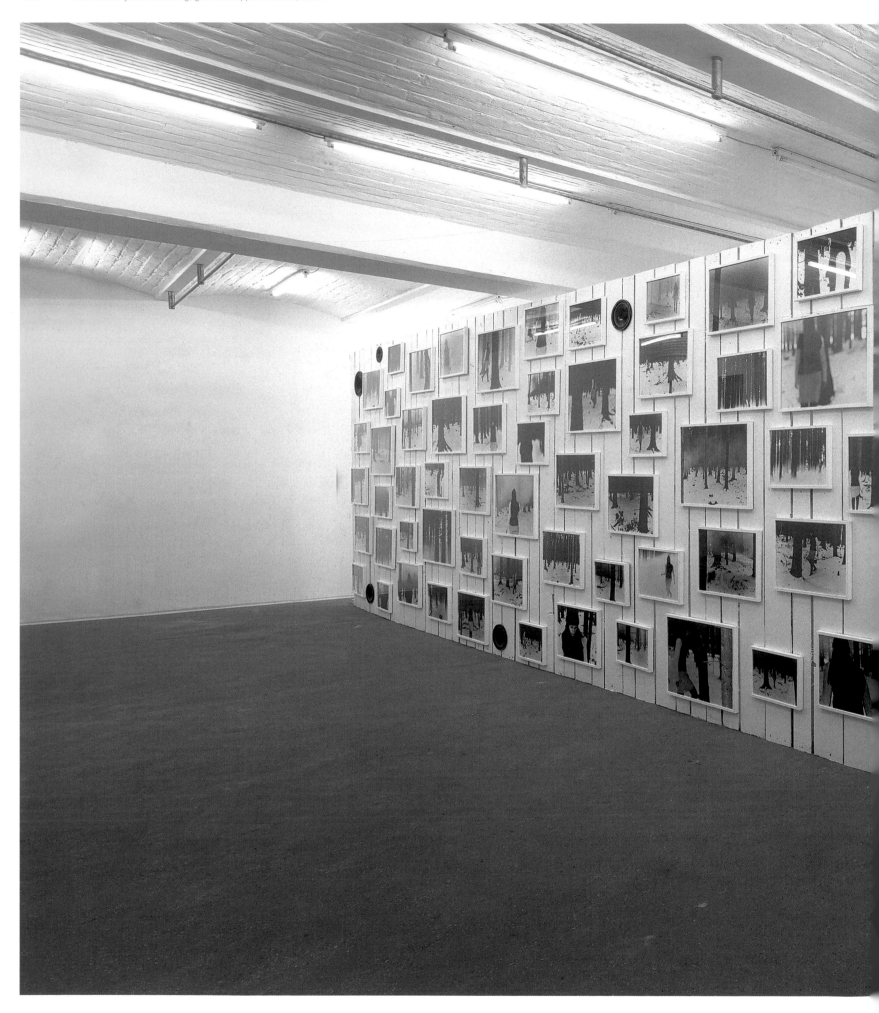

102 in the sweet years remaining
 1998, wooden wall, paint, speakers, 13 spotlights,
 sound, 72 framed c prints; 292 × 980 cm

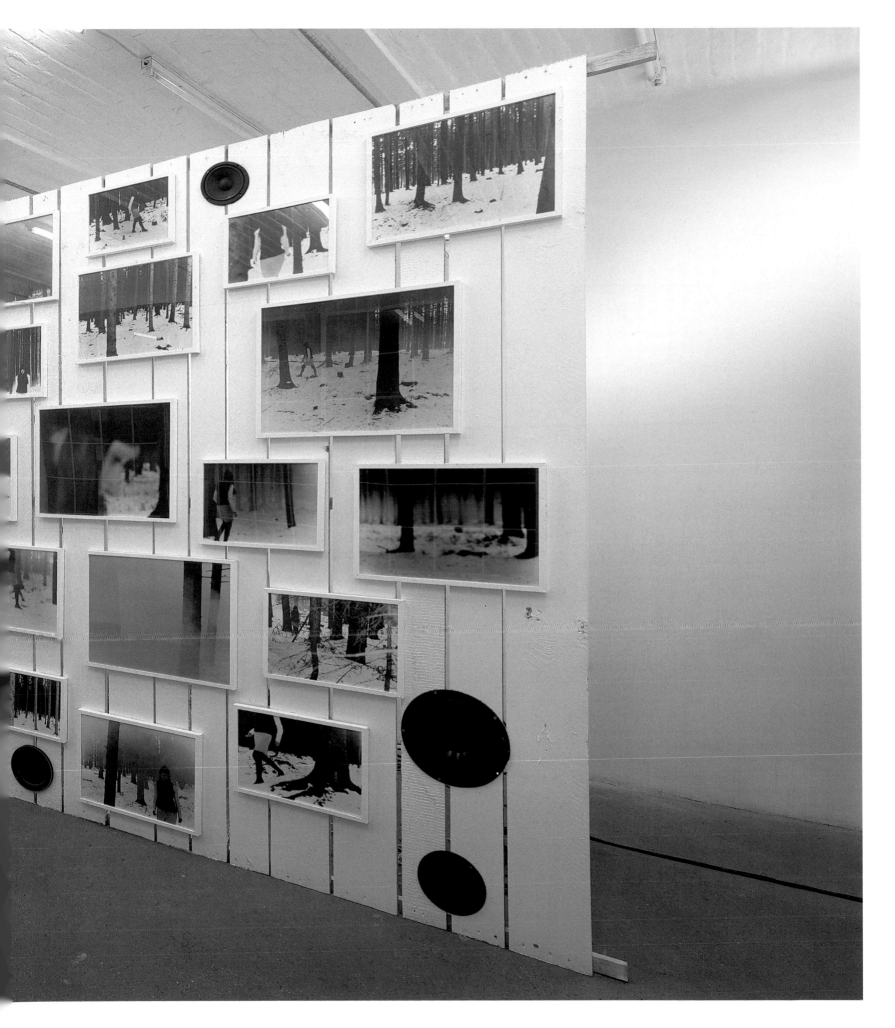

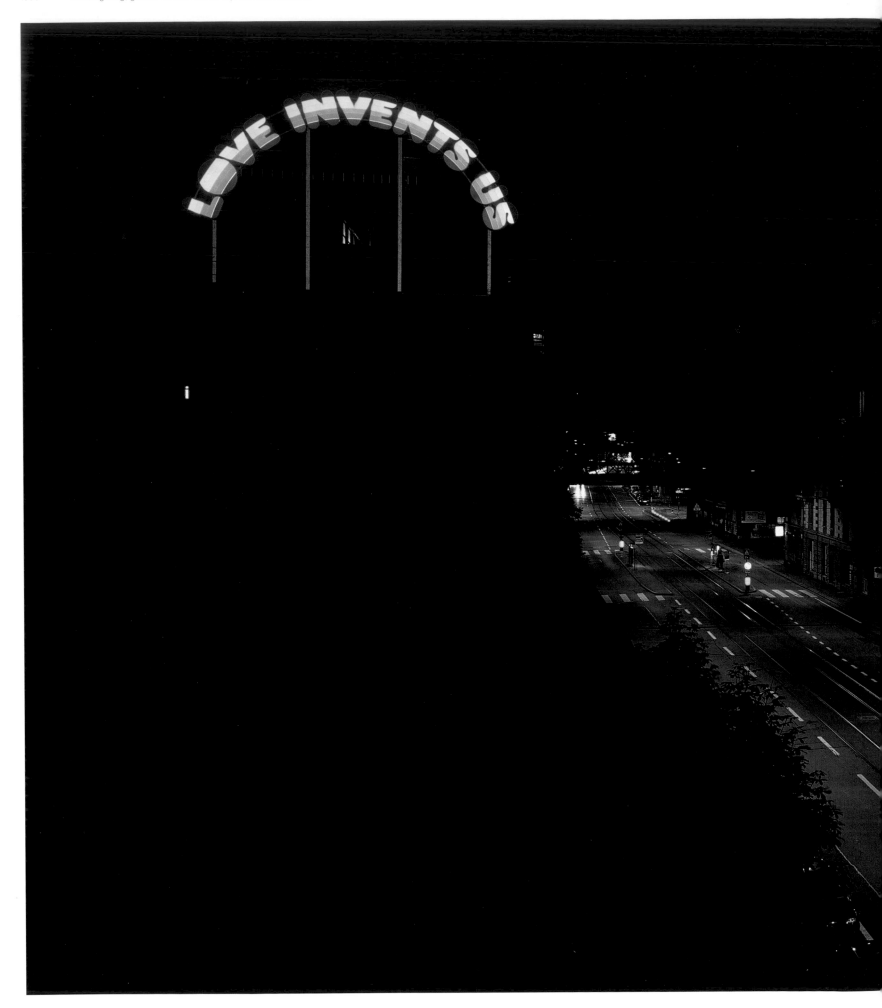

104 love invents us
1999, neon, perspex, transluscent film,
aluminium; 310 × 721 × 10 cm

grand central station
1999, walls of wood and plaster, speakers,
sound, text loop; 300 × 1130 × 700 cm

m. can i see you tonight?
w. perhaps.
m. what's that supposed to mean?
w. it's what you always say.
m. is it?
w. yes, perhaps.
m. when do i say that?
w. whenever you don't wanna admit
 that you're wrong, you always
 look away and say perhaps.
m. no, i don't.
w. yes, you do.
m. i always admit when i'm wrong.
w. that's not true.
m. yes it is, i cherish my flaws.
w. i'll make a note of that.
m. you haven't answered my question.
w. what question is that?
m. can i see you tonight?
w. perhaps.
m. what's that supposed to mean?
w. it's what you always say.

m. is it?
w. yes, perhaps.
m. when do i say that?
w. whenever you don't wanna admit
 that you're wrong, you always
 look away and say perhaps.
m. no, i don't.
w. yes, you do.
m. i always admit when i'm wrong.
w. that's not true.
m. yes it is, i cherish my flaws.
w. i'll make a note of that.
m. you haven't answered my question.
w. what question is that?
m. can i see you tonight?
w. perhaps.
m. what's that supposed to mean?
w. it's what you always say.
m. is it?
w. yes, perhaps.
m. when do i say that?
w. whenever you don't wanna admit

 that you're wrong, you always
 look away and say perhaps.
m. no, i don't.
w. yes, you do.
m. i always admit when i'm wrong.
w. that's not true.
m. yes it is, i cherish my flaws.
w. i'll make a note of that.
m. you haven't answered my question.
w. what question is that?
m. can i see you tonight?
w. perhaps.
m. what's that supposed to mean?
w. it's what you always say.
m. is it?
w. yes, perhaps.
m. when do i say that?
w. whenever you don't wanna admit
 that you're wrong, you always
 look away and say perhaps.
m. no, i don't.
...

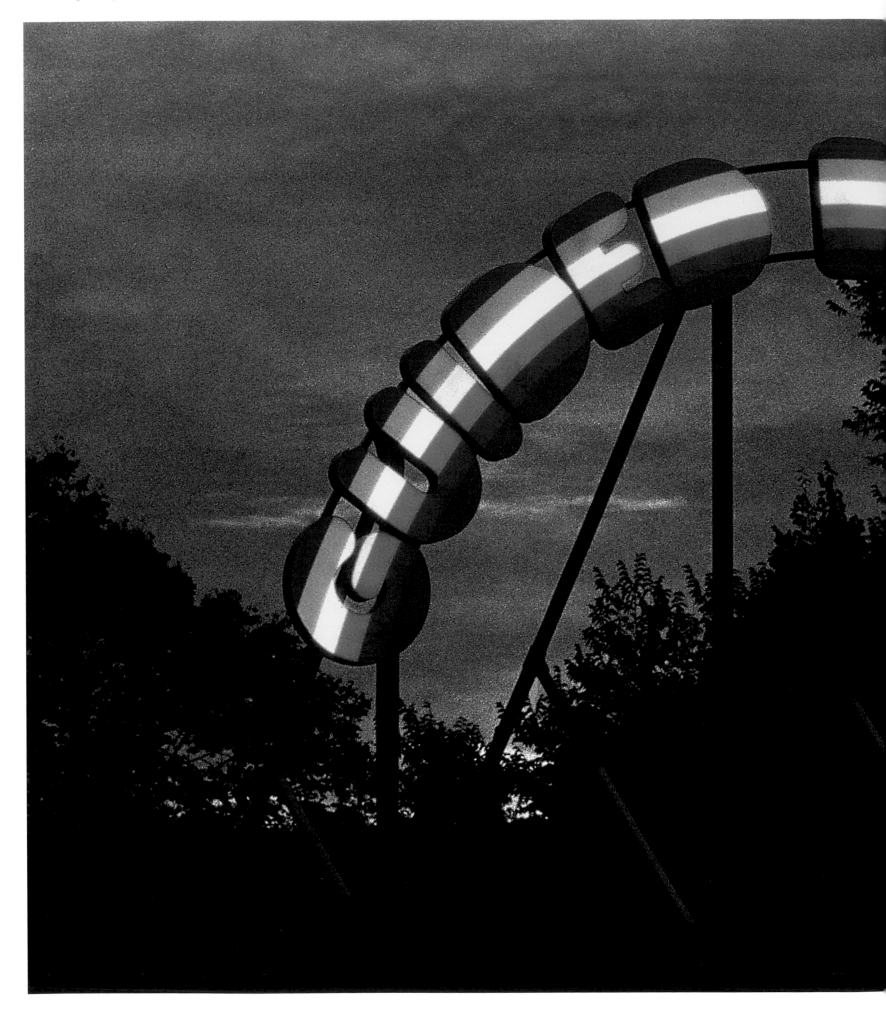

guided by voices
1999, neon, perspex, transluscent film,
aluminium; 330 × 785 × 10 cm

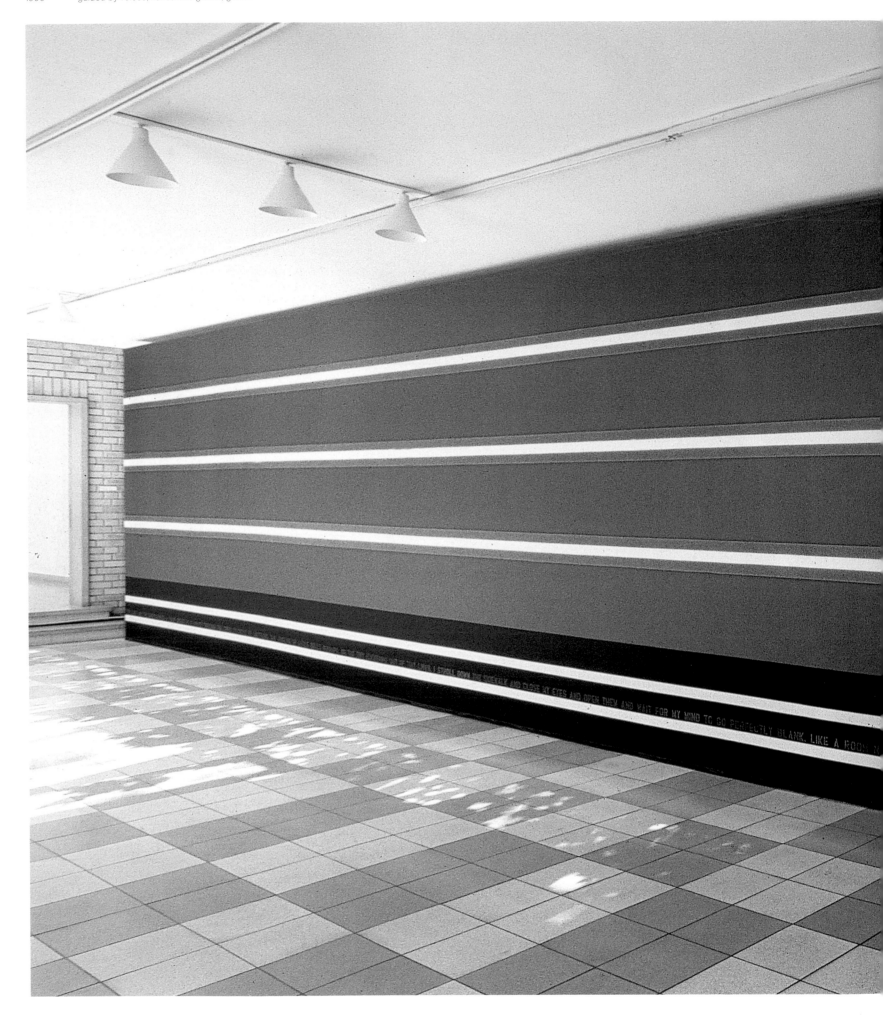

110 it's late
1999, nylon, adhesive letters,
metal; 300 × 1300 cm

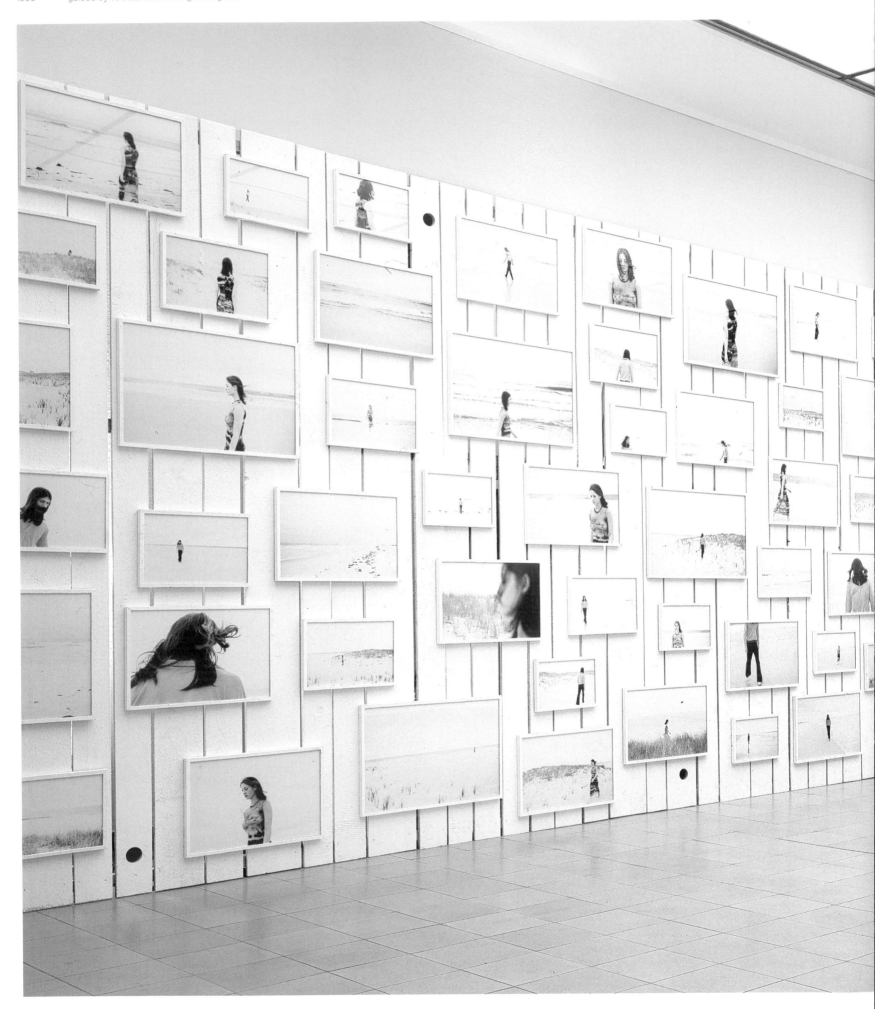

112 sleep
 1999, wooden wall, paint, speakers, 30 spotlights,
 sound, 165 framed c-prints; dimensions variable

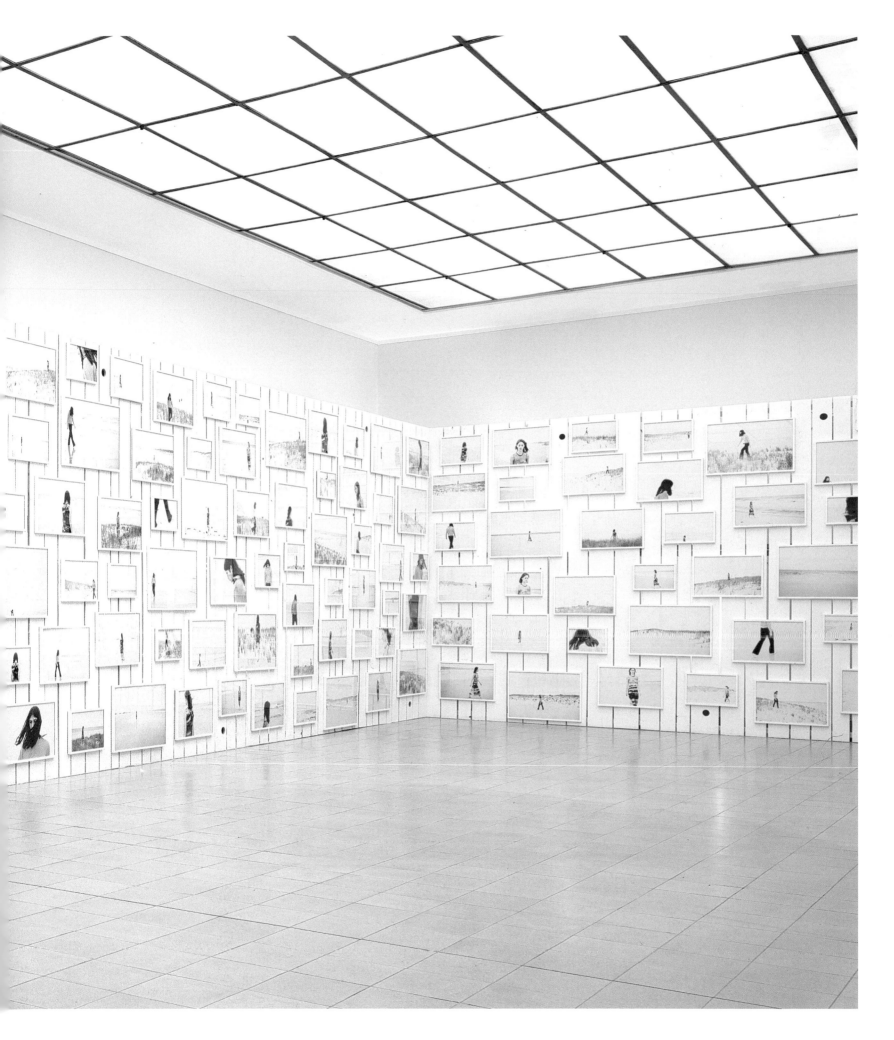

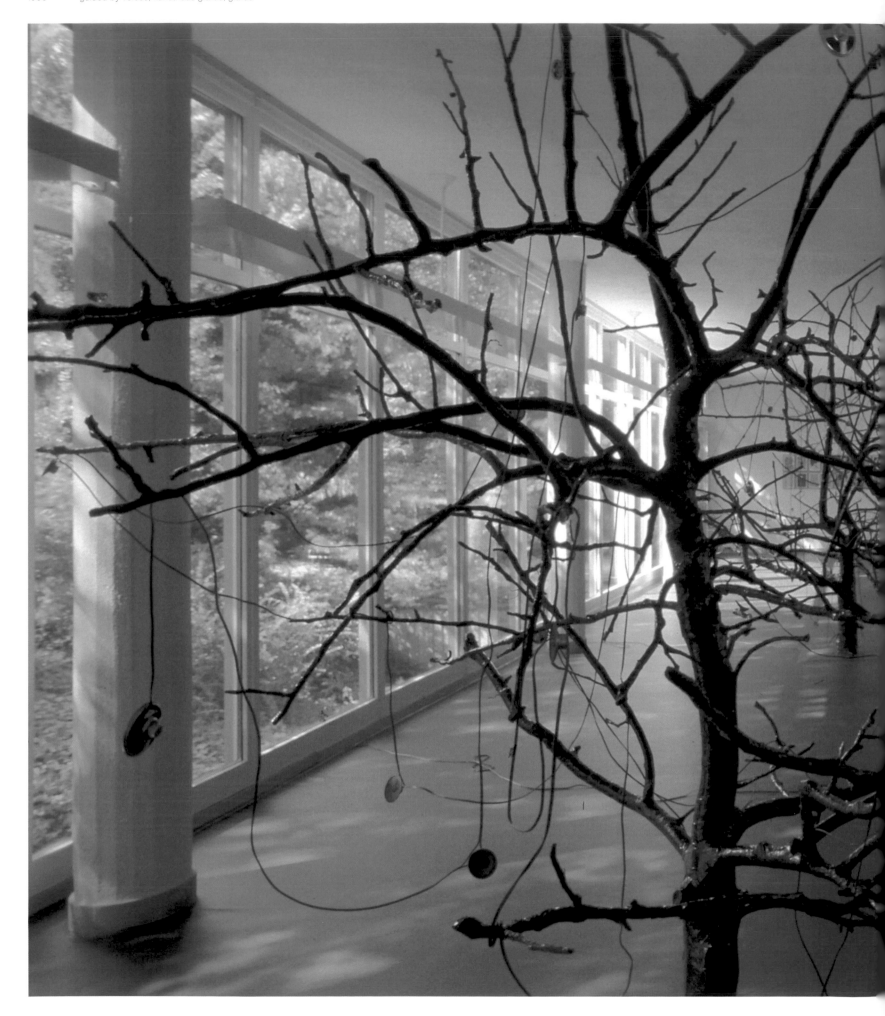

114 i never sleep. i've never slept at all. i've never had a dream. all of that could be true.
1999, rubber floor, 8 parts, polyester, rubber tape, transluscent foil, speakers, sound, text loop;
dimensions variable

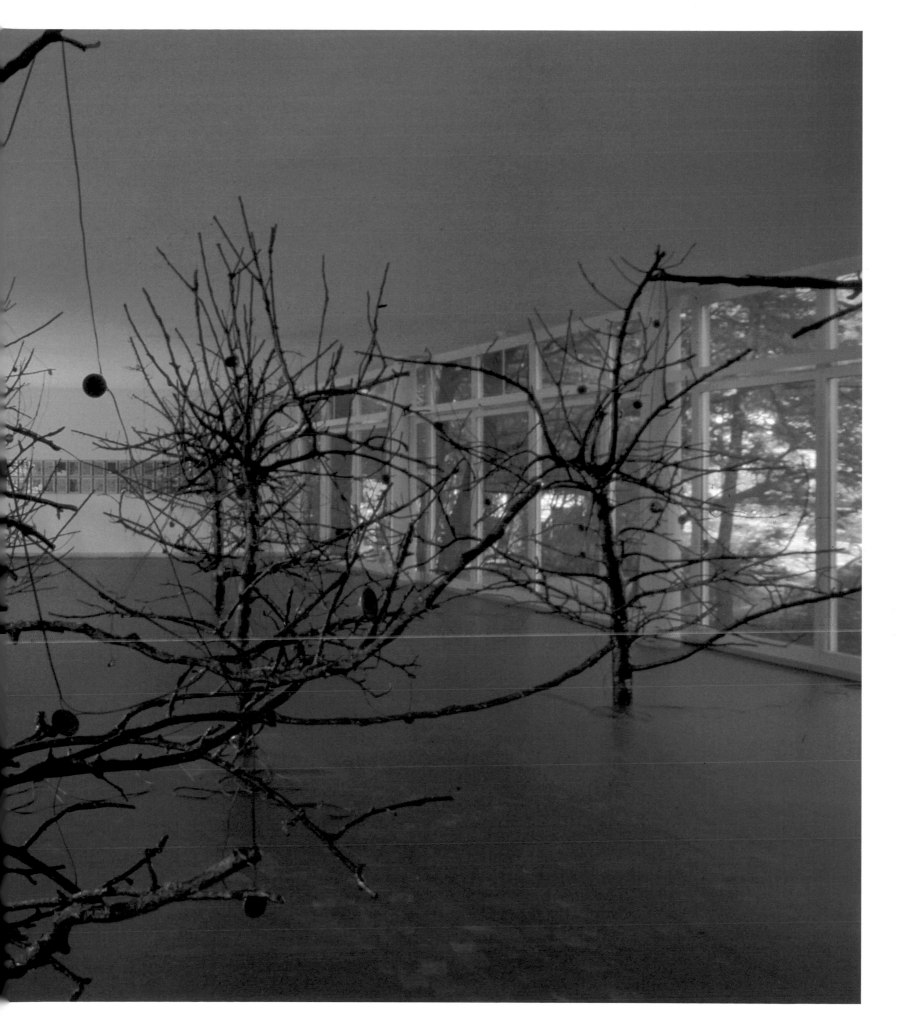

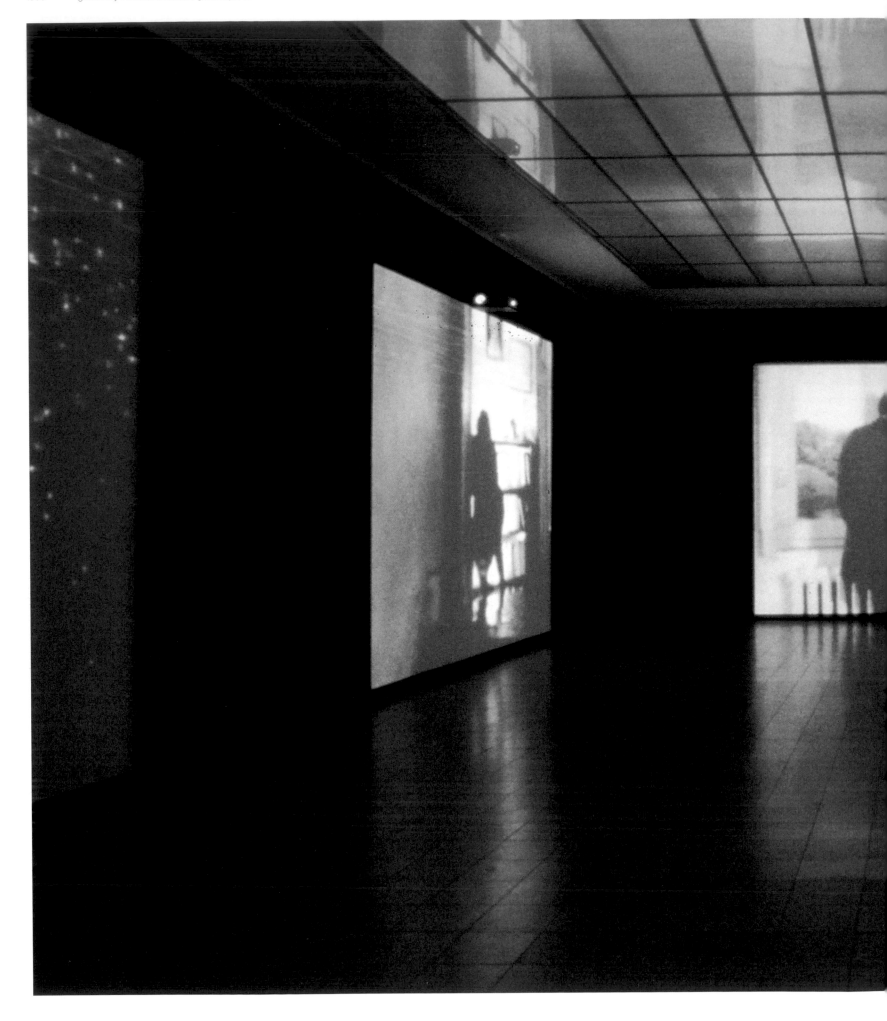

116 it's late and the wind carries a faint sound as it moves through the trees. it could be anything. the jingling of little bells perhaps,
 or the tiny flickering out of tiny lives. i stroll down the sidewalk and close my eyes and open them and wait for my mind to go
 perfectly blank. like a room no one has ever entered, a room, without doors or windows. a place where nothing happens.
 1999, 6 dvds, 6 projections, aluminium, perspex, neon, sound; 500 × 1684 × 970 cm

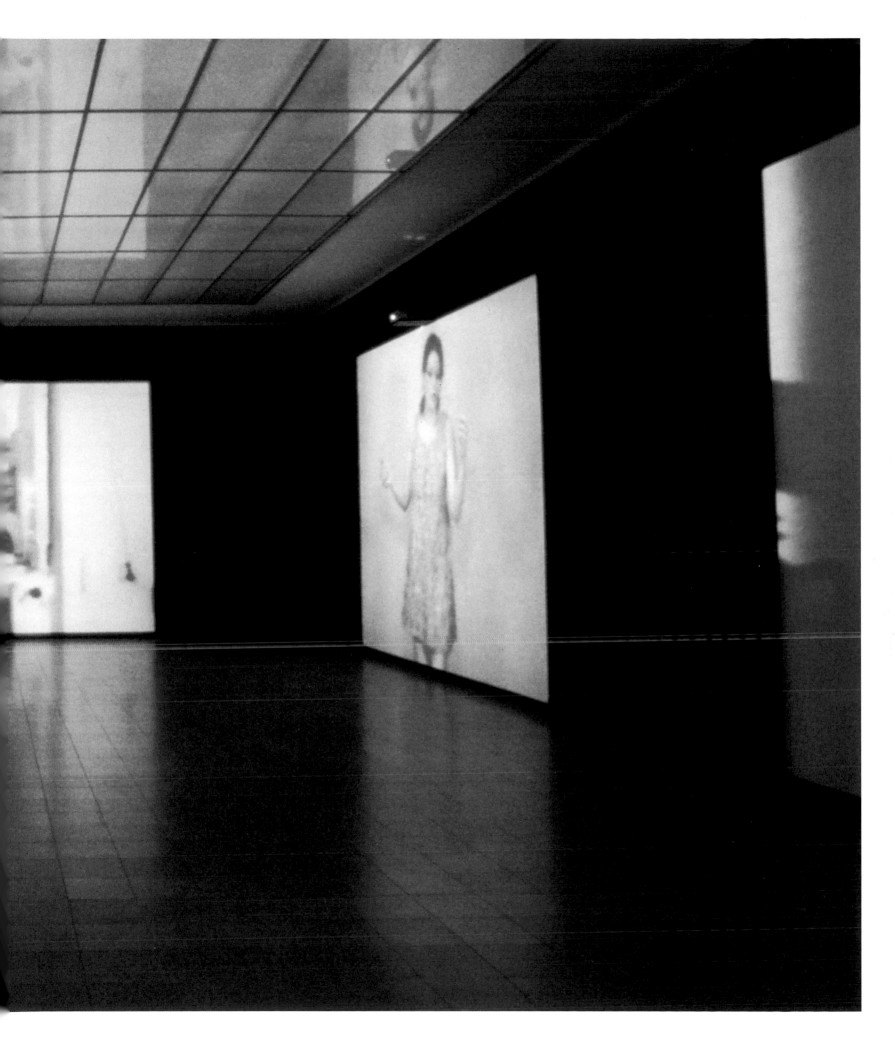

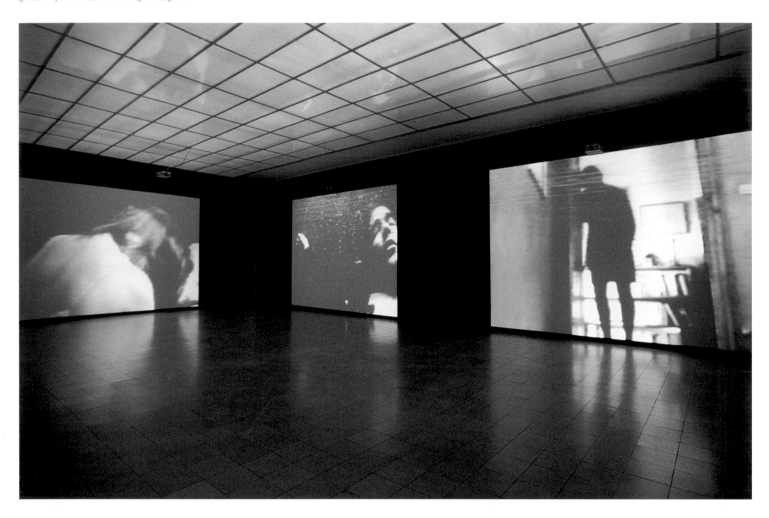

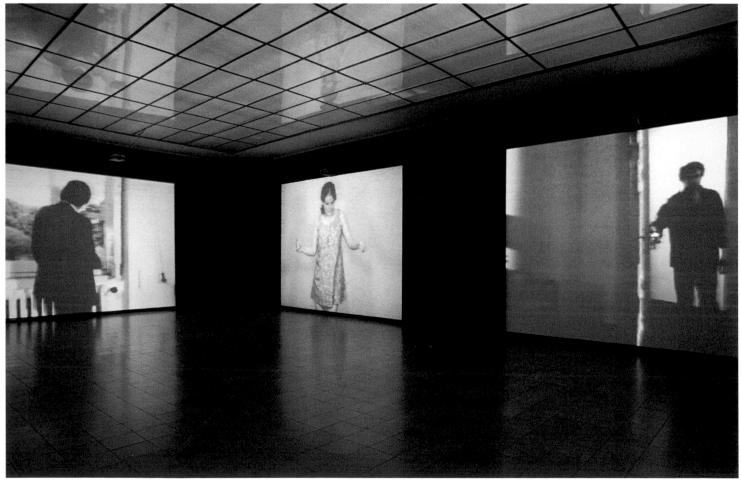

118 it's late and the wind carries a faint sound as it moves through the trees. it could be anything. the jingling of little bells perhaps, or the tiny flickering out of tiny lives. i stroll down the sidewalk and close my eyes and open them and wait for my mind to go perfectly blank. like a room no one has ever entered. a room, without doors or windows. a place where nothing happens.
1999, 6 dvds, 6 projections, aluminium, perspex, neon, sound; 500 × 1684 × 970 cm

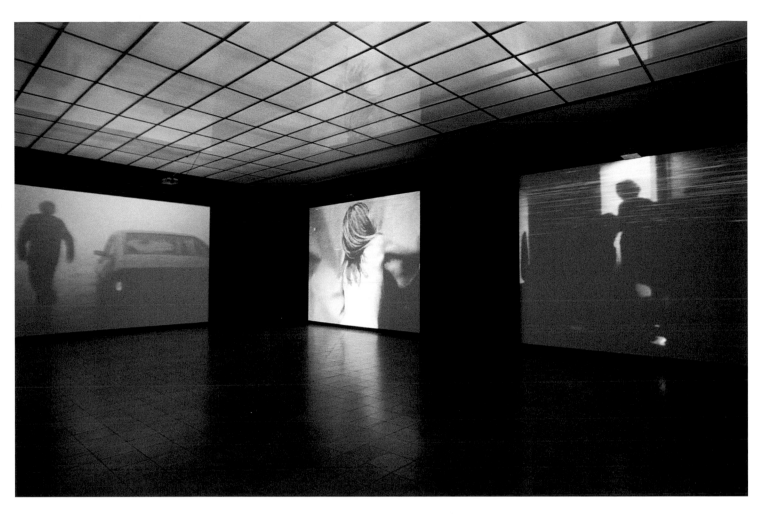

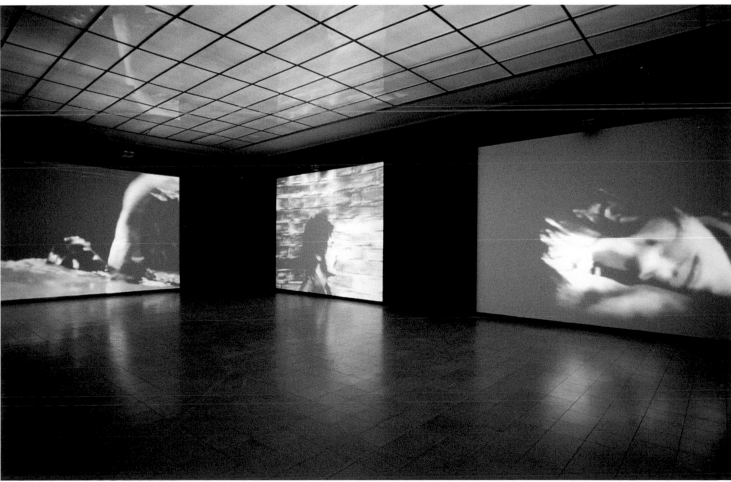

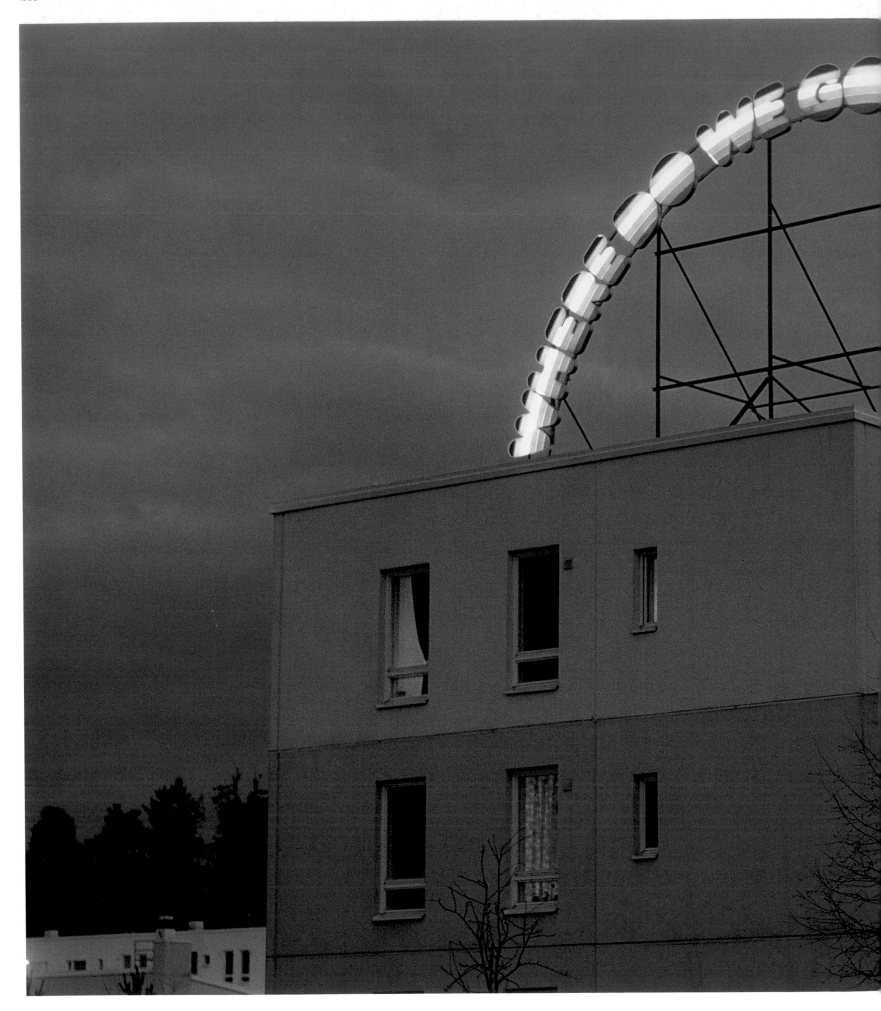

120 where do we go from here?
 1999, neon, perspex, transluscent film,
 aluminium; 625 × 1150 × 10 cm

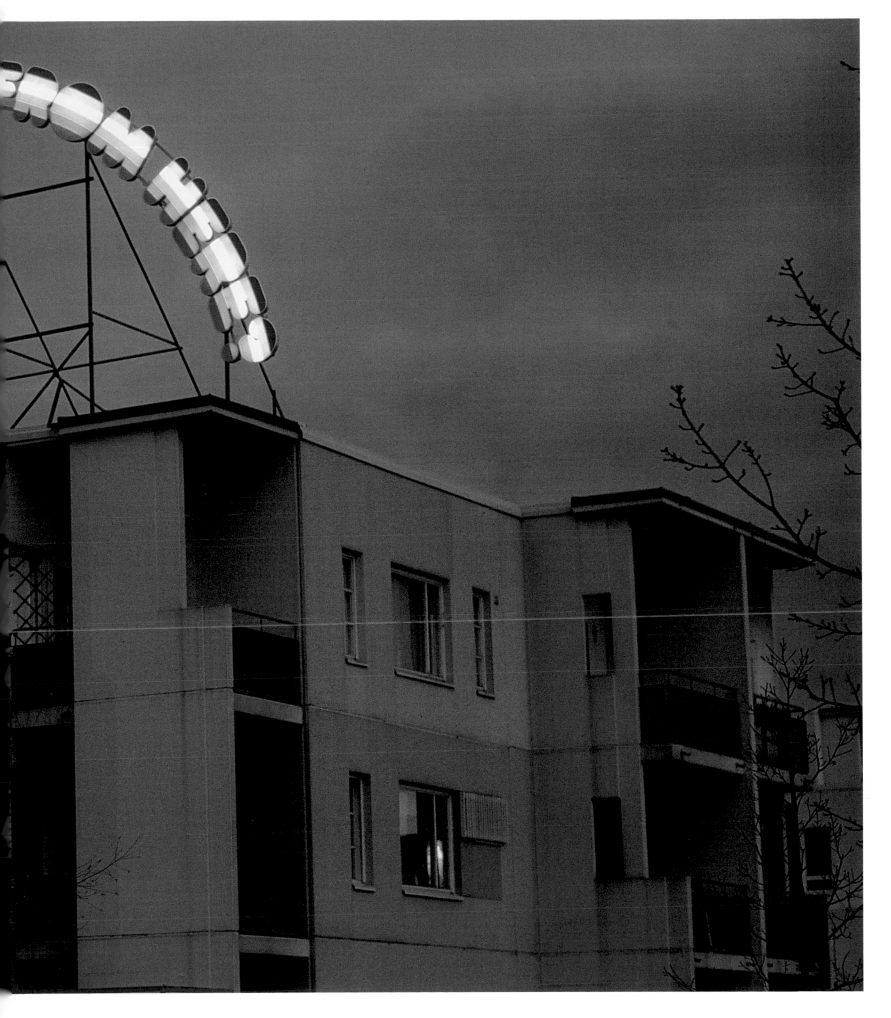

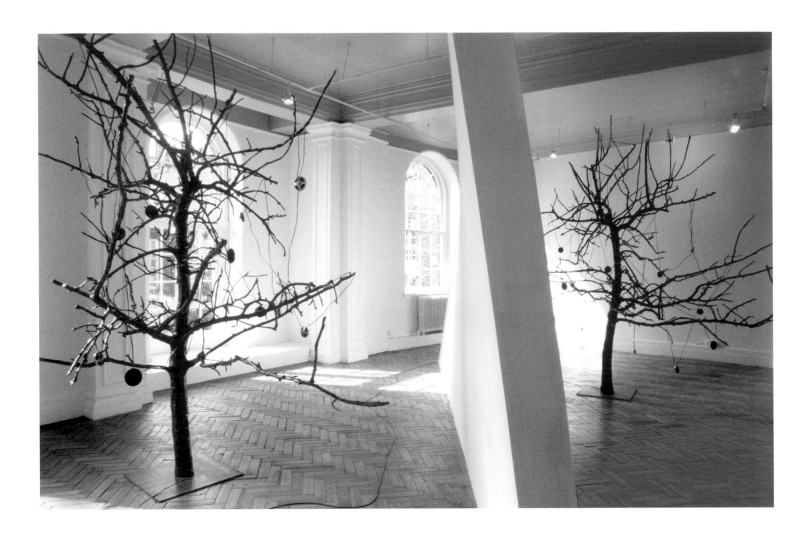

when the sun goes down and the moon comes up
1999, part I: wall of wood and plaster, 300 × 700 cm; part II: 2 parts,
polyester, rubber tape, speakers, sound, text loop; 280 × 80 cm each

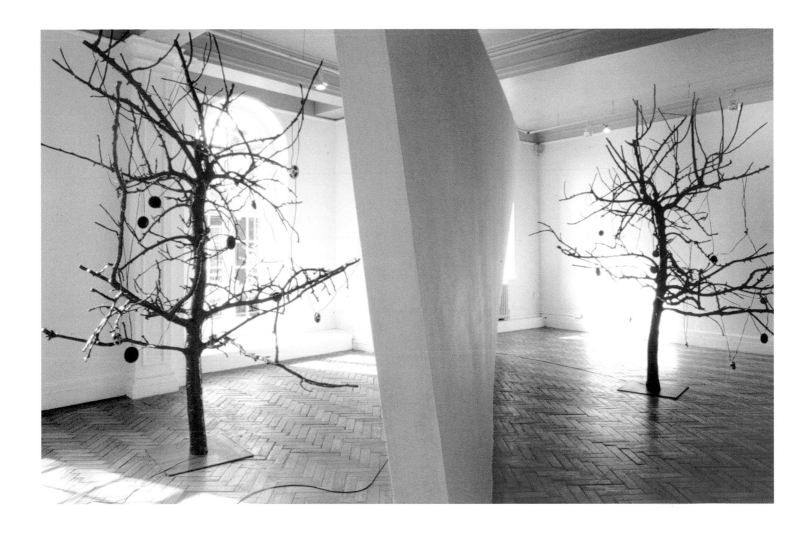

m1. go to sleep.
m2. i can't sleep.
m1. why not?
m2. i'm in pain.
m1. what?
m2. i got a broken heart.
m1. bullshit.
m2. i do.
m1. what happened?
m2. i was set up. doublecrossed.
 betrayed by the woman i love.
m1. who?
m2. i don't wanna talk about it.

m1. suit yourself.
m2. you wanna see a picture of her?
m1. she's pretty.
m2. i would have done everything
 for her.
m1. sorry.
m2. i just can't understand it.
m1. you'll get over it.
m2. no, i will not get over it.
m1. yes, you will.
m2. i love this woman.
m1. you loved other women.
m2. not like her. she was special.

m1. believe me, you'll get over it.
m2. bullshit.
m1. come on.
m2. come on what?
m1. go to sleep.
m2. i can't sleep.
m1. why not?
m2. i'm in pain.
m1. what?
m2. i can't sleep.
m1. why not?
m2. i'm in pain.
...

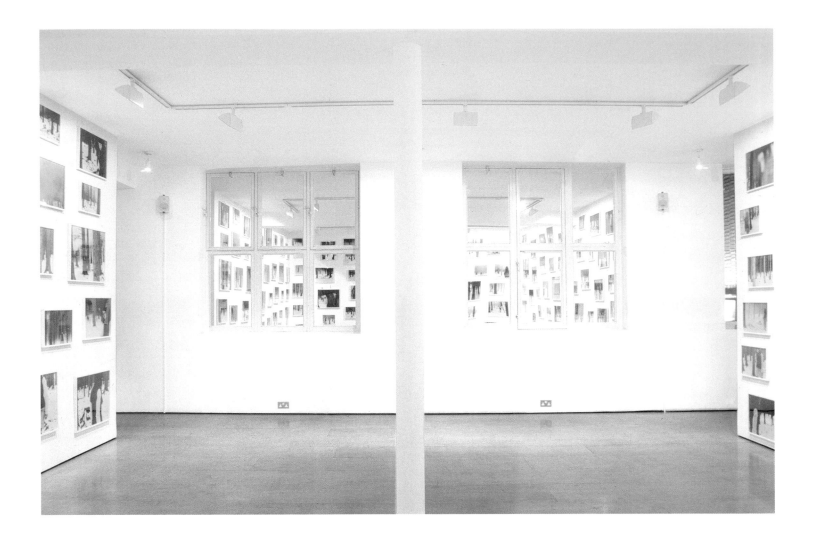

vierteroktoberneunzehnhundertneunundneunzig

siebteroktoberneunzehnhundertneunundneunzig

dreizehnteroktoberneunzehnhundertneunundneunzig

einundzwanzigsteroktoberneunzehnhundertneunundneunzig

zweiternovemberneunzehnhundertneunundneunzig

fünfzehnternovemberneunzehnhundertneunundneunzig

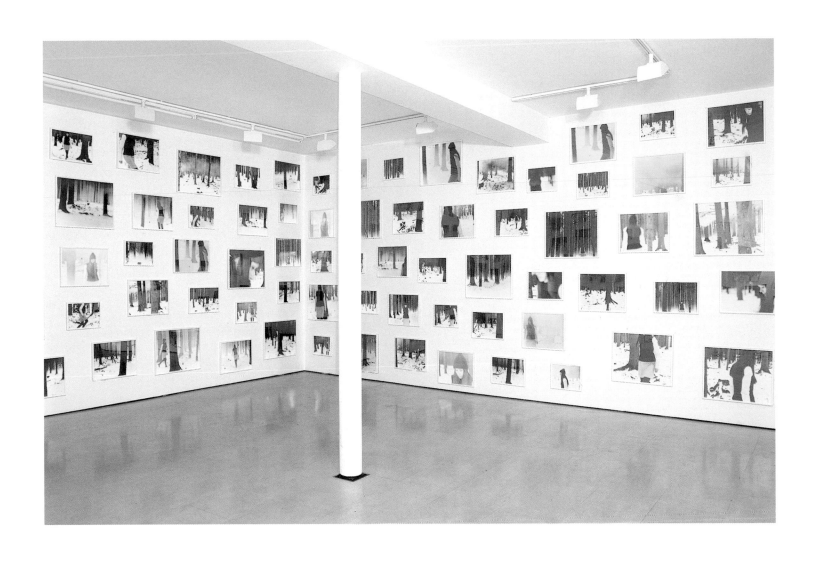

achtzehnternovemberneunzehnhundertneunundneunzig

dreissigsternovemberneunzehnhundertneunundneunzig

vierterdezemberneunzehnhundertneunundneunzig

fünfzehnterdezemberneunzehnhundertneunundneunzig

all: 1999, 15 framed c-prints, fluorescent perspex; 200 × 300 cm

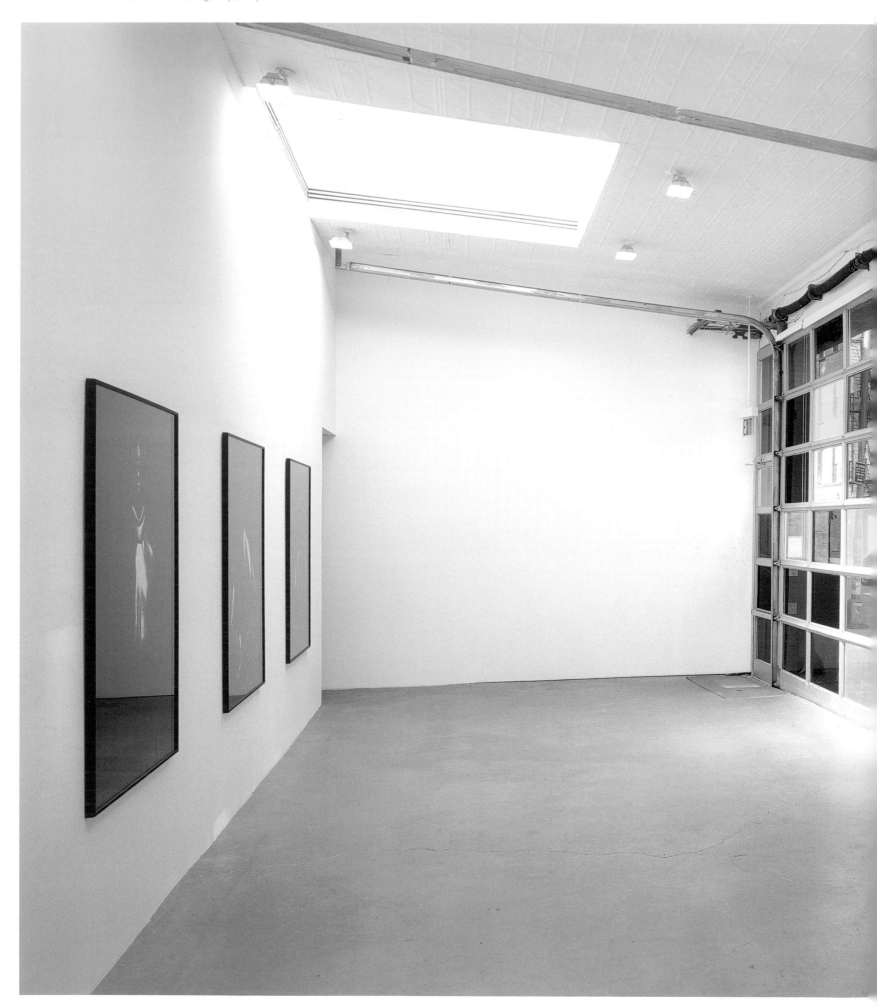

moonlighting
1999, c-prints mounted on aluminium,
wooden frame; 164 × 120 cm each

love invents us
1999, wall for a house, steel, glass,
transluscent film; dimensions variable

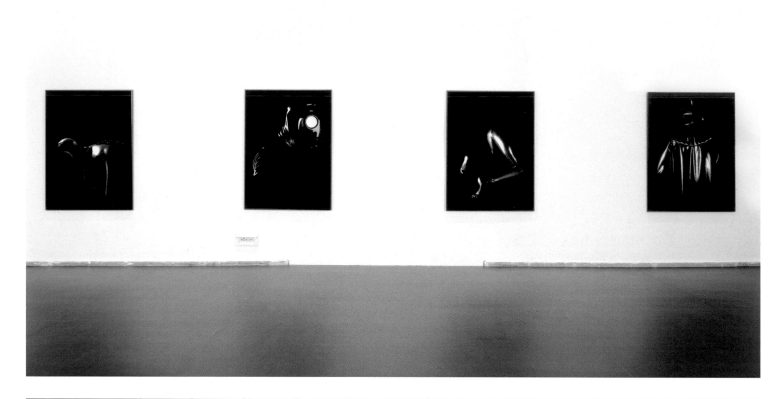

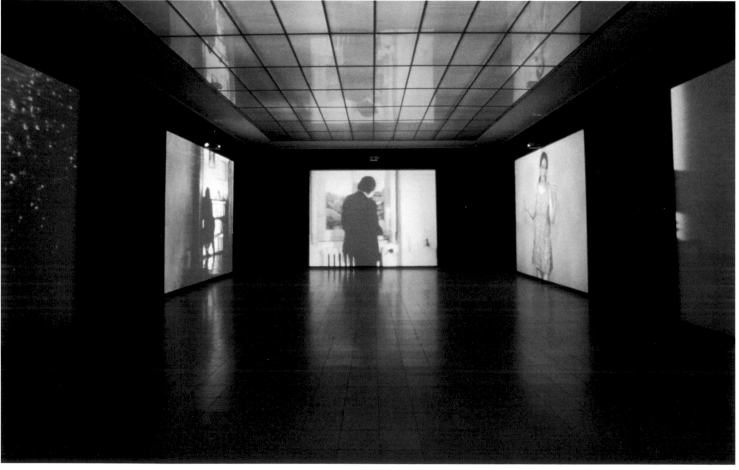

moonlighting
1999, c-prints mounted on aluminium, wooden frame; 164 × 120 cm each

it's late and the wind carries a faint sound as it moves through the trees. it could be anything. the jingling of little bells perhaps, or the tiny flickering out of tiny lives. i stroll down the sidewalk and close my eyes and open them and wait for my mind to go perfectly blank. like a room no one has ever entered, a room, without doors or windows. a place where nothing happens.
1999, 6 dvds, 6 projections, aluminium, perspex, neon, sound; 500 × 1684 × 970 cm

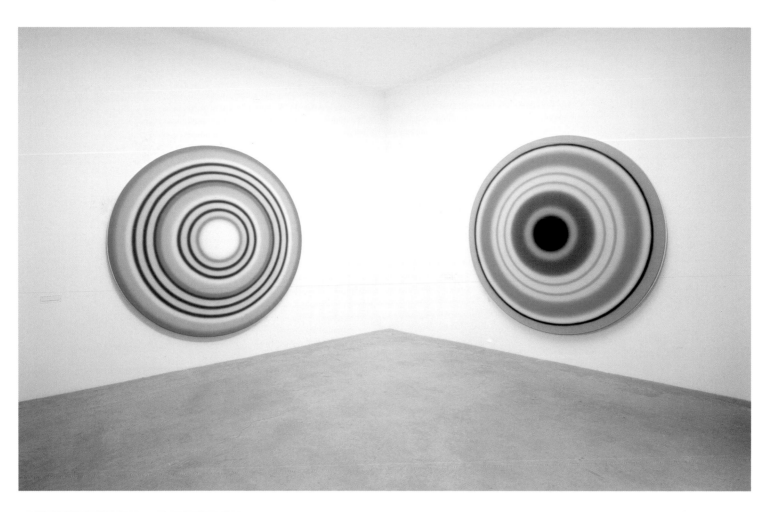

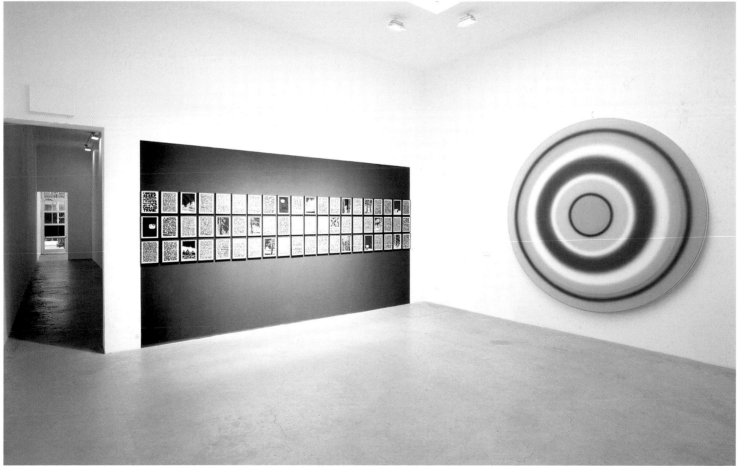

sechsundzwanzigsterfebruarzweitausendundnull
2000, acrylic paint on canvas; ø 270 cm

zweiundzwanzigsterfebruarzweitausendundnull
2000, acrylic paint on canvas; ø 270 cm

achtzehnterjanuarzweitausendundnull
2000, acrylic paint on canvas; ø 270 cm

1998
1998, 60 parts, ink on paper; 29.7 × 21 cm each

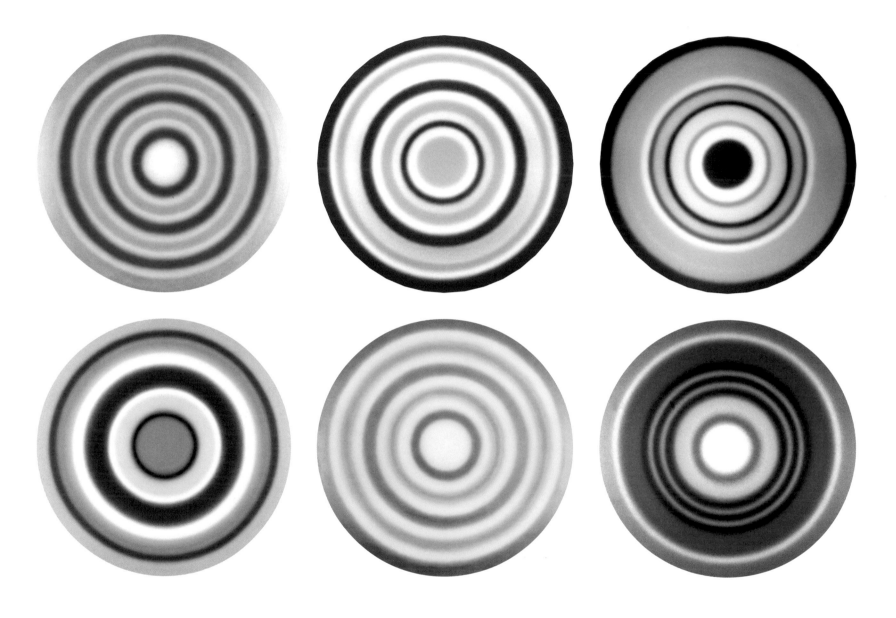

achtermärzneunzehnhundertsiebenundneunzig
1997, acrylic paint on canvas; ø 220 cm

achtzehnterjanuarzweitausendundnull
2000, acrylic paint on canvas; ø 270 cm

achtzehnteraprilneunzehnhundertfünfundneunzig
1995, acrylic paint on canvas; ø 220 cm

vierundzwanzigsteroktoberneunzehnhundertsiebenundneunzig
1997, acrylic paint on canvas; ø 220 cm

neuntermaineunzehnhundertfünfundneunzig
1995, acrylic paint on canvas; ø 220 cm

dritterseptemberneunzehnhundertsiebenundneunzig
1997, acrylic paint on canvas; ø 220 cm

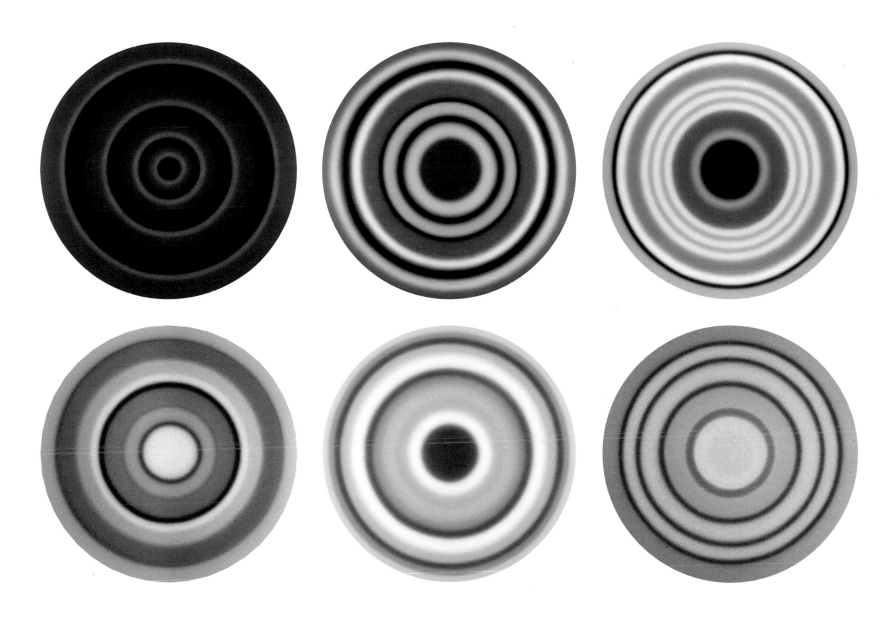

dritterjanuarzweitausendundnull
2000, acrylic paint on canvas; ø 270 cm

fünfzehneraugustneunzehnhundertsiebenundneunzig
1997, acrylic paint on canvas; ø 220 cm

zweiundzwanzigsterfebruarzweitausendundnull
2000, acrylic paint on canvas; ø 270 cm

zwölftermärzneunzehnhundertfünfundneunzig
1995, acrylic paint on canvas; ø 220 cm

zweiterjunizweitausendundnull
2000, acrylic paint on canvas; ø 220 cm

elfteraugustneunzehnhundertfünfundneunzig
1995, acrylic paint on canvas; ø 220 cm

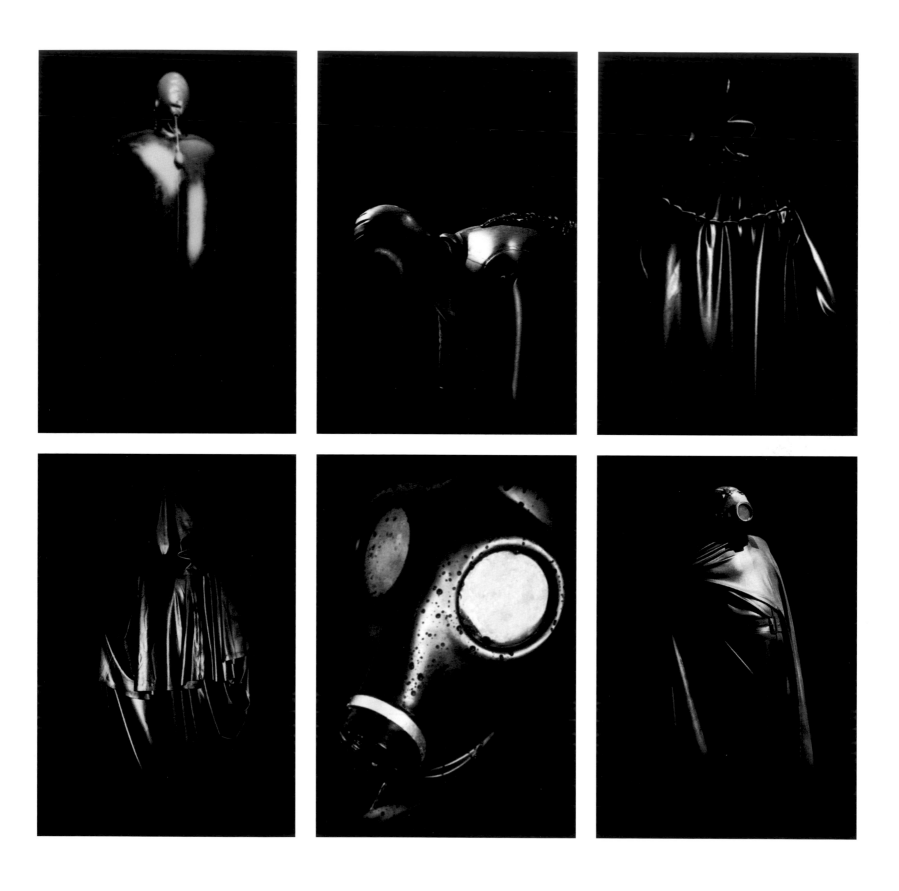

all: moonlighting
1999, c-prints mounted on aluminium,
wooden frame; 164 × 120 cm each

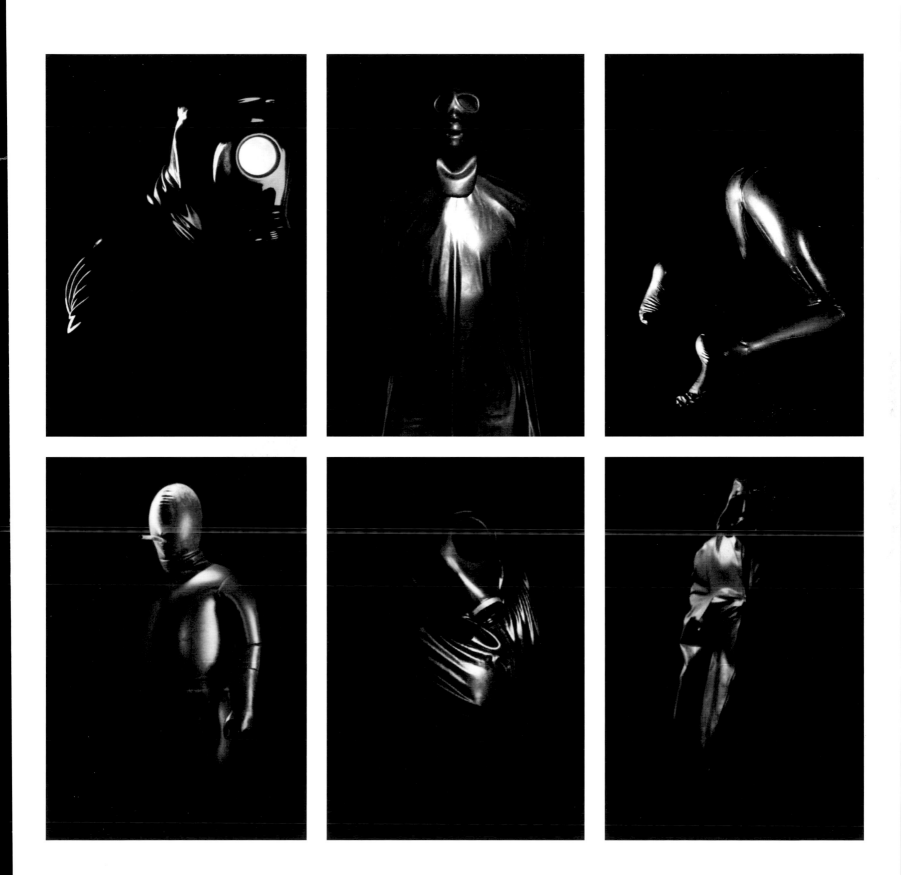

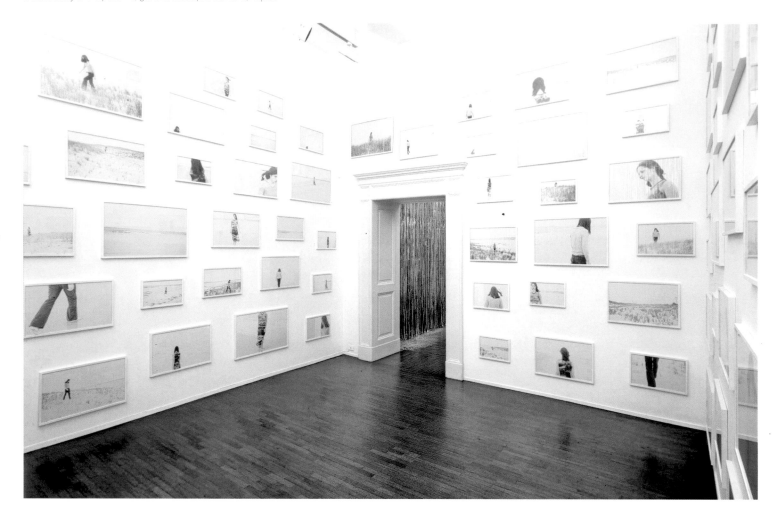

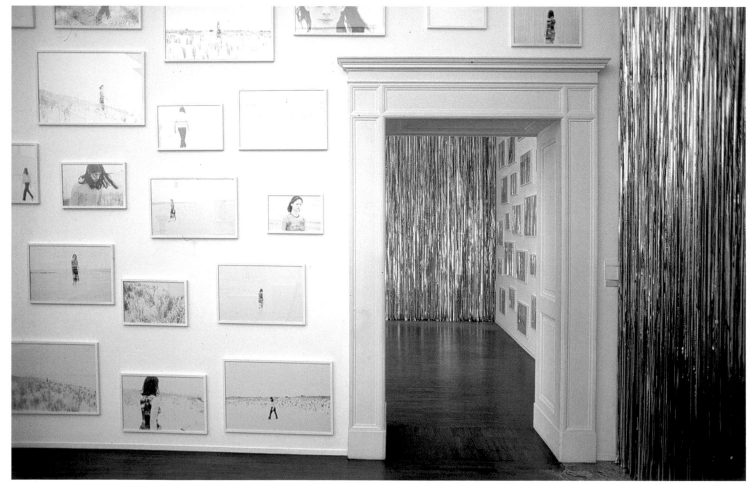

134 a doubleday and a pastime
2000, 4 speakers, sound, text loop, 2 gold tinsel
curtains, glitter; dimensions variable

neunundzwanzigstermärzzweitausendundnull

sechsteraprilzweitausendundnull

einunddreissigstermärzzweitausendundnull

neunteraprilzweitausendundnull

sechsundzwanzigstermärzzweitausendundnull

zweiteraprilzweitausendundnull

zehnteraprilzweitausendundnull

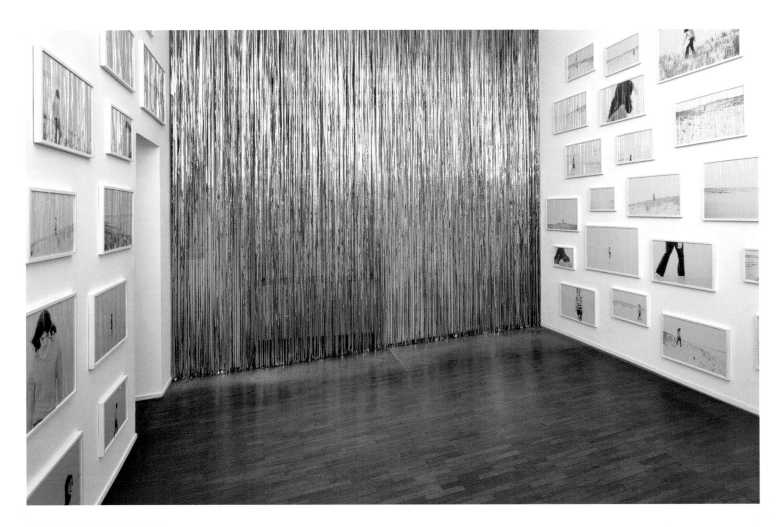

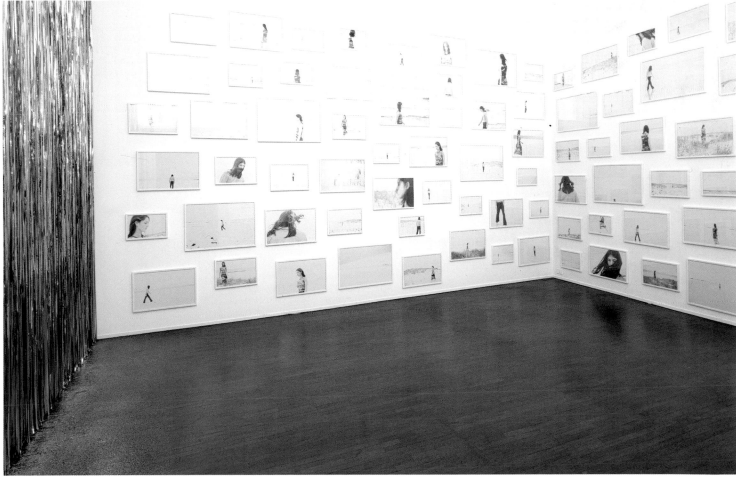

zwanzigsteraprilzweitausendundnull

neunundzwanzigsteraprilzweitausendundnull

dreissigsteraprilzweitausendundnull

viertermaizweitausendundnull

achtermaizweitausendundnull

zehntermaizweitausendundnull

einundzwanzigstermaizweitausendundnull

all: 2000, 15 framed c-prints; 200 × 300 cm

136 ultramarine
2000, 8 white speakers, 6 walls of wood and plaster,
sound, text loop; 400 × 280 × 40 cm each wall

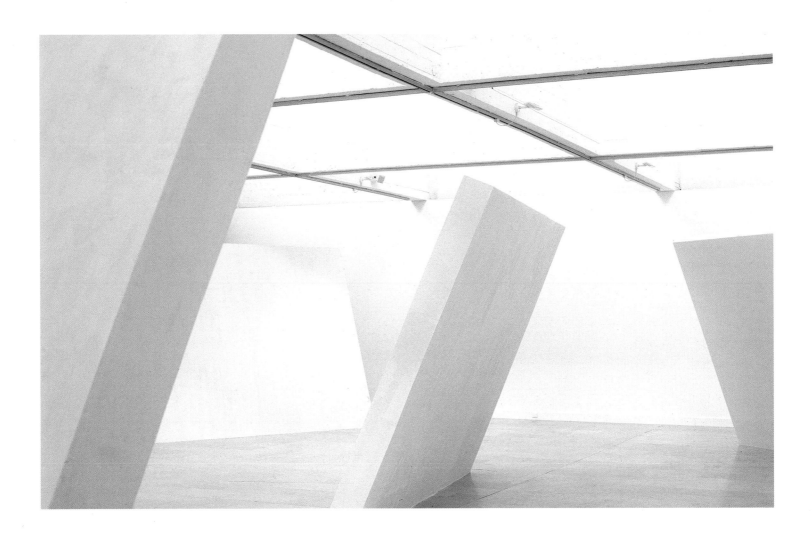

m1. who the hell do you think you are?
m2. i think...
m1. you think you're something
special. don't you?
m2. just tell me what i've done
wrong?
m1. you think you shit ice cream
cones, don't you?
m2. just tell me.
m1. tell me this, tell me that. give
me this, give me that. other
people need things too. you ever
think about that? you ever think
about me?
m2. i think about you all the time.
m1. who was that? did you say
something?
m2. i don't know what you want.
m1. you don't know what i want?
i don't know – maybe it's
my fault.

m2. it's not your fault.
m1. so – who's fault is it, if it
isn't my fault – who's fault is it?
m2. it's maybe my fault.
m1. it's maybe your fault?
who the hell do you think you are?
m2. i think...
m1. you think you're something
special. don't you?
m2. just tell me what i've done
wrong?
m1. you think you shit ice cream
cones, don't you?
m2. just tell me.
m1. tell me this, tell me that. give
me this, give me that. other
people need things too. you ever
think about that? you ever think
about me?
m2. i think about you all the time.
m1. who was that? did you say

something?
m2. i don't know what you want.
m1. you don't know what i want?
i don't know – maybe it's
my fault.
m2. it's not your fault.
m1. so – who's fault is it, if it
isn't my fault – who's fault is it?
m2. it's maybe my fault.
m1. it's maybe your fault?
who the hell do you think you are?m2.
m1. i think...
m1. you think you're something
special. don't you?
m2. just tell me what i've done
wrong?
m1. you think you shit ice cream
cones, don't you?
m2. just tell me.
m1. tell me this, tell me that. give
me this, give me that...

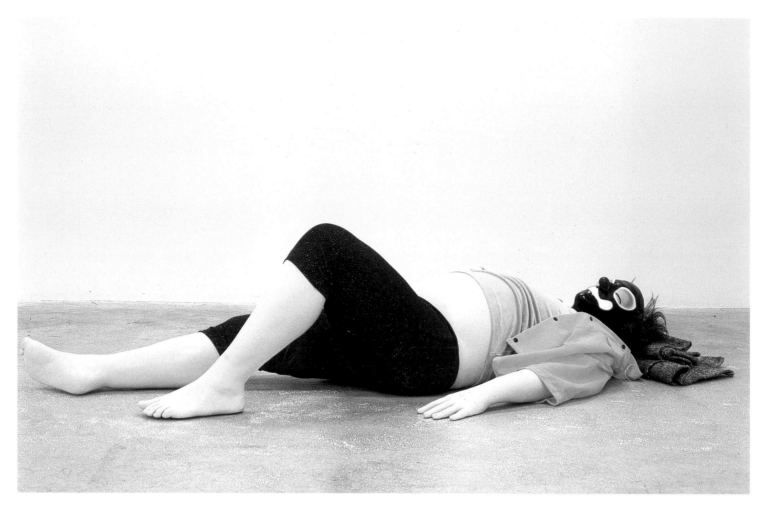

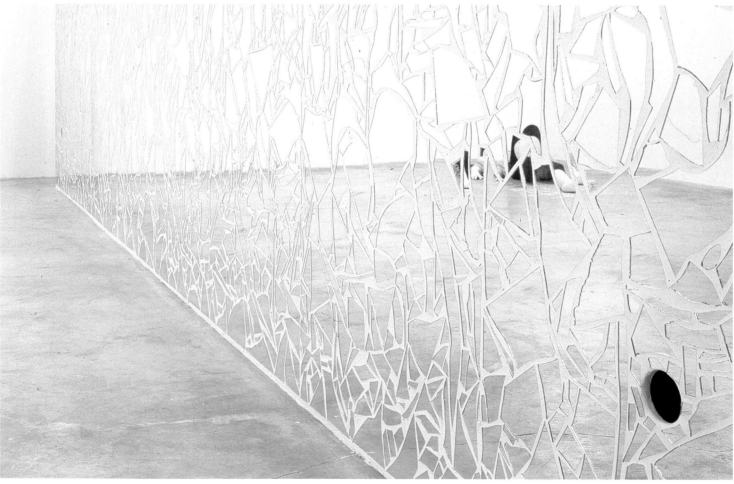

if there were anywhere but desert. 0.
2001, fibreglass, paint, clothing, glitter; 49 × 172 × 71 cm

hell, yes!
2001, wooden wall, mirror, plaster, 4 speakers, sound, text loop; 250 × 1000 × 1000 cm

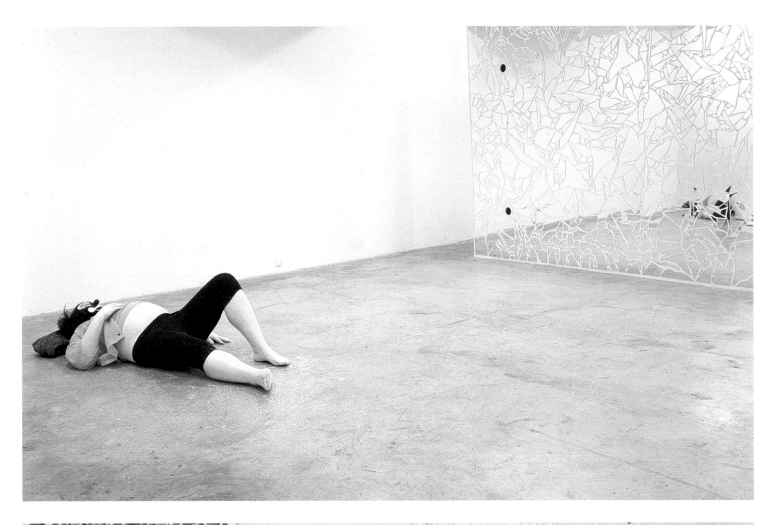

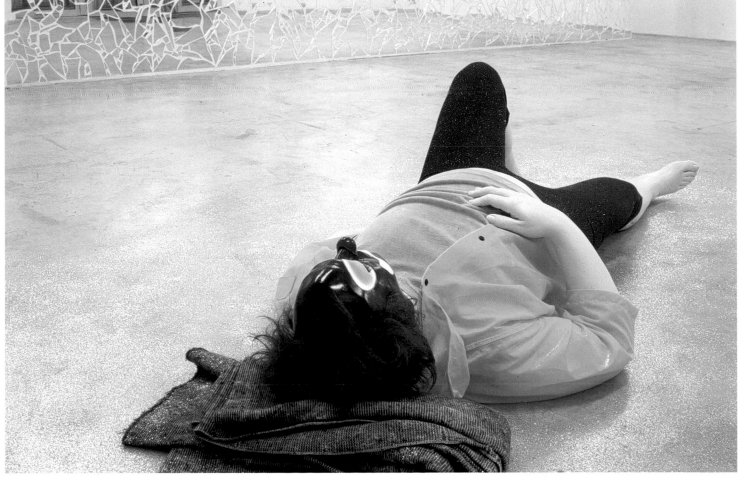

kiss tomorrow goodbye
2001, neon, perspex, transluscent film,
aluminium; 1133 × 455 × 10 cm

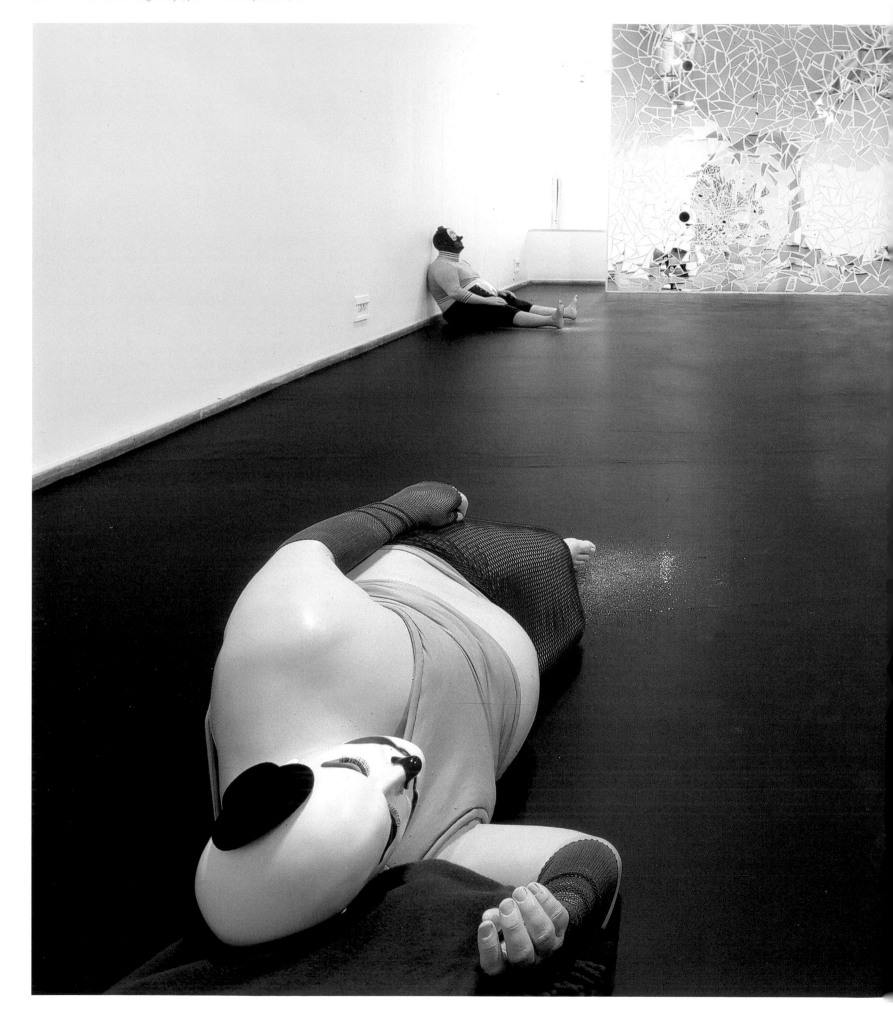

142 hell, yes!
2001, part I: wooden wall, mirror, plaster, 4 speakers, sound, text loop; site-specific size

if there were anywhere but desert. monday.
2001, fibreglass, paint, clothing; 86 × 106 × 122 cm

if there were anywhere but desert. thursday.
2001, fibreglass, paint, clothing, glitter; 40 × 162 × 54 cm

rubber floor

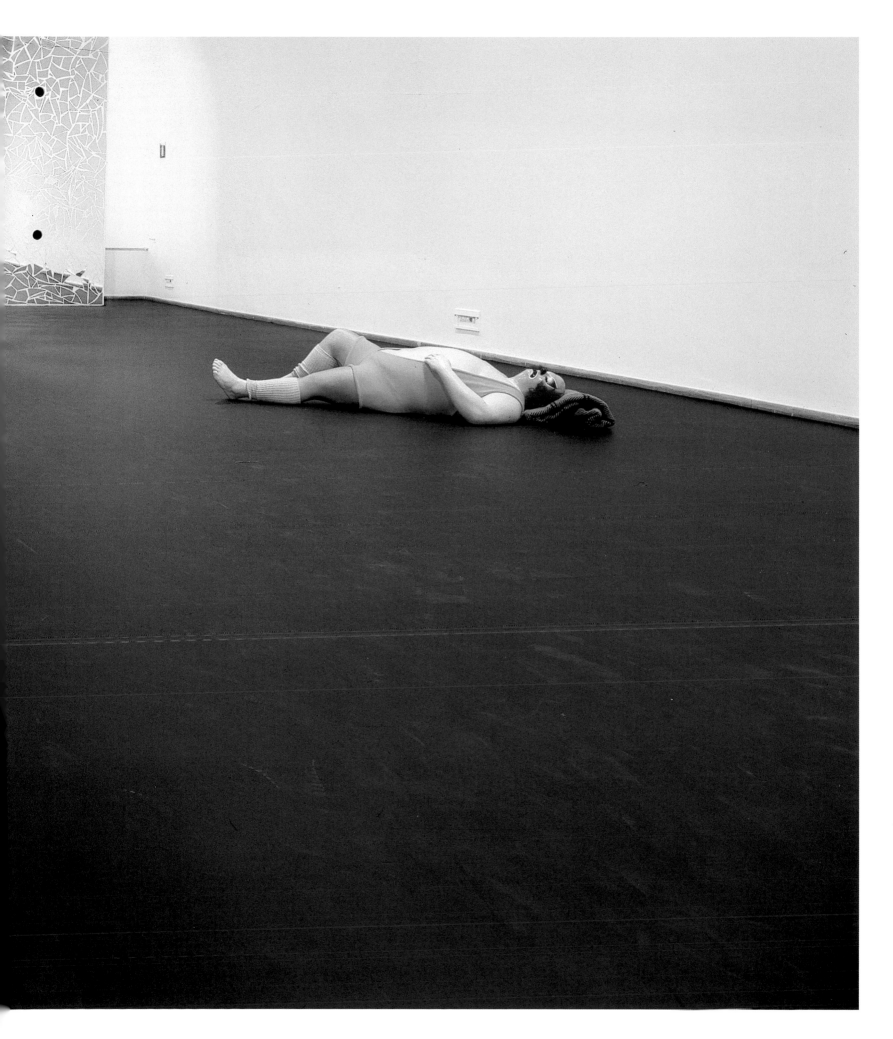

if there were anywhere but desert. sunday.
2001, fibreglass, paint, clothing, glitter; 41 × 172 × 87 cm

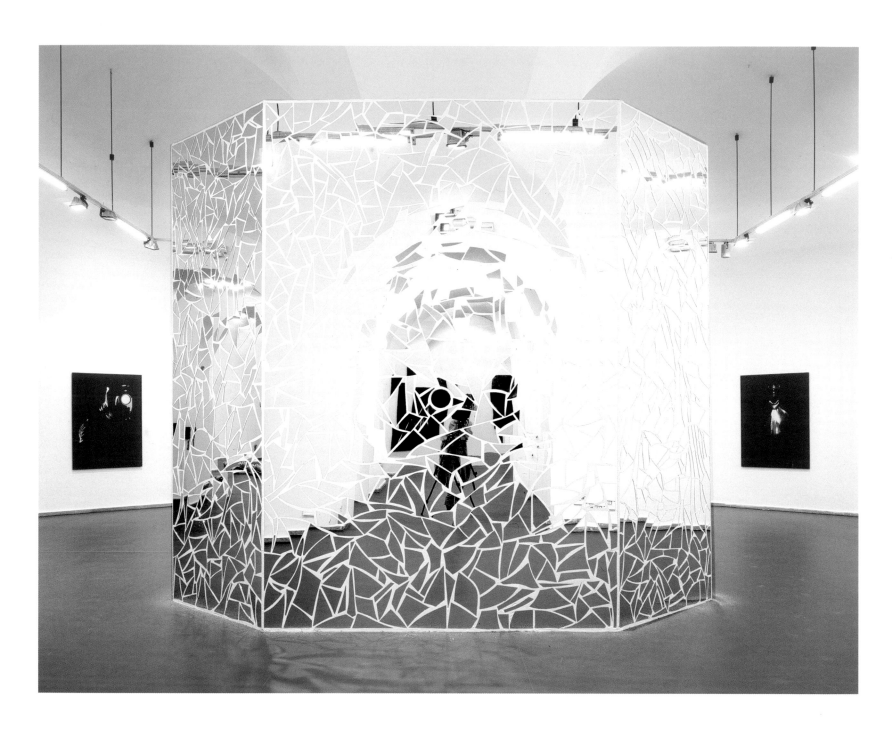

144 hell, yes!
 2001, part II: wooden column, mirror, plaster, 4 speakers,
 sound, text loop; site-specific size

 rubber floor

moonlighting
1999, c-prints mounted on aluminium,
wooden frame; 164 × 120 cm each

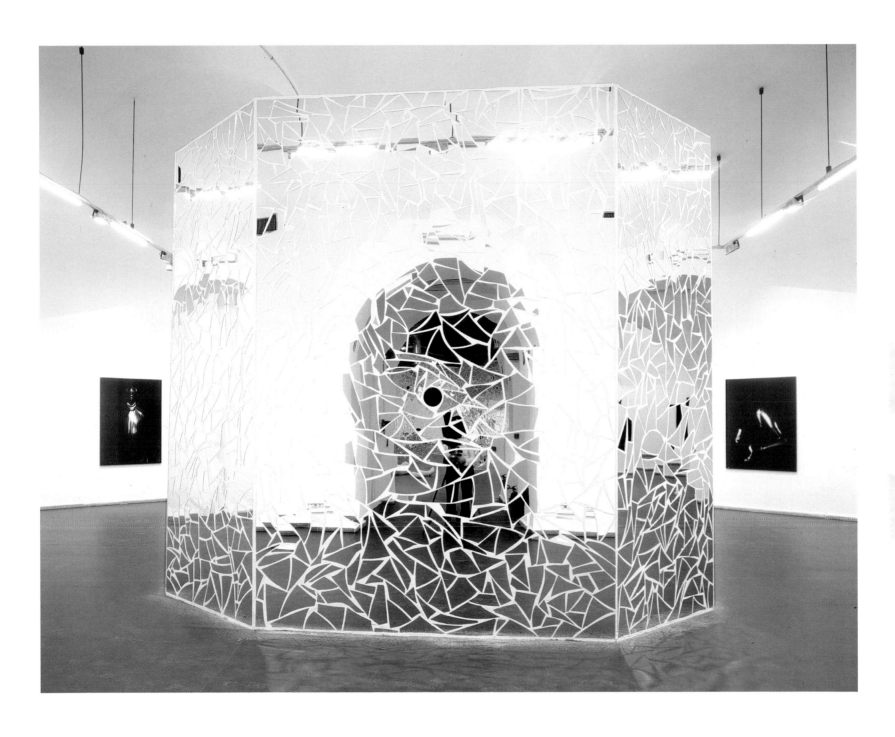

146 dreams and dramas
2001, neon, perspex, transluscent film, aluminium;
259 × 691 × 10 cm

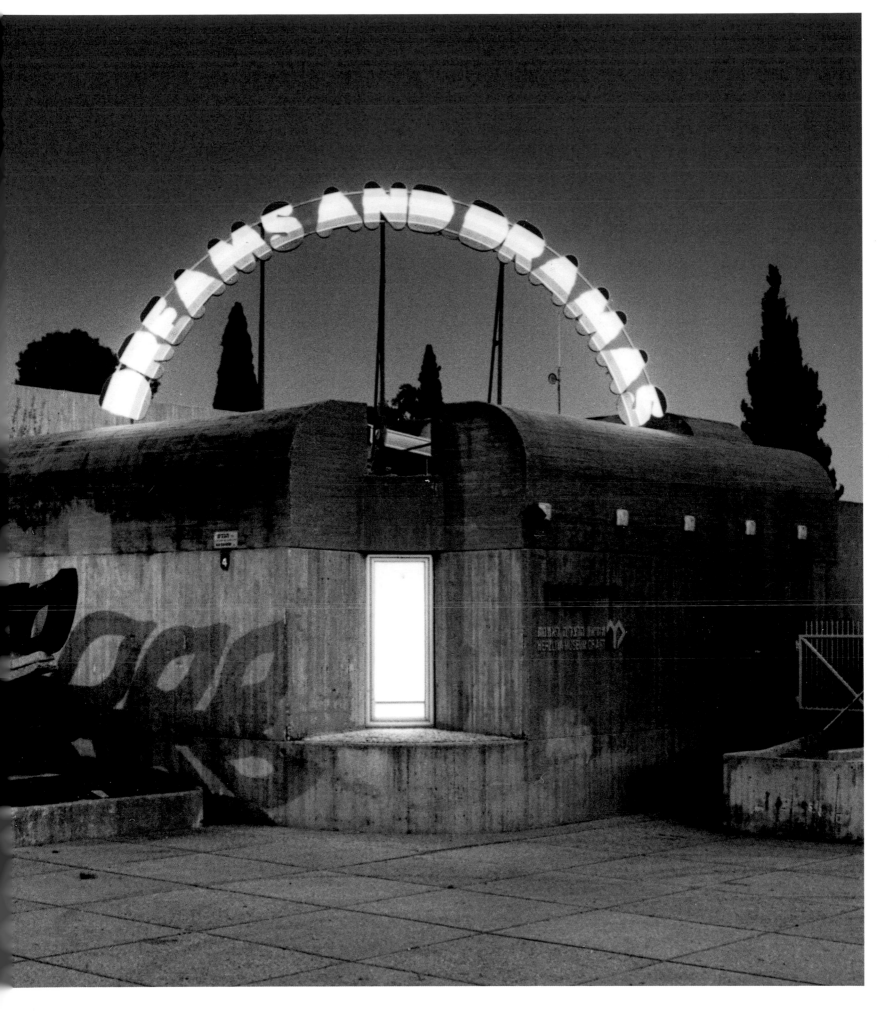

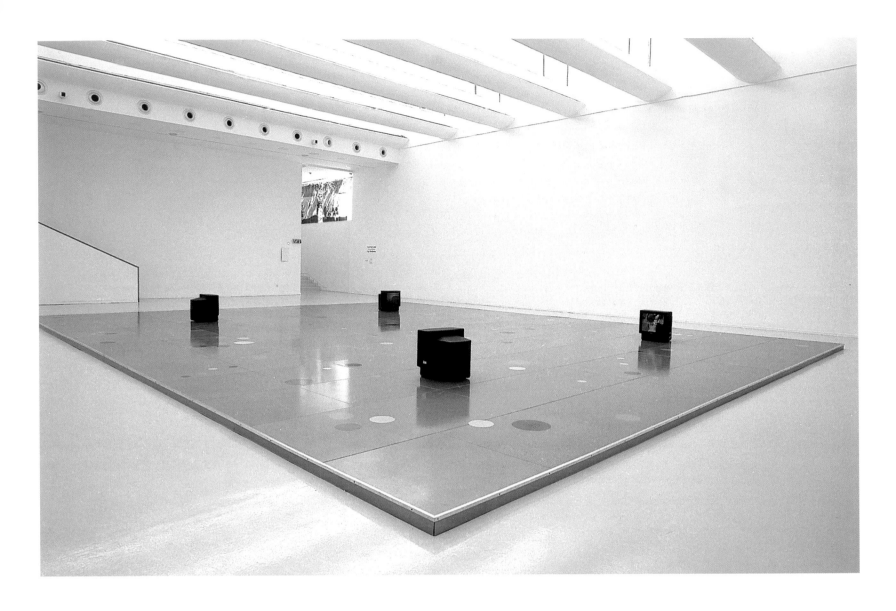

dreams and dramas
2001, 4 dvds, 12 speakers, wooden floor, baked car enamel,
sound; 55 × 1200 × 1000 cm

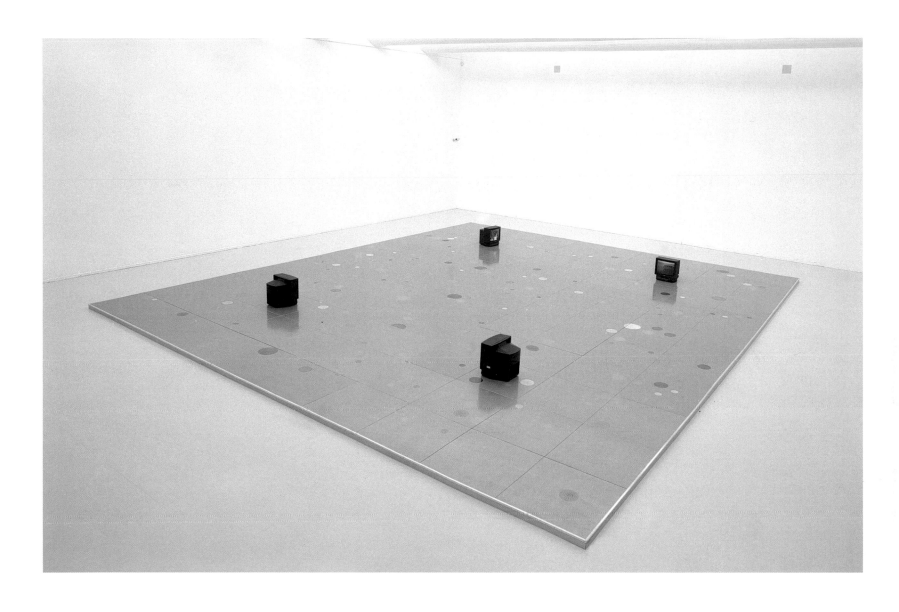

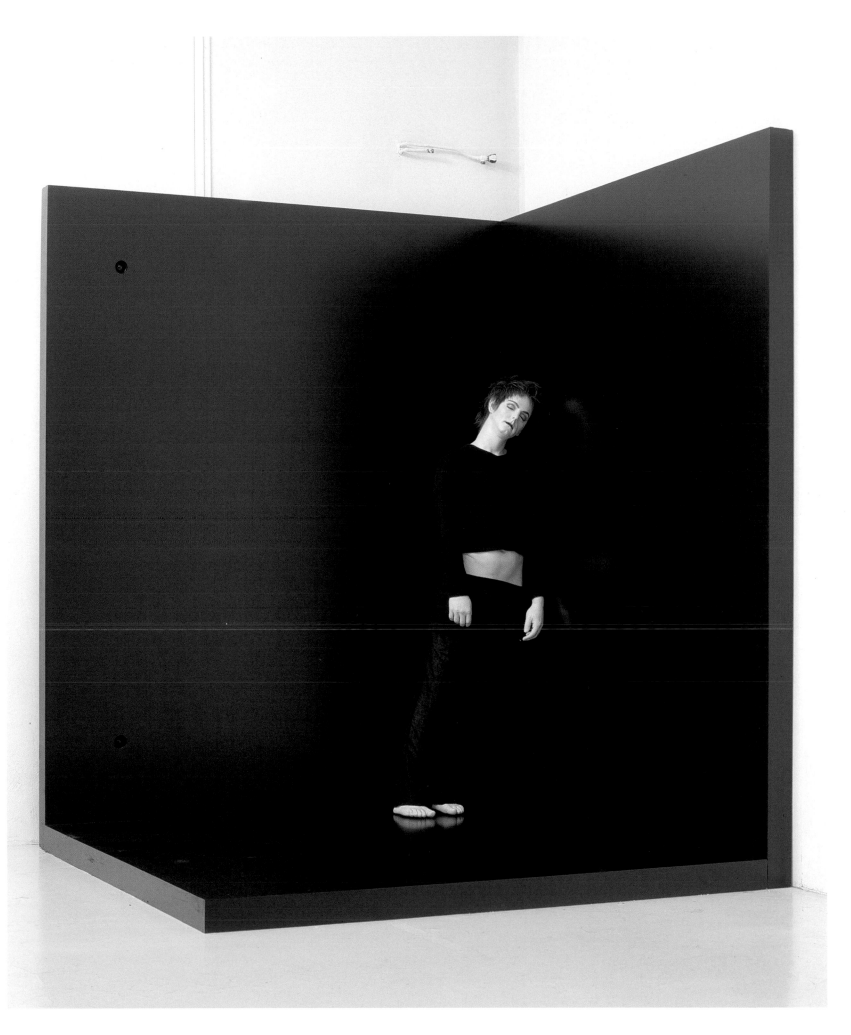

guided by voices
1997, polyester, cotton, acrylic paint, wooden wall,
speakers, sound; 250 × 250 × 100 cm

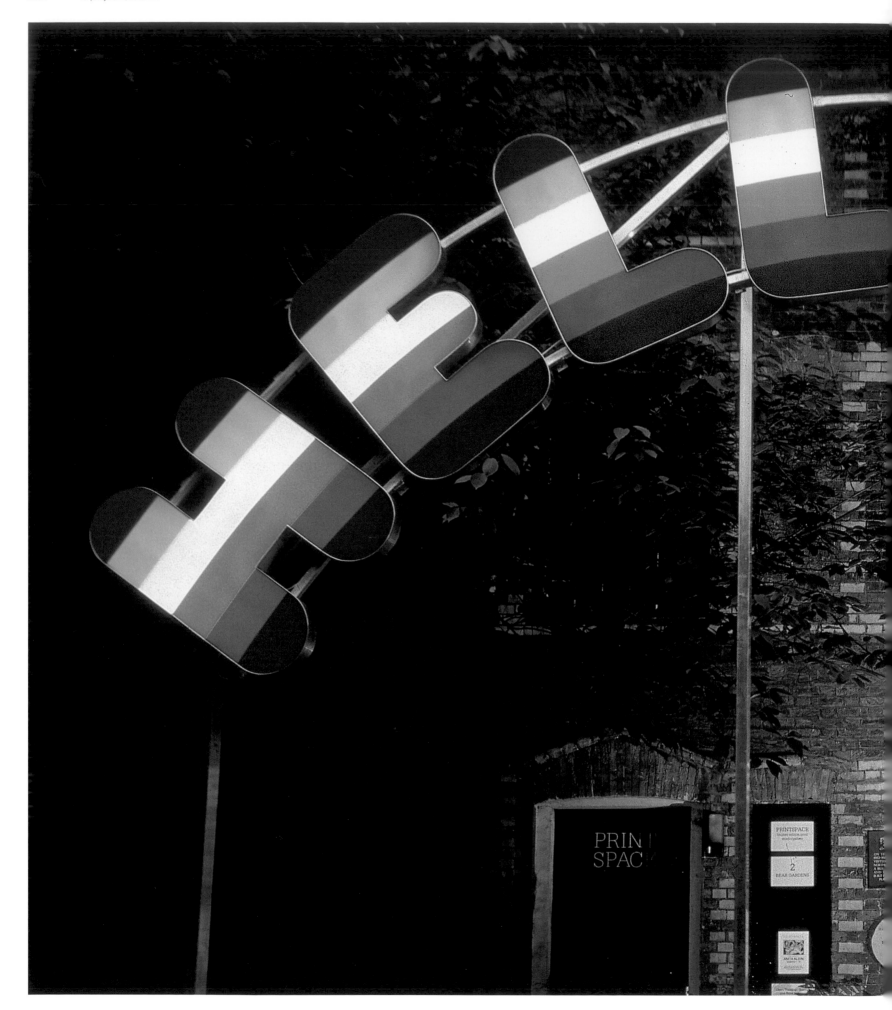

152 hell, yes!
2001, neon, perspex, transluscent film,
aluminium; 284 × 734 × 15 cm

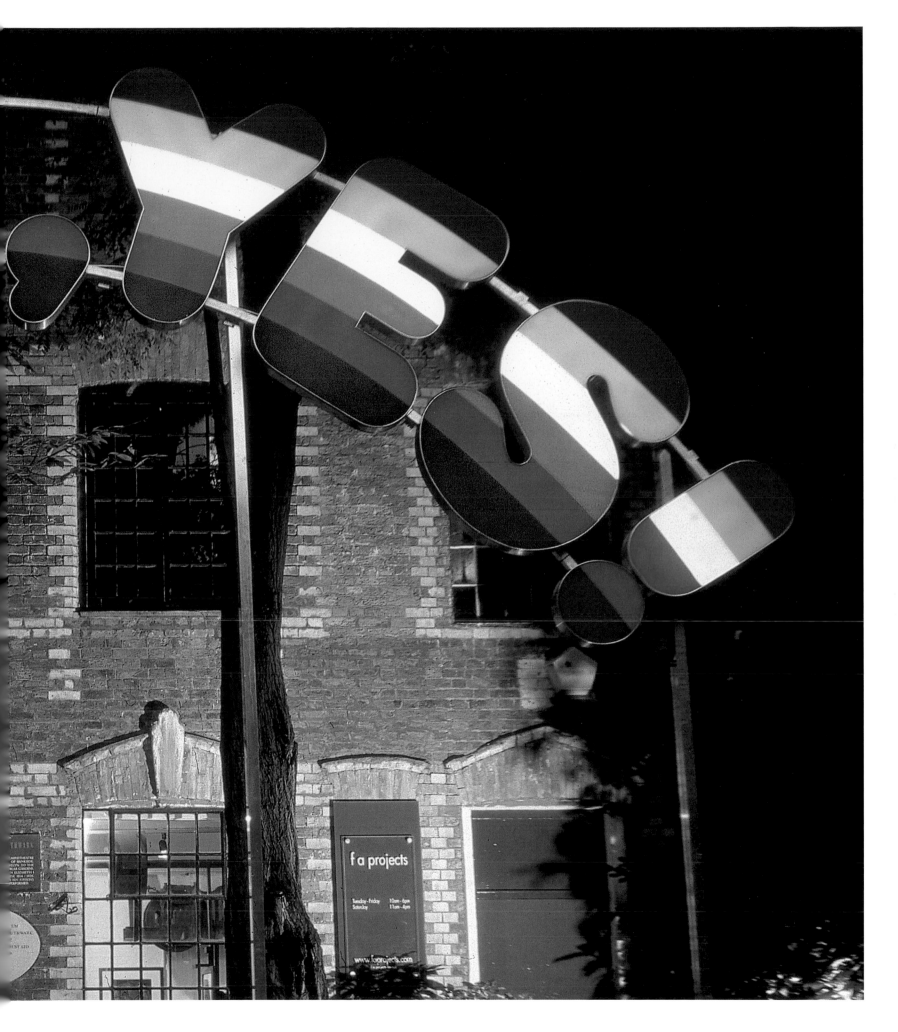

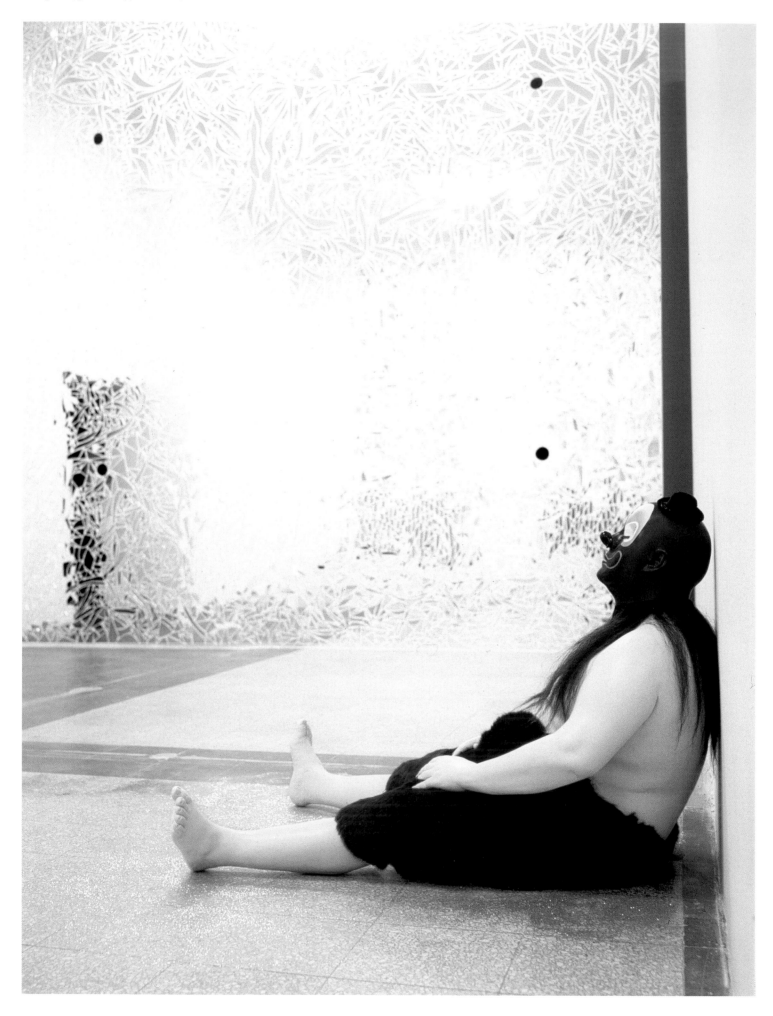

what do you want?
2001, wooden wall, mirror, plaster, 18 speakers,
sound, text loop; 250 × 500 cm

if there were anywhere but desert. monday.
2001, fibreglass, paint, clothing;
86 × 106 × 122 cm

m. what do you want?
w. what do i want?
m. yes, what do you want?
w. i don't want anything.
m. really?
w. yes, really.
m. why?
w. why what?
m. why don't you want anything?
w. because i don't think anything
 is gonna help.
m. what do you mean by that?
w. forget it.
m. do you live around here?
w. not far.
m. i don't have anywhere to go.
w. so.
m. forget it.
w. what do you want?
m. i don't want anything from you -
 that's for sure.

w. really?
m. yes really.
w. so get lost.
m. what do you want?
w. what do i want?
m. yes, what do you want?
w. i don't want anything.
m. really?
w. yes, really.
m. why?
w. why what?
m. why don't you want anything?
w. because i don't think anything
 is gonna help.
m. what do you mean by that?
w. forget it.
m. do you live around here?
w. not far.
m. i don't have anywhere to go.
w. so.
m. forget it.

w. what do you want?
m. i don't want anything from you -
 that's for sure.
w. really?
m. yes really.
w. so get lost.
m. what do you want?
w. what do i want?
m. yes, what do you want?
w. i don't want anything.
m. really?
w. yes, really.
m. why?
w. why what?
m. why don't you want anything?
w. because i don't think anything
 is gonna help.
m. what do you mean by that?
w. forget it.
m. do you live around here?
...

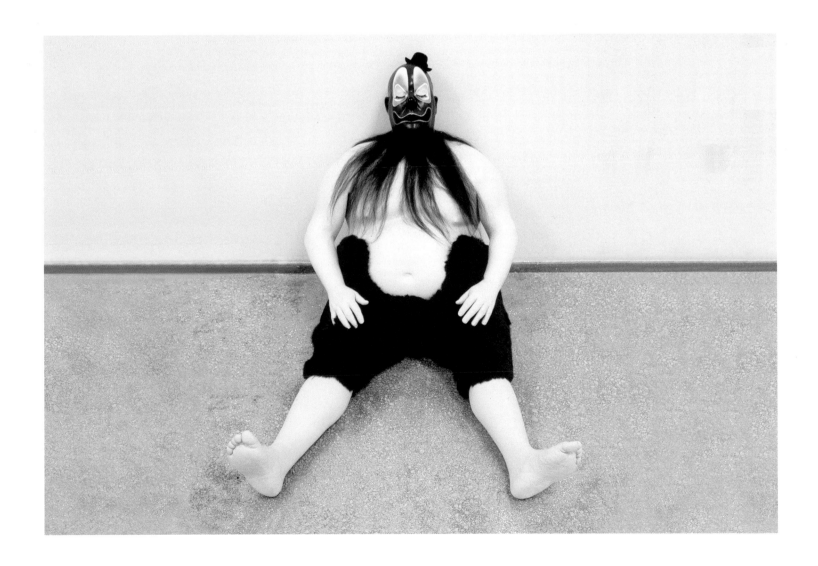

156 a horse with no name
2002, neon, perspex, transluscent film,
aluminium; 395 × 917 × 10 cm

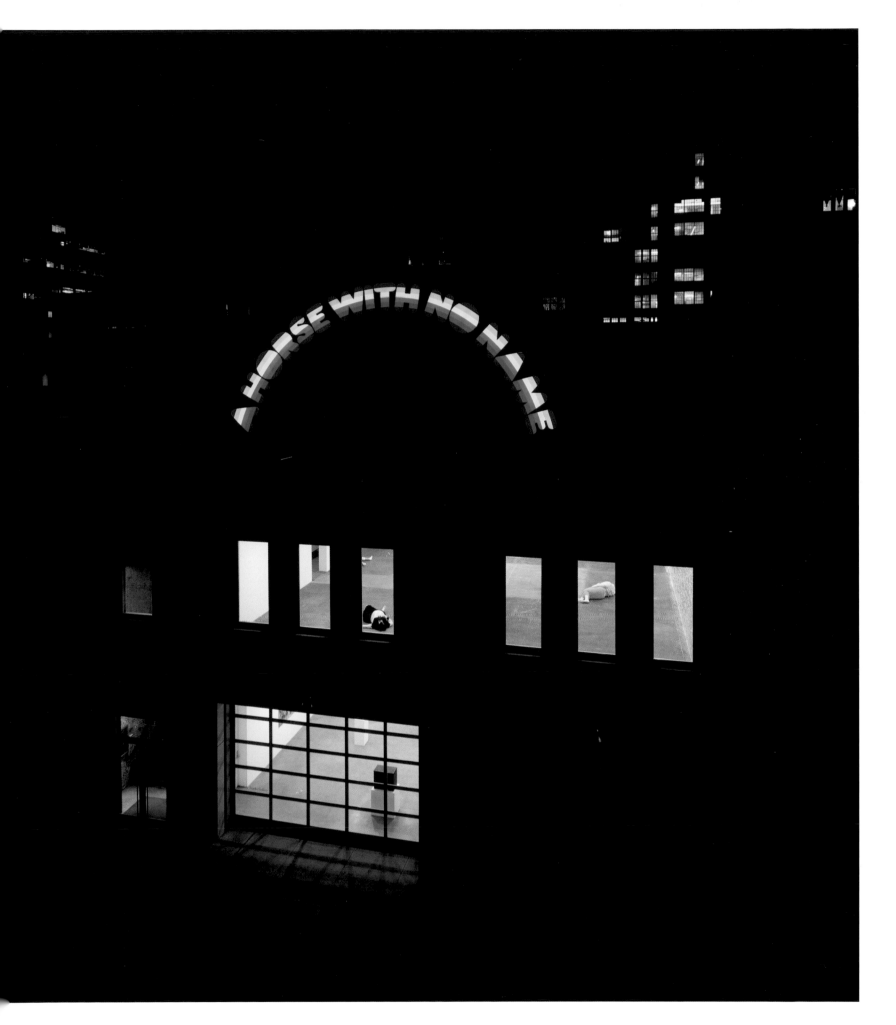

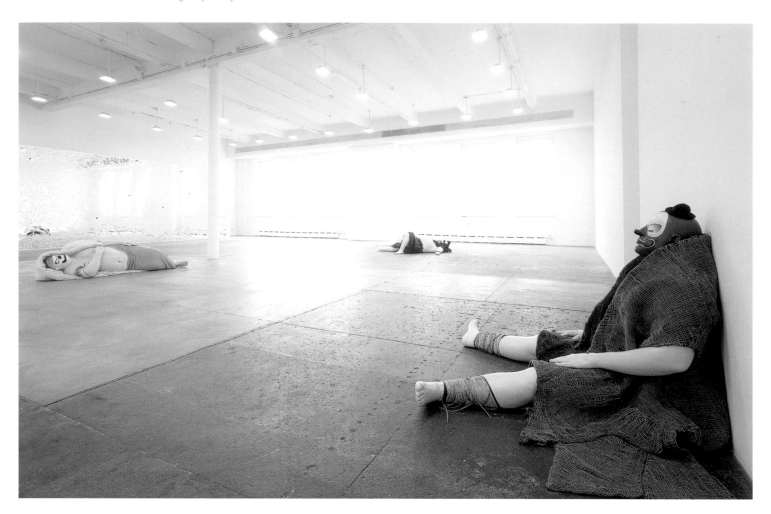

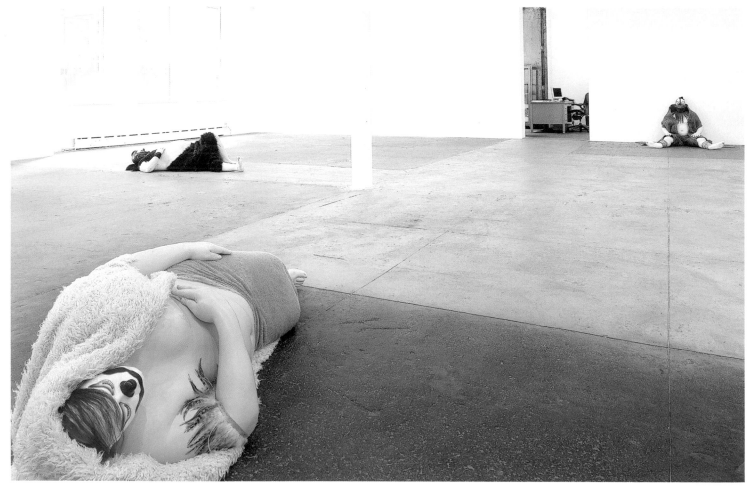

if there were anywhere but desert. friday.
2001, fibreglass, paint, clothing; 40 × 170 × 45 cm

if there were anywhere but desert. saturday.
2001, fibreglass, paint, clothing; 86 × 106 × 122 cm

if there were anywhere but desert. tuesday.
2001, fibreglass, paint, clothing; 51 × 167 × 118 cm

what do you want?
2001, wooden wall, mirror, plaster, 18 speakers, sound, text loop; site-specific size

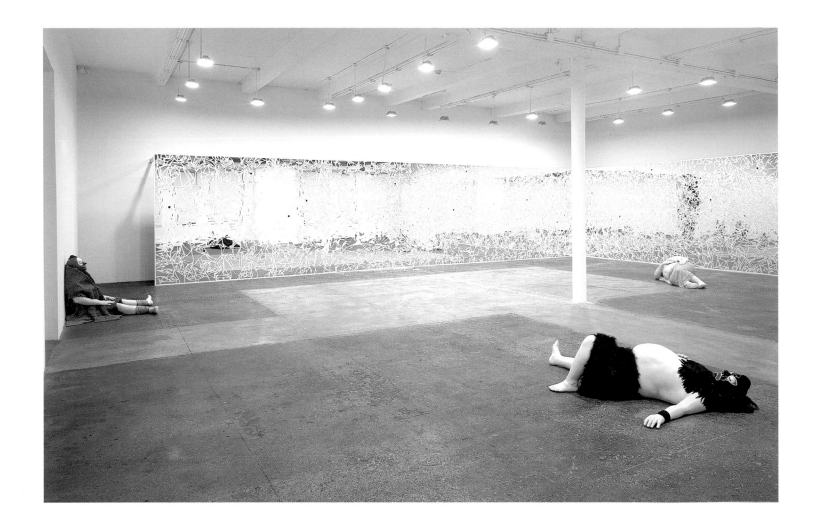

m.	what do you want?	w.	really?	w.	what do you want?
w.	what do i want?	m.	yes really.	m.	i don't want anything from you -
m.	yes, what do you want?	w.	so get lost.		that's for sure.
w.	i don't want anything.	m.	what do you want?	w.	really?
m.	really?	w.	what do i want?	m.	yes really.
w.	yes, really.	m.	yes, what do you want?	w.	so get lost.
m.	why?	w.	i don't want anything.	m.	what do you want?
w.	why what?	m.	really?	w.	what do i want?
m.	why don't you want anything?	w.	yes, really.	m.	yes, what do you want?
w.	because i don't think anything	m.	why?	w.	i don't want anything.
	is gonna help.	w.	why what?	m.	really?
m.	what do you mean by that?	m.	why don't you want anything?	w.	yes, really.
w.	forget it.	w.	because i don't think anything	m.	why?
m.	do you live around here?		is gonna help.	w.	why what?
w.	not far.	m.	what do you mean by that?	m.	why don't you want anything?
m.	i don't have anywhere to go.	w.	forget it.	w.	because i don't think anything
w.	so.	m.	do you live around here?		is gonna help.
m.	forget it.	w.	not far.	m.	what do you mean by that?
w.	what do you want?	m.	i don't have anywhere to go.	w.	forget it.
m.	i don't want anything from you -	w.	so.	m.	do you live around here?
	that's for sure.	m.	forget it.		...

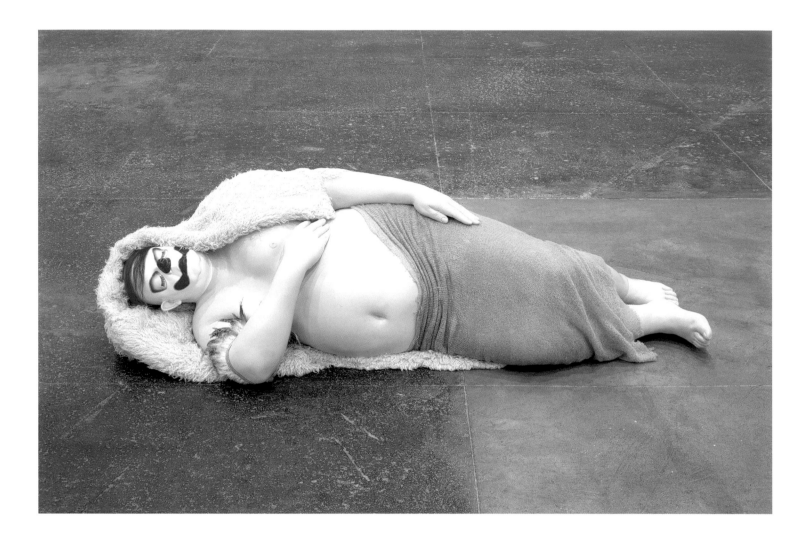

if there were anywhere but desert. friday.
2002, fibreglass, paint, clothing; 40 × 170 × 45 cm

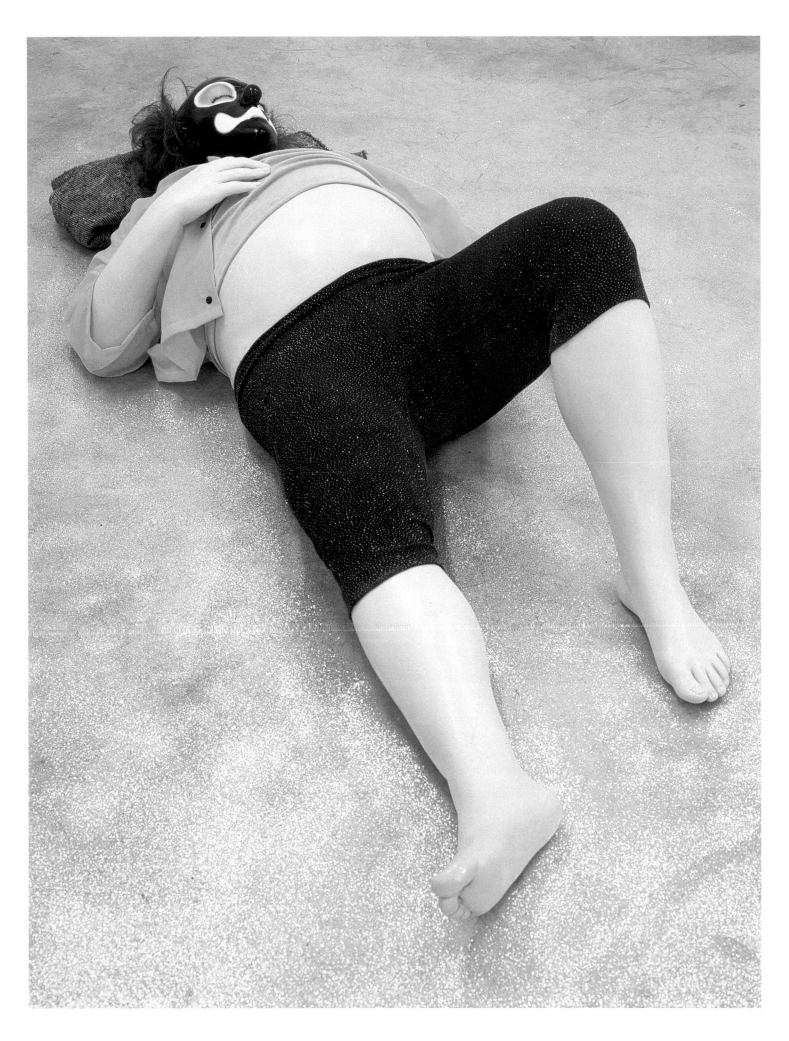

if there were anywhere but desert. 0.
2000, fibreglass, paint, clothing, glitter; 49 × 172 × 71 cm

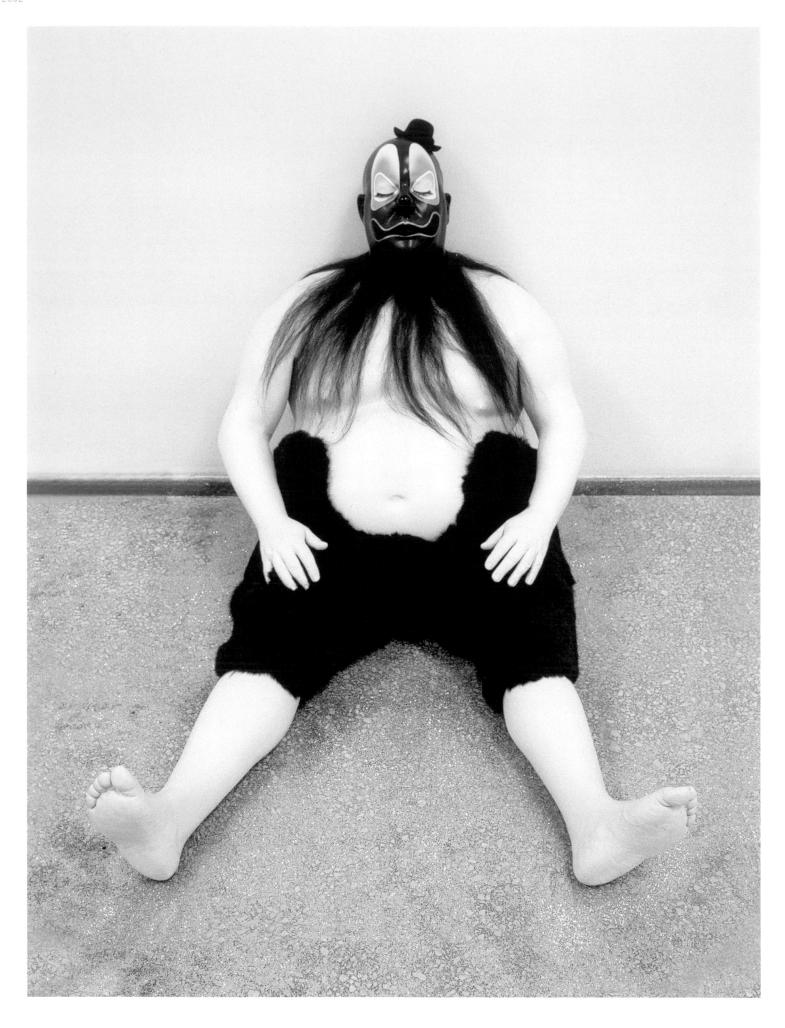

162 if there were anywhere but desert. monday.
2000, fibreglass, paint, clothing; 86 × 106 × 122 cm

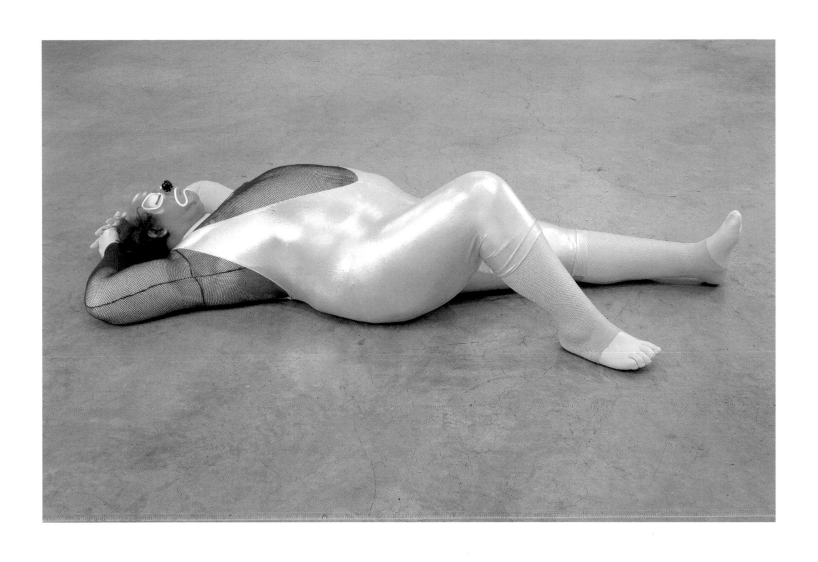

if there were anywhere but desert. wednesday.
2002, fibreglass, paint, clothing; 46 × 175 × 95 cm

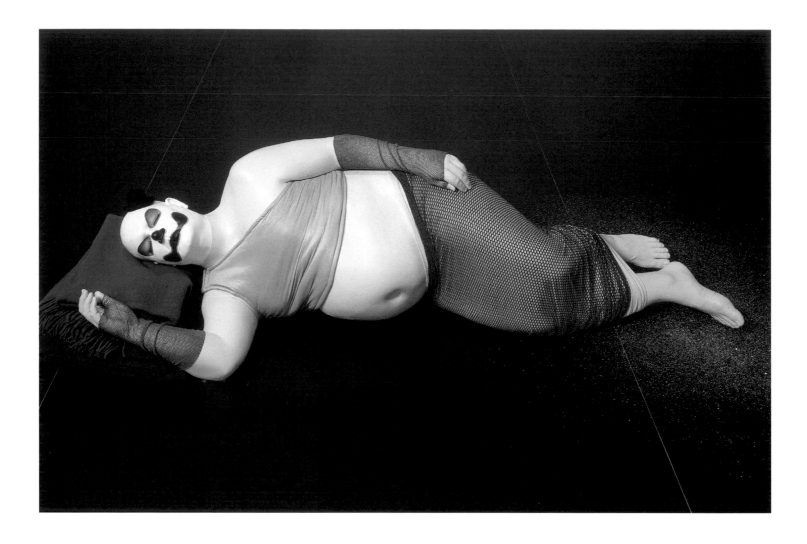

if there were anywhere but desert. thursday.
2000, fibreglass, paint, clothing, glitter; 40 × 162 × 54 cm

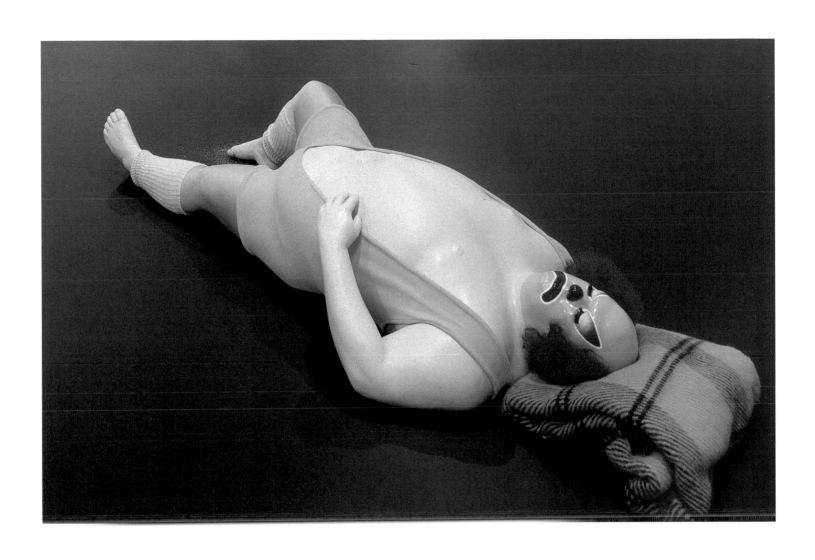

if there were anywhere but desert. sunday.
2000, fibreglass, paint, clothing, glitter; 41 × 172 × 87 cm

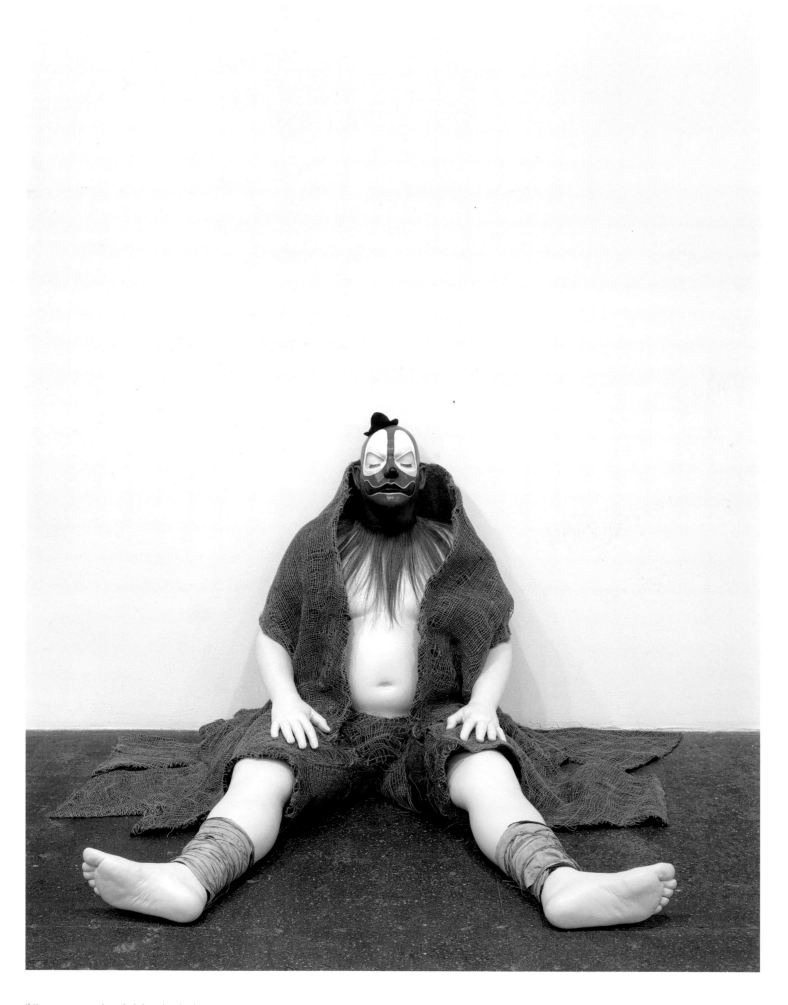

166 if there were anywhere but desert. saturday.
2002, fibreglass, paint, clothing; 86 × 106 × 122 cm

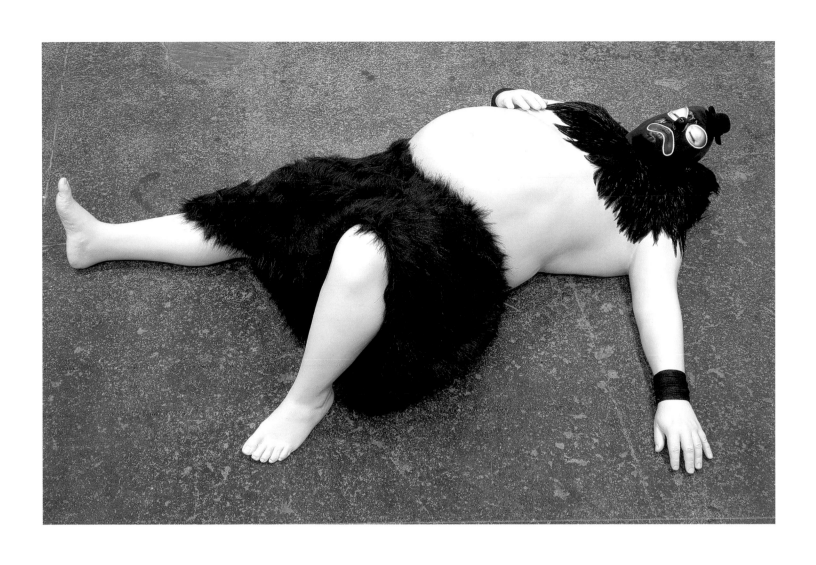

if there were anywhere but desert. tuesday.
2002, fibreglass, paint, clothing; 51 × 167 × 118 cm

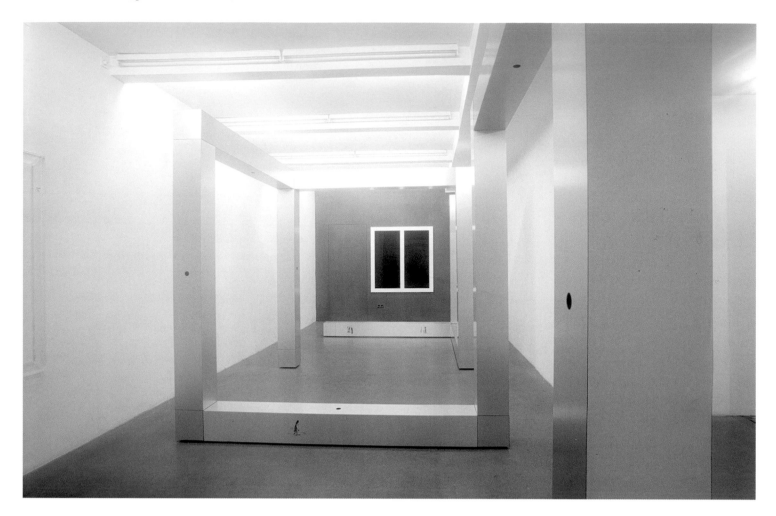

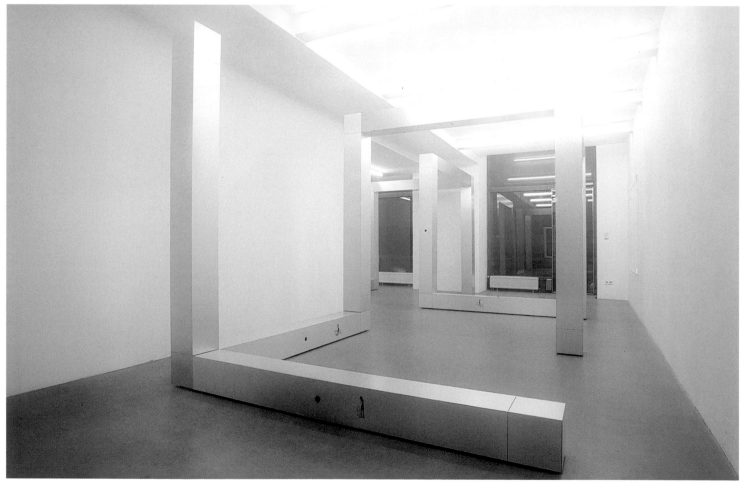

the dancer and the dance
2002, 18 pillars, aluminium, felt tip pen, 16 speakers, sound; modular system

all MOMENTS stop here and together we become every memory that has ever been.
2002, perspex; 160 × 150 × 4 cm

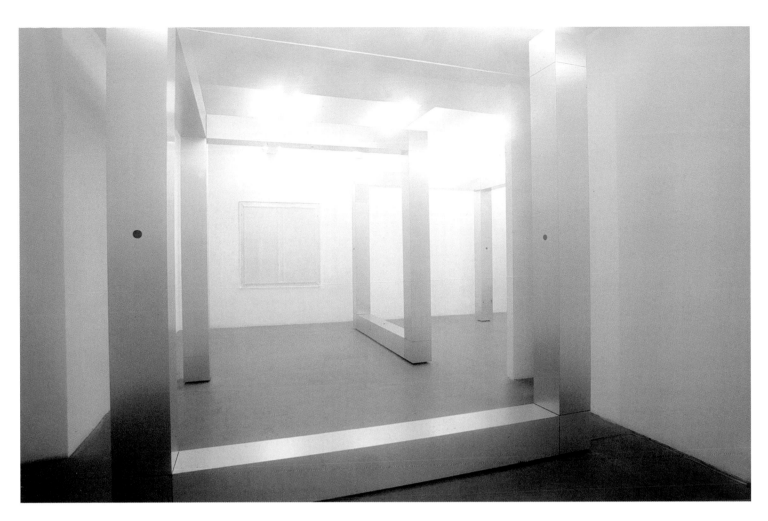

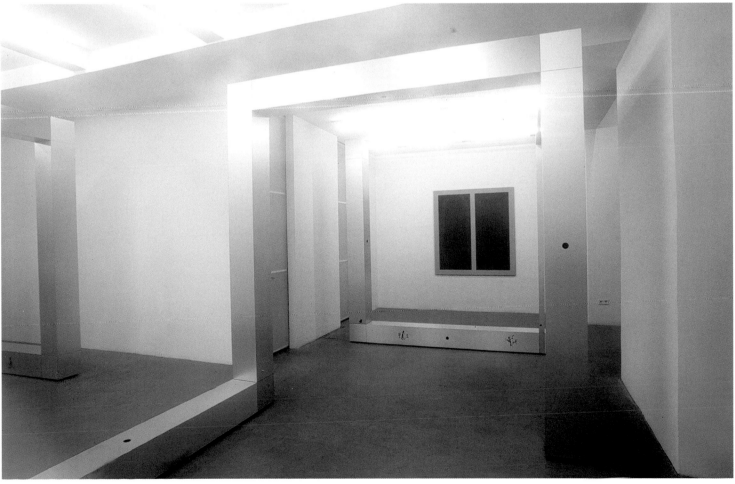

all moments stop here and together we become every memory THAT has ever been.
2002, perspex; 160 × 150 × 4 cm

all moments STOP here and together we become every memory that has ever been.
2002, perspex; 160 × 150 × 4 cm

ALL moments stop here and together we
become every memory that has ever been.

all MOMENTS stop here and together we
become every memory that has ever been.

all moments STOP here and together we
become every memory that has ever been.

170

all moments stop here and together WE
become every memory that has ever been.

all moments stop here and together we
BECOME every memory that has ever been.

all moments stop here and together we
become EVERY memory that has ever been.

all moments stop here and together we
become every memory that has EVER been.

all moments stop here and together we
become every memory that has ever BEEN.

all moments stop HERE and together we
become every memory that has ever been.

all moments stop here AND together we
become every memory that has ever been.

all moments stop here and TOGETHER we
become every memory that has ever been.

all moments stop here and together we
become every MEMORY that has ever been.

all moments stop here and together we
become every memory THAT has ever been.

all moments stop here and together we
become every memory HAS ever been.

all: 2002, perspex; 160 × 150 × 4 cm each

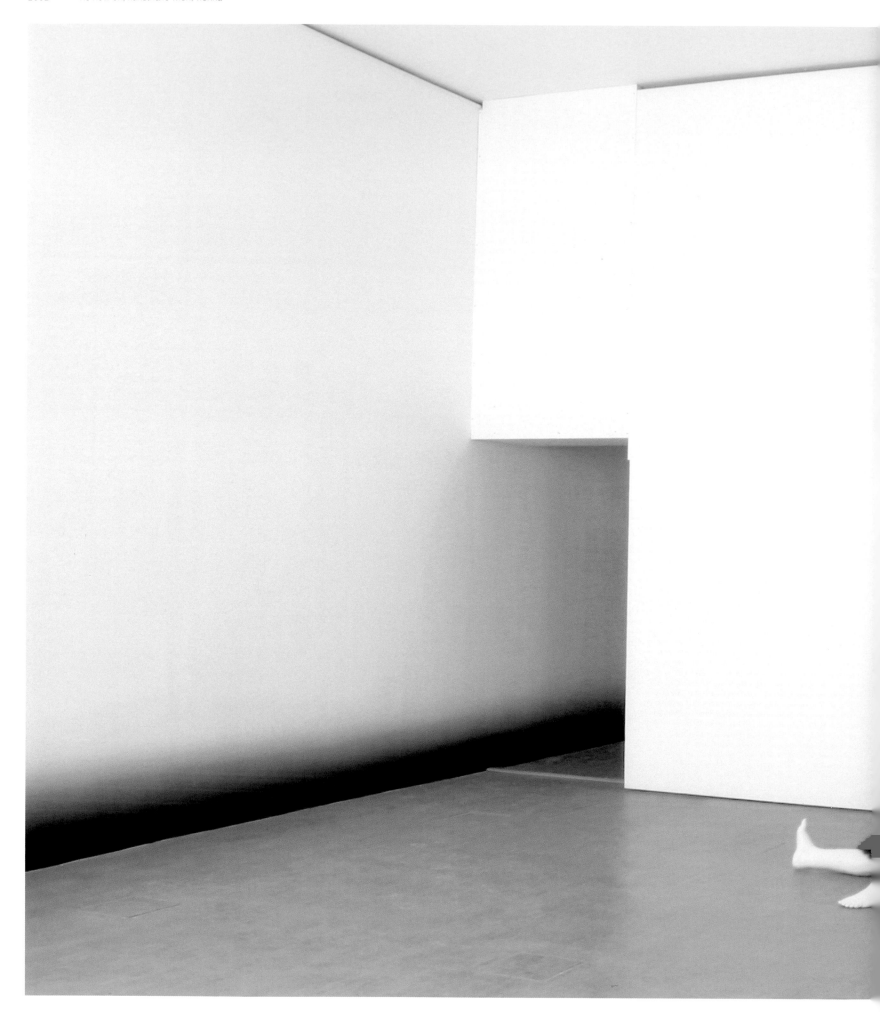

172 siebenundzwanzigsterjunizweitausendundzwei
2002, acrylic mural painting; ø 400 cm

if there were anywhere but desert. tuesday.
2002, fibreglass, paint, clothing; 51 × 167 × 118 cm

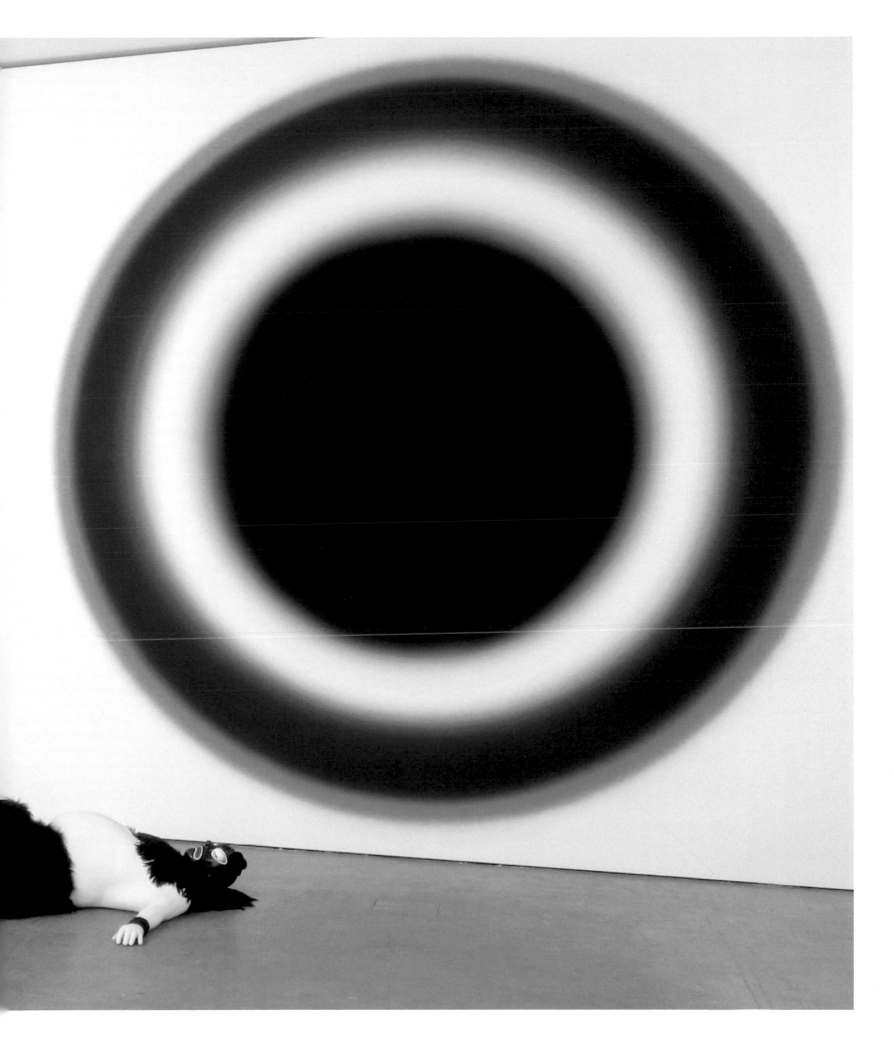

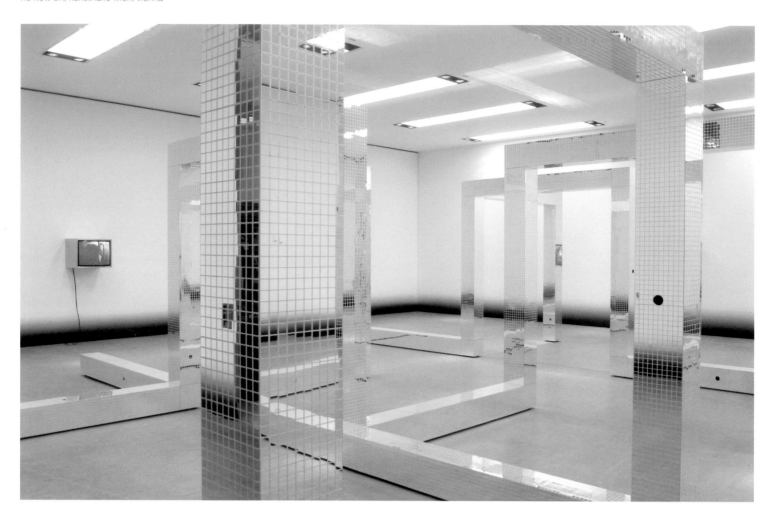

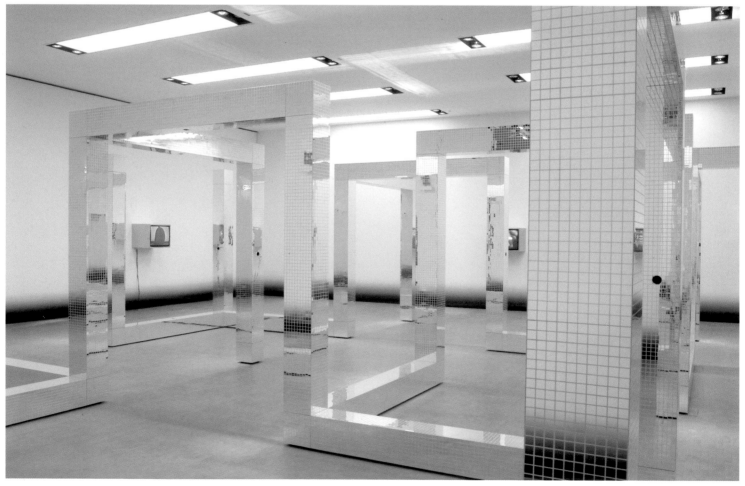

174 no how on
2002, 46 pillars, mirror, paint, 6 dvds, speakers,
sound; modular system

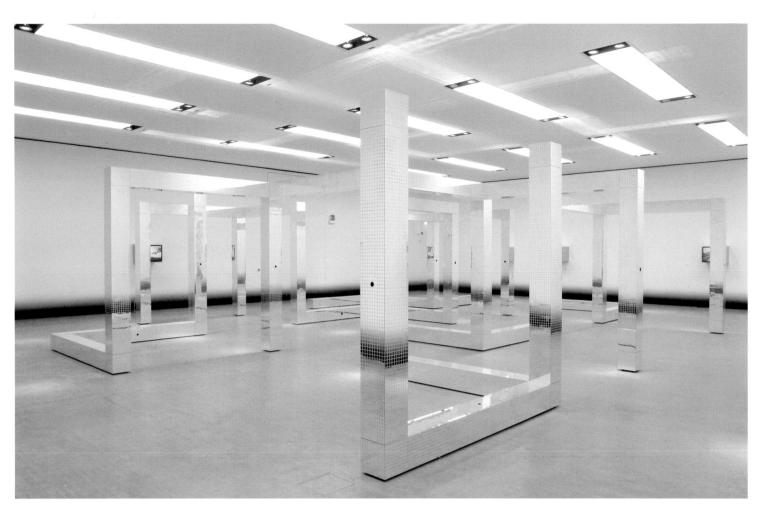

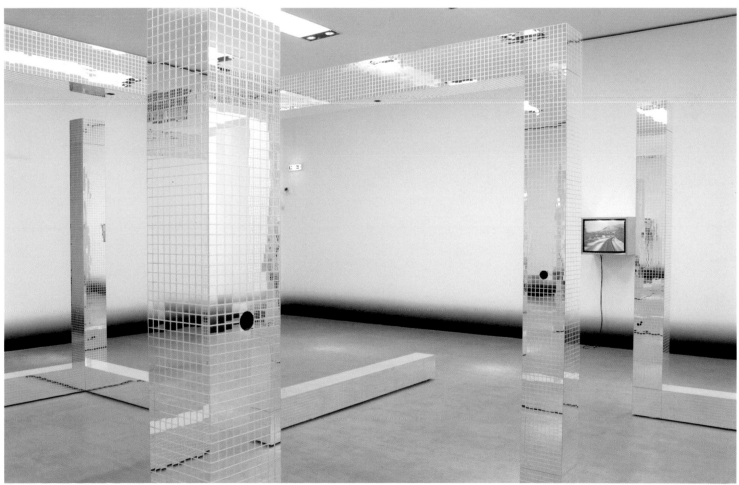

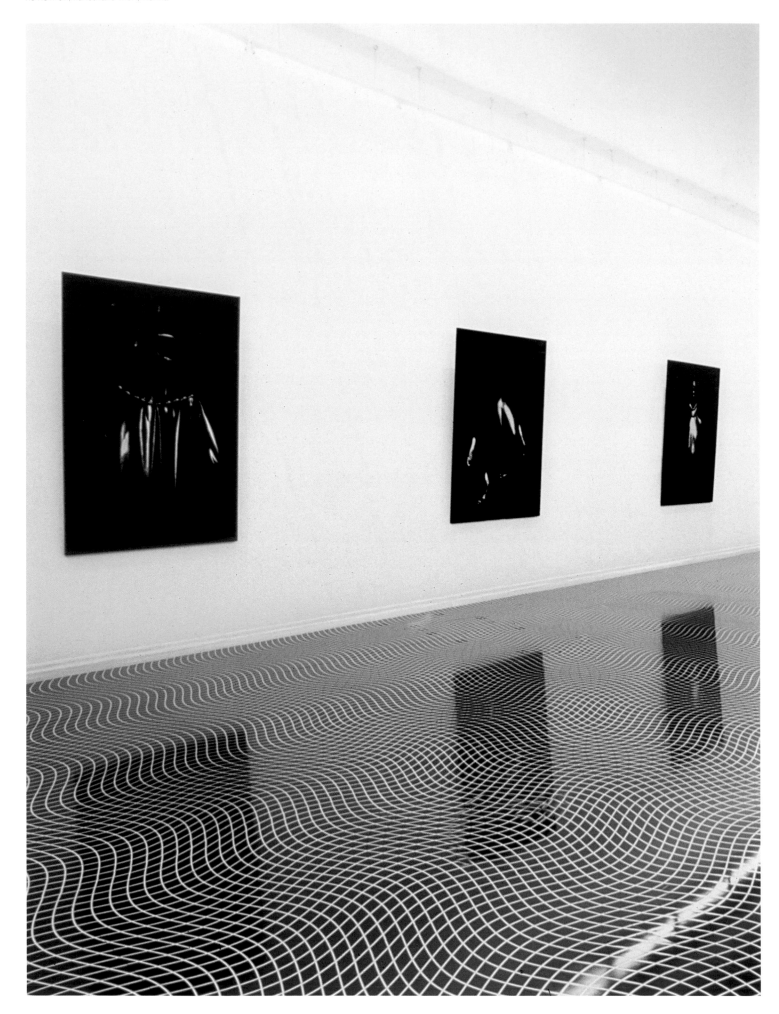

lowland lullaby
2002, wooden pannels, silk-screen printing, polyurethane,
speakers, sound, text loop; modular system

moonlighting
1999, c-prints mounted on aluminium,
wooden frame; 164 × 120 cm each

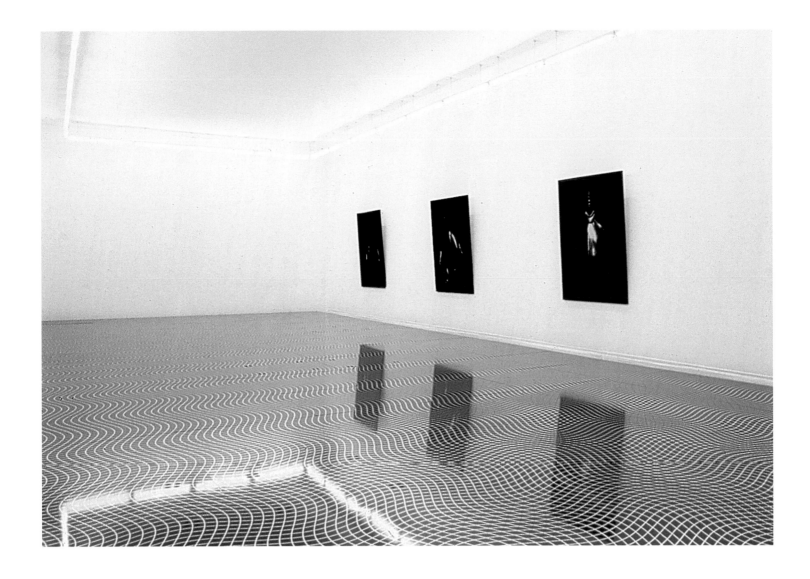

m. i'm not stupid. don't
fuck with me.
w. i know you aren't stupid.
m. then why are you fucking
with me?
w. who is fucking with you?
m. you were.
w. me?
m. oh come on.
w. come on what?
m. i heard you.
w. heard me what?
m. fucking with me.
w. you heard me fucking with you?
m. you're not going to say you
weren't.
w. of course i wasn't. we were
having a normal conversation.
m. you call that a normal
conversation?
w. oh come on.
m. come on what?
w. it's fucked up.

m. fucked up?
w. yes. fucked up.
m. what's fucked up?
w. what you've just said.
m. what i've just said is fucked
up? can you tell me why?
w. it's just fucked up. you
should hear yourself.
m. you should hear yourself.
putting on that voice to
speak to me.
w. what voice?
m. i'm not stupid. don't
fuck with me.
w. i know you aren't stupid.
m. then why are you fucking
with me?
w. who is fucking with you?
m. you were.
w. me?
m. oh come on.
w. come on what?
m. i heard you.

w. heard me what?
m. fucking with me.
w. you heard me fucking with you?
m. you're not going to say you
weren't.
w. of course i wasn't. we were
having a normal conversation.
m. you call that a normal
conversation?
w. oh come on.
m. come on what?
w. it's fucked up.
m. fucked up?
w. yes. fucked up.
m. what's fucked up?
w. what you've just said.
m. what i've just said is fucked
up? can you tell me why?
w. it's just fucked up. you
should hear yourself.
m. you should hear yourself.
putting on that voice to
...

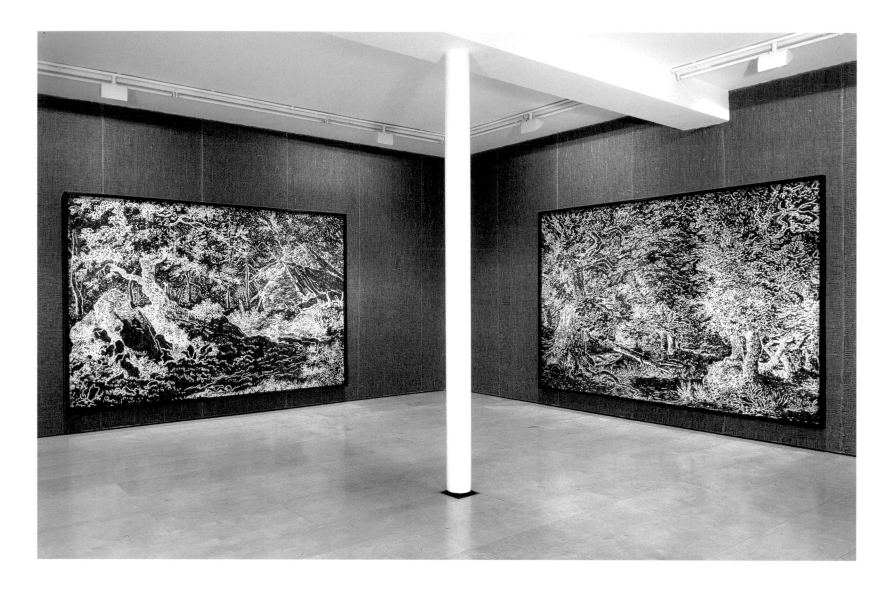

ersterseptemberzweitausendundzwei
2002, ink on paper, wooden frame; 200 × 300 cm

fünfzehnteraugustzweitausendundzwei
2002, ink on paper, wooden frame; 200 × 300 cm

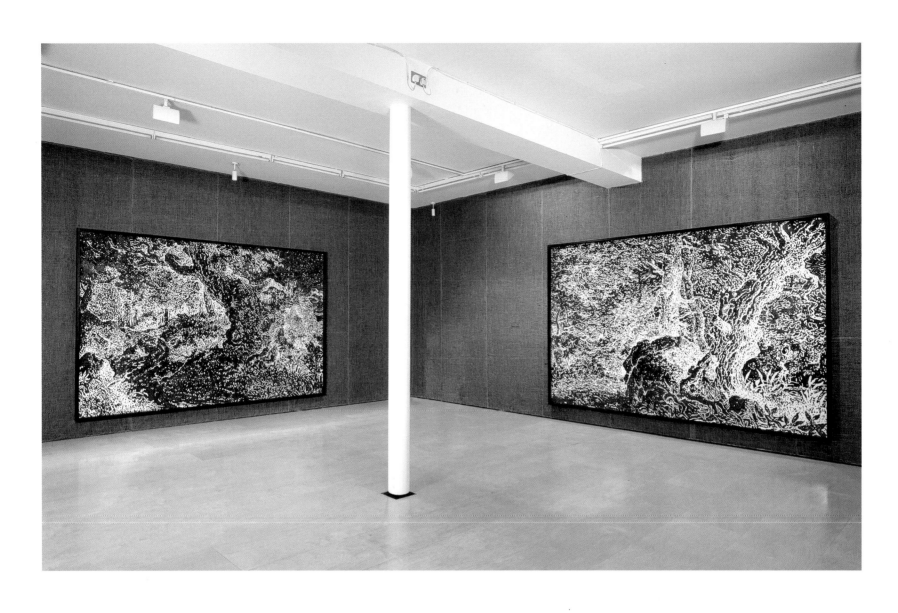

achteraugustzweitausendundzwei
2002, ink on paper, wooden frame; 200 × 300 cm

neunundzwanzigsterjulizweitausendundzwei
2002, ink on paper, wooden frame; 200 × 300 cm

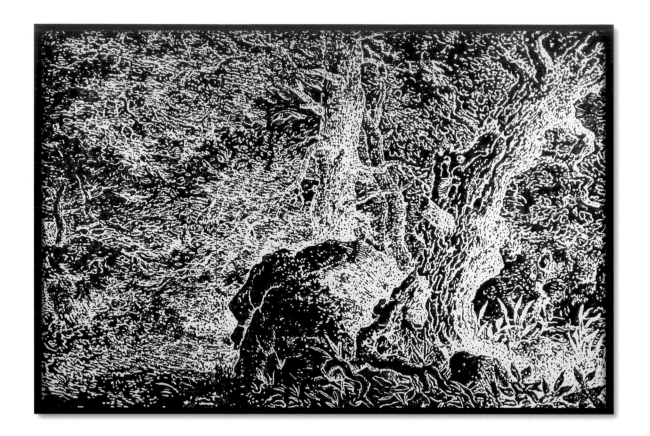

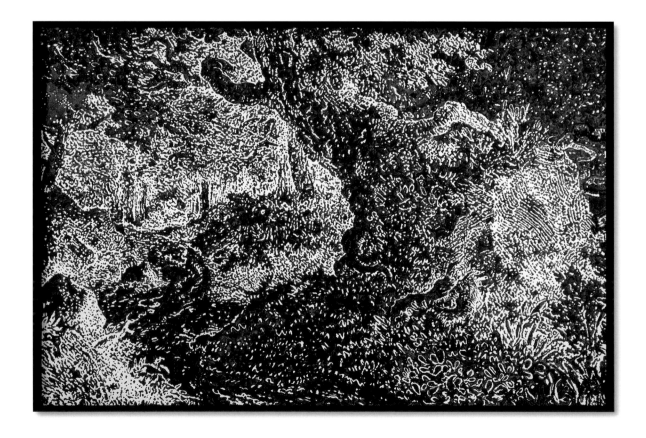

180 neununddzwanzigsterjulizweitausendundzwei
2002, ink on paper, wooden frame; 200 × 300 cm

achteraugustzweitausendundzwei
2002, ink on paper, wooden frame; 200 × 300 cm

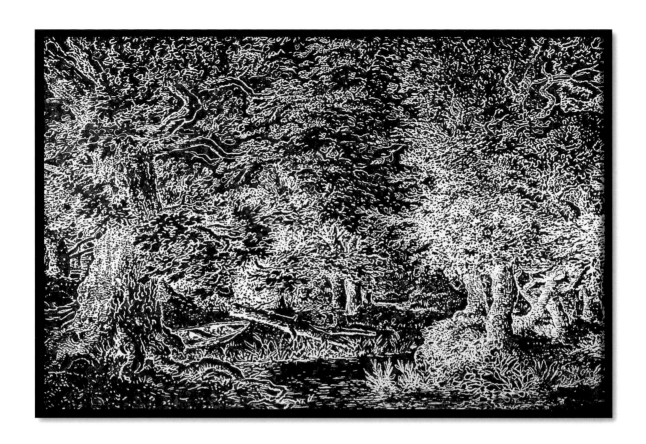

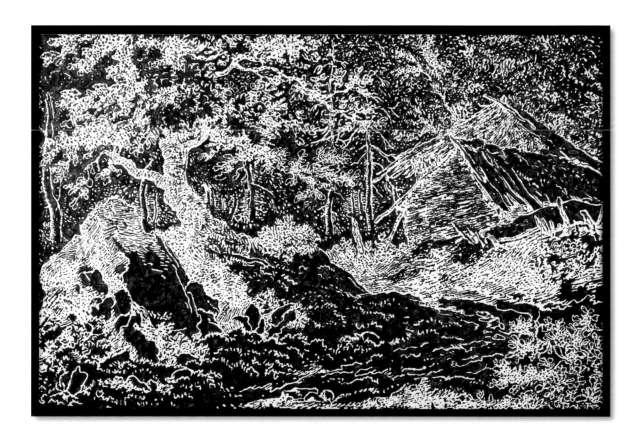

fünfzehnteraugustzweitausendundzwei
2002, ink on paper, wooden frame; 200 × 300 cm

ersterseptemberzweitausendundzwei
2002, ink on paper, wooden frame; 200 × 300 cm

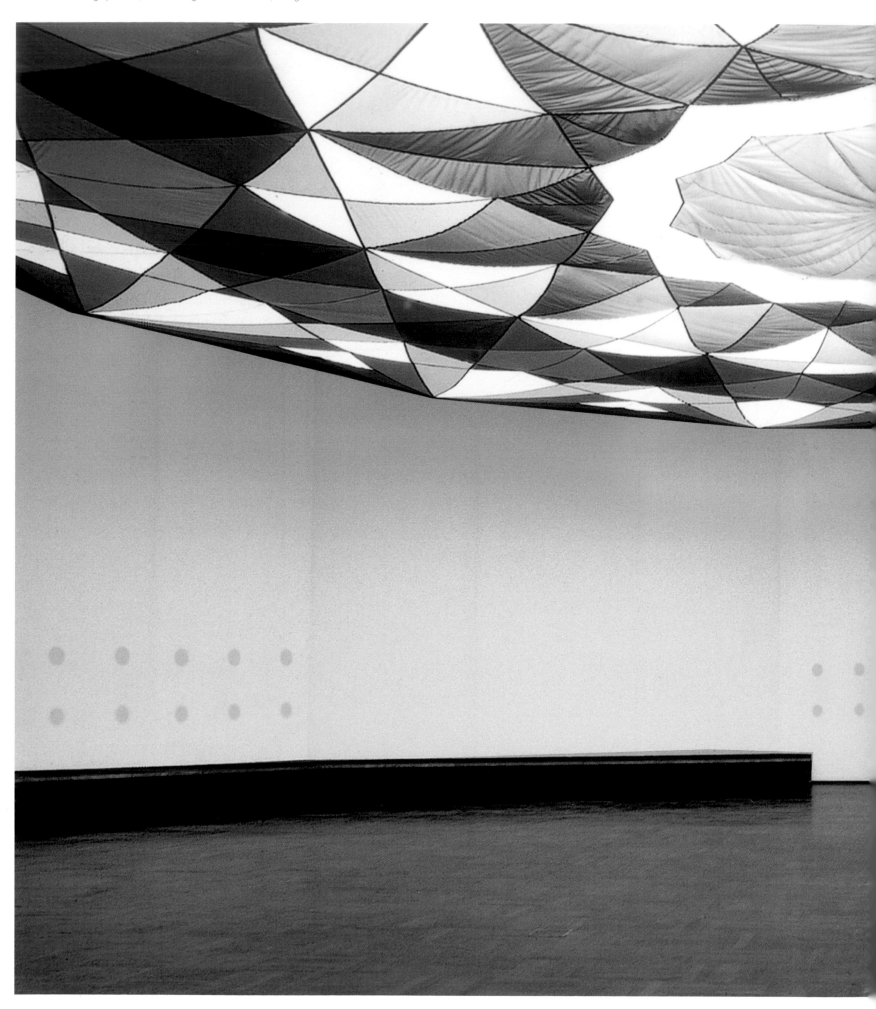

coming up for air
2002, print on polyester, speakers, sound,
text loop; ø 1840 cm

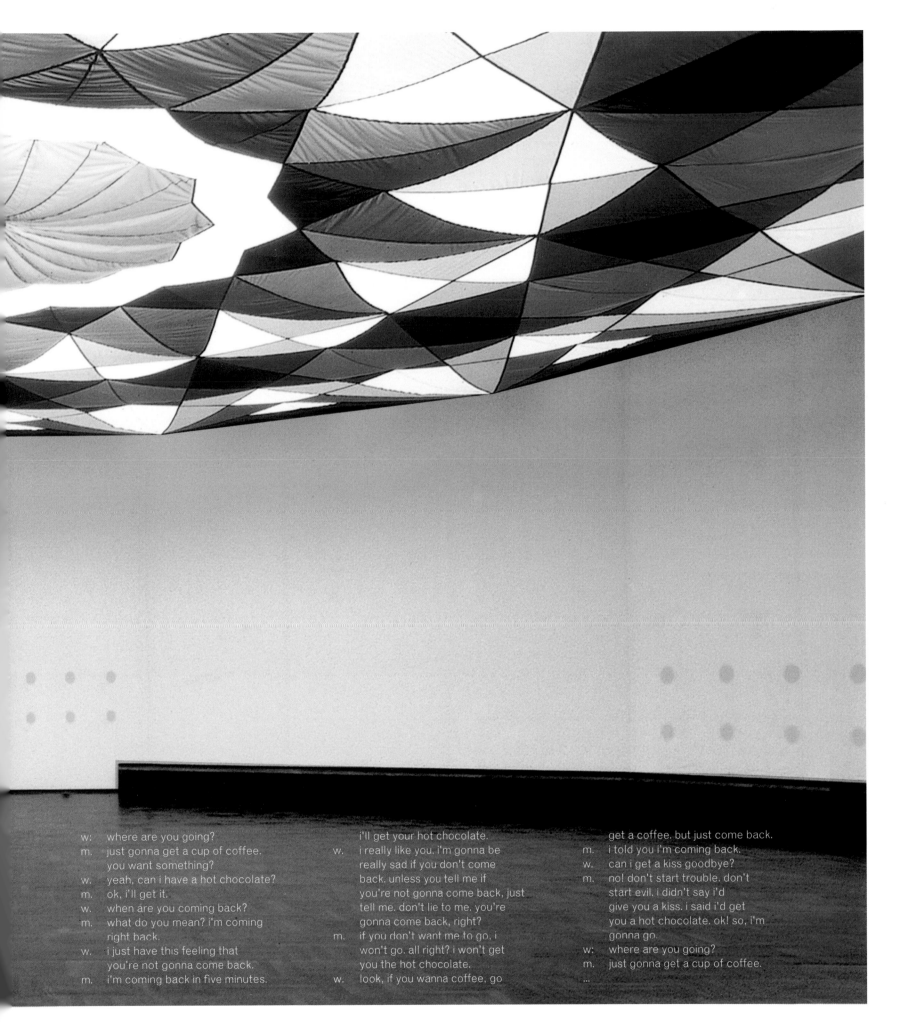

w: where are you going?

m. just gonna get a cup of coffee.
you want something?

w. yeah, can i have a hot chocolate?

m. ok, i'll get it.

w. when are you coming back?

m. what do you mean? i'm coming
right back.

w. i just have this feeling that
you're not gonna come back.

m. i'm coming back in five minutes.

i'll get your hot chocolate.

w. i really like you. i'm gonna be
really sad if you don't come
back. unless you tell me if
you're not gonna come back, just
tell me. don't lie to me. you're
gonna come back, right?

m. if you don't want me to go, i
won't go. all right? i won't get
you the hot chocolate.

w. look, if you wanna coffee, go

get a coffee. but just come back.

m. i told you i'm coming back.

w. can i get a kiss goodbye?

m. no! don't start trouble. don't
start evil. i didn't say i'd
give you a kiss. i said i'd get
you a hot chocolate. ok! so, i'm
gonna go.

w. where are you going?

m. just gonna get a cup of coffee.

...

roundelay
2003, outside part: 3 plaster walls; 550 × 1200 × 1200 cm,
inside part: 6 walls of wood, jute and felt, light bulb, 6 dvds,
6 projections, 18 speakers, sound; 500 × 1000 × 1000 cm

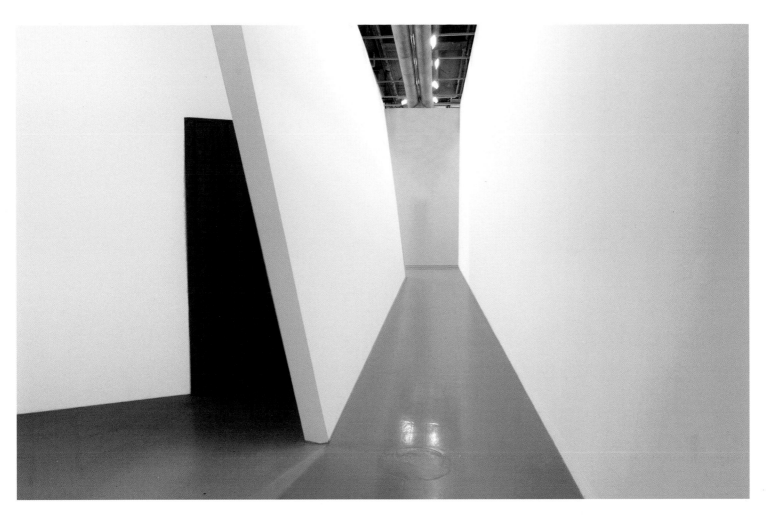

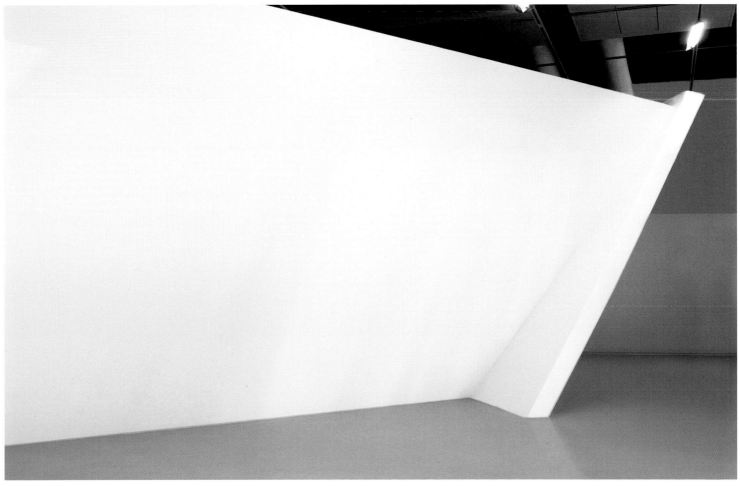

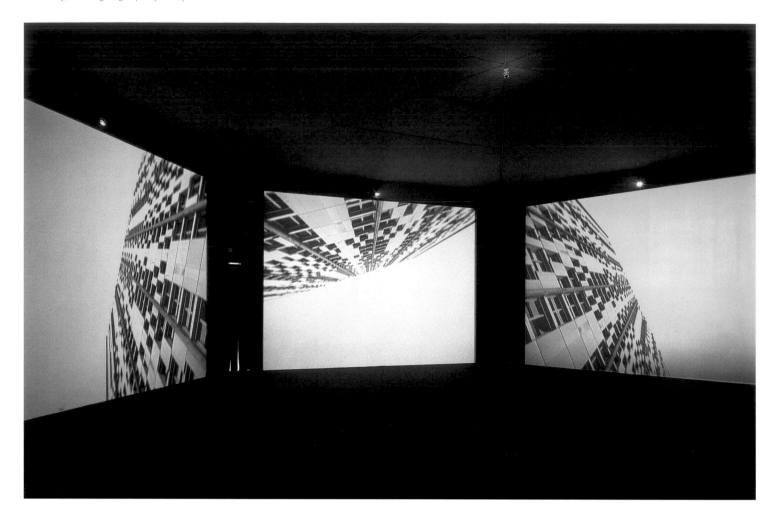

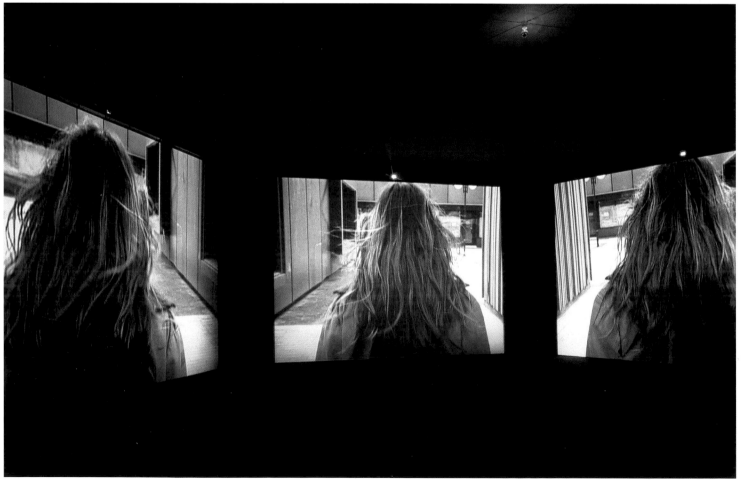

roundelay
2003, outside part: 3 plaster walls; 550 × 1200 × 1200 cm,
inside part: 6 walls of wood, jute and felt, light bulb, 6 dvds,
6 projections, 18 speakers, sound; 500 × 1000 × 1000 cm

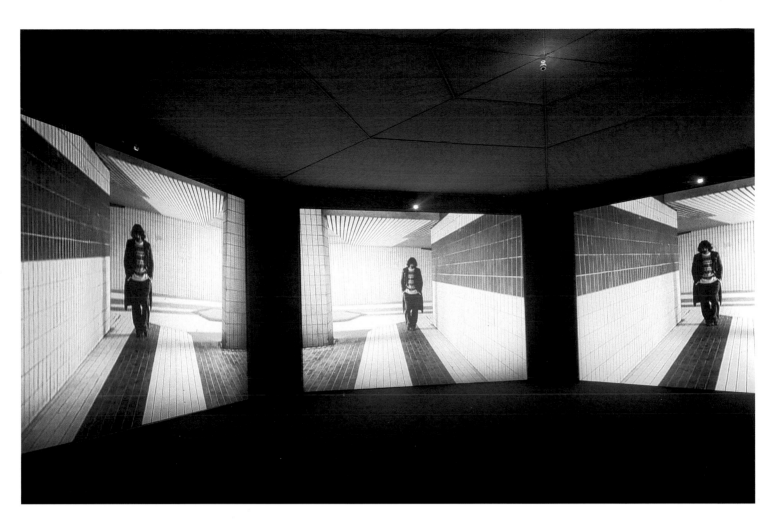

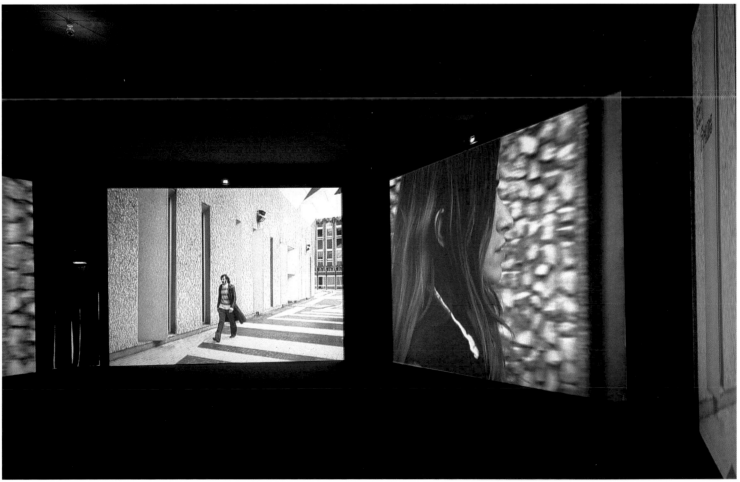

neunundzwanzigsteroktoberzweitausendundnull
2000, acrylic on glass reinforced plastic; 150 x 300 cm

einundreissigsterdezemberzweitausendundnull
2000, acrylic on glass reinforced plastic; 150 x 400 cm

siebenundzwanzigstermaineunzehnhundertneunundneunzig
1999, acrylic on glass reinforced plastic; 150 x 300 cm

elfternovemberzweitausendundeins
2001, acrylic on glass reinforced plastic; 150 x 400 cm

einundzwanzigsterfebruarzweitausendundvier
2004, acrylic on glass reinforced plastic; 150 x 400 cm

siebtermaizweitausendundzwei
2002, acrylic on glass reinforced plastic; 150 x 400 cm

neunundzwanzigstcraprilzweitausendundnull
2000, acrylic on glass reinforced plastic; 150 x 300 cm

einundzwanzigstermaizweitausendundnull
2000, acrylic on glass reinforced plastic; 150 x 300 cm

drittermaizweitausendundzwei
2002, acrylic on glass reinforced plastic; 150 x 400 cm

fünfzehnterdezemberzweitausendundeins
2001, acrylic on glass reinforced plastic; 150 x 400 cm

neunundzwanzigsterseptemberzweitausendundnull
2000, acrylic on glass reinforced plastic; 150 x 400 cm

achtzehntermaizweitausendundvier
2004, acrylic on glass reinforced plastic; 150 x 400 cm

sechsteraugustzweitausendundvier
2004, acrylic on glass reinforced plastic; 150 x 400 cm

zwölfterjanuarzweitausendundfünf
2005, acrylic on glass reinforced plastic; 150 x 400 cm

190 achterjanuarzweitausendundfünf
2005, acrylic on glass reinforced plastic; 150 x 400 cm

dritterjanuarzweitausendundeins
2000, acrylic on glass reinforced plastic; 150 x 400 cm

neunundzwanzigstermärzzweitausendunddrei
2003, acrylic on glass reinforced plastic; 150 x 400 cm

zweiundzwanzigstermärzzweitausendunddrei
2003, acrylic on glass reinforced plastic; 150 x 400 cm

neunzehnteraugustzweitausendundnull
2000, acrylic on glass reinforced plastic; 150 x 400 cm

dreiundzwanzigsterdezemberzweitausendundnull
2000, acrylic on glass reinforced plastic; 150 x 400 cm

dritteraprilzweitausendunddrei
2003, acrylic on glass reinforced plastic; 150 x 400 cm

vierterjunizweitausendundvier
2004, acrylic on glass reinforced plastic; 150 x 400 cm

fünfzehnterjunizweitausendundvier
2004, acrylic on glass reinforced plastic; 150 x 400 cm

fünfzehnterseptemberneunzehnhundertneunundneunzig
2000, acrylic on glass reinforced plastic; 150 x 400 cm

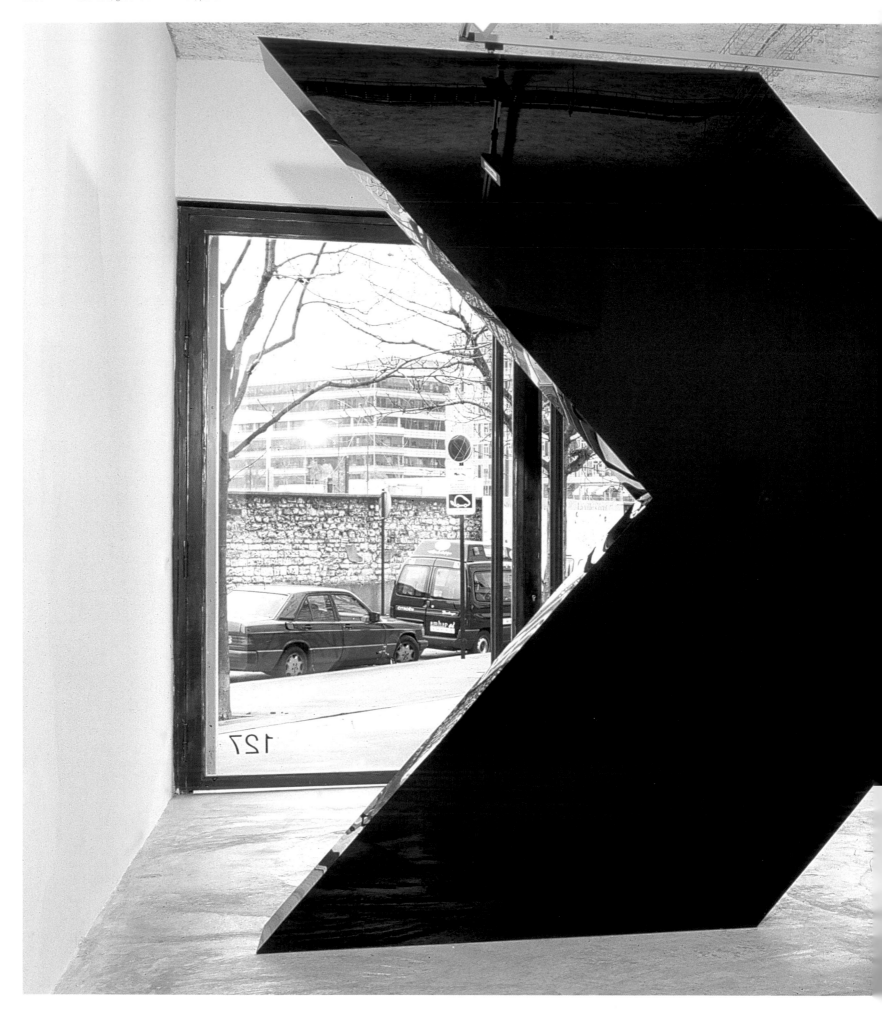

192 lessness
2003, wood, perspex, speakers,
sound; 280 × 400 × 40 cm

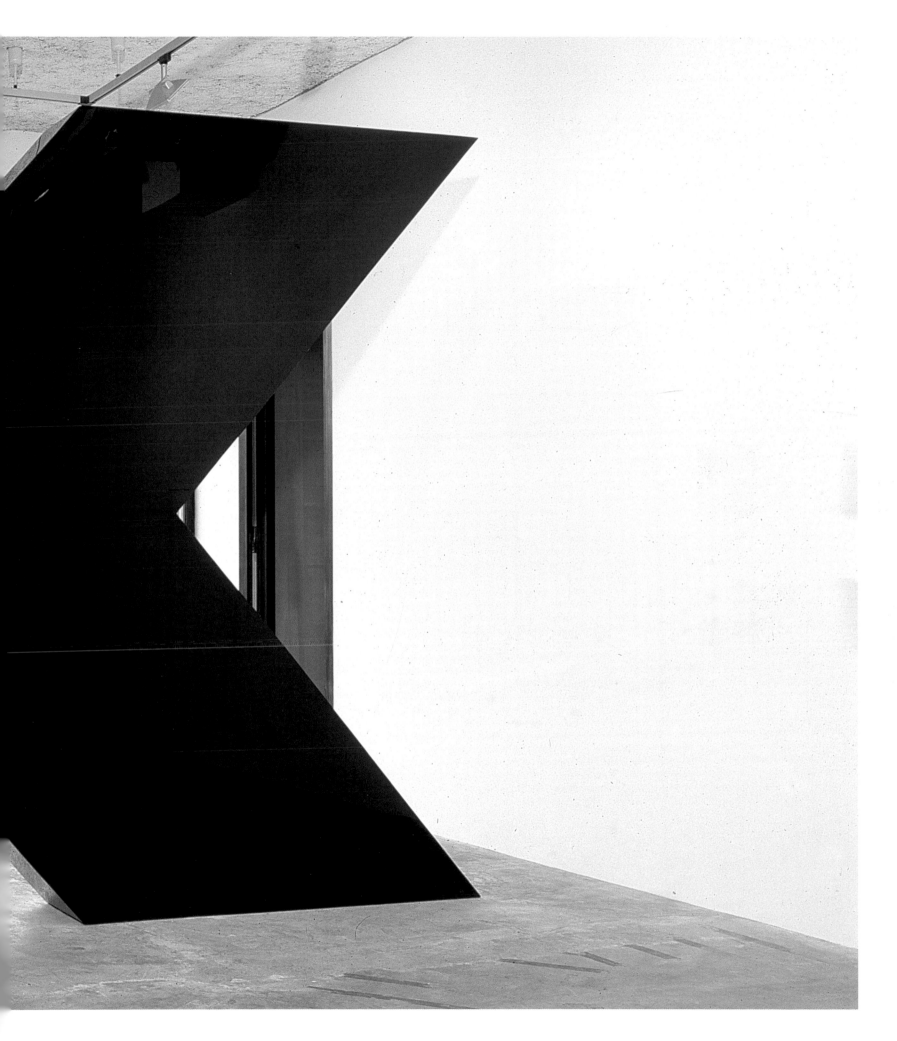

194 our magic hour
 2003, neon, perspex, transluscent film,
 aluminium; 783 × 1700 × 15 cm

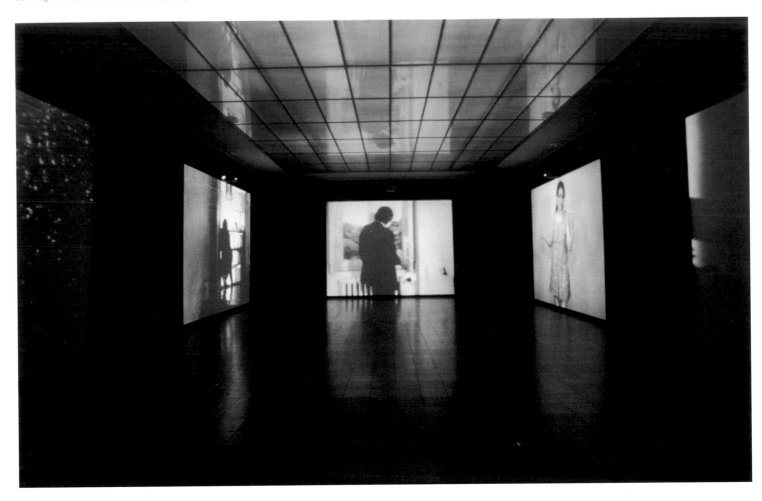

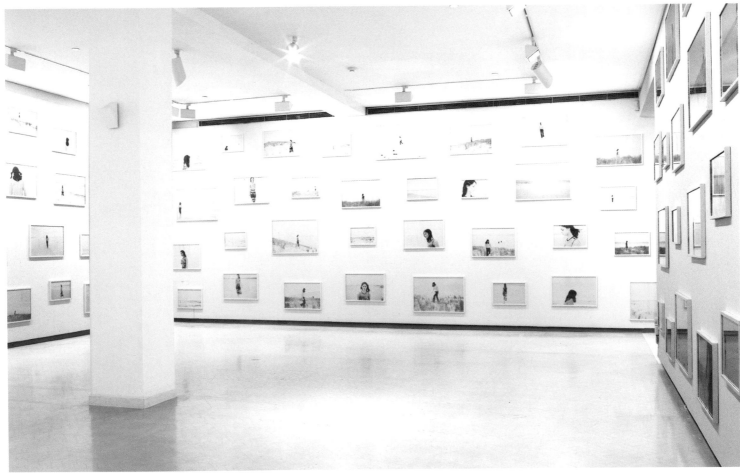

196 it's late and the wind carries a faint sound as it moves through the trees. it could be anything.
the jingling of little bells perhaps, or the tiny flickering out of tiny lives. i stroll down the sidewalk and
close my eyes and open them and wait for my mind to go perfectly blank. like a room no one has
ever entered, a room, without doors or windows. a place where nothing happens.
1999, 6 dvds, 6 projections, aluminium, perspex, neon, sound; 500 × 1684 × 970 cm

sleep
1999, wooden wall, paint, speakers, 30 spotlights,
sound, 165 framed c-prints; site-specific size

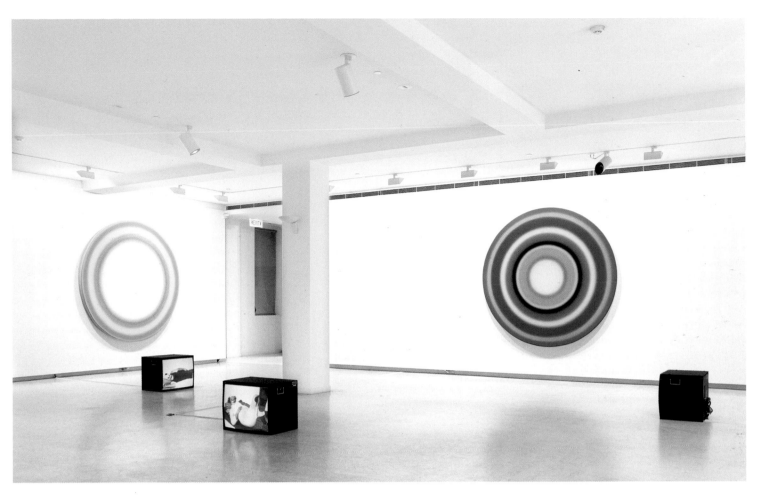

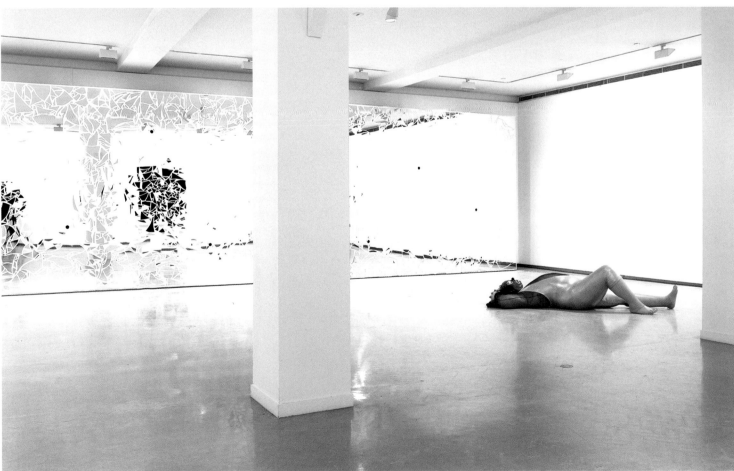

zweiundzwanzigstermärzzweitausendundeins
2001, acrilyc paint on canvas; ø 220 cm

siebterjulizweitausendundnull
2000, acrilyc paint on canvas; ø 220 cm

dog days are over
1996, 6 dvds, 12 speakers, 12 sensors, sound; dimensions variable

if there were anywhere but desert. wednesday.
2002, fibreglass, paint, clothing; 46 × 175 × 95 cm

what do you want?
2001, wooden wall, mirror, plaster, 18 speakers,
sound, text loop; site-specific size

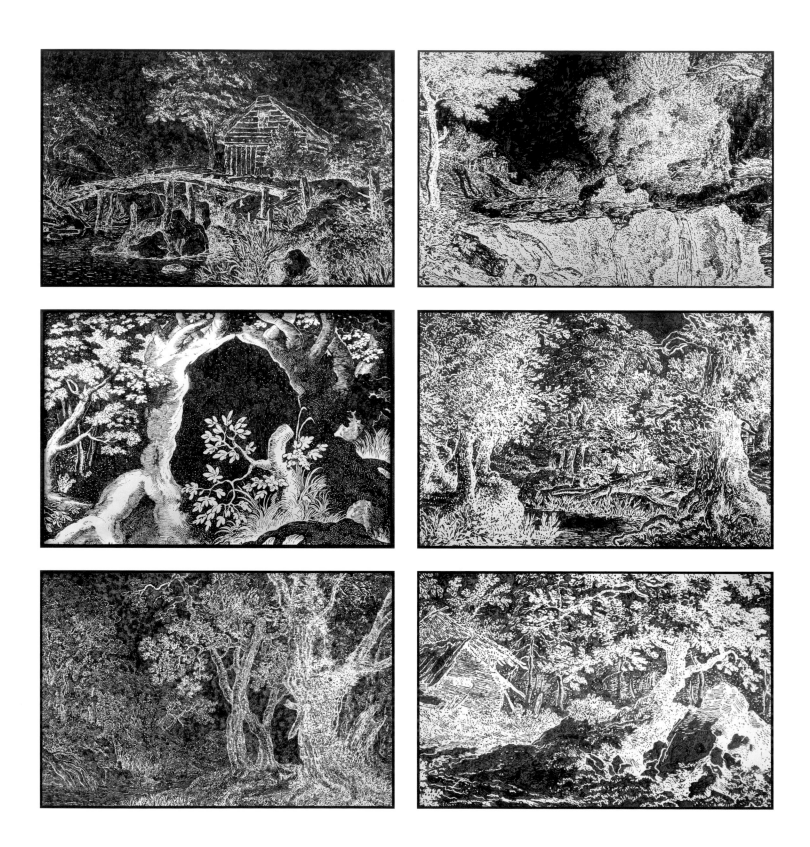

fünfzehnterjulineunzehnhundertneunundneunzig
1999, ink on paper, wooden frame; 200 x 300 cm

siebzehntermaineunzehnhundertneunzig
1990, ink on paper, wooden frame; 200 x 300 cm

198

viertermärzzweitausendundvier
2004, ink on paper, wooden frame; 200 x 300 cm

neunzehntermärzzweitausendundnull
2000, ink on paper, wooden frame; 200 x 300 cm

zwölftermärzzweitausendundzwei
2002, ink on paper, wooden frame; 200 x 300 cm

neunzehntermaineunzehnhundertneunundneunzig
1999, ink on paper, wooden frame; 200 x 300 cm

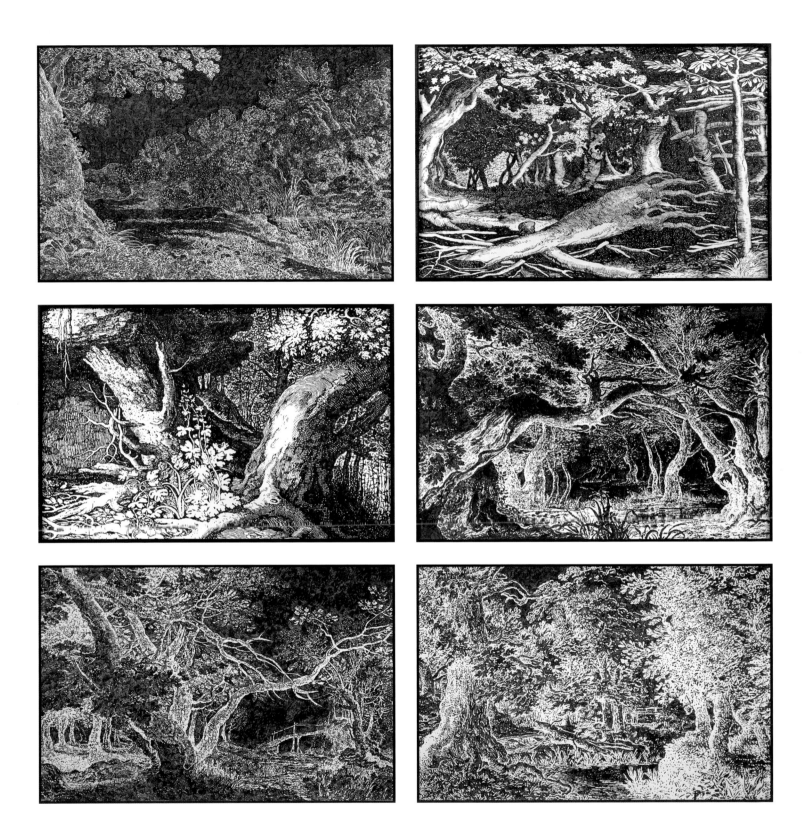

fünfzehnterfebruarzweitausendundzwei
2002, ink on paper, wooden frame; 200 x 300 cm

fünfzehntermärzzweitausendundvier
2004, ink on paper, wooden frame; 200 x 300 cm

sechsundzwanzigsterjanuarzweitausendundvier
2004, ink on paper, wooden frame; 200 x 300 cm

dreiundzwanzigsteraprilzweitausendundnull
2000, ink on paper, wooden frame; 200 x 300 cm

einundzwanzigsterseptemberzweitausendundeins
2001, Ink on paper, wooden frame; 200 x 300 cm

vierundzwanzigstermaizweitausendundnull
2000, ink on paper, wooden frame; 200 x 300 cm

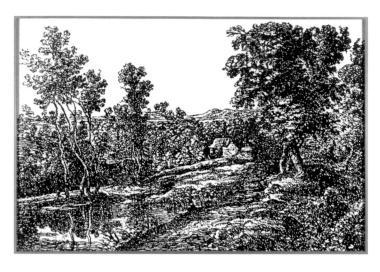

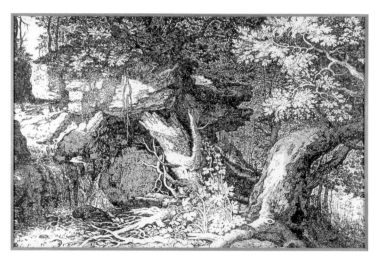

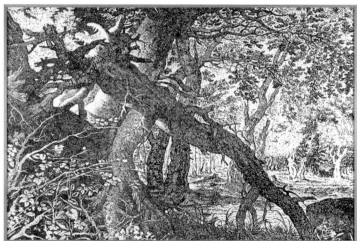

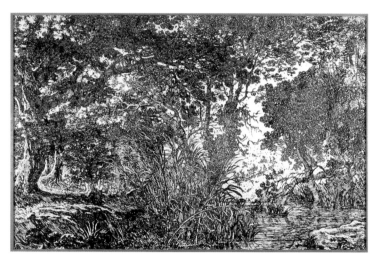

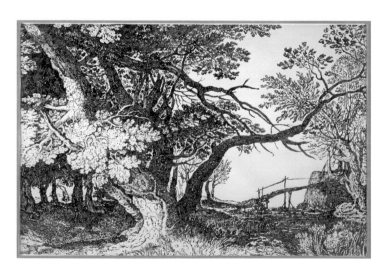

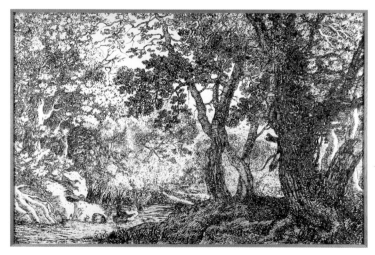

elfterjunineunzehnhundertsechsundneunzig
1997, ink on paper, wooden frame; 200 x 300 cm

achtundzwanzigstermaizweitausendunddrei
2003, ink on paper, wooden frame; 200 x 300 cm

dreizehnterjanuarzweitausendundzwei
2002, ink on paper, wooden frame; 200 x 300 cm

fünfzehnteraprilzweitausendunddrei
2003, ink on paper, wooden frame; 200 x 300 cm

fünfzehnterjunizweitausendunddrei
2003, ink on paper, wooden frame; 200 x 300 cm

achtzehnterjunizweitausendunddrei
2003, ink on paper, wooden frame; 200 x 300 cm

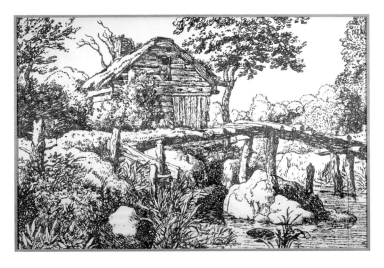

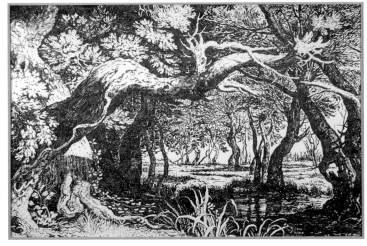

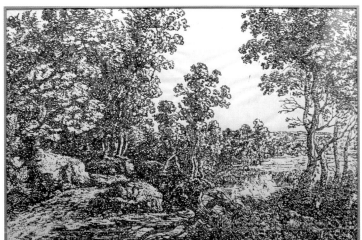

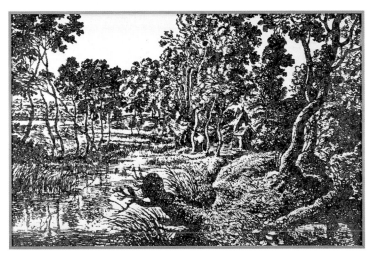

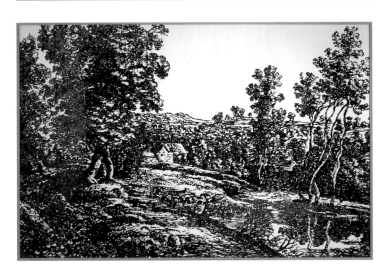

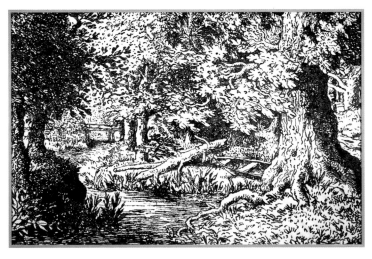

siebenundzwanzigsterjanuarzweitausendundnull
2000, ink on paper, wooden frame; 200 x 300 cm

viertermaizweitausendunddrei
2003, ink on paper, wooden frame; 200 x 300 cm

vierundzwanzigsterjulineunzehnhundertsechsundneunzig
1997, ink on paper, wooden frame; 200 x 300 cm

siebtermaineunzehnhundertneunundneunzig
1999, ink on paper, wooden frame; 200 x 300 cm

sechsterdezemberneunzehnhundertsiebenundneunzig
1997, ink on paper, wooden frame; 200 x 300 cm

neunzehnterjulineunzehnhundertneunundneunzig
2000, ink on paper, wooden frame; 200 x 300 cm

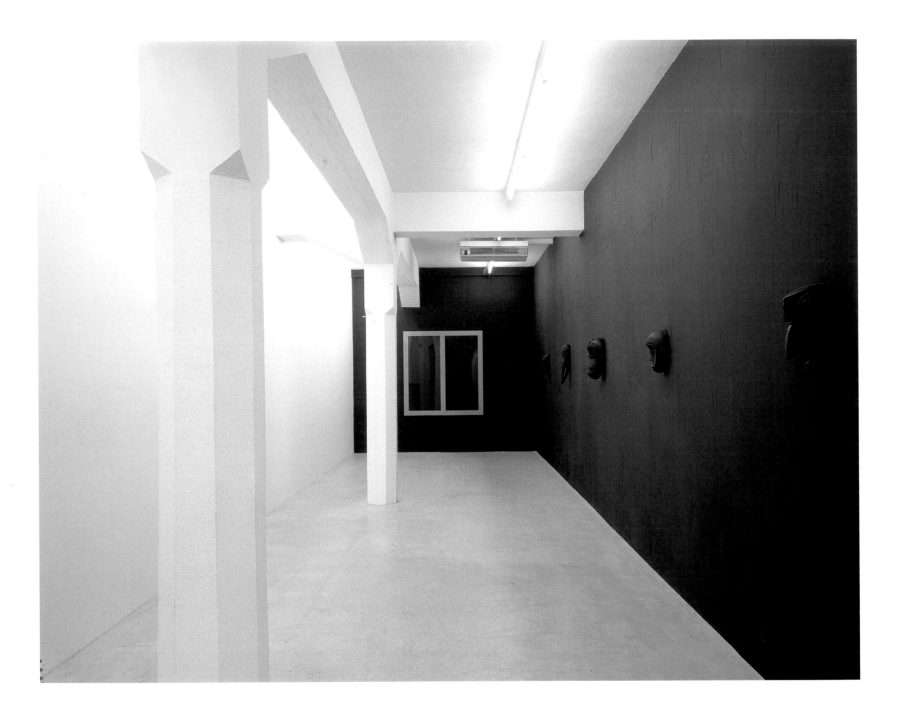

202 all moments stop here and together we become moonrise. north. october moonrise. north. november
 every memory that HAS ever been.
 2002, perspex; 160 × 150 × 4 cm moonrise. north. july all: 2003, cast polyurethane, black;
 between 30 × 20 × 12 cm and 53 × 17 × 12 cm

 moonrise. north. april moonrise. north. june

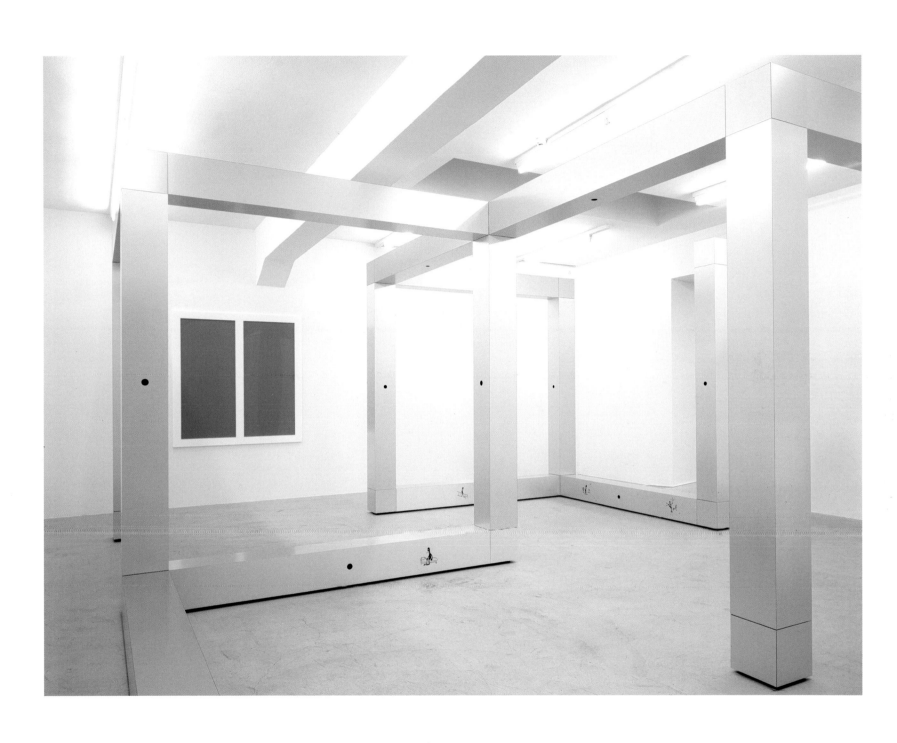

the dancer and the dance
2002, 18 pillars, aluminium, felt tip pen, 16 speakers, sound; modular system

all moments stop here and together we become every MEMORY that has ever been.
2002, perspex; 160 × 150 × 4 cm

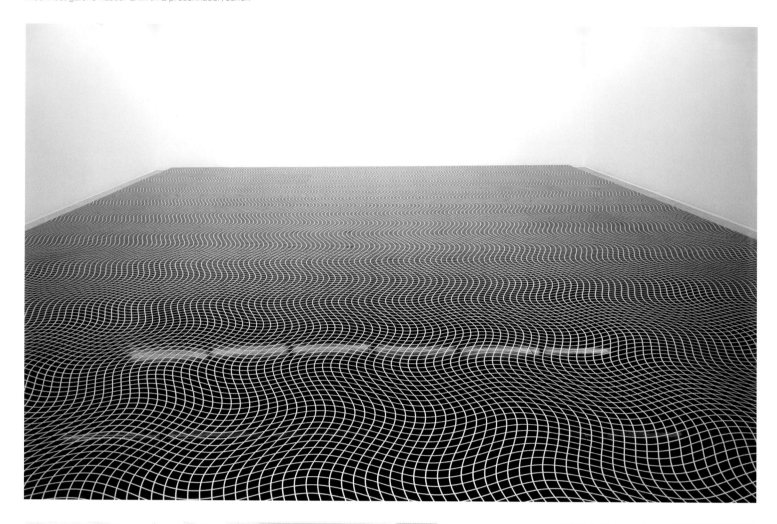

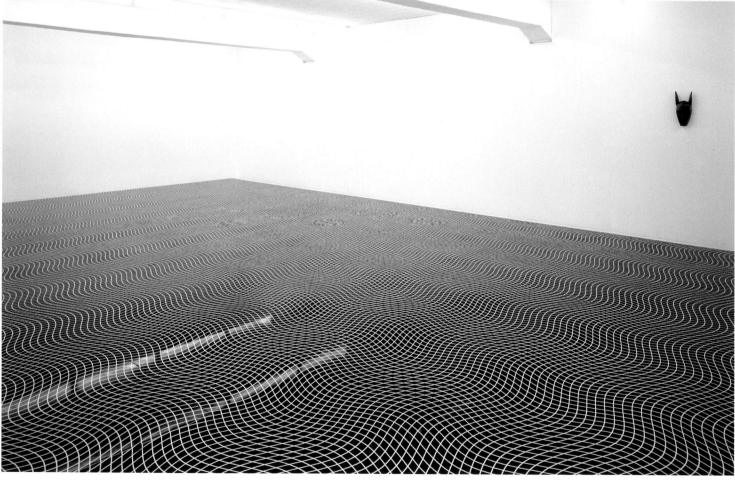

204 lowland lullaby
2002, wood pannels, silk-screen printing, polyurethane
speakers, sound, text loop; modular system

moonrise. north. march
2003, cast polyurethane, black;
45 × 17 × 13 cm

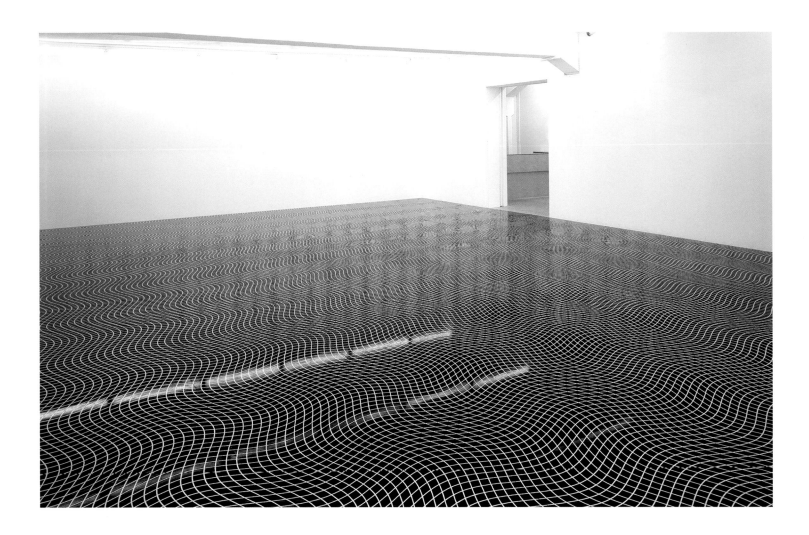

m. i'm not stupid. don't
 fuck with me.
w. i know you aren't stupid.
m. then why are you fucking
 with me?
w. who is fucking with you?
m. you were.
w. me?
m. oh come on.
w. come on what?
m. i heard you.
w. heard me what?
m. fucking with me.
w. you heard me fucking with you?
m. you're not going to say you
 weren't.
w. of course i wasn't. we were
 having a normal conversation.
m. you call that a normal
 conversation?
w. oh come on.
m. come on what?
w. it's fucked up.

m. fucked up?
w. yes. fucked up.
m. what's fucked up?
w. what you've just said.
m. what i've just said is fucked
 up? can you tell me why?
w. it's just fucked up. you
 should hear yourself.
m. you should hear yourself.
 putting on that voice to
 speak to me.
w. what voice?
m. i'm not stupid. don't
 fuck with me.
w. i know you aren't stupid.
m. then why are you fucking
 with me?
w. who is fucking with you?
m. you were.
w. me?
m. oh come on.
w. come on what?
m. i heard you.

w. heard me what?
m. fucking with me.
w. you heard me fucking with you?
m. you're not going to say you
 weren't.
w. of course i wasn't. we were
 having a normal conversation.
m. you call that a normal
 conversation?
w. oh come on.
m. come on what?
w. it's fucked up.
m. fucked up?
w. yes. fucked up.
m. what's fucked up?
w. what you've just said.
m. what i've just said is fucked
 up? can you tell me why?
w. it's just fucked up. you
 should hear yourself.
m. you should hear yourself.
 putting on that voice to
...

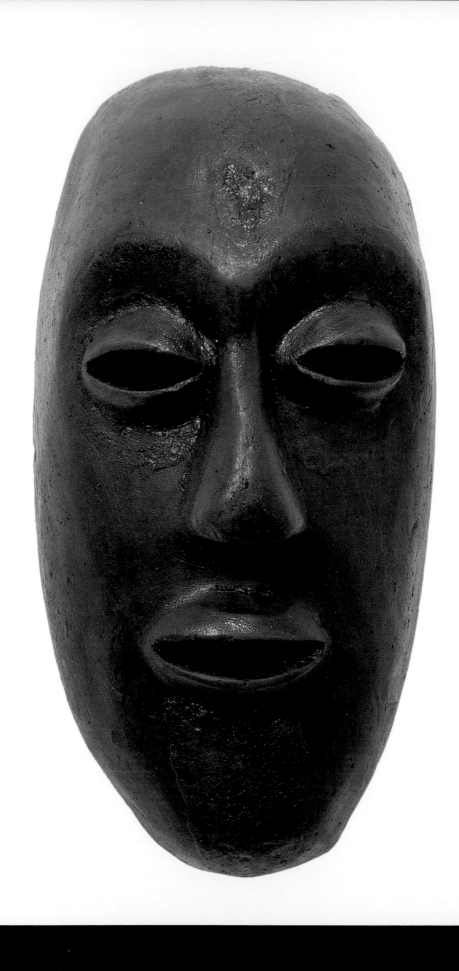

6 moonrise. north, april
2003, cast polyurethane, black;
35 × 17 × 11 cm

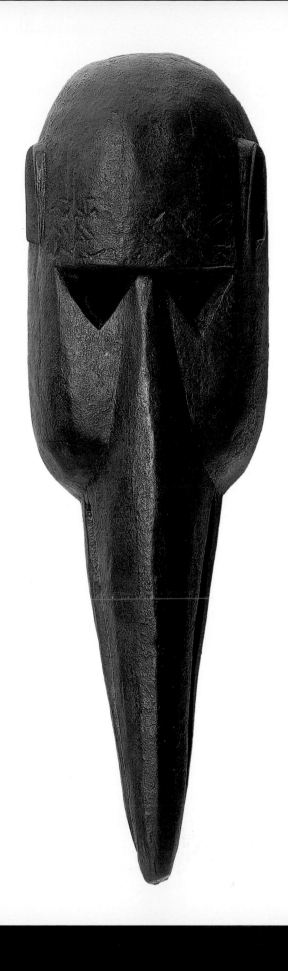

moonrise. north. october
2003, cast polyurethane, black;
53 × 17 × 12 cm

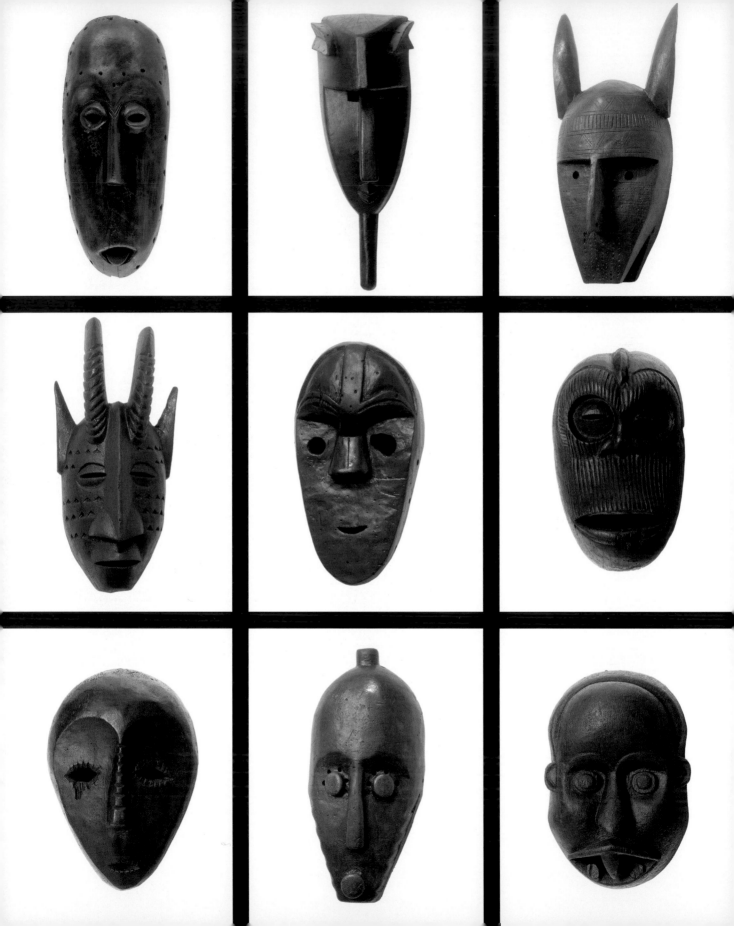

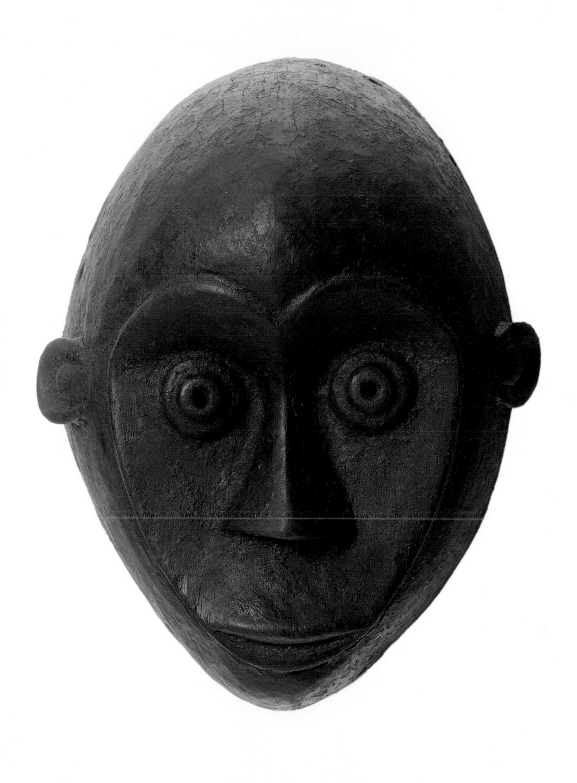

all: 2003, cast polyurethane, black;
between 30 × 20 × 12 cm and 53 × 17 × 12 cm

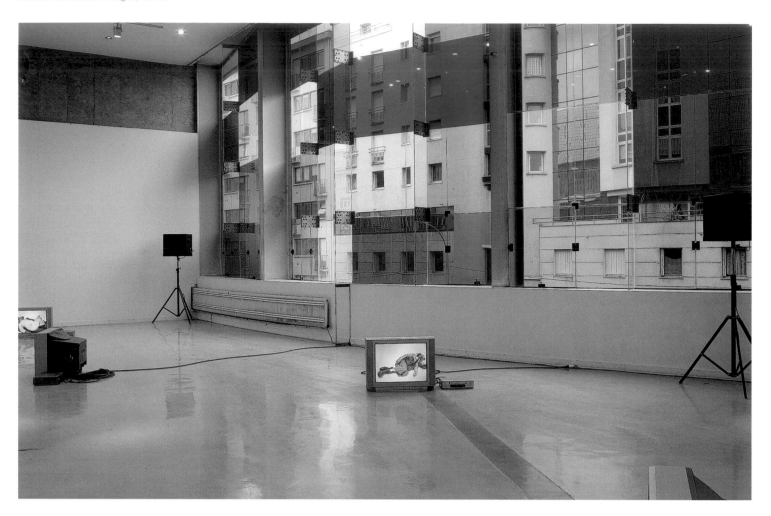

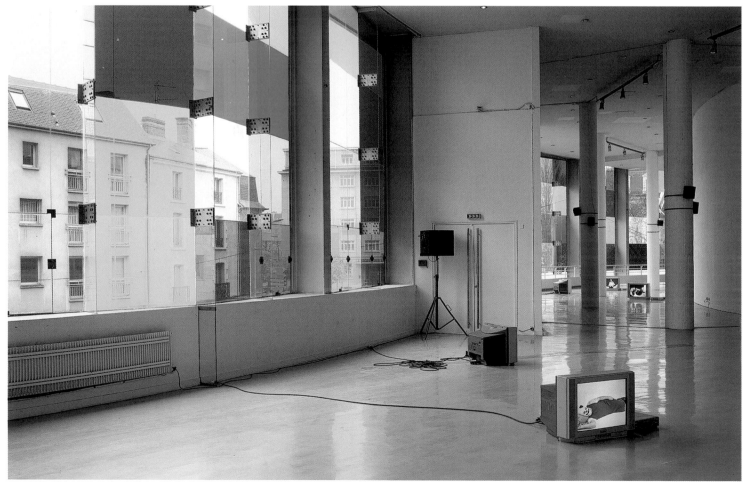

210 love invents us dog days are over
 1999, wall for a house, steel, glass, 1996, 12 dvds, 12 speakers, 12 sensors,
 transluscent film; dimensions variable sound; dimensions variable

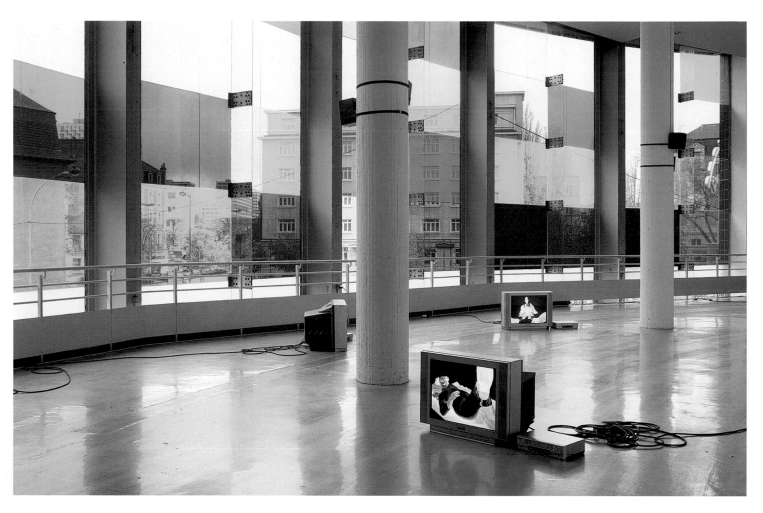

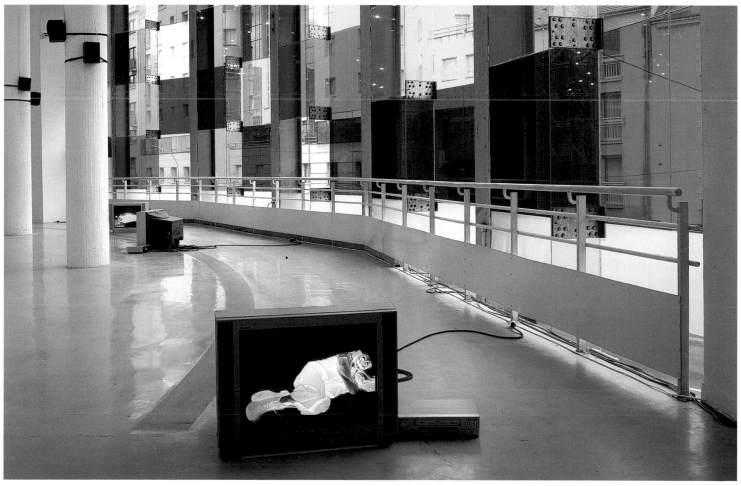

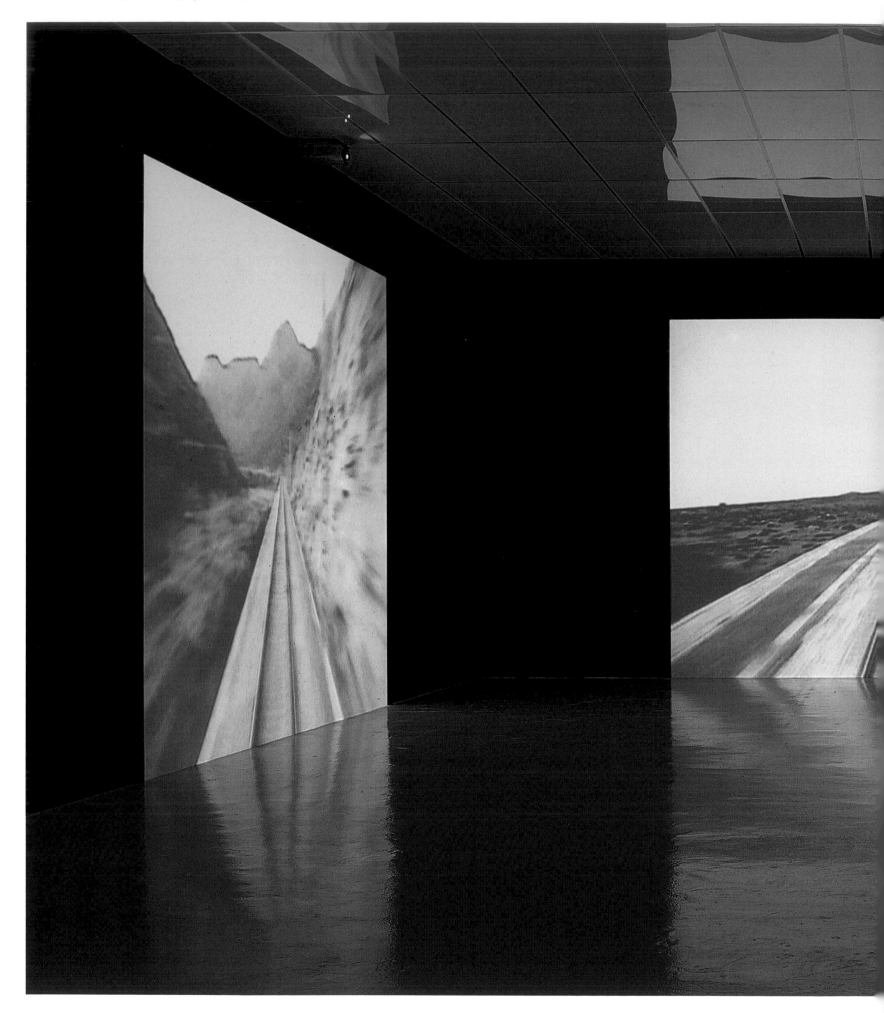

a spider. a spider is running across my heart and then another. spiders run across my heart and
if I close my eyes, I can hear the rush and the rustle of their tiny dry bodies scurrying through me
2003, 6 dvds, 6 projections, aluminium, perspex, neon, sound; 500 × 1684 × 970 cm

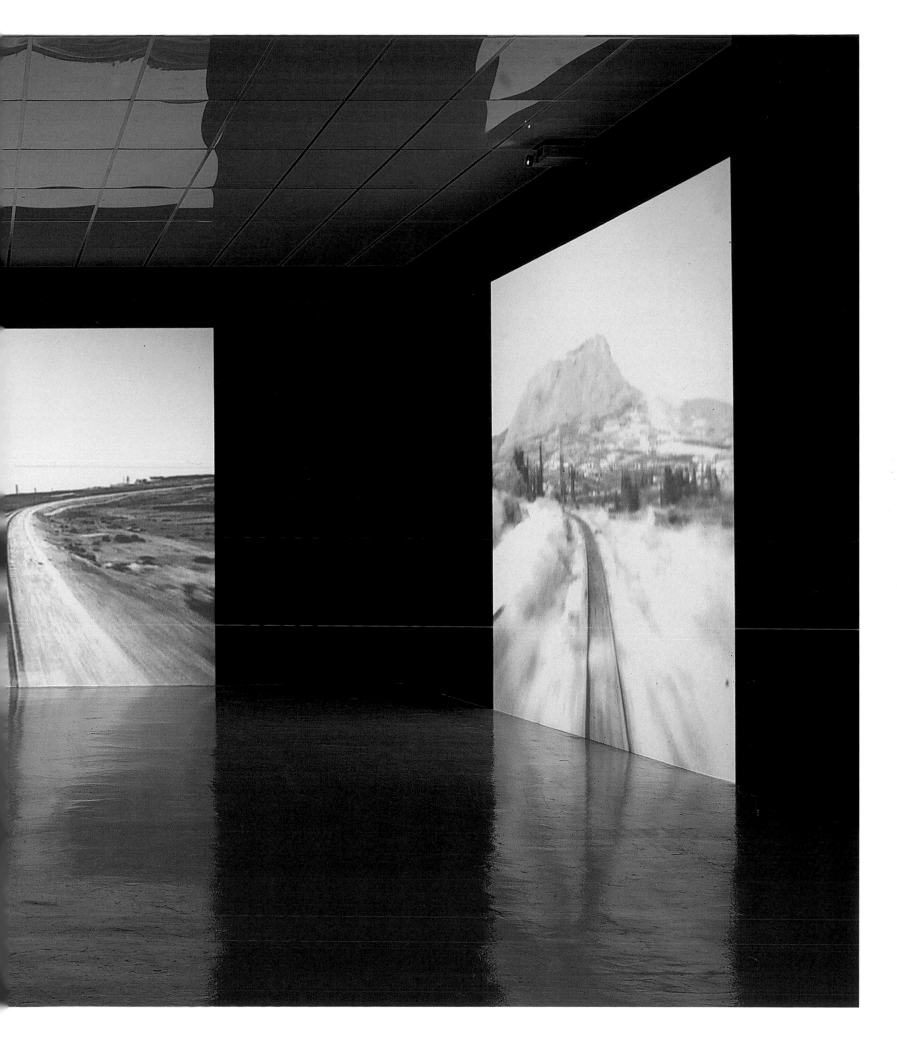

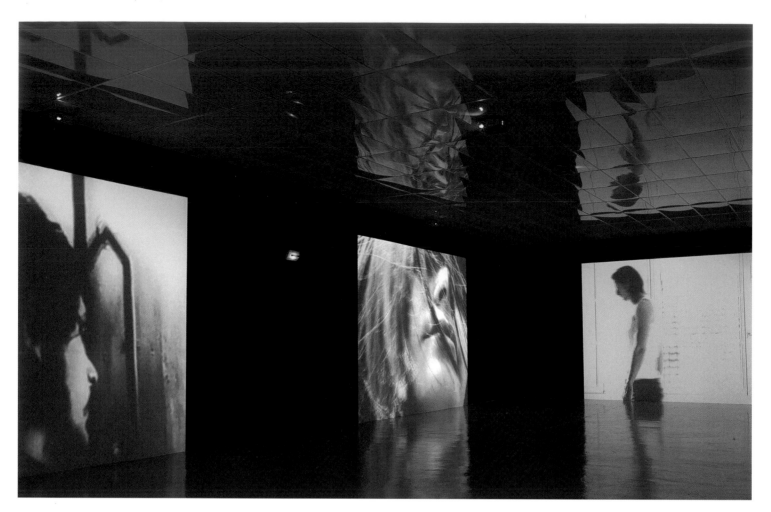

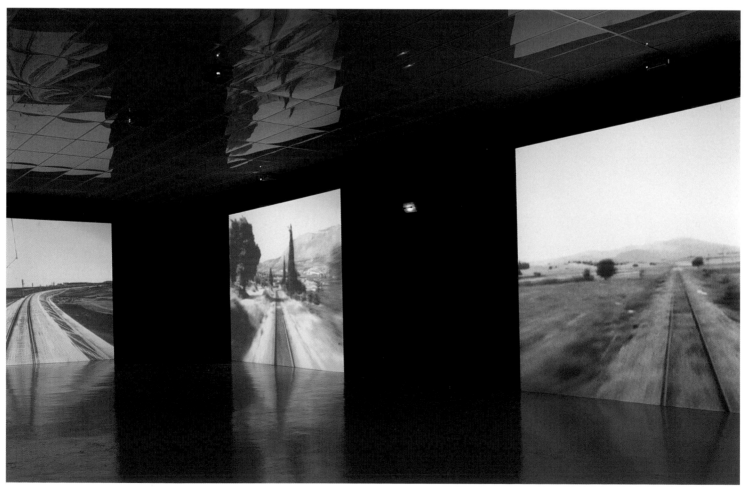

214 a spider. a spider is running across my heart and then another. spiders run across my heart and
f I close my eyes, I can hear the rush and the rustle of their tiny dry bodies scurrying through me.
2003, 6 dvds, 6 projections, aluminium, perspex, neon, sound; 500 × 1684 × 970 cm

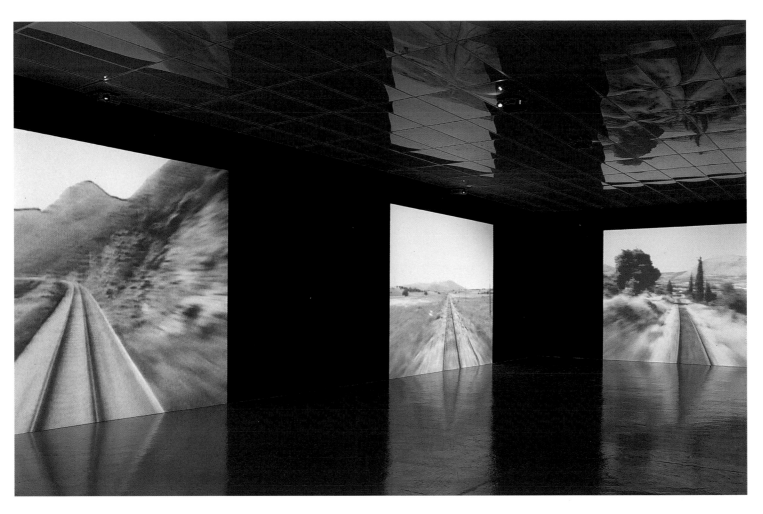

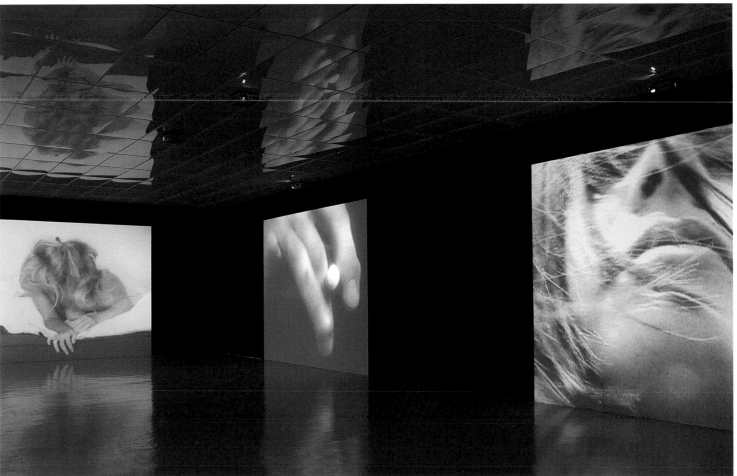

A snowlike still

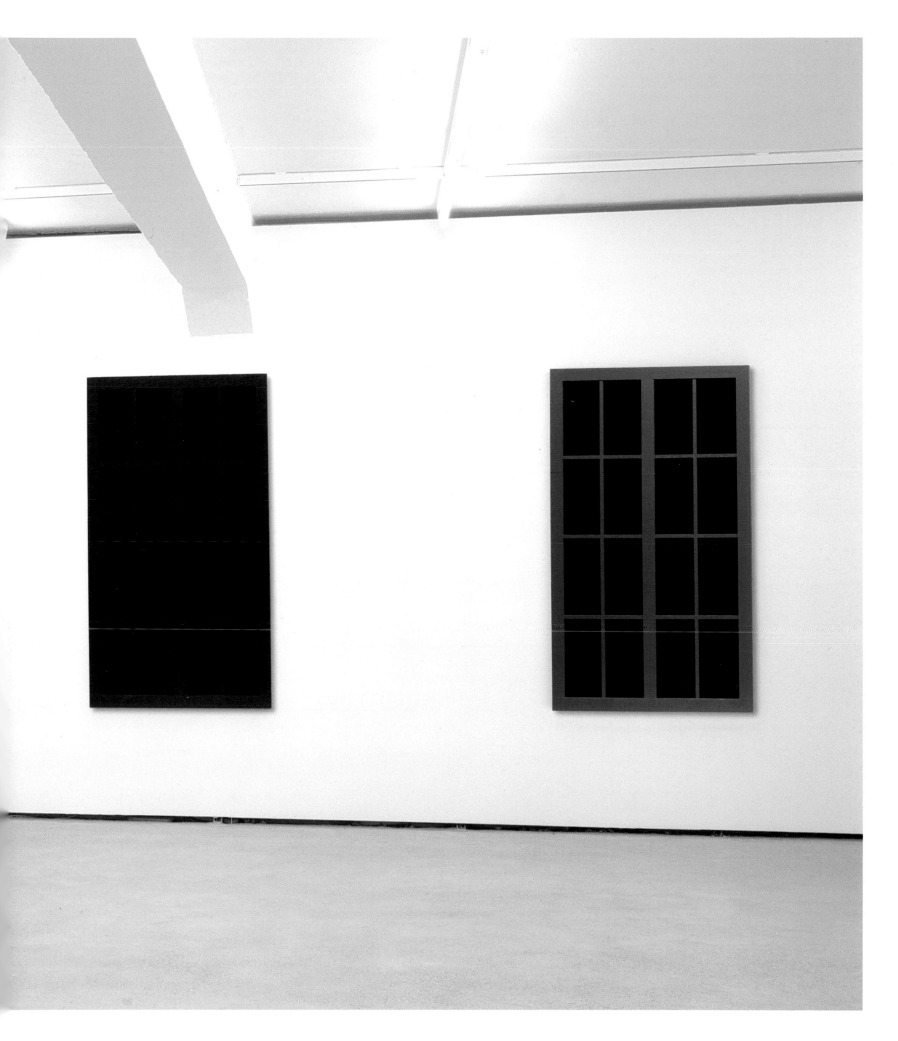

a SNOWLIKE still

all: 2003, perspex, wooden frame;
190 × 110 × 4 cm each

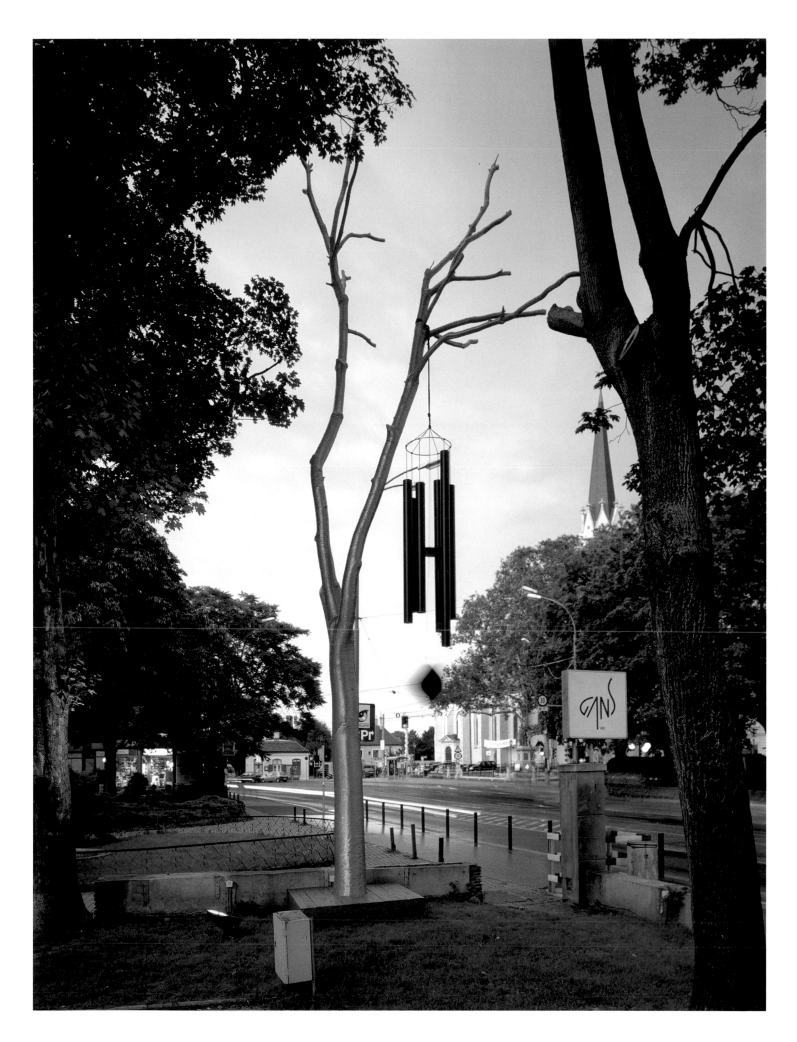

nothing has changed
2004, wooden base, wind chime, rubber tape;
dimensions variable

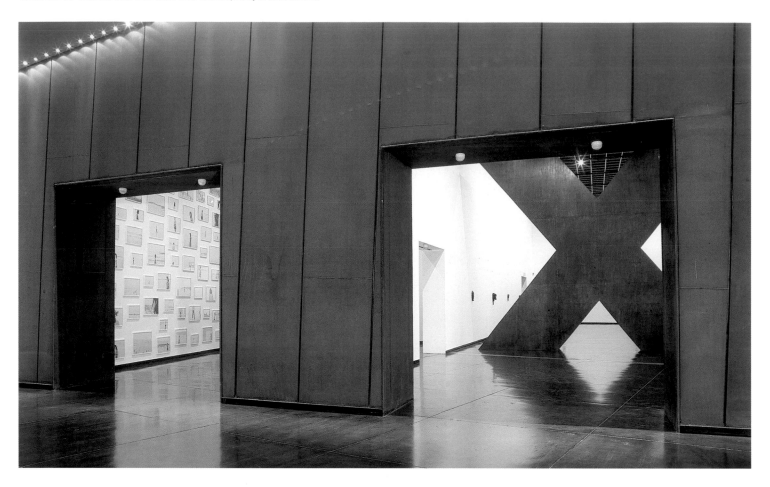

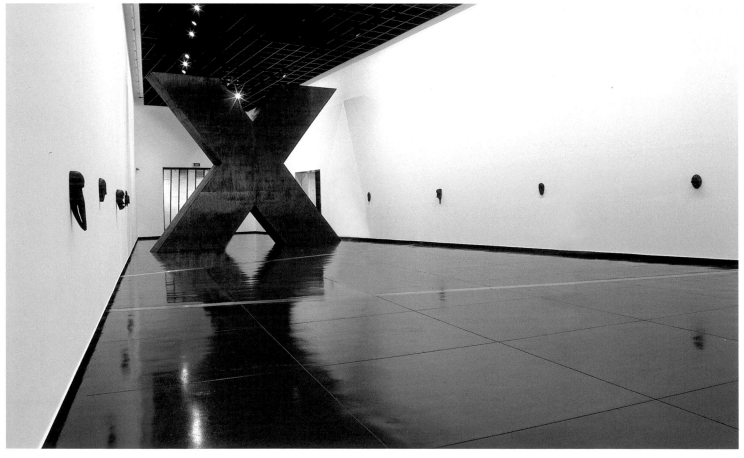

220 twentyfourhours moonrise. north. february moonrise. north. may
 2004, stained plywood, steel, speakers,
 sound; 600 × 700 × 100 cm moonrise. north. march moonrise. north. june

 moonrise. north. january moonrise. north. april moonrise. north. july

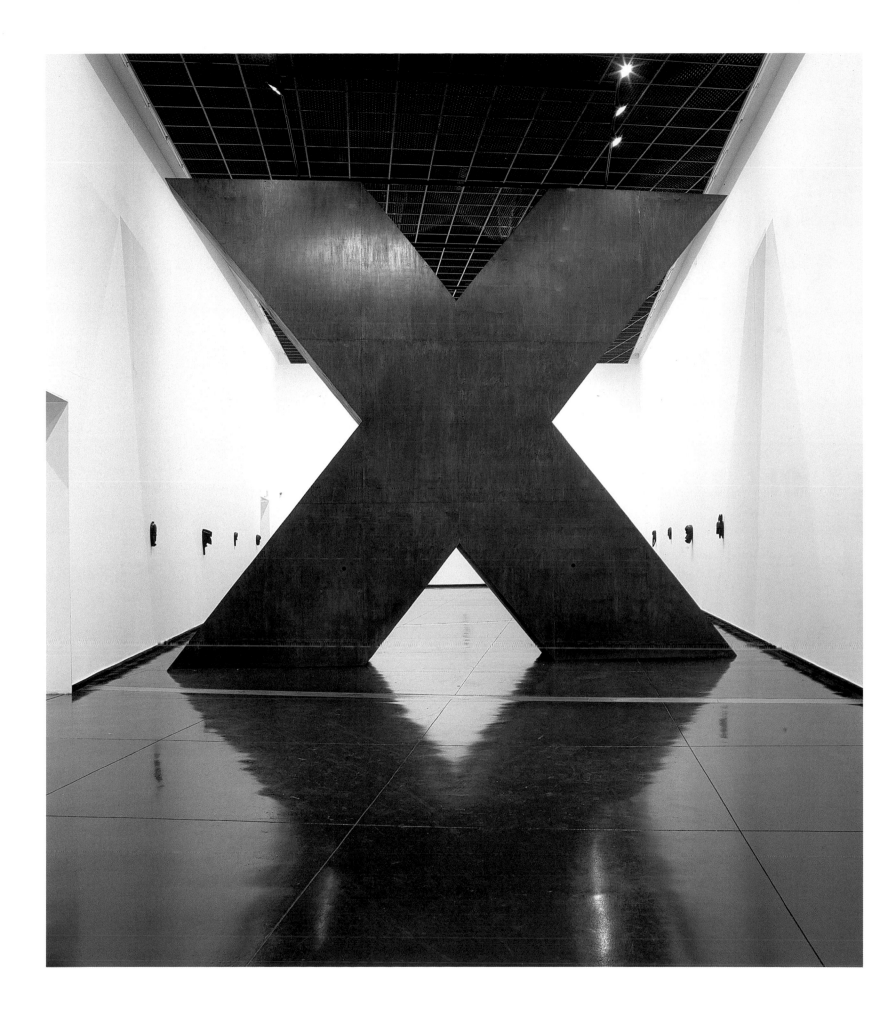

moonrise. north. august

moonrise. north. september

moonrise. north. october

moonrise. north. november

moonrise. north. december

all: 2003, cast polyurethane, black;
between 30 × 20 × 12 cm and 53 × 17 × 12 cm

221

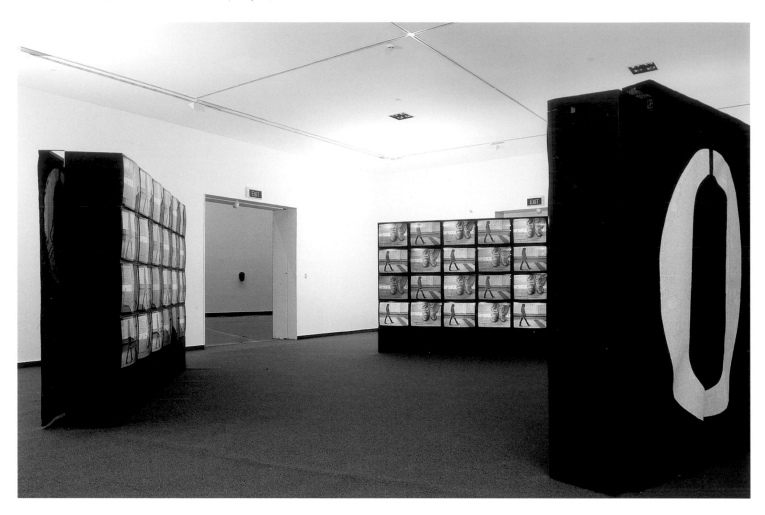

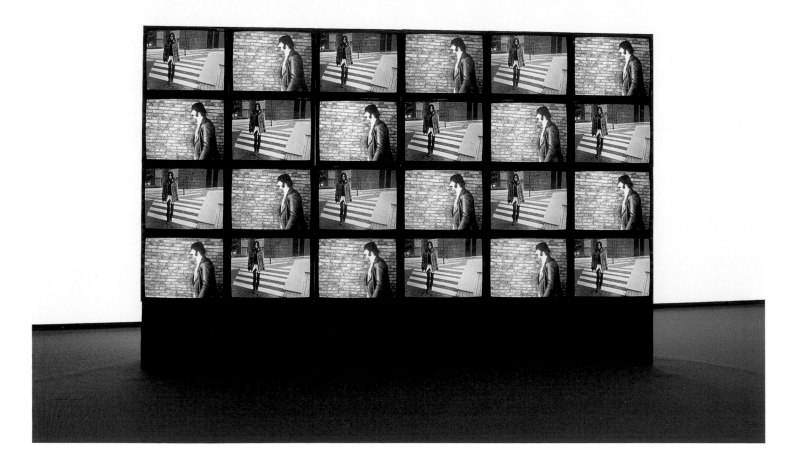

clockwork for oracles
2004, 3 videowalls, 3 stencilled hessians,
3 wooden bases, sound, black carpet;
233 × 354 × 45 cm each wall

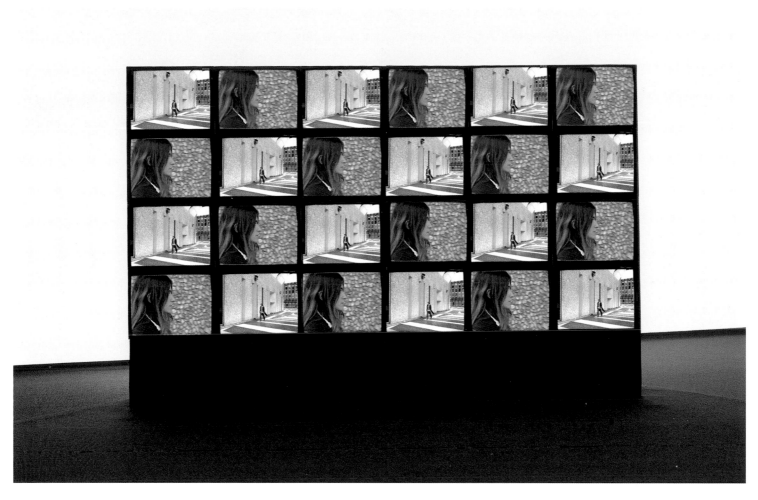

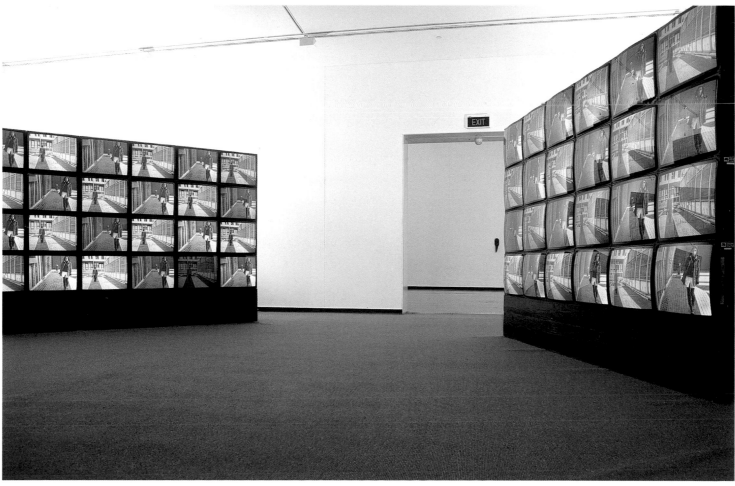

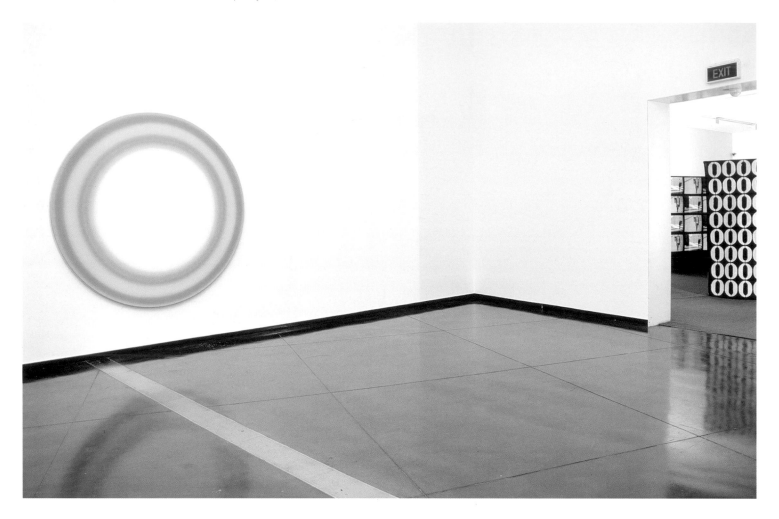

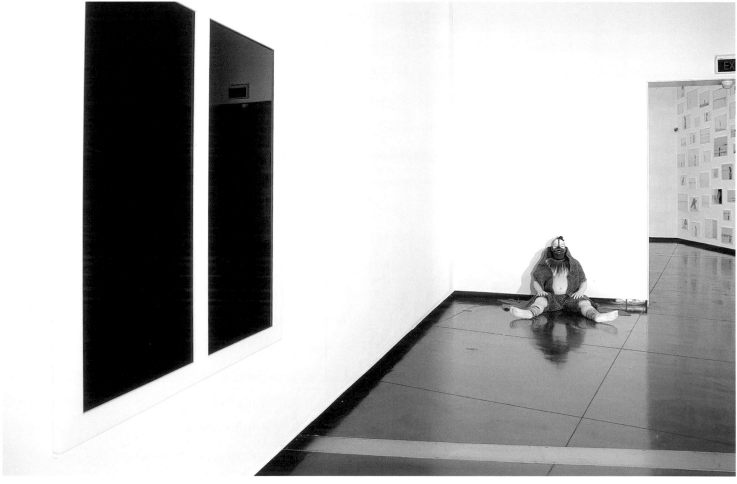

zweiundzwanzigstermärzzweitausendundeins
2001, acrylic paint on canvas; ø 220 cm

all MOMENTS stop here and together we become every memory that has ever been.
2002, perspex; 160 × 150 × 4 cm

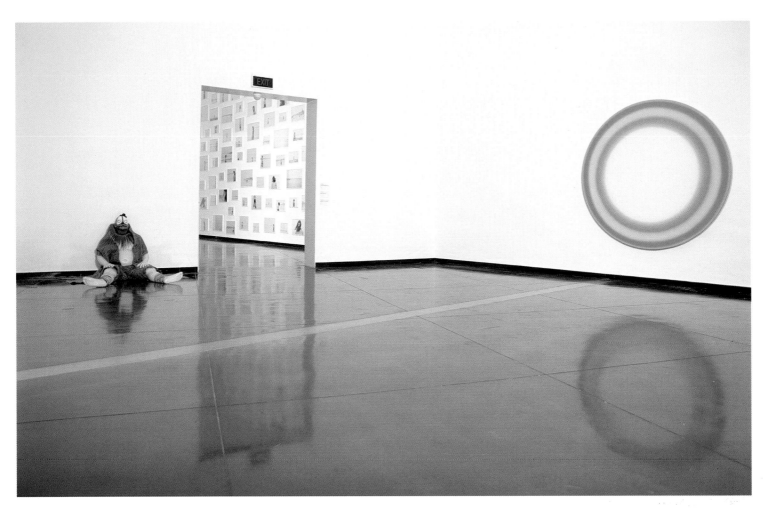

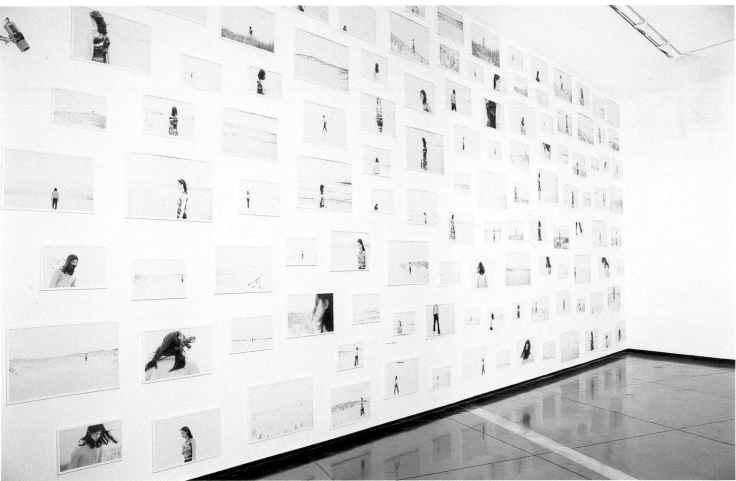

if there were anywhere but desert. saturday.
2002, fibreglass, paint, clothing; 86 × 106 × 122 cm

sleep
1999, wooden wall, paint, speakers, 30 spotlights, sound,
165 framed c-prints; site-specific size

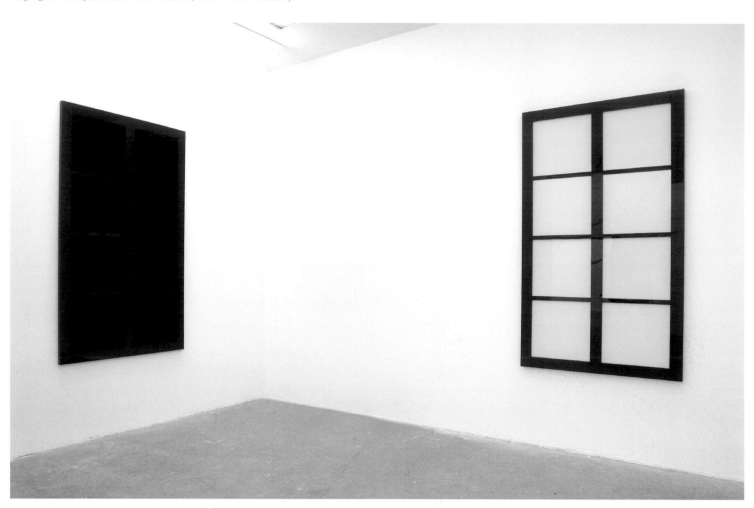

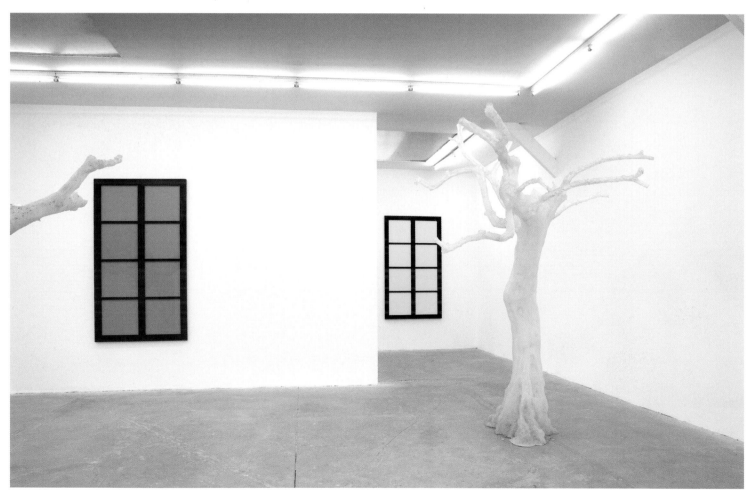

226 long nights short YEARS long nights SHORT years

long NIGHTS short years LONG nights short years

all: 2004, perspex; 197 × 112 × 3 cm each

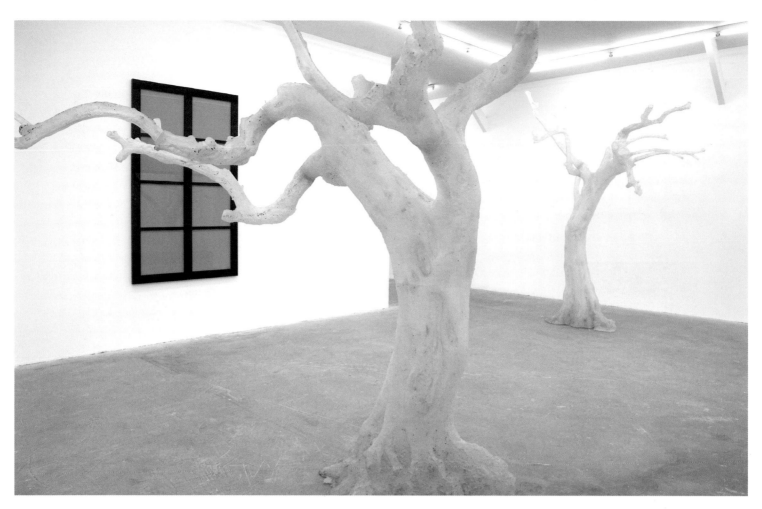

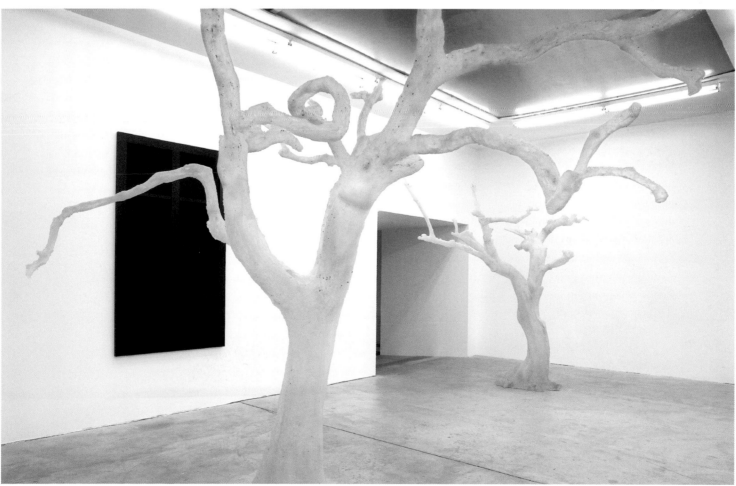

when the water went south for the winter it carried us down like storm driven gulls.
2003, semi-transparent, cast resin; 300 × 240 × 240 cm

out of reach until it's magic we are crossing our own stony ocean.
2003, semi-transparent, cast resin; 307 × 277 × 247 cm

across dark stream of shooting stars.
2003, semi-transparent, cast resin; 300 × 240 × 240 cm

we sail into pleasure and unload our spacious soul.
2003, semi-transparent, cast resin; 280 × 280 × 160 cm

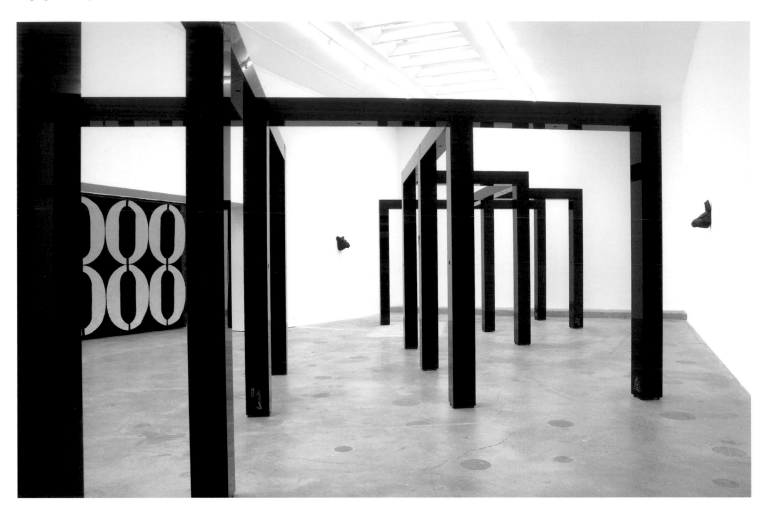

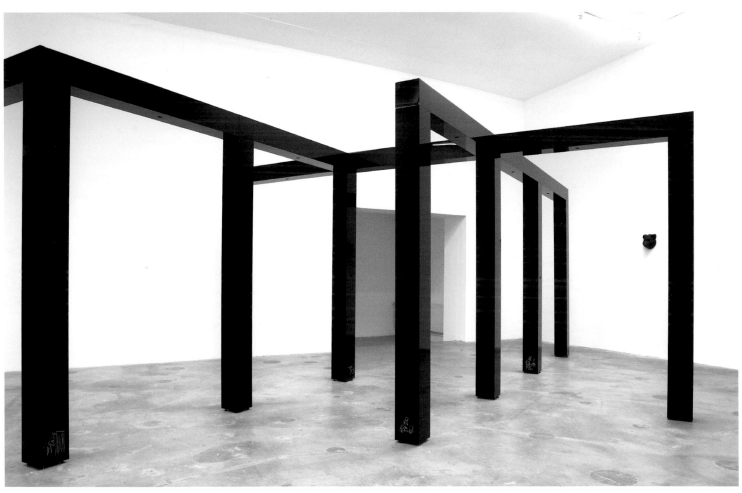

228 all those doors
 2003, 15 pillars and 14 beams of acrylic glass,
 felt tip pen, speakers, sound; modular system

moonrise. south. june

moonrise. south. august

moonrise. south. october

moonrise. south. november

all: 2003, cast polyurethane, black;
between 22 × 17 × 20 cm and 41 × 40 × 18 cm

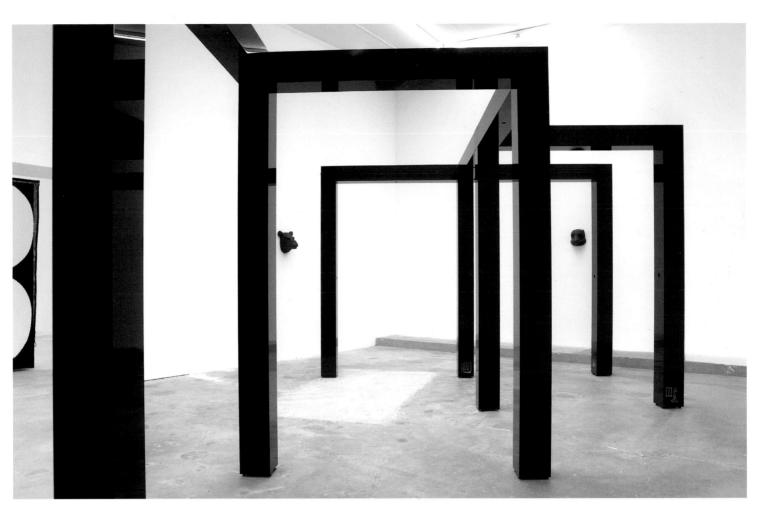

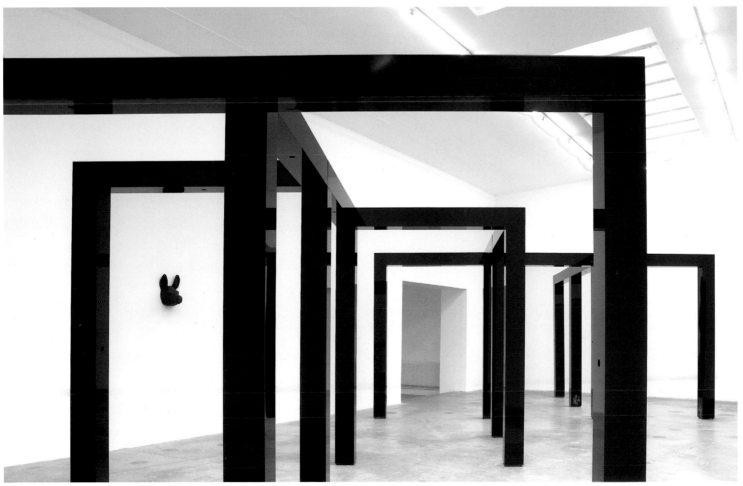

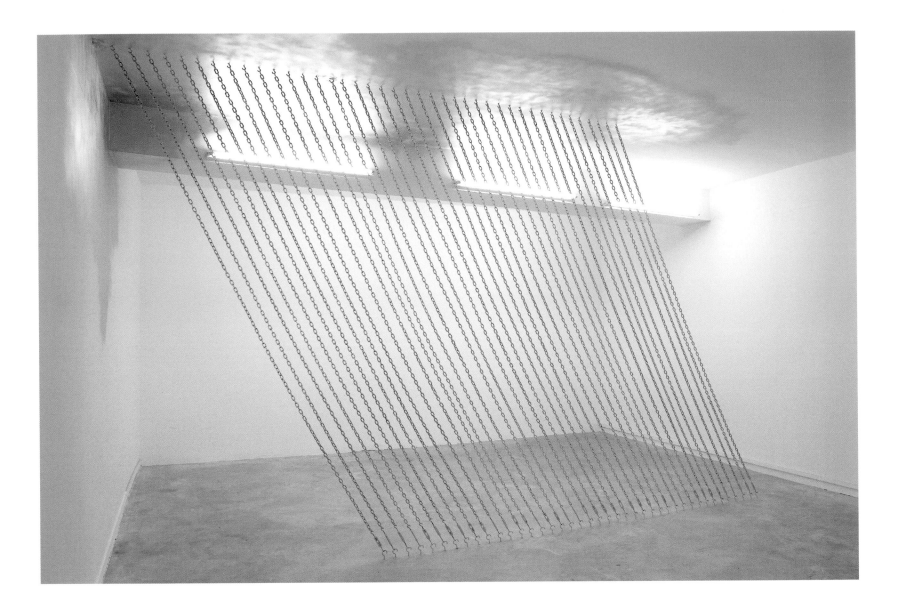

230 rain
 2004, chains, spray paint; dimensions variable

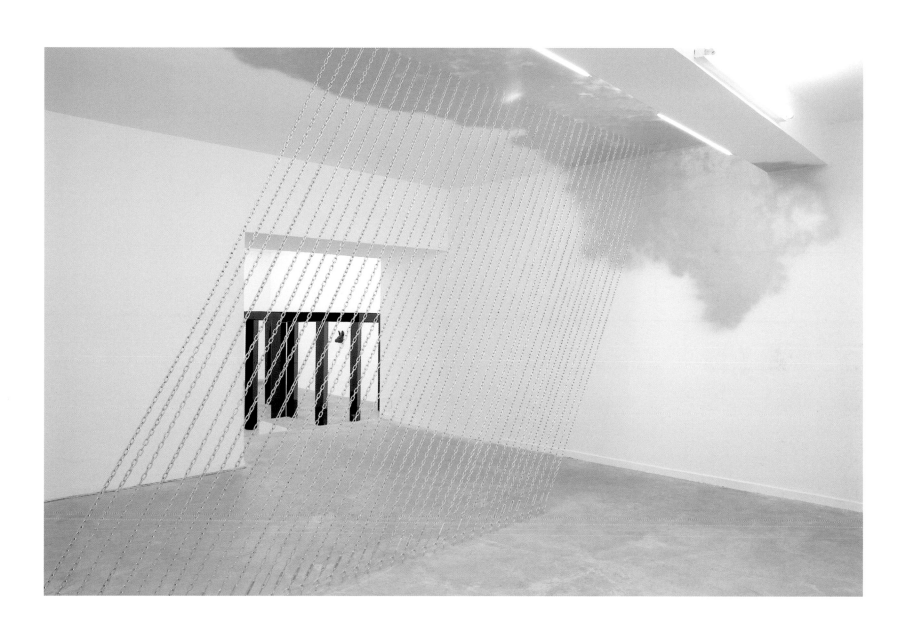

all those doors
2003, 15 pillars and 14 beams of acrylic glass,
felt tip pen, speakers, sound; modular system

moonrise. south. october
2003, cast polyurethane, black; 37 × 25 × 22 cm

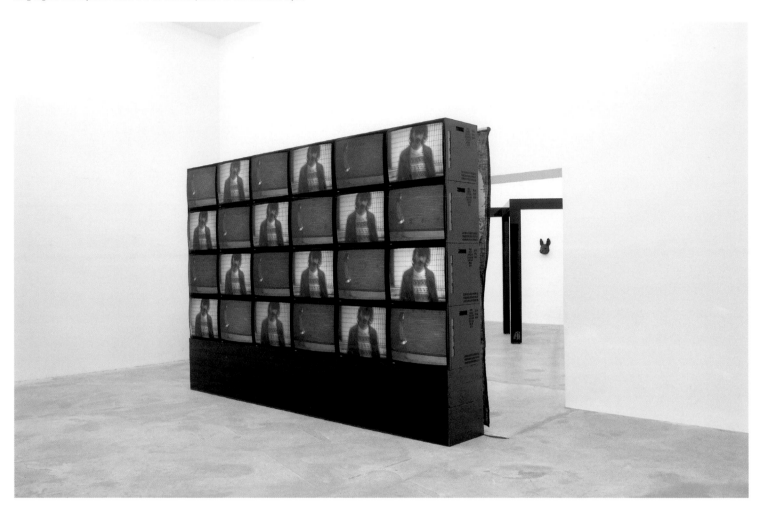

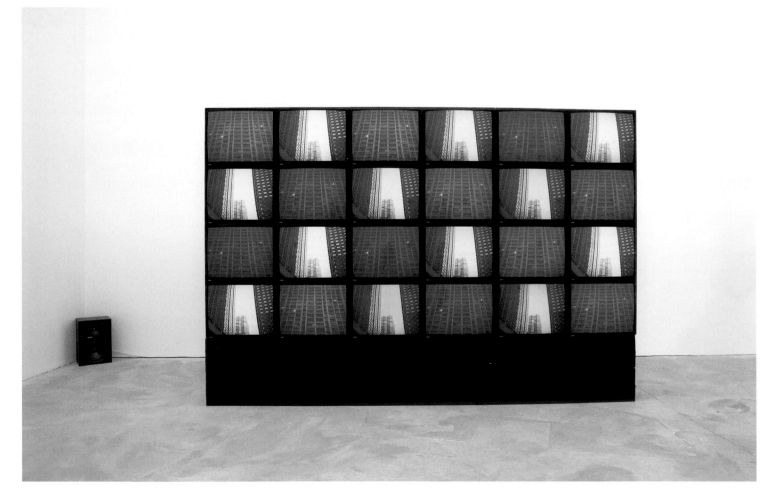

232 clockwork for oracles
2004, videowall, stencilled hessian, wooden base,
sound, black carpet; 233 × 354 × 45 cm

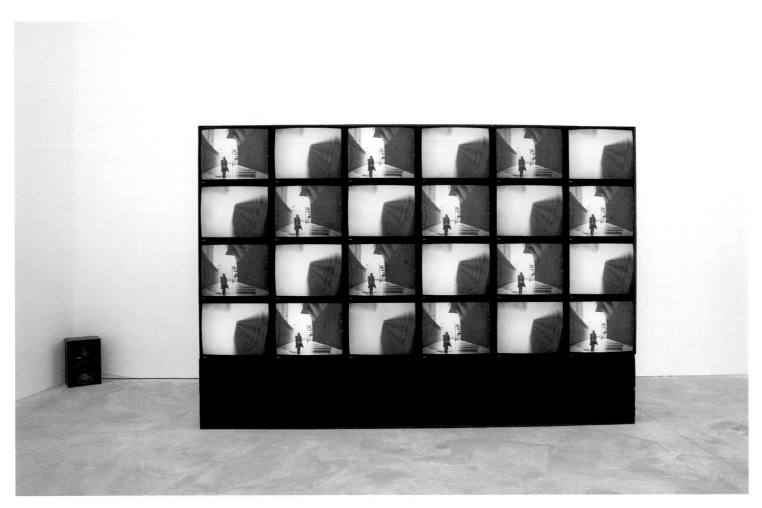

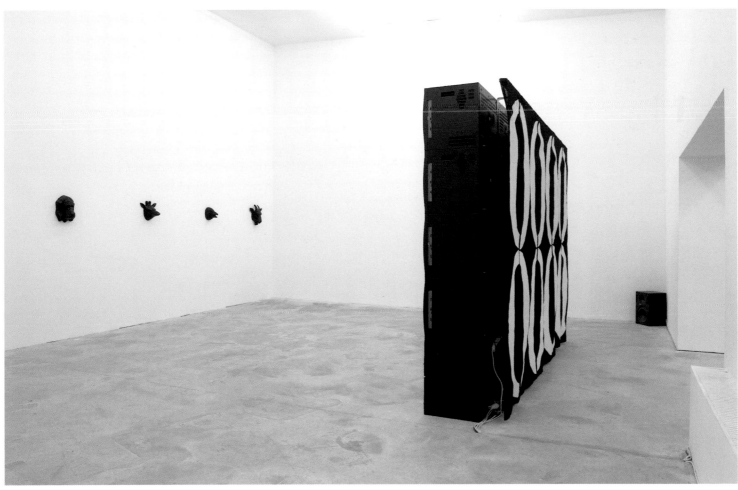

moonrise. south. october

moonrise. south. march

moonrise. south. may

moonrise. south. september

moonrise. south. december

all: 2003, cast polyurethane, black;
between 22 × 17 × 20 cm and 41 × 40 × 18 cm

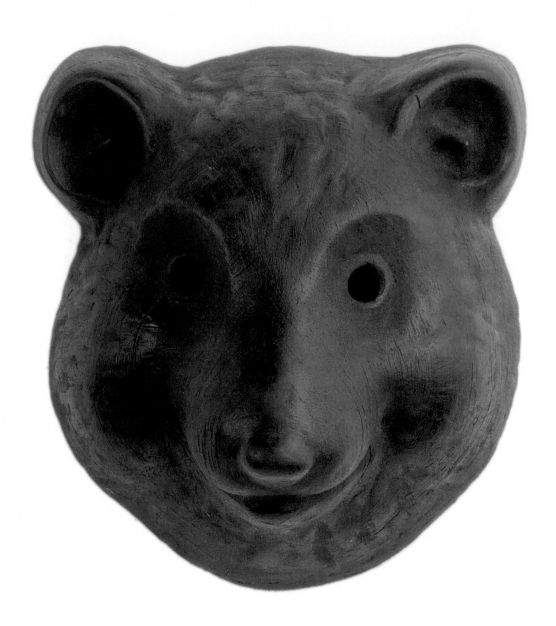

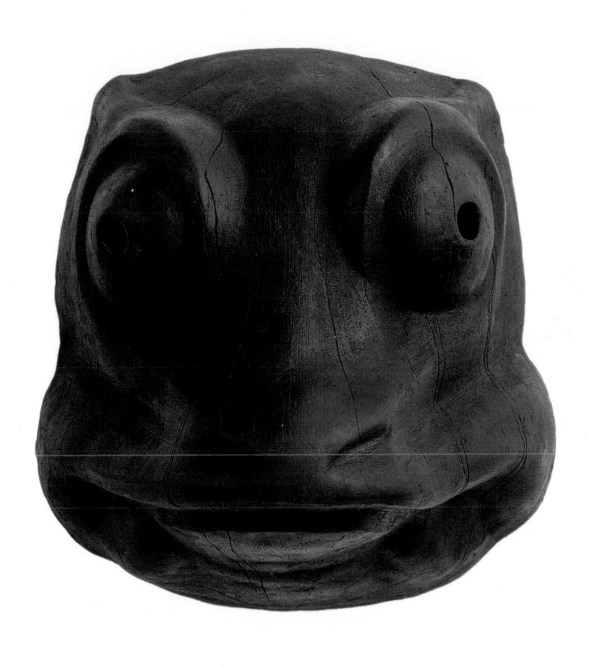

moonrise. south. june
2003, cast polyurethane, black;
23 × 22 × 11 cm

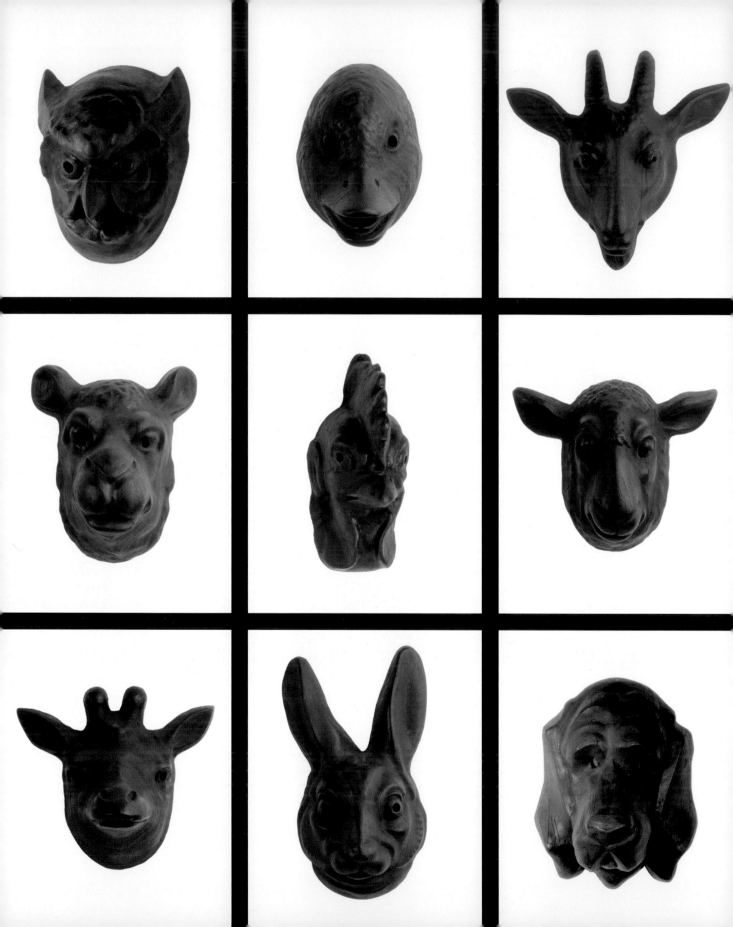

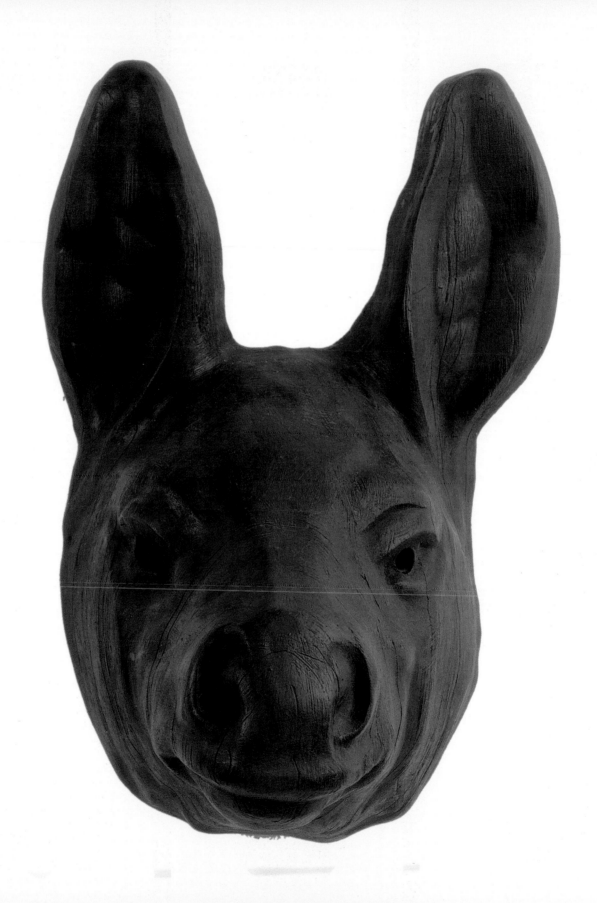

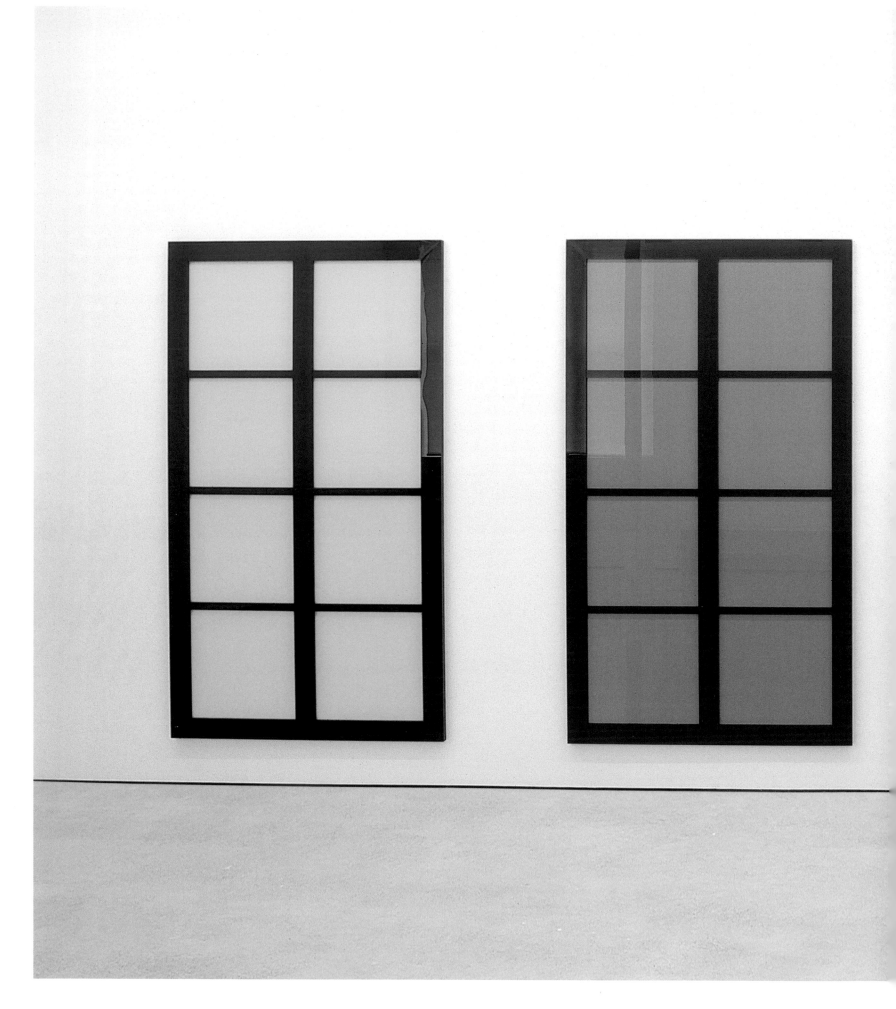

long NIGHTS short years

long nights SHORT years

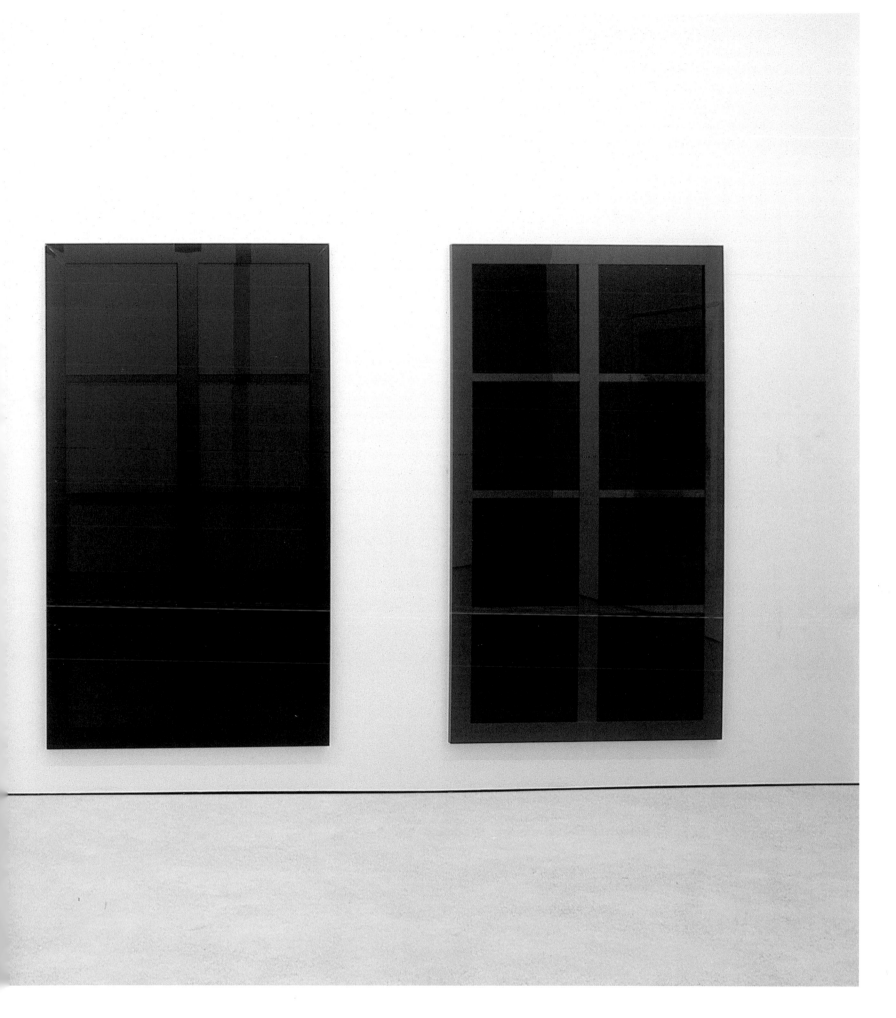

long nights short YEARS

LONG nights short years

all: 2004, perspex; 197 × 112 × 3 cm each

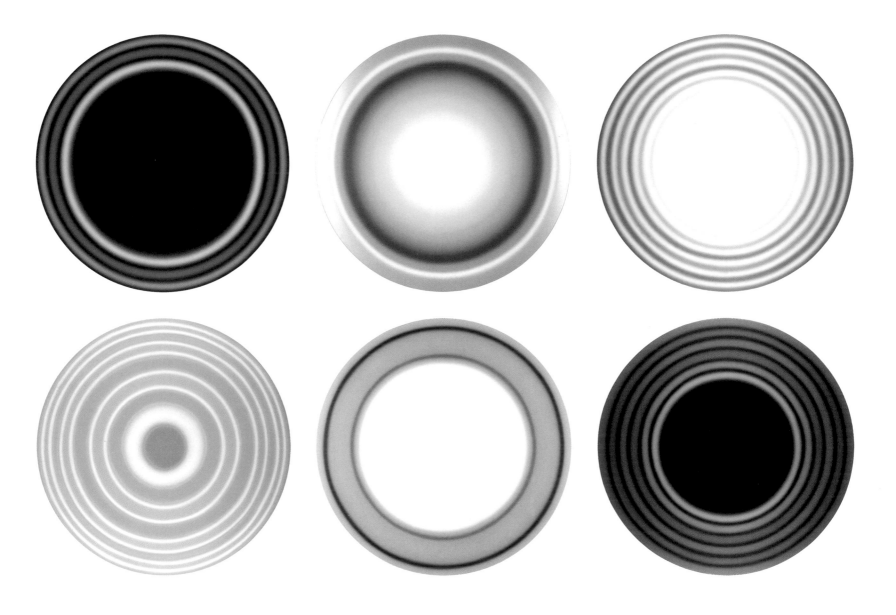

240 dreiundzwanzigsterjanuarzweitausendundfünf siebterjanuarzweitausendunddrei siebterfebruarzweitausendundfünf
 2005, acrylic paint on canvas; ø 220 cm 2003, acrylic paint on canvas; ø 220 cm 2005, acrylic paint on canvas; ø 220 cm

 einundzwanzigsteraugustzweitausendundnull einunddreissigsterjanuarzweitausendunddrei ersterfebruarzweitausendundfünf
 2000, acrylic paint on canvas; ø 220 cm 2003, acrylic paint on canvas; ø 220 cm 2005, acrylic paint on canvas; ø 220 cm

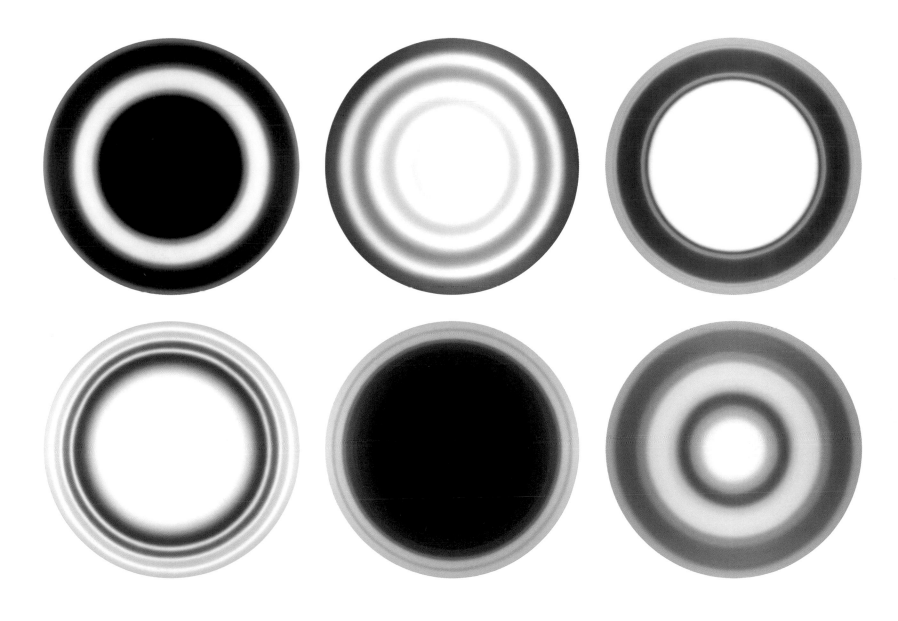

achtermaizweitausendundzwei
2002, acrylic paint on canvas; ø 220 cm

fünfundzwanzigstermaizweitausendundvier
2004, acrylic paint on canvas; ø 270 cm

einundzwanzigstermaizweitausendundzwei 241
2002, acrylic paint on canvas; ø 220 cm

achtzehnterjanuarzweitausendunddrei
2003, acrylic paint on canvas; ø 220 cm

siebterfebruarzweitausendunddrei
2003, acrylic paint on canvas; ø 220 cm

fünfzehnterseptemberzweitausendundeins
2001, acrylic paint on canvas; ø 220 cm

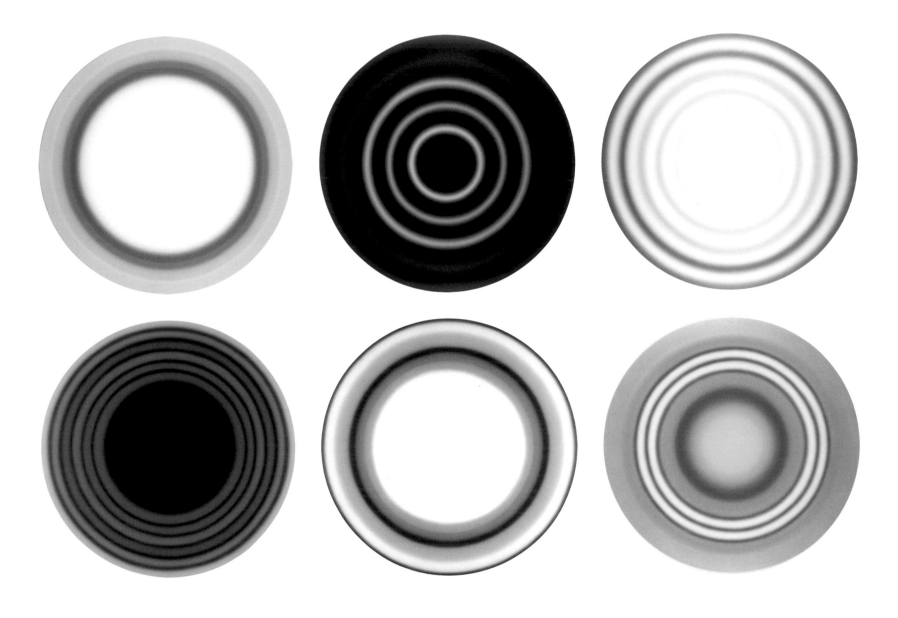

242 dritterfebruarzweitausendundzwei
2002, acrylic paint on canvas; ø 80 cm

elfterfebruarzweitausendundfünf
2005, acrylic paint on canvas; ø 220 cm

einundzwanzigstermaizweitausendundvier
2004, acrylic paint on canvas; ø 270 cm

siebzehntermaizweitausendundzwei
2002, acrylic paint on canvas; ø 220 cm

neunzehnterjanuarzweitausendundfünf
2005, acrylic paint on canvas; ø 220 cm

zweiundzwanzigsterjulizweitausendundnull
2000, acrylic paint on canvas; ø 220 cm

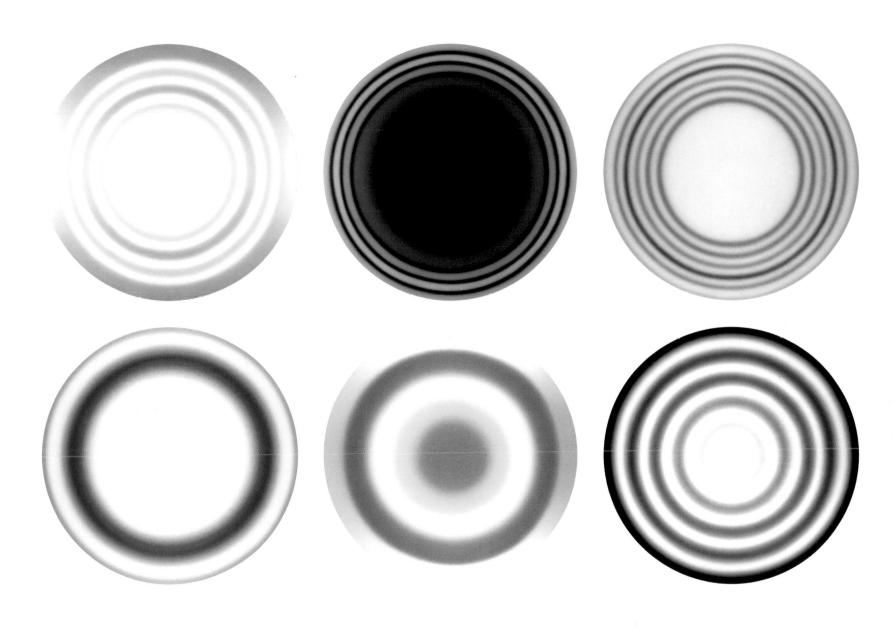

zweiterfebruarzweitausendunddrei
2003, acrylic paint on canvas; ø 220 cm

neunterjanuarzweitausendunddrei
2003, acrylic paint on canvas; ø 220 cm

achtundzwanzigsteraugustzweitausendundvier 243
2004, acrylic paint on canvas; ø 220 cm

zwölfterjunizweitausendundzwei
2002, acrylic paint on canvas; ø 220 cm

achtzehnterjulizweitausendundeins
2001, acrylic paint on canvas; ø 220 cm

achtundzwanzigstermaizweitausendundvier
2004, acrylic paint on canvas; ø 220 cm

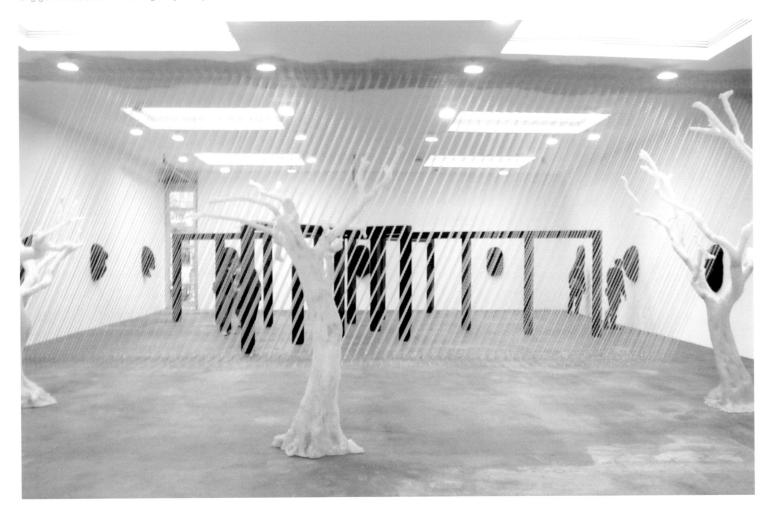

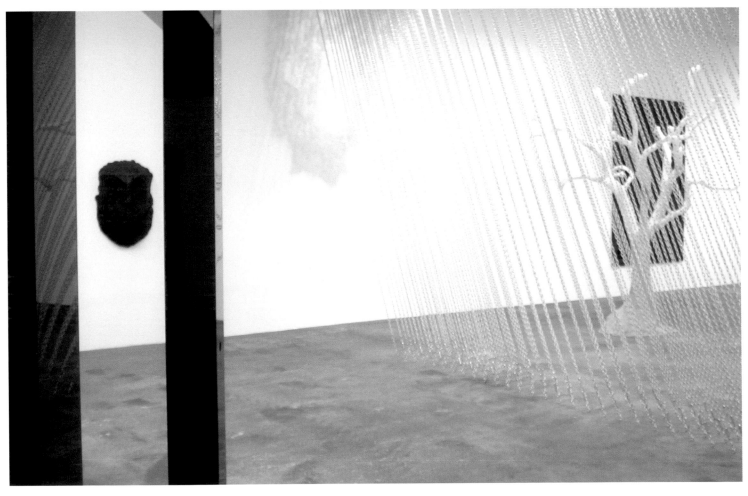

244 LONG gone sole long gone SOLE when the water went south for the winter it carried us down like storm driven gulls.
 2003, semi-transparent, cast resin; 300 × 240 × 240 cm

 long GONE sole all: 2004, perspex; 289 × 197 × 3 cm each

 out of reach until it's magic we are crossing our own stony ocean.
 2003, semi-transparent, cast resin; 307 × 277 × 247 cm

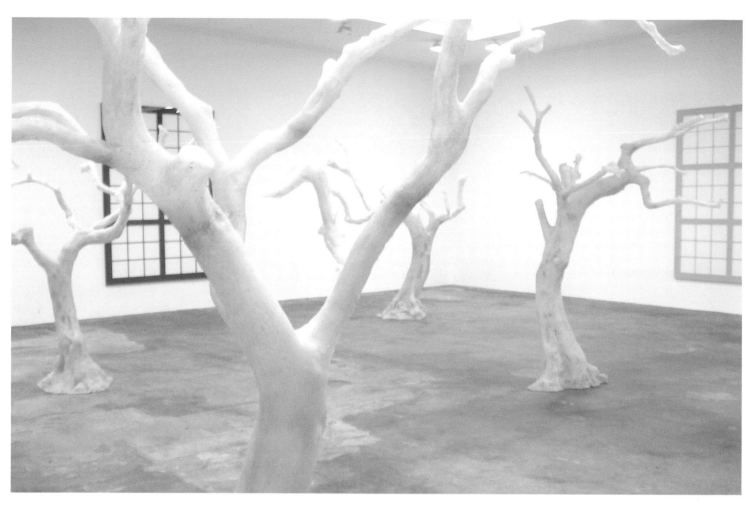

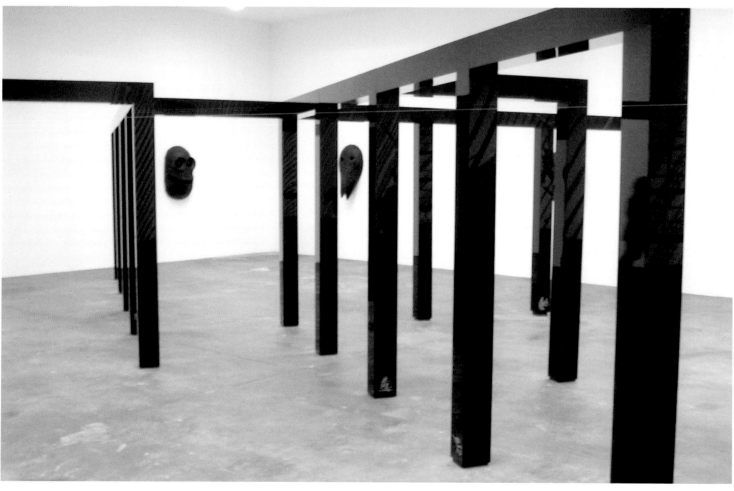

across dark stream of shooting stars.
2003, semi-transparent, cast resin; 300 × 240 × 240 cm

we sail into pleasure and unload our spacious soul.
2003, semi-transparent, cast resin; 280 × 280 × 160 cm

everything gets lighter everyone is light.
2003, semi-transparent, cast resin; 294 × 223 × 248 cm

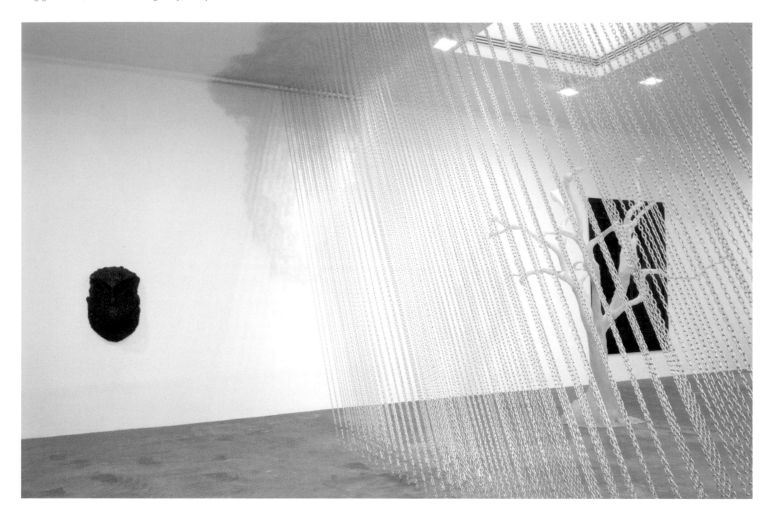

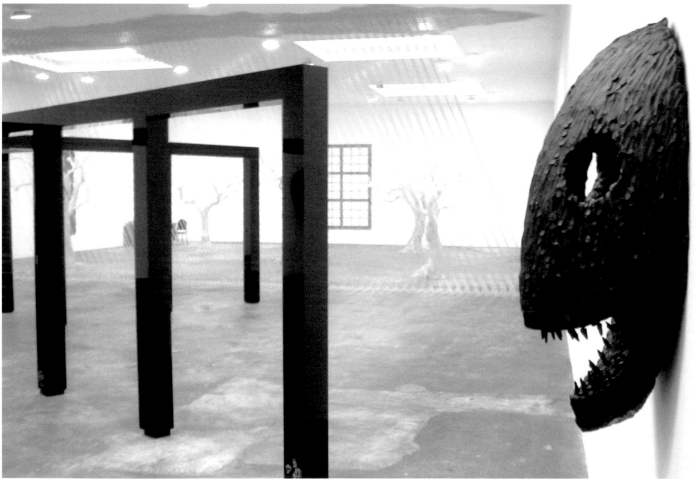

rain
2004, chains, spray paint; dimensions variable

all those doors
2003, 18 pillars and 14 beams of acrylic glass,
felt tip pen, speakers, sound; modular system

moonrise. west. january–december

all: 2004, cast polyurethane, black;
between 96 × 67 × 30 cm and 118 × 65 × 30 cm

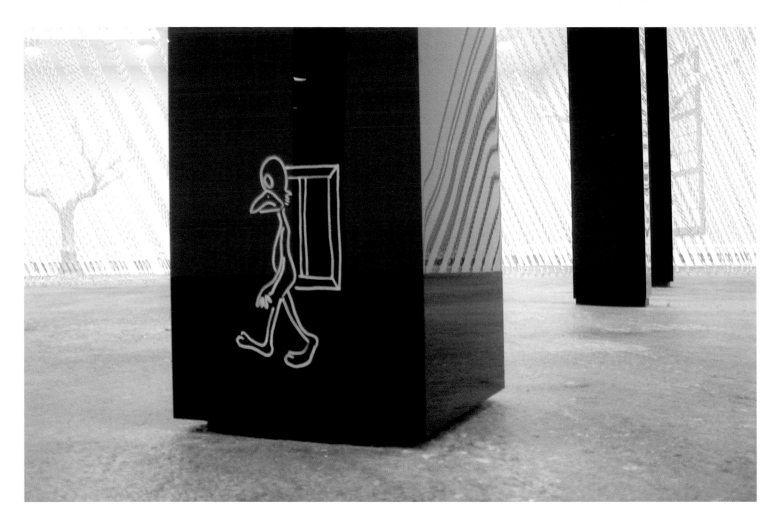

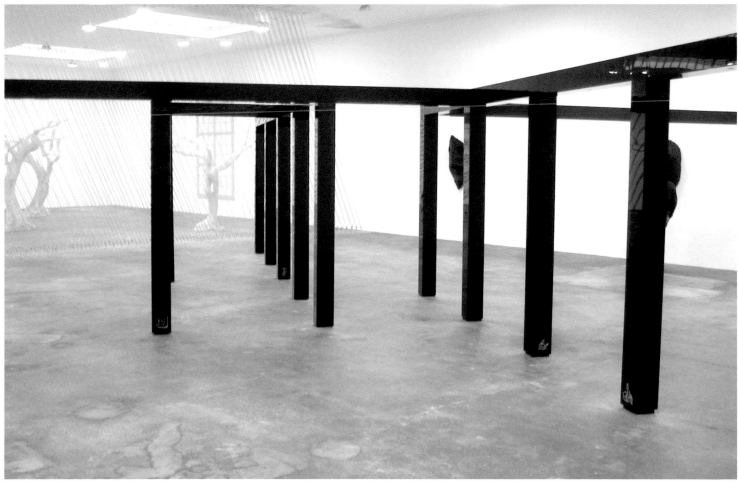

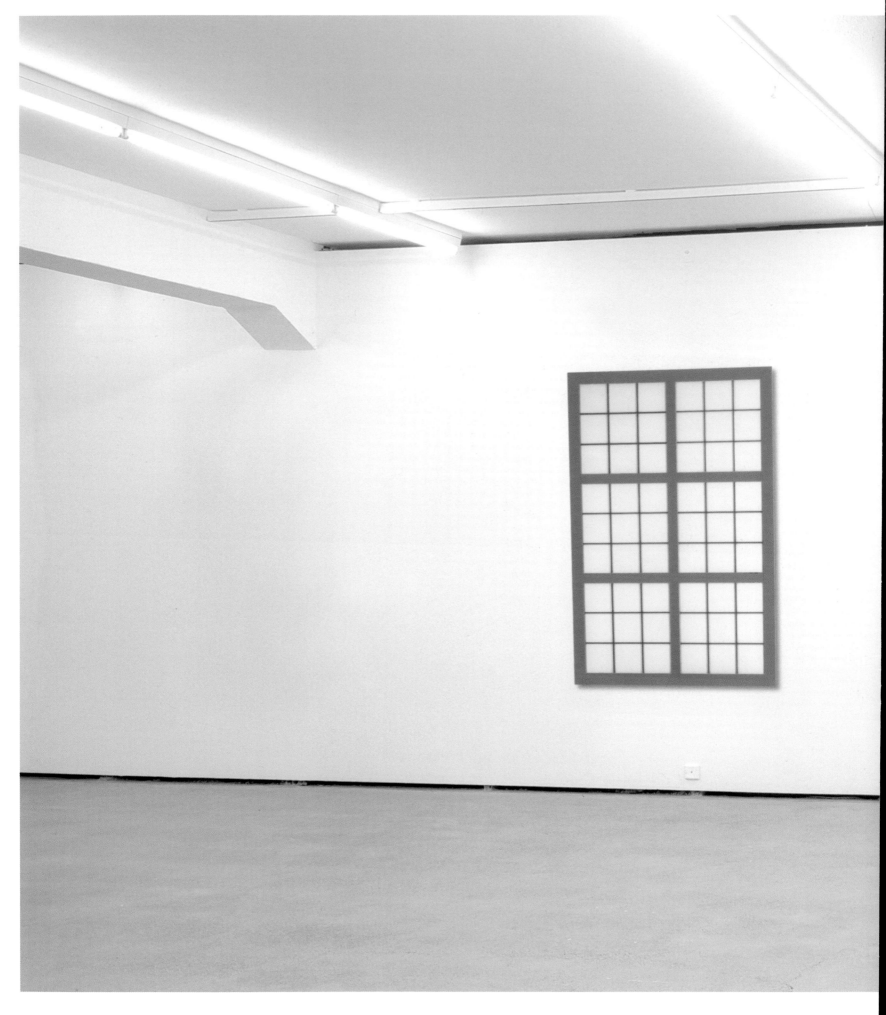

LONG gone sole

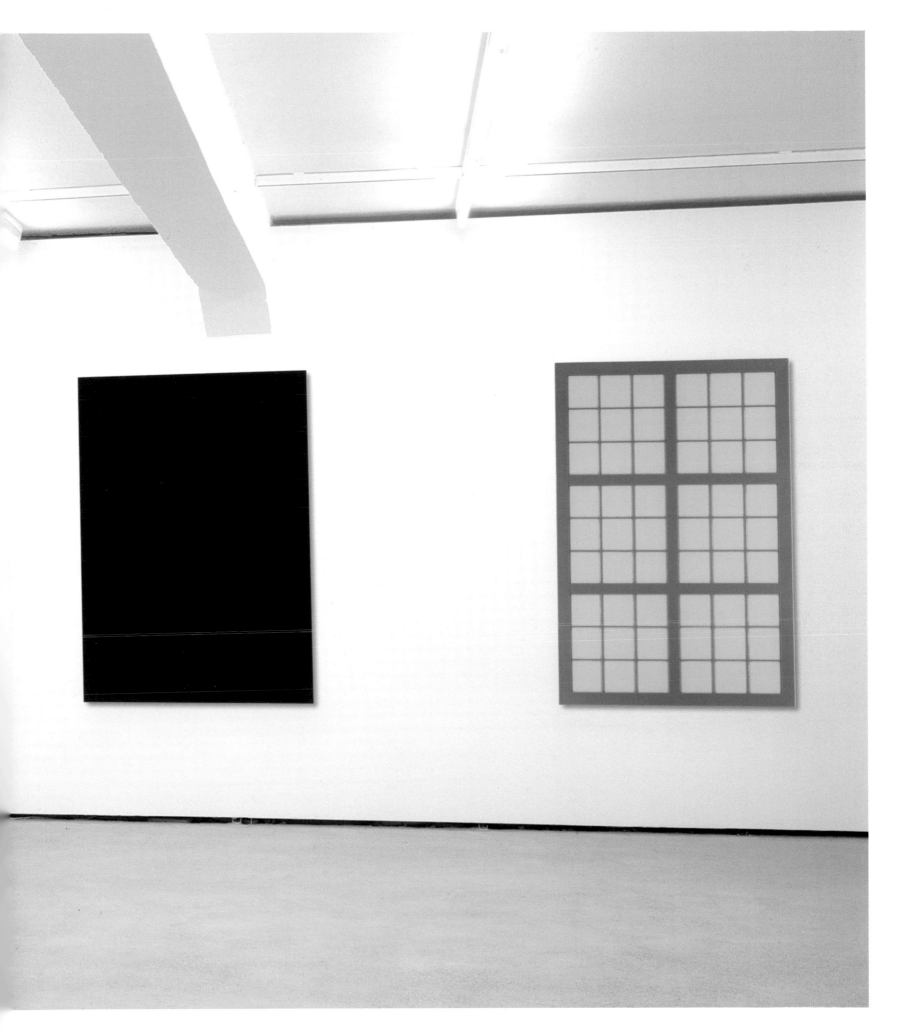

long GONE sole

long gone SOLE

all: 2004, perspex; 289 × 197 × 3 cm each

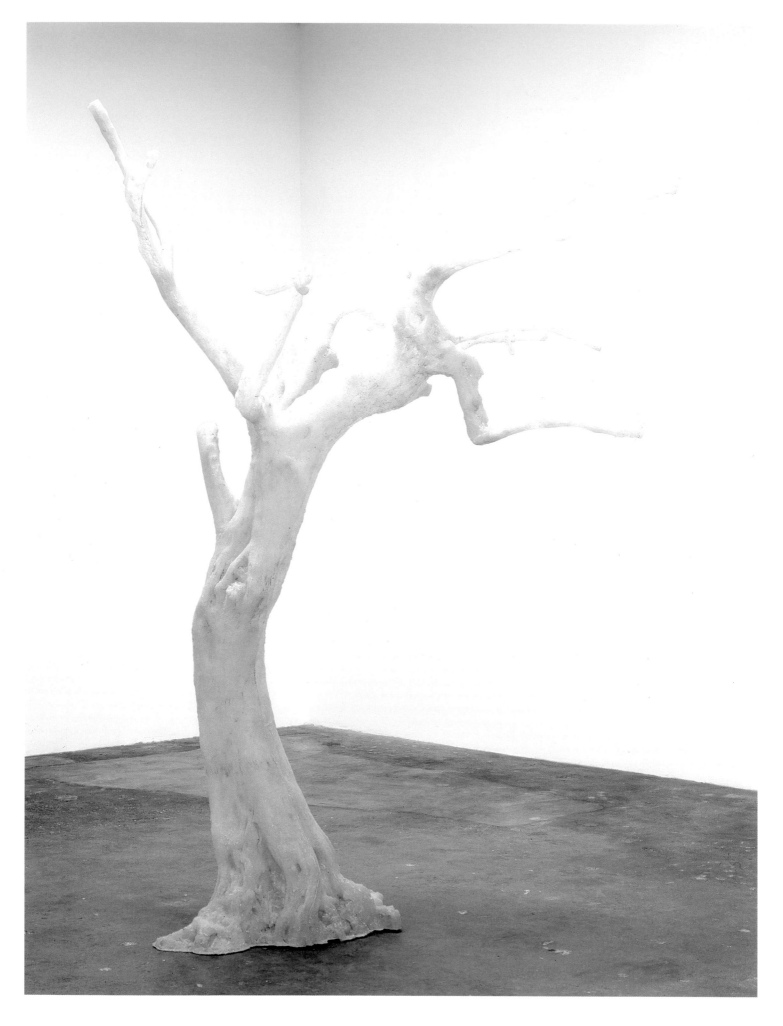

250 when the water went south for the winter it carried us down like storm driven gulls.
2003, semi-transparent, cast resin; 300 × 240 × 240 cm

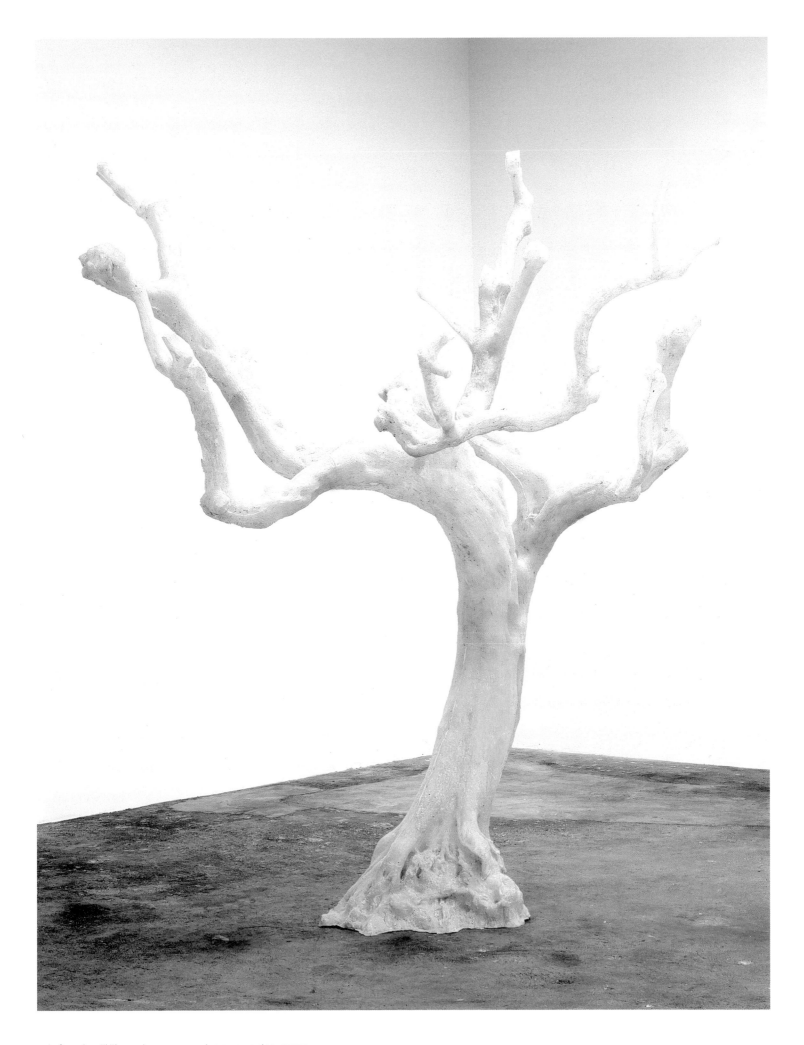

out of reach until it's magic we are crossing our own stony ocean.
2003, semi-transparent, cast resin; 307 × 277 × 247 cm

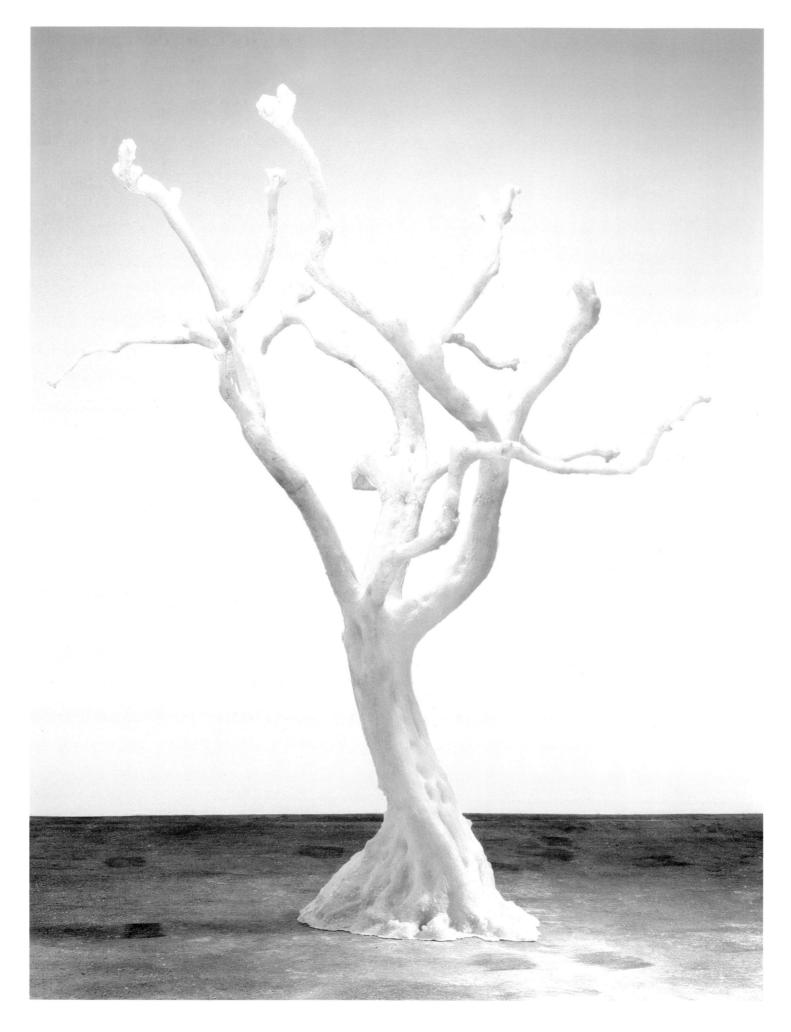

252 across dark stream of shooting stars.
2003, semi-transparent, cast resin; 300 × 240 × 240 cm

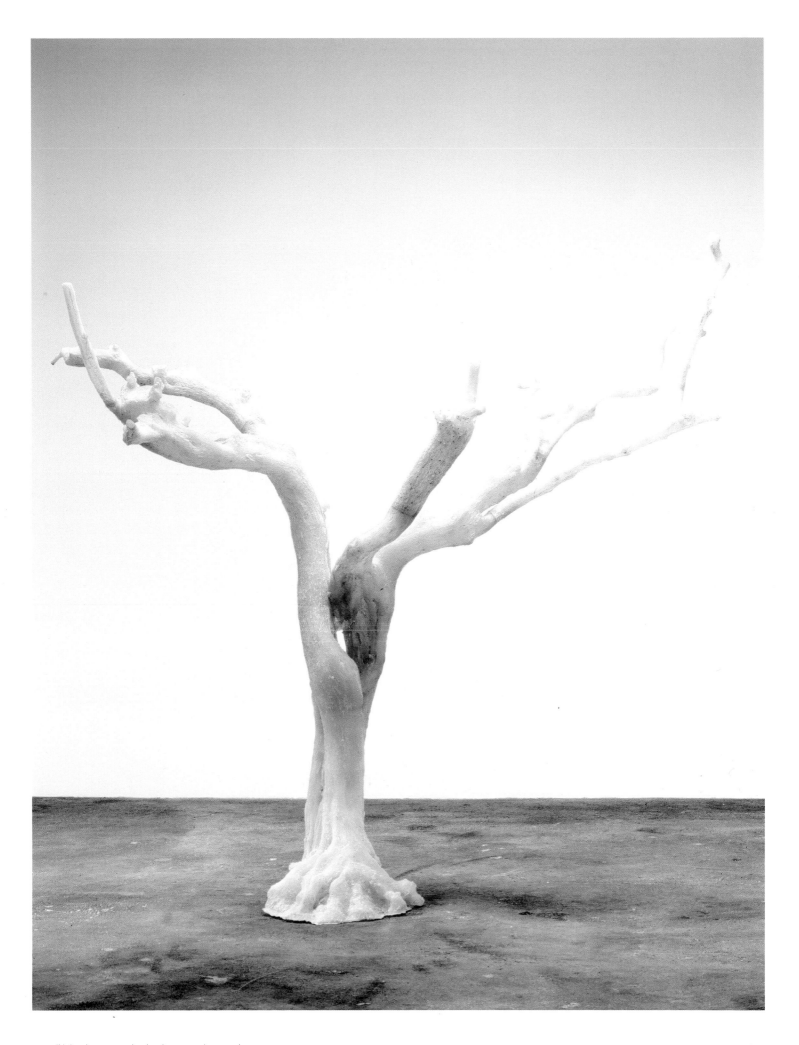

we sail into pleasure and unload our spacious soul.
2003, semi-transparent, cast resin; 280 × 280 × 160 cm

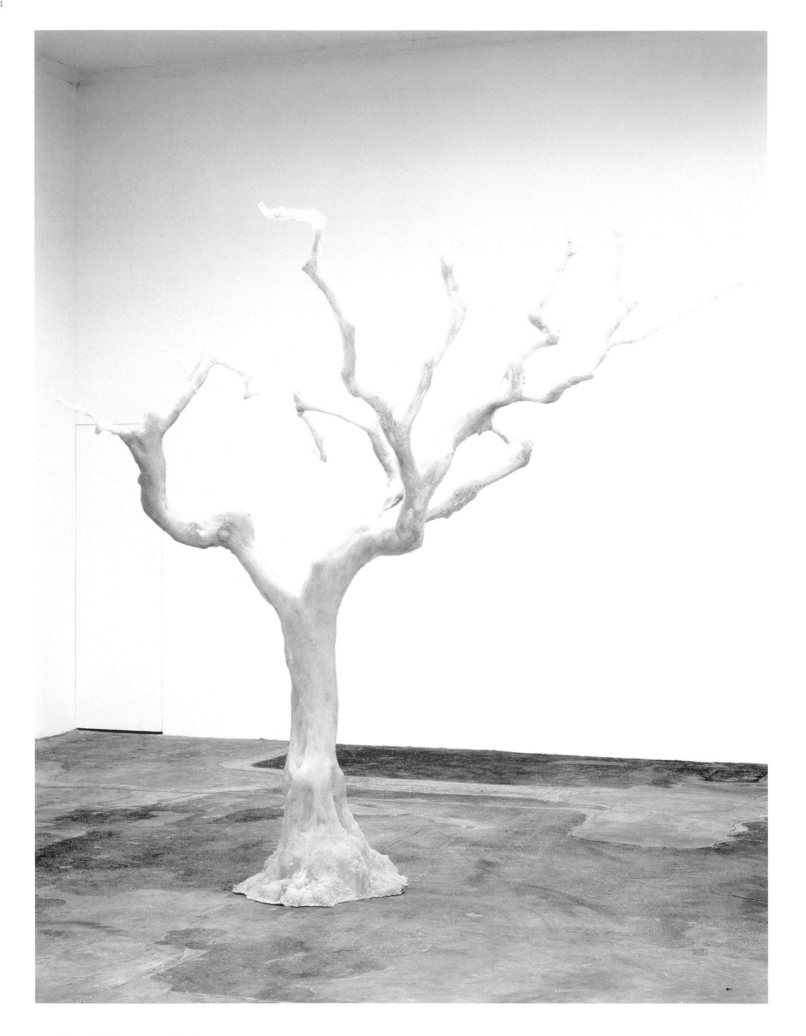

everything gets lighter everyone is light.
2003, semi-transparent, cast resin; 294 × 223 × 248 cm

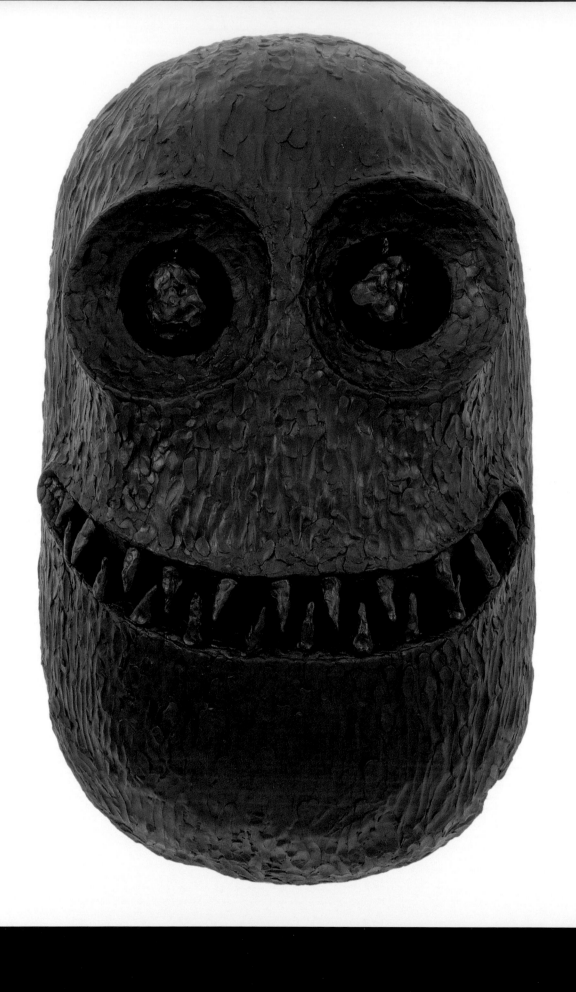

moonrise. west. may
2004, cast polyurethane, black;
102 × 60 × 27 cm

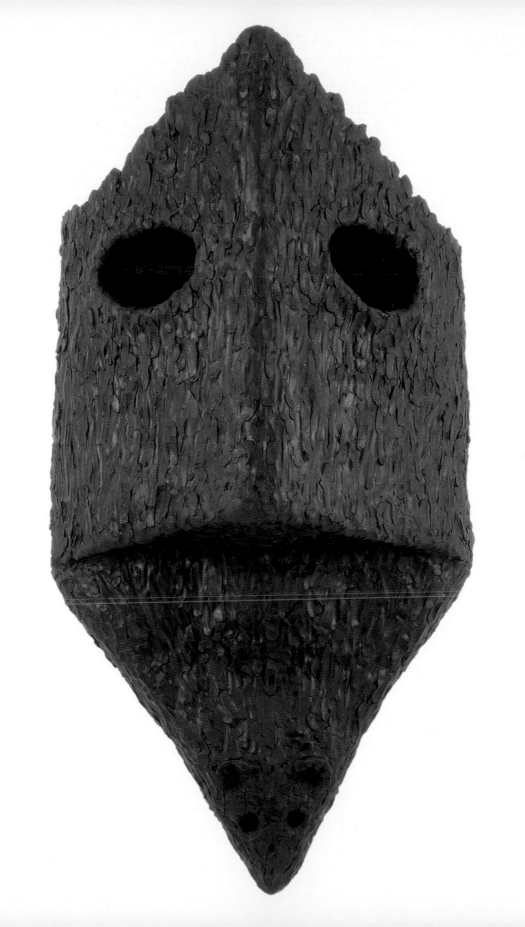

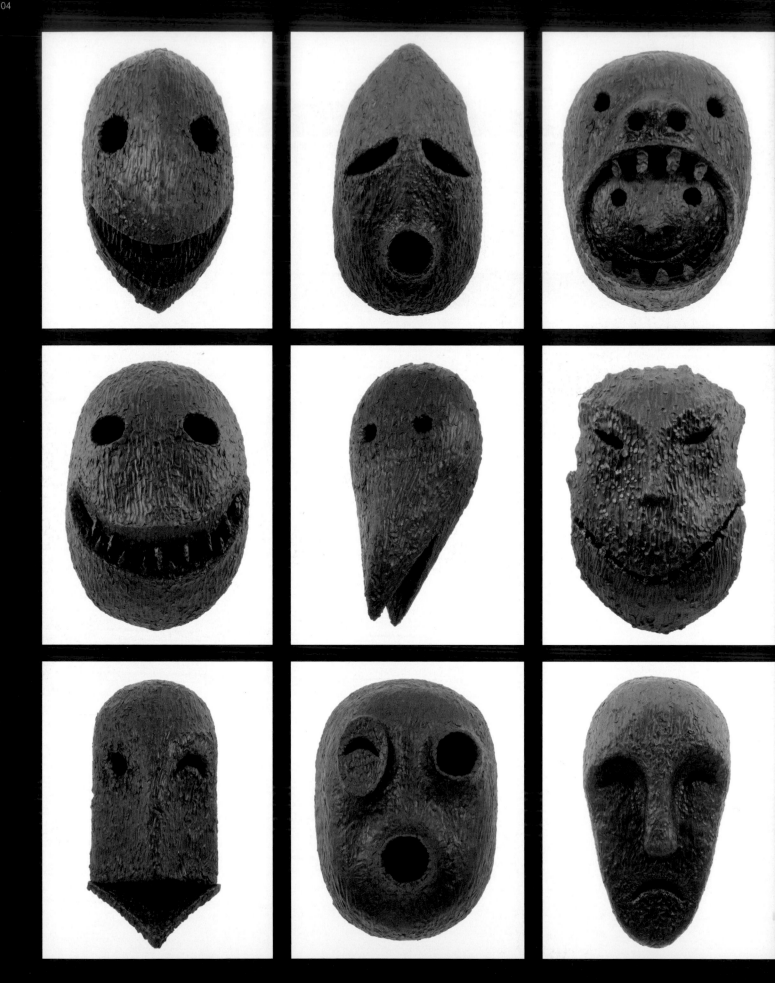

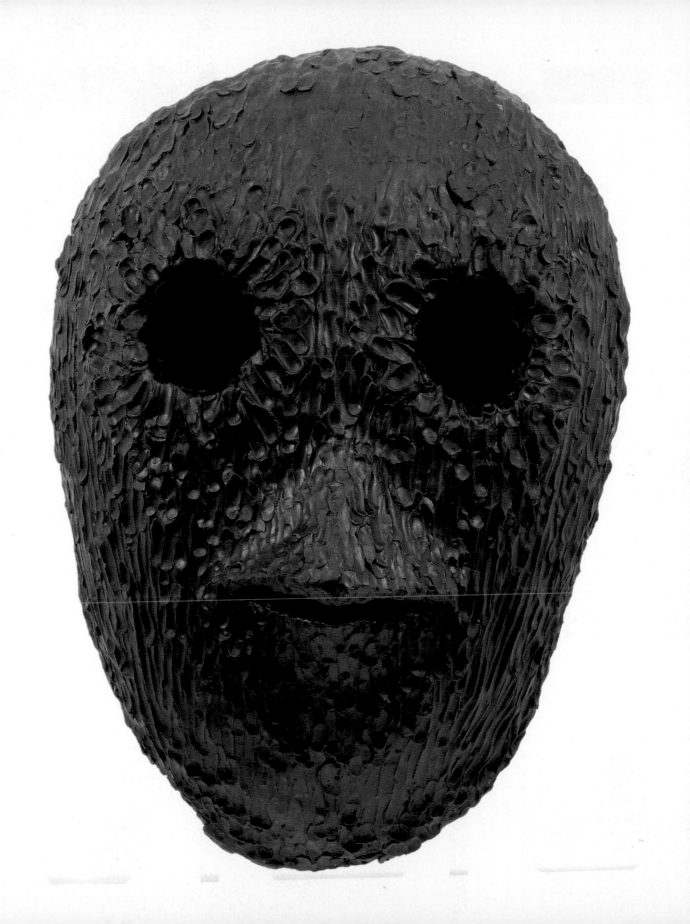

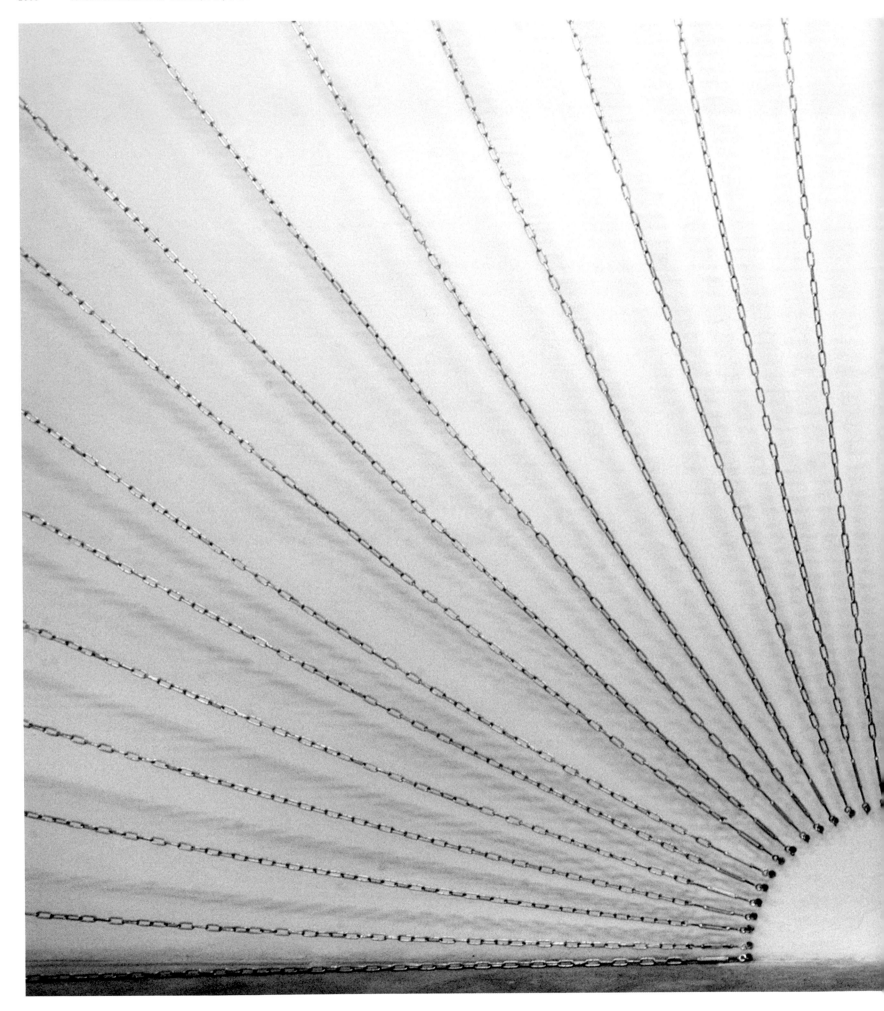

sunsetsunrise
2004, chains; dimensions variable

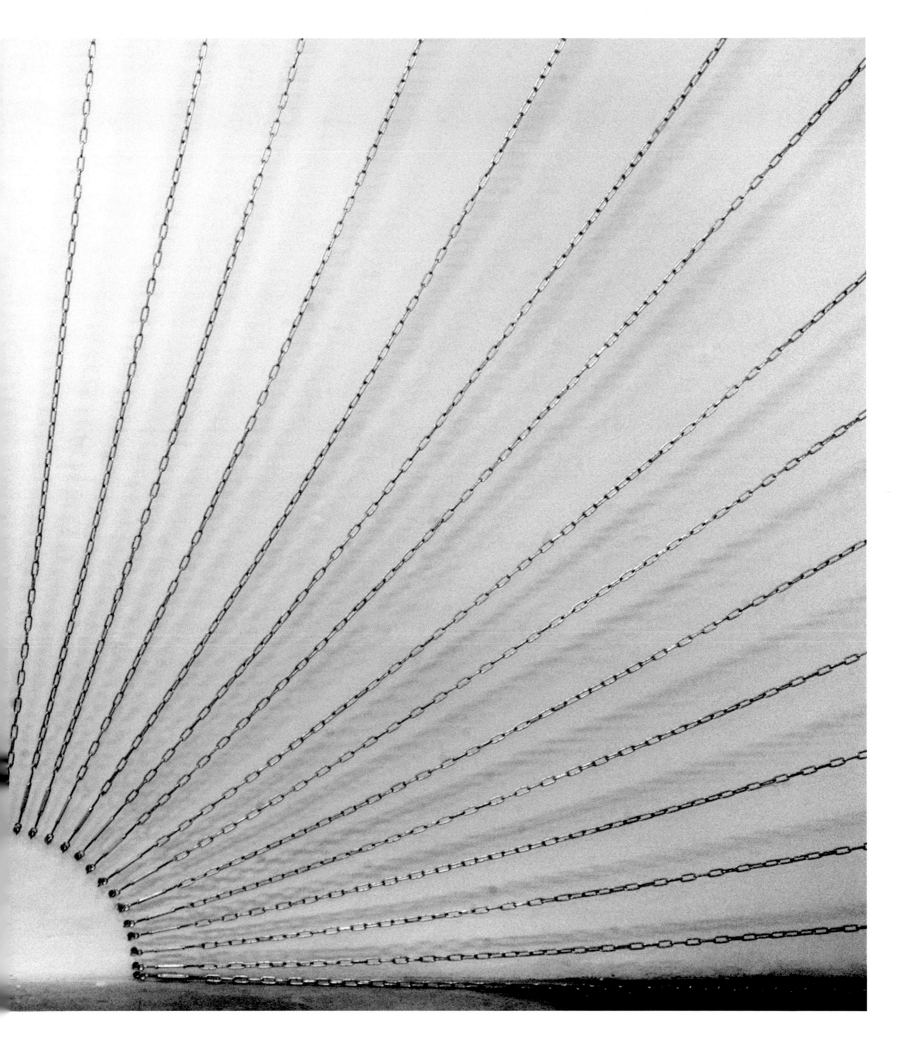

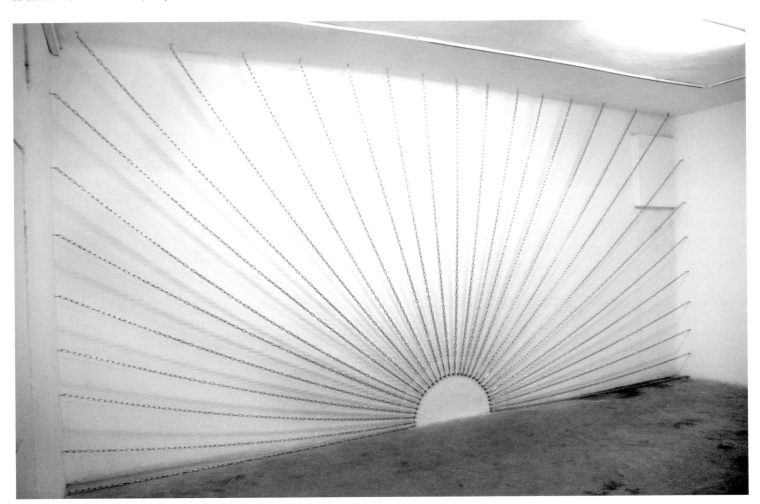

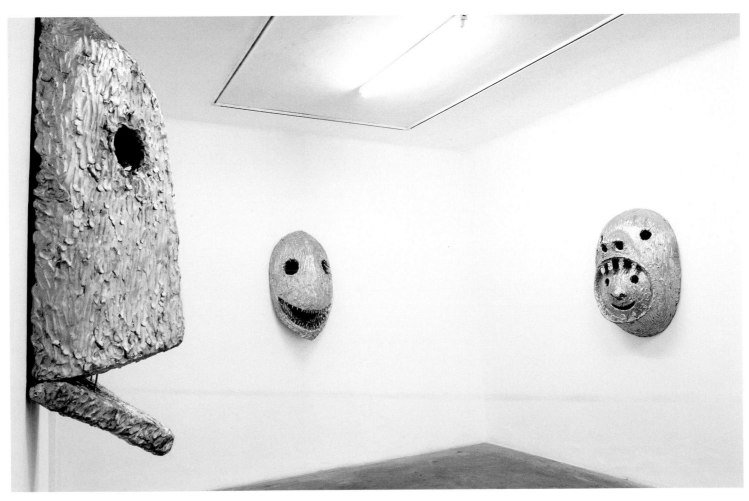

sunsetsunrise
2004, chains; dimensions variable

sunrise. august

sunrise. september

sunrise. october

all: 2004, cast aluminium;
between 100 × 72 × 32 cm and 115 × 60 × 37 cm

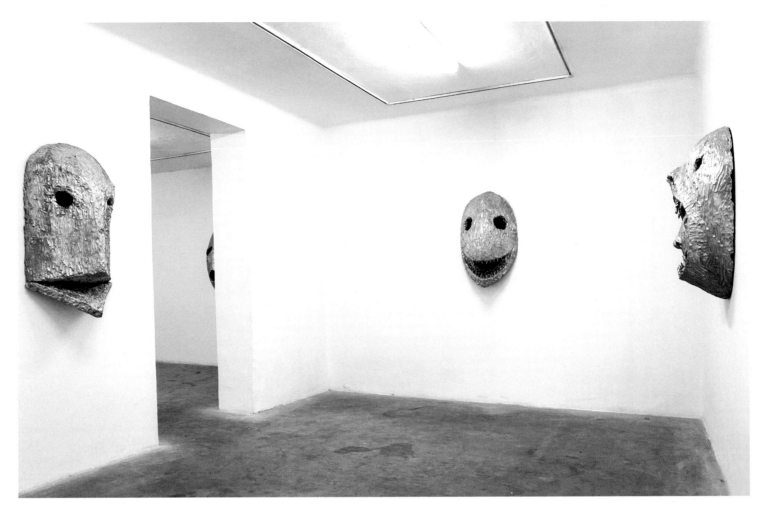

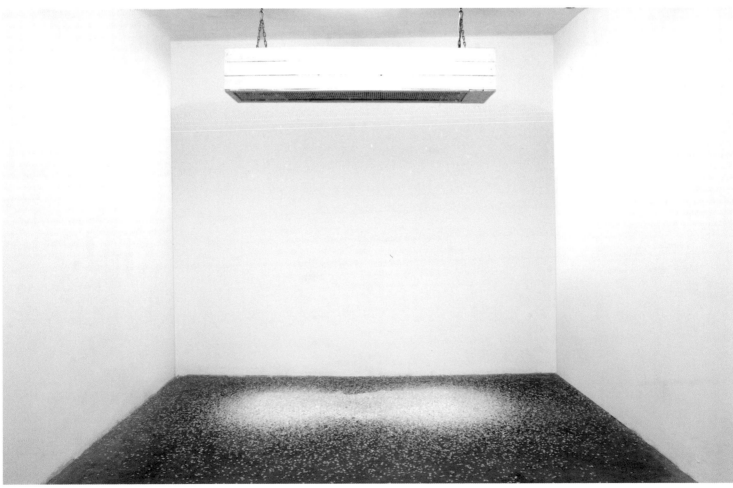

thank you silence
2004, wood, paper, motor activity,
sound; 30 × 200 × 40 cm

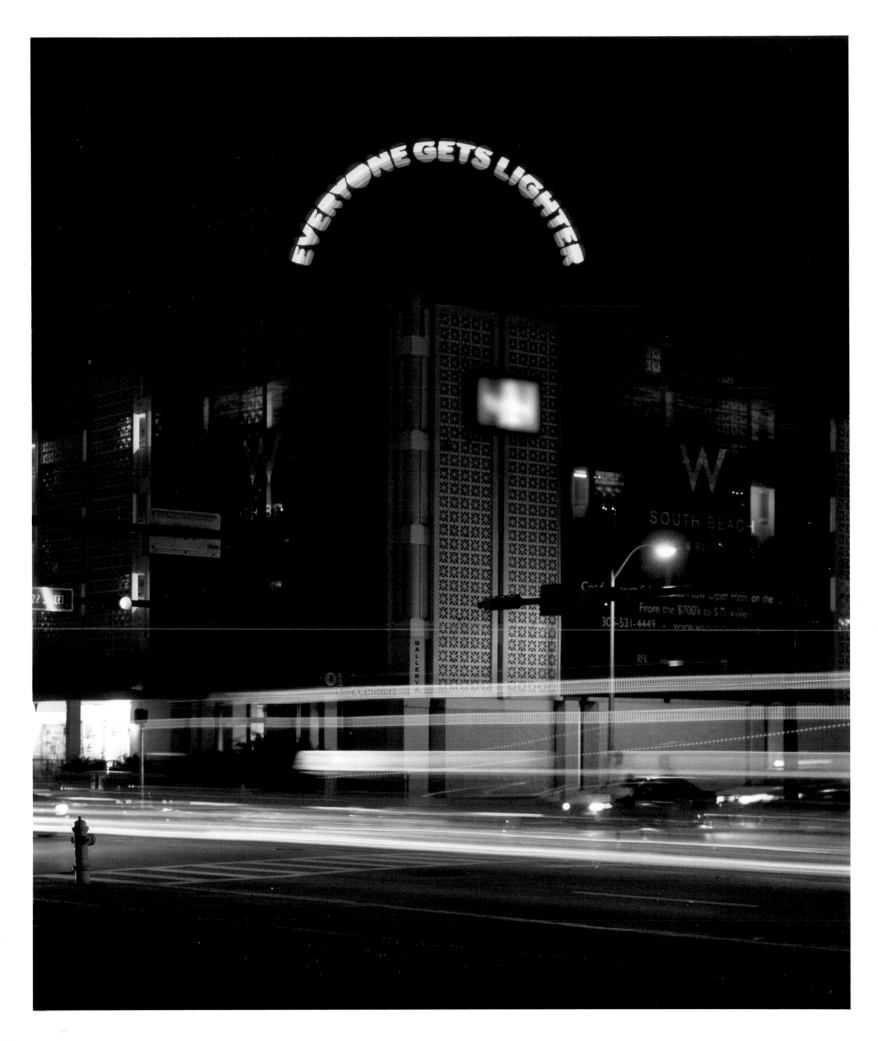

everyone gets lighter
2004, neon, acrylic glass, translucent foil,
aluminium; 414 × 950 × 10 cm

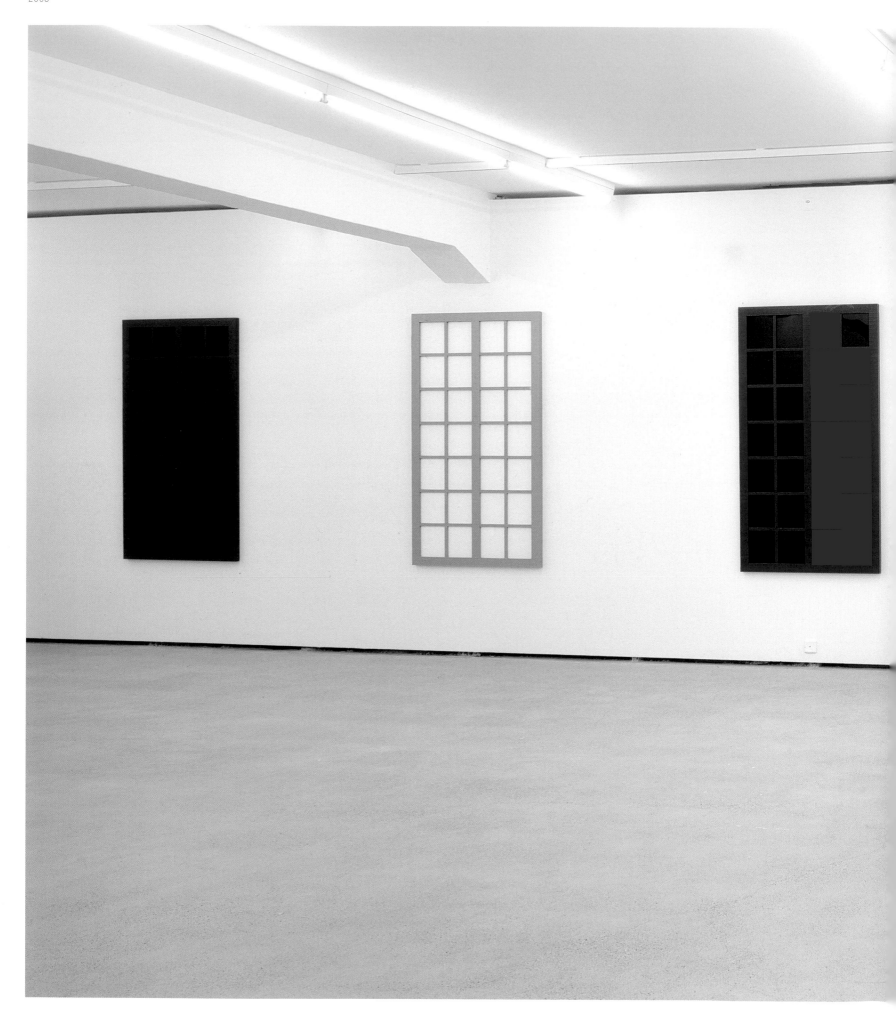

MEET me here at dawn meet ME here at dawn meet me HERE at dawn

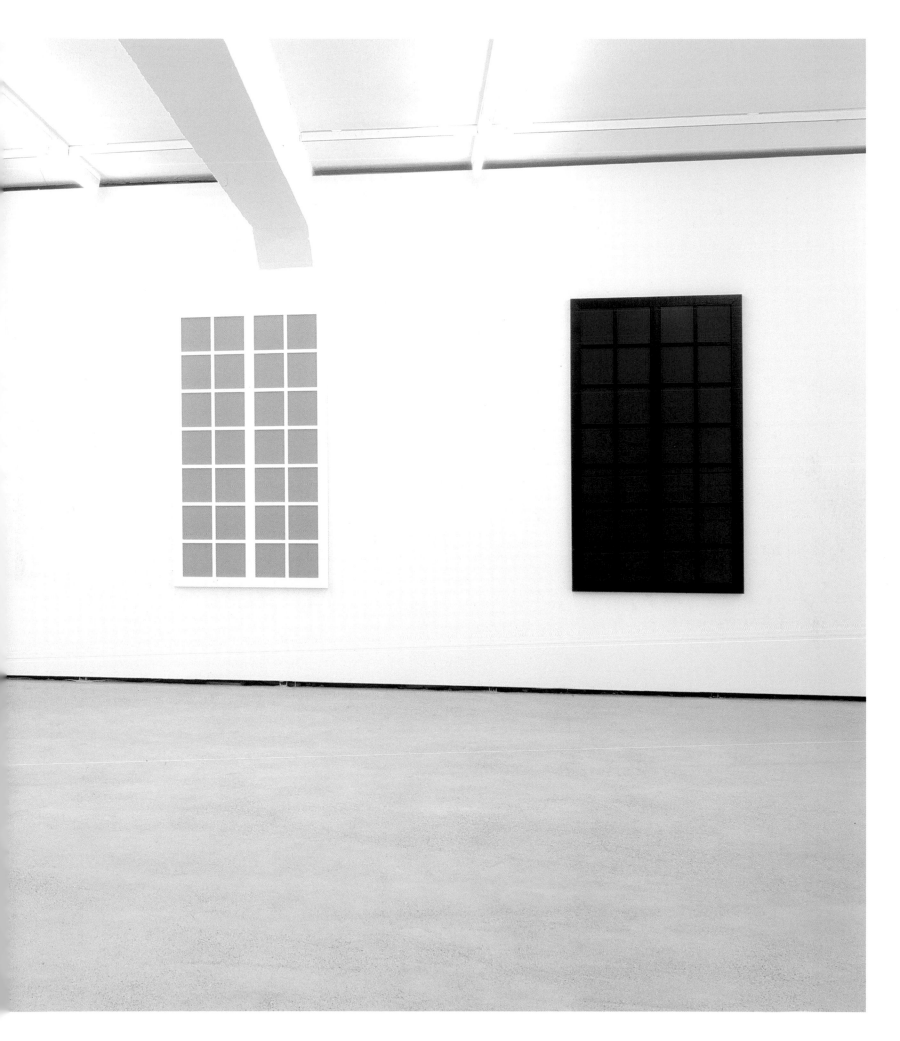

meet me here AT dawn meet me here at DAWN

all: 2005, perspex, wooden frame; 180 × 100 × 4 cm each

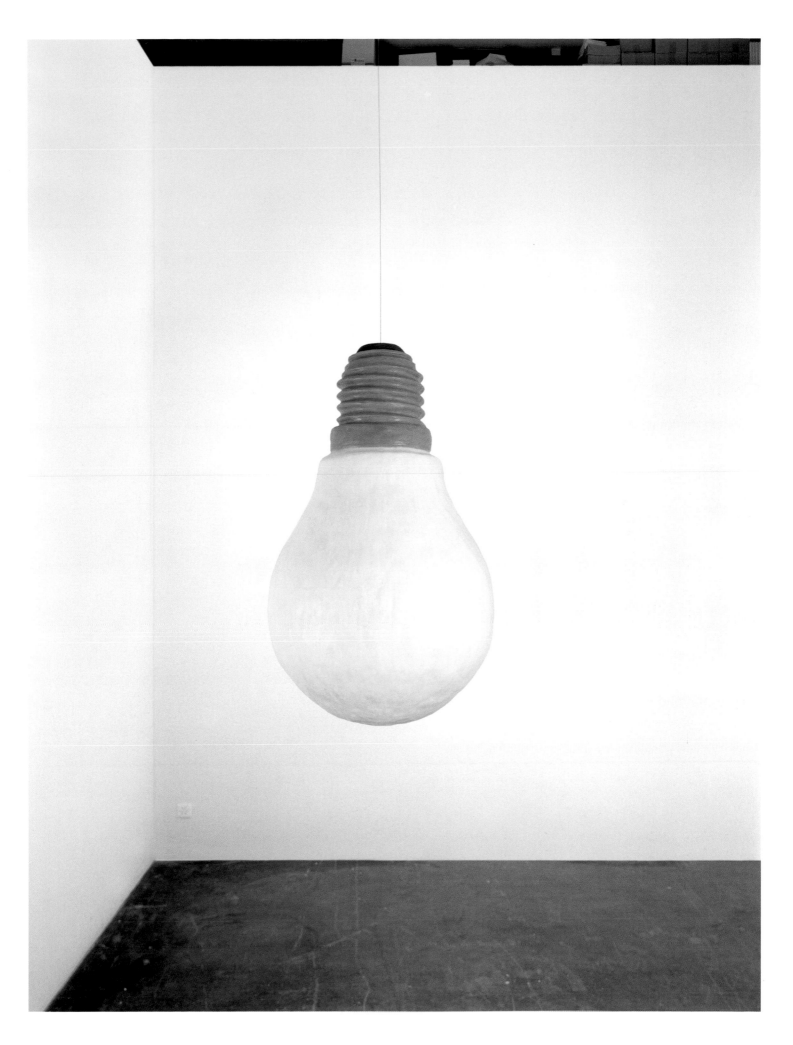

the second hour of the poem
2005, cast wax, pigments; 140 × 82 × 82 cm

Foreword

Iwona Blazwick, Director

This publication accompanies *zero built a nest in my navel,* Ugo Rondinone's exhibition at the Whitechapel Gallery. The exhibition is presented in collaboration with The Henry Moore Foundation and is curated by David Thorp.

We are grateful to the following for supporting the exhibition and this publication: Stanley Thomas Johnson Foundation, Fondation Nestlé Pour L'Art, Pro Helvetia and the Swiss Embassy; Galerie Eva Presenhuber, Sadie Coles HQ, Matthew Marks Gallery, Galerie Almine Rech, Galerie Esther Schipper, and Galleria Raucci/Santamaria; Shane Akeroyd and other Exhibition Patrons who wish to remain anonymous. We would especially like to thank Markus Rischgasser, Kerstin Weiss, Glenn Frei, Lionel Bovier and Salome Schnetz for their advice and support.

This publication has been developed in close collaboration with the artist, and presents his most comprehensive monograph to date. We would like to thank Alison Gingeras, David Thorp and Gilda Williams for their insights into Rondinone's practice. Scipio Schneider, a long-standing collaborator of the artist's, has designed this publication, which is published by JRP|Ringier, Zurich. Most of all, we would like to thank Ugo Rondinone for conceiving such a powerful and poetic exhibition for London.

Introduction

Andrea Tarsia, Head of Exhibitions and Projects

It has often been said of Ugo Rondinone's exhibitions that they resemble group shows with works by several artists. The formal and stylistic diversity that typifies his practice is one in a series of slippages that the artist sets in motion; a continuous shift in register in which style, subject matter, title, references, relationships between parts and the whole, are skilfully played off against each other. Born in Zurich in 1964, Rondinone studied at the Hochschule für Angewandte Kunst, Vienna, in the late 1980s, emerging alongside a generation of artists whose installations explore how a sense of self is defined by how we occupy both real and fictive space. His work spans painting, drawing, photography, video, sculpture, neon and sound. A search for connection, identification and signification lies at the core of his practice. Its elusiveness is played out in the disorienting effect of his installations, which offer readings of experience as transitory as our own.

Rondinone's work addresses the nature of subjectivity as it struggles to position itself in relation to the world. Such a struggle induces feelings of reverie and contemplation, a suspended state of melancholy, longing and desire that is redeemed through poetic and aesthetic engagement. Moving between interiority and exteriority, the incongruities in Rondinone's work are also often very funny.

A number of photographic works give form to the self's desire for the other. In *Moonlighting,* 1999, the artist appears encased in a full-body leather costume, wrapped in an alien skin as though driven by an impetus to fuse it with his own. In *I Don't Live Here Anymore,* 1995–2001, his face peers out at us, superimposed on a woman's body. His expression is blank, almost bored, while his eyes look straight ahead at us. Here I am, he seems to say, now what? While these images attain a level of humour in the deadpan delivery of his transformation, his patently artificial migration into female form suggests a desire for identification that cannot be fulfilled. Other photographs, such as *Sleep*, 1999, consist of two series of images: one depicting a man and the other a woman, walking by a winter sea as though in search of each other. They remain contained within the framed confines of each image installed in such a way that they face away from, rather than towards one another.

Underlying all Rondinone's work is a tension between interior essence and exterior appearance, enacted in the first instance through a disparity between form and content. India ink drawings of Arcadian, preindustrial landscapes and hypnotic target paintings, rendered in hazy concentric circles of vivid colour, induce feelings of meditative or transcendental reflection. Yet the surface of his target paintings is flat and blurred, a depthless plane that contradicts the absorptive qualities they promise. His landscapes on the other hand are rendered in haunting black and white, like ghostly photographic negatives that appear to negate their very presence. This disparity is amplified by the many references each work evokes. Played out at both visual and linguistic levels, they constantly refer to something other than the works themselves. While the landscapes point to the Romantic sublime, the target paintings recall colourfield painting and the mandalas of 1960s psychaedelia; each inhabits these traditions like a masquerade. They evoke but do not reconcile personal and cultural expression, individual artistic practice and a wider aesthetic discourse. Turn to the titles, furthermore, and both are named with the day and date of their production. Any promise of spiritual fulfilment is undercut by the banality of a daily act, transformed into a testament of presence and of ritualised activity.

Rondinone's installations take the hermetic nature of his practice and propel it outwards, to reflect on the relationship between the artist and the world around him. For his exhibition *Cry Me A River,* at Galerie Walcheturm, Zurich, in 1995, the artist created a polyester figure of himself sitting on wooden planks inside the gallery, while a window framed by wooden slats reveals the world outside. Rondinone frequently invokes the solitary nature of studio practice. In this work, titled *Heyday,*

the artist's forlorn expression could be interpreted as a bout of post-creative exhaustion, a send-up of his own artistic prowess. Conversely, it could embody a poignant testament to the gap that both shapes that gesture and separates it from the world itself.

In reflecting an existentialist sense of disconnection, alienation or Baudelairian detachment, Rondinone's interest lies in exploring the creative possibilities that the gap between a search for meaning and its attainment can generate. He does so by locating personal narratives of search within wider cultural traditions, triggering a chain of references that speak of art's more poetic engagements with life. In its framing of street activities, his installation at Galerie Walcheturm proposes a window on to the world that points to Renaissance and history painting; its unedited framing of daily life might also be conceived as the ultimate durational film. By infusing his installation with a sense of melancholic detachment, however, Rondinone transforms the window from a realist device into a projective membrane, one that superimposes a psychic and emotive state onto reality. Like his target paintings or landscapes, *Heyday* suggests that we are driven by a desire for connection and meaning that is doomed to failure, yet that in the process also shapes the world in our own image of it.

Looking back over a career that has now spanned two decades, it becomes apparent that Rondinone creates recurring images that amount to a personal vocabulary, bringing them together to suggest different meanings with each installation. Theatrically staged, they present immersive, sensory environments that alter our sense of reality, suspending the spatial and temporal coordinates that locate us. For his Whitechapel Gallery installation, two maze-like structures in black Perspex titled *All Those Doors,* 2003, catch our reflections in their surfaces, framing our passage through fragmented space. Suspended from the ceiling, *Thank You Silence,* 2005, releases paper fragments in a daily snowstorm, while a solitary light bulb cast from wax further confuses our sense of exterior and interior. Its title, *The Fourth Hour of the Poem,* introduces a temporal dimension. The meditative tinkling of a bell and a pre-recorded, looping dialogue, affect our reading of the space as they suspend us in a mood-infused, eternal present. At the rear of the gallery a giant zero, woven onto jute, suggests both nothing and infinity; the vanishing point that centred viewers in Brunelleschi's paintings or space-time's organising principle in Einstein's theory of relativity.

Twelve black rubber masks look down at us from the surrounding walls, one for each month of the year. Once completed there will be four series in all, each consisting of twelve masks. They will be titled *Moonrise. North, Moonrise. South, Moonrise. East,* and *Moonrise. West* (2003 – ongoing). Poetically referring to the monthly calendar and to the four needles of a compass, they conjure up images glimpsed in a white, night-time light. Part animal, part human, they point to a dual nature steeped in the world of folkloric archetypes – more Brothers Grimm than Caspar David Friedrich. As masks they address a split between our inner selves and public personas, yet wrap totemic values into the folds of a synthetic materiality and in their hand-made furrows, stamp the fetishism of craft into the impersonal mould of machined production.

Brought together in an installation, our encounter with these works triggers the same sense of disconnection – a literal and metaphorical collision between competing interiorities – that Rondinone explores in each individual work. Art-historical tradition and linguistic definition provide a frame for interpretation that does not contain their meaning. Instead, Rondinone's installation bears the fragmentary nature of dreams or mental landscapes; through the slow unfolding of memory and association – with references to literature, poetry, music, theatre, popular culture and the visual arts – connections begin to emerge.

Artist In The Landscape

David Thorp

Ugo Rondinone is a skilful creator of mood-infused rooms. In these rooms he establishes an atmospheric place in which the solitary figure of the artist can try to enter into relationships, make intuitive choices, interpret the world or stare blankly at the eternally recurring round of life. Art is Rondinone's distraction from life's daily requirements; the artist the one who, by copying himself and art, is able to sustain his particular mentality in the face of overwhelming ordinariness. At the heart of Rondinone's practice is a resigned, melancholic acceptance of a world in which beauty still remains a redeeming feature.

Open the front cover of the book *Guided by Voices,* published in 1999 to accompany the artist's exhibition of the same name, and one is confronted by the expressionless gaze of a young person. The image is part of the photographic series *I Don't Live Here Anymore,* 1995–2001, in which Rondinone digitally manipulated fashion shots of female models in provocative poses and superimposed the image of his own face upon them. Dressed in a short black dress, ankle length black boots and a broad brimmed black hat, this blond-haired figure sits on her heels leaning forward to support his head delicately on her hand, his elbow resting on the floor. On her upper lip the faint shadow of a moustache can be discerned. Turn the first page of the same publication and a photograph of a lone figure appears (titled *Heyday*), part of Rondinone's 1995 exhibition *Cry Me A River.* Bearing a striking similarity to the artist, the figure dressed in jeans and t-shirt lolls on rough wooden boards against the wall of an empty gallery, beyond which, seen through the gallery window, a busy street scene rushes by.

These two images portray the basics of Ugo Rondinone's practice as an artist. He illustrates inner and outer worlds quite literally in *Cry Me A River* and metaphorically in *I Don't Live Here Anymore.* Rondinone was once described as a dandy overly concerned with his appearance and maybe this slight stemmed from the latter photographic series. Yet inside and outside are portrayed as sites for expressing and understanding underlying human dilemmas, such as anxiety and dread or freedom and the consciousness of existing. These concerns mark Rondinone out as a practitioner who is seriously attempting to make a statement incorporating themes that have consistently underpinned the making of modern art. They suggest that we can only be understood from the inside rather than from without and comprehended in terms of a lived experience of reality that we make for ourselves. In doing so, Rondinone acknowledges the absurd nature of reality, in which ambiguity is a norm.

Rondinone has been described as obsessed with history and passing time. But such a description, while broadly accurate, fails to address what it is about this condition that engages his attention. As the frontispiece of *Guided by Voices* shows, during the 1990s Rondinone dressed up in a range of costumes. While he may have delighted in acting out the various personas he adopted, his underlying intention was to say something about himself in his body, at a specific time when his overwhelming sense is one of boredom, of an ennui that stems from a lack of occupation or interest. The images in *I Don't Live Here Any More* lose none of their erotic charge as a result. In fact, through its fashionable beauty, his gender disorientation attests to dark desires and a concern with appearance that marks more than mere playful gender bending, revealing instead a mental weariness and a want that will not be fulfilled except through the versatility and completeness of artistic expression.

Rondinone's undertaking as an artist might be described as a strategy to keep such weariness at bay. Now and again it defeats him; the lone figure propping up the wall in *Heyday* testifies to the difficulty that confronts anyone attempting to find anything significant or stimulating enough to do. Paradoxically, the potency of this position and the ability Rondinone has to turn the negative state of ennui into an act of art culminating in an installation, increases his audience's awareness of the problem while alleviating it for himself. At a time when a generation of young contemporary artists has moved away from an overt concern with the philosophical underpinning of art's relationship to life, the maturity implicit in a practice that deals with the big issues of human existence makes demands on an artist that resonate with a poetic relevance.

In the early months of 1993 Ugo Rondinone created a dark ink installation, for an exhibition in the Shedhalle, Zurich, titled *if.* It was roughly executed and primitive in its mood. Rondinone in part devised the installation in response to Richard Serra's *Verb List Compilation: Actions to Relate to Oneself,* 1967– 69, in which Serra produced a long list of actions in a poetic monologue for the artist to contemplate. Across the floor of the gallery a great puddle of ink spread out from a hole in the wall and trickled into the corners of the room. Objects lay about the floor and on the walls were texts crudely written onto black and white rubber and fabric. Scattered around were several dog leads, while each day Rondinone would visit this installation and change it. There is something about this early work that evokes a sense of the animal returning to its lair, the dog leads acting as symbols of restraint in a chaotic environment. The room spilt out a visceral language into which the artist's personal memorabilia and writing had been discarded.

The use of ink is essential to Rondinone's work, and his early paintings in India ink on paper, begun in 1991, can now be seen as central to his practice. In contrast to the chaos of *if,* these paintings depict an Arcadian ideal. The woods and hills, streams and cottages of a pre-modern world conjure up connections with well-known 19th-century works and feelings for a time ensconced in a romantic sensibility. Sometimes these landscapes are rendered in negative, and they are often exhibited alongside video, wall texts and photographs that create the incongruous combinations of which the early Surrealists were so fond. Unlike the animal intrusions of ink and chaos in *if,* the paintings stand apart both in their original starting point in pre-modernity and in the pristine quality of their execution, beautifully framed in black behind Plexiglas. Furthermore, there are no figures in these landscapes. While *if* contained the detritus of the artist's life, his presence ever present, Ugo Rondinone only appears alongside, rather than in, his landscape paintings, on a video monitor or in personal photographs that are sometimes strewn around. On these occasions, Rondinone's persona presents itself as a quiet intrusion through which the artist obliquely takes his place in the landscape.

The relationship between the modern artist, art and the landscape as a site for melancholy reflection, is primary in Ugo Rondinone's work. His installations are landscapes within which he can express his separateness from the outer world, by creating indoor rooms which act as equivalents for real life. In these rooms couples talk in unresolved circular conversations and arguments, individuals soliloquise or droop languidly in a tired state of disinterest. Outdoors, landscapes, often depicted in series of photographs, describe the same lack of connection and communication between people. Precedents exist within recent art. In the 1970s British artists Gilbert & George began a practice that was predicated upon a melancholic vision of the world. They too worked to overcome the tragic boredom of daily existence and, between 1970 and 1974, made a series of large drawings collectively entitled *The Charcoal on Paper Sculptures.* In this phase of their work Gilbert & George depict the artist in the landscape, aestheticised, troubled but labouring to overcome life's bitter emptiness. Something of the same can be said of Rondinone's use of contrived landscape, which acts as a backdrop to the present-day life of the artist.

Rondinone was brought up in Switzerland, the son of Italian parents. He displays a distinctly Swiss sense of humour that emanates from a prosperous, well-settled generation which has not been disrupted by

war. Rondinone shares this somewhat bleak humour with his Swiss predecessors, artists Roman Signer and Fischli and Weiss. It is a humour that cannot really be described as funny, owing more to the tragic-comic than farce, and closer to Samuel Beckett's Lucky or Bruce Nauman's clowns. Beckett's metaphors about the inertia inherent in the authentic condition of life are on occasion alluded to by Rondinone, as a way of revealing in a succinct manner the essential elements of his own concerns and philosophical position. Nauman's work *Clown Torture,* 1987, in which traditionally made-up circus clowns are subjected to a range of raucously repetitive and humiliating experiences, accentuates the dual nature of their identity; entertainers for an audience that is looking for some kind of distraction from the existential void and is thus ironically forced into a complicit and uncomfortable relationship with the clown's discomfort. Although obviously staged, the clowns are regarded as outcasts from normality, doomed to appear and reappear in an inconclusive cycle of entertainment that can never be experienced as fun.

In Rondinone's installation *Where Do We Go From Here,* 1996, he has described his images of landscape and clowns brought together in one installation as follows:

A room within a room measuring 12 × 10 × 4.5 meters is placed in a corner. The two outside walls of the room are painted all around with a negative ink landscape. I walk in through the landscape and enter a long corridor illuminated with yellow neon light. The ceiling, walls, and floor are made of plywood panels. The unfinished panels of plywood have a conspicuous grain. The sound of breathing spills out from the room at the end of the corridor. The room is square and the ceiling, walls and floor are made of plywood panels. A large video image measuring 5 × 4 meters is projected onto each wall. Each video shows a clown against a white background. The silent videos were filmed with a stationary camera. Their reflection of the bright white immerses the room and the psychedelic grain of the plywood panels is clearly visible. The clowns are all sitting or lying and seem to be sleeping with their eyes open, occasionally they change their position. The sound of breathing fills the entire space.[1]

The clowns have the aura of jesters temporarily freed from their duty to cheerily amuse. It is as if Nauman's clowns had been released by Rondinone from the turmoil they have been subjected to and are now able to doze and snore, slumped in dreams. And so it is with Rondinone's clown mannequins who, in *If There Were Anywhere but Desert,* 2001, exist in the same psychic space as Rondinones' reproduction of himself blankly contemplating nothing in *Heyday.* The artist and the clown, both entertainers, are leading double lives in which reality is always a hand's breadth away from the grasp.

The examples of Gilbert & George, Roman Signer, Fischli and Weiss and Bruce Nauman remind us that Rondinone's work is full of art-historical references and, for those who are involved in art in a serious way, his pieces are redolent with the complexities of modern art. Rondinone understands that all media have a history and his constant excavation of art-historical models, as well as imagery from recent popular culture, repeatedly creates something that is reminiscent of something else. His early drawings, for example, evoke the French Situationists' use of cartoons as a popular tool. Kitsch rainbows proclaiming the titles of his exhibitions as poetic slogans like *Kiss Tomorrow Goodbye*; *Where Do We Go From Here?* or *Guided By Voices* belong to the psychedelic era; while androgynous pop imagery conflated with fashion photography

hearkens back to David Bowie's *Aladdin Sane* and London's Biba Boutique in the 1970s. High and low culture merge and jostle for attention with Ronald Bladen's seminal minimal sculpture *X,* 1967, or with colourfield painting. In Rondinone's enriched spectacle of visual culture he makes his own contexts for these simulations, taking his references to unremitting extremes. The interminable weight of modern visual culture conjoins with Rondinone's particular mentality to make a language that is capable of expressing the connotations of beauty and boredom.

Although Rondinone's works (most specifically his rainbow sculptures) can exist outside the gallery, he is masterful within its walls. There he makes his mental landscapes palpable, in sequences of rooms that represent the indoor and the outdoor as metaphors for our inner and outer worlds. Rondinone's landscape paintings always prominently feature trees, which also play a central part in his indoor landscapes. Outdoor rooms may contain polyester casts of old olive trees, sometimes bound in black or brown tape, on other occasions cast in white. The trees are festooned with wiring and small black speakers from which voices and music emanate. The voices read texts from Rondinone's books or speak dialogues that he has written and had performed specifically for the room setting. So from the wooded landscapes people emerge. In other rooms Rondinone will hang framed colour photographs of a woman wandering aimlessly through a forest in winter. There are speakers here too; from them comes a man's voice and the sound of slow guitar music. In another photographic series titled *Sleep,* 1999, figures of a man and woman are seen circling in separate photographs on a lonely windswept beach. In an endless exchange their voices are transmitted through accompanying speakers, wandering from speaker to speaker around the room. Windows look out from Rondinone's indoor rooms. His Plexiglas window sequence *All Moments Stop Here And Together We Become Every Memory There Has Ever Been,* 2002, consists of fourteen windows each bearing one word from the title. As the sequence develops, the frames and windowpanes alternate in colour. Some are transparent, others opaque. Sometimes Rondinone's indoors and outdoors upturn their separate states and become one. Cascading rain buckets down in the form of diagonal lines of silver chain dividing the inner from the outer, trees grow indoors, windows too dark to see through act as mirrors whose reflective surfaces look back inside rather than out. It makes no difference; there is nothing to be seen through them. Indoor rooms contain intricate modular structures that stand above head height and wend throughout the gallery space. They owe something to Minimalism but their seriousness is confounded by the image of a little cartoon bird perched at the foot of each column, carrying out his daily chores. Each upright module contains a speaker from which the audience can listen to the voice or voices of those disconnected from functional relationships, as the circular discourse loops in an unresolved incommunicative process.

The inevitability of failure to communicate is illustrated clearly in Rondinone's major video installation from 2003, *Roundelay.* Installed in a huge sculptural construction, this room is entered as if walking into the heart of a giant work by Richard Serra. Once inside, the homely, musty smell of Hessian that lines the walls pervades the room. On each of the six walls a large projection is played out accompanied by a sound track composed by Philip Glass. This time the landscape has shed its romantic Arcadian identity to become urban. *Roundelay* is played out in the city, along the passages and walkways of a public housing estate. Walking incessantly, a young man strides out down passageway after passageway. On adjacent screens a young woman does the same. They walk and walk but are destined never to meet. Whether or not they are seeking or pursuing each other or trying to escape, the audience will never know. When shown separately on a bank of monitors, *Roundelay*

1 *No How On,* exhibition catalogue, Kunsthalle Wien, June 28 – September 22, 2002, ed. Gerald Matt.

reveals a beauty that is not apparent in its projected form. A wonderful kaleidoscope of images turns and turns in the most beautiful combinations of rhythm and colour. Beauty once again redeems the plight of human isolation.

Rondinone's symbols owe something to the pagan, to an animism inherent in the consciousness of nature, in trees, mountains, the sky, and the sea. His ancient olive trees whisper in oracular voices, guiding us or leading us astray. In the Whitechapel Gallery his modular structures are surrounded by masks that look down upon us, large, black, grotesque. They are reminiscent of tribal societies in far off places, geographically remote or lodged deep inside our dreams. More specifically these masks are based on those of the Yup'ik Eskimos, an indigenous Alaskan tribe. They were collected by the Surrealists, whose interest in them stemmed from the incongruity of their imagery, such as a walrus combined with a caribou. When creatures of the land and sea were traditionally separated in everyday life, the Yuk'ip combined them, uniting opposites that symbolically play opposing or complimentary roles. In the hands of Rondinone, for whom duality and the playful aspects of binary opposites are fundamental, these masks represent aspects of a personal zodiacal calendar – gorilla man in July, goat head man for January, moon head in June and so on. They create a totemic encounter with forces that are removed from the modern traits of existentialism and place us in the realm of the occult. A huge light-bulb hangs from the gallery ceiling but fails to illuminate the scene. Paper snow falls on the indoor landscape. The setting is reminiscent of a pagan temple as the convoluted structure wends its way towards the back of the room. Here a rear chamber is divided from the main gallery, curtained off by jute drapes bearing the image of a huge '0'. Is this the zero of nothingness or the circle of everything? The audience can part the drapes and slip between the centre of the '0' into an inner sanctum. The territory that Rondinone's landscape occupies has shifted to a darker realm.

Being a Box Man – Ugo Rondinone's Existential Quest

Alison Gingeras

'Just making the box is simple enough […] However, it requires considerable courage to put the box on, over your head, and get to be a box man. Anyway, as soon as anyone gets into this simple, unprepossessing cubicle and goes out into the streets, he turns into an apparition that is neither man nor box.' – Kobo Abe, *The Box Man,* 1973, p. 7.

Ugo Rondinone is a box man. While Rondinone does not literally inhabit a cardboard box like the titular protagonist of Kobo Abe's existential novel, the artist has a great deal in common with this curious, allegorical character. A nameless man who, without any apparent reason, decides to forfeit his own identity, the box man trades in the accoutrements of a 'normal' life for itinerant existence on the streets of Tokyo. As the box man's story unfolds and the reader gains access to his state of mind, it becomes apparent that the box man is in search of a formal solution to an existential problem. Its simple architecture notwithstanding, the box has been transformed into a sophisticated tool: it mediates his search for purpose in life; it acts as (an albeit precarious) filter for the outside world; it is also a doorway into another, self-created reality. Like Kobo Abe's box man, Rondinone – in grappling with his own state of being – toils to invent adequate forms and tools to express his existential quest.

Despite the heterogeneous appearance of Rondinone's *œuvre*, there is a unifying thread of melancholia, self-referentiality and devotional ritual that unites seemingly disparate styles and media. Like the box man, Rondinone imposes a similarly radical set of life conditions upon himself from which he derives a distinct and complex artistic language. Solitary and replete with an air of hermeticism, Rondinone seems to conceptualise his studio practice not as a retreat, but as a confined mental space where he can distil his existential state of being into a complex, disparate range of forms, experiences, sounds and images. It is as if the creation of each body of work – whether taking the shape of drawings of an empty forest landscape, cryptic, totemic masks, or a visually vibrating, abstract painting – is comparable to the act of placing a box over the artist's head. Extrapolating from Abe's fictive psychological study, it is possible to glean some clues that could be used to (at least partially) penetrate Rondinone's existential, box-like work.

Loner-ism

'But for some reason there is absolutely no relationship to being a social dropout. Not once does he feel guilty about the box. I personally feel that a box, far from being a dead end, is an entrance to another world.' Kobo Abe, *The Box Man,* p. 18.

A box man is essentially a loner. The donning of a box provides a simple, yet radical means of creating distance between the self and normative society. The box becomes a marker; it provides an affirmation of difference. In a similar way that Abe's personage uses his box to both set himself apart and paradoxically mark his 'special' status, Rondinone has found a way to translate his own loner-ism into a number of theatrical personas that episodically appear in his art. The clown – with its obvious evocation of absurdity, aloofness, and exaggerated masquerade – has served as a primary alter ego for Rondinone. Refusing to entertain, Rondinone's jaded clowns lounge around the gallery (whether in a moving image or in sculptural form), indulging in the monotony of everyday existence. While his clown guise is intentionally imbued with references to popular culture and art history – in contrast to the stark, anti-visuality of a plain cardboard box – it nonetheless provides an ideal vehicle for the introverted journey towards self-isolation.

More recently, Rondinone has turned to the animal kingdom to find a new 'container' for his furtive persona. *Corvus corax,* otherwise known as a raven, is recognised for its fiercely solitary character, its stealthy sense of vanity, as well as for its cleverness. Unlike the flamboyant presence of the clown, the raven is a more quiet stand-in for the artist. Etched almost like a tattoo at the base of a series of minimalist, portico-like sculptures titled *All Those Doors*, 2003, it functions as a voyeur glaring at the viewer as he passes through these open cubes. The raven's silent observation from the bottom of these structures seems analogous to the box man's gaze, emanating from a rectangular slit cut out of the façade of his cardboard shell. Both figures provoke an uneasy self-consciousness in those observed – simultaneously goading the viewed subject to confront their own solitude and to question where they are walking: Is this post-and-lintel labyrinth a gateway to nowhere? Or does it serve as the threshold to another, more interior world?

Time and ritual

'One is absolutely never bored, for the background goes by swiftly; but the foreground goes at a snail's pace, and the center things are perfectly still. Anyway, it's the fake box man who's bored in his box.' Kobo Abe, *The Box Man,* p. 149.

Time is an essential element for Ugo Rondinone. Mirroring the box man's own observation – 'paralysis of the sense of time is one of the chronic ailments of a box man' (p. 23) – the artist often creates works that heighten the viewer's awareness of the pace in which time passes. In a video installation entitled *Roundelay,* 2003, Rondinone orchestrated a double projection showing images of a man and a woman aimlessly traversing an anonymous urban landscape in an endless loop. While the banality of the action and the mundaneness of the backdrop suggest the repetition and alienation of everyday life, the images also conjure the kind of suspended time that one experiences in dreams or mnemonic reverie. In a more allegorical sculpture, *Thank You Silence,* 2005, Rondinone suspends a box from the ceiling from which artificial flakes of snow slowly drift onto the gallery floor. This technologically lo-fi, yet surprisingly atmospheric 'snow machine' seems designed to generate a chain of associations, drawing the viewer into an extended moment inbetween nostalgia and memory.

Duration is also an essential component of Rondinone's practice. Various ongoing bodies of work – such as his landscape drawings, target paintings, and more recently, his series of totemic masks – are subjected to a ritualised time of production. Likening his practice to a series of devotional rituals, Rondinone stretches the production of his work in such a way that he makes at least one example of each 'typology' of work per year. Take for example his out of focus, Kenneth Noland-meets-mandala paintings. Each one is self-referentially titled according to the date of their creation (e. g. *Octobereighteenthnineteenhundredninetysix,* 1996), not only as a commemoration of the actual moment of the object's making, but as a means to compel the viewer to reflect upon the temporal context and ritual nature of the act of creation. Similarly, Rondinone's recent series of mask-like sculptures entitled *Moonrise* is ritually stretched out over an entire year. Produced at a rhythm of one for each month of the year, the features of twelve oversized masks seem to be derived from abstracting human and animal facial features. Hung along the perimeter of the gallery, these impenetrable countenances mutely stare at the viewer, revealing nothing about their identity or possible use. Associated with the performance of sacred rites or celebrations, Rondinone's masks – like the box man's box – are also meditative devices that bid the wearer to suppress their boredom and sentiment of alienation, and transform their contemplation of the cadence of passing time into an existential exercise.

Talking to oneself

In reading Kobo Abe's novel, the reader wonders if the box man (who speaks in the first person) is recounting his story to an audience, or if he is talking to himself in the style of a rambling, obsessive monologue. A corresponding sense of incertitude persists in terms of voices that 'speak' through Rondinone's work. The existential musings and melancholic ambiance that runs throughout his *œuvre* often seems too introverted to be taken as an external dialogue. In numerous works, Rondinone includes soundtracks that feature circular conversations between a man and woman, spoken against a backdrop of repetitive, minimalist music. These inconclusive, irresolvable exchanges[1] are allegories of internal discordance:

> The Man: 'What do you want?'
> The Woman: 'What do I want?'
> The Man: 'Yes, what do you want?'
> The Woman: 'I don't want anything.'
> The Man: 'Really?'
> The Woman: 'Yes, really.'
> The Man: 'Why?'
> The Woman: 'Why what?'
> The Man: 'Why don't you want anything?'
> The Woman: 'Because I don't think anything is gonna help'

Spoken by anonymous archetypes, these sound pieces are the manifestation of Rondinone's futile struggle to reclaim meaning where there is nothing but meaninglessness.

Like the box man – who talks to himself as a means to grapple with his own alienation and lack of direction – Rondinone creates a multifarious landscape of forms and experiences as a means to challenge his own sense of isolation and longing. By adopting a box-man-like existence, Rondinone not only confronts his own existential dilemma but also creates an opportunity for the viewer to be engulfed by the same kind of introverted, self-examination. More than describing their own internal journeys, these box men more importantly provide the impetus for the viewer to muster the courage to put a box over their own heads.

1 Taken from *A Horse with No Name*, sound installation at Matthew Marks Gallery, New York, 2002.

Gravity's Rainbow – On Ugo Rondinone

Gilda Williams

'A screaming across the sky' reads the first line of Thomas Pynchon's sprawling, encyclopaedic 1973 novel *Gravity's Rainbow.* In its first chapter alone we find: technical details of a V-2 rocket; a Porky Pig cartoon; two real fish behaving like the one-up/one-down fishes in the astrological symbol Pisces; and a smouldering romance. From an introduction to *Gravity's Rainbow* we read:

> To attempt to create a summary of such a work is to embark upon the fabrication of a catalogue of Linnean proportions, a delineation of the bewildering flora and fauna which populate that distinct global topography we call the [...] *œuvre.* But attempt it we must.

In the same spirit of determination and marvel, 'attempt we must' a summary of the work of Ugo Rondinone, the Swiss artist and poet now based in New York, whose art presents a similar confounding admixture. Since the early 1990s Rondinone's work has taken many forms: cross-gendered, fashion-photograph self-portraits; large, colourful, hallucinatory 'target' paintings; Arcadian forests rendered in the manner of 18th-century engravings, enlarged to billboard size; hyperreal effigies of the artist himself or of clowns, slumped against gallery walls; videos, sound installations, rubber masks, photo-based, gallery-sized constructions. Confused? Perhaps you have seen some of Rondinone's large, rainbow-like illuminated signs arching over the cities of Europe, with their reassuring messages calling out in the night sky: 'Dog Days Are Over', 'Guided by Voices', 'Love Invents Us' and 'Hell, Yes!'. Pynchon's term 'gravity's rainbow' referred to the semi-circular path produced by a rocket; once launched it momentarily travels straight upwards, then succumbs to gravity and follows a parabolic trail, inescapably nose-diving back to earth. Ugo Rondinone's work follows a similar trajectory, ever-changing, hovering between the vertical and horizontal like a lonely, sometimes desperate and sometimes ironic screaming against the sky.

In many of Rondinone's early installations, the artist depicts himself alone, physically exhausted and idle, oblivious to the sanctimony of the art gallery. In *Yesterday's Dancer,* 1998, the artist-effigy leans against a black wall, eyes closed as if emerging from a long and gruelling night of excess. He is wholly indifferent to our presence, semi-delirious, consumed by the darkness of his existence. In *Cry Me A River,* 1995, the same figure sits forlorn and pathetic, staring down at the empty floor and ignoring the large picture window beside him, occupying the gallery more like a squatter than an invited guest (*Heyday*). Finally, in *Bonjour Tristesse,* 1997, he's lying flat-out, like a teenager lost in the lonely pleasure of his music-filled bedroom. Is he asleep? Anaesthetised? Maybe he's passed out drunk? How embarrassing! Why, this artist is obviously in no fit state to contemplate – much less create – works of art. Art theory has taught us that the very act of beholding art, of human 'contemplation, wonder, scientific enquiry, disinterededness, aesthetic pleasure'[1] requires that we occupy an attentive, standing position, eyes wide open. For centuries, the very condition of experiencing art – observing a painted picture hung on the wall, or walking around an object of sculpture raised on a pedestal – required that we assume our distinctly human, vertical posture. As Rosalind Krauss has identified in *Informe,* art has conventionally been a 'function of the upright posture', well distinct from an animal-like, 'base' position closer to the ground: the horizontal 'expanded field' where so much contemporary art takes place.

Indeed much of Rondinone's art is literally knocked off the pedestal, on the floor, shed of any lofty dignity – like *Heyday's* figure slumped on the ground. Spilled black ink spreads outwards in messy puddles (*if,* 1993). Photos and sheets of paper lie scattered about, like so much litter (*House of Dust,* 1994 and *Pastime,* 1992). In *Thank You Silence,* 2005, bits of white paper flutter briefly overhead before floating to the ground in a snowy heap. Clownish, overweight figures lie in shameless abandon on the parquet floor (*Now How On,* 2002). In *Moonlighting,* 1999 – his black-on-black, fetish-like photographs – leather-clad, faceless figures creep on all fours in the semi-darkness, barely human. This persistent horizontality has been noticed before; critic Francesco Bonami observed that the 'latent reality of Rondinone's vision [is] the desire to fall'.[2] In *Heyday,* the sitting (horizontal) figure/self-portrait is contrasted with a vast (vertical) picture window opening onto the street, as if inverting the postures associated with the art experience. The condition of art-viewing (here represented by the sculpture, and the artist himself) occupies a horizontal plane, sitting inattentively and dishevelled on the floor; while the 'art-object' is the unmediated, non-art reality outside, the framed window 'hung' on the wall's vertical plane. In the sound installation *Sleep*, 1999, photographs of a man and of a woman, each alone and wandering along a beach, are hung on a wooden, slatted wall. This wall is hardly solid: light shines right through it, and we can see the flimsy, tilted wooden support behind its precarious construction. Meanwhile, the humans depicted appear to sleepwalk through the experience: the frailty of art's dependency on the vertical, via the gallery wall itself, and of the vigilant upright *homo sapiens* are both equally laid bare.

In Rondinone's photographic series *I Don't Live Here Anymore,* the artist's face is seamlessly overlaid (through the miracles of computer technology) on the body of a female fashion model. Particularly in an early red-tinted series of these (made in 1997), the figure is never upright: crouching, cross-legged or kneeling, s/he is as much half-human/half animal as half-male/half-female. In a 1998 sequence in the same series, the mustachioed 'model' masquerades as some kind of chic butcher, holding the formless, 'base' meat in his/her hand. Elsewhere, more blood-red meat slumps shapelessly on the cutting board. Transvestite portraits have long permeated the photographic performances of 20th-century artists, from Marcel Duchamp to Claude Cahun to Andy Warhol, to the androgynous self-portraits of fellow Swiss Urs Lüthi in the 1970s. In Rondinone's work, however, this cross-gendered content is enhanced by the artist's borrowing from the vast lexicon of awkward, uncomfortable fashion poses – sitting upright on one's knees with a hand holding an extended high-heel; extreme *contrapposto* with hips jutting straight out; or a full-frontal pose with face and gaze turned away from the camera in an extreme neck-twist (1998). In their uncomfortable and deliberate posing, Rondinone makes us aware of the manipulation of these passive (female) bodies, heightened by the contrast with the active (male) face. Finally, in a black-and-white image from 1998, the bare-breasted female figure only becomes vertical by being literally hung from a hook on the ceiling: strung up like meat or dangling like a puppet – a suggestion reinforced by her impossibly skinny, doll-like legs. This violently upright posture at once contradicts and reinforces her passivity: she is erect, yes, but never grounded, swinging hopelessly like a living pendulum.

There is often in Rondinone's work this contrast between the animate and the inanimate, artifice and nature. In *Grand Central Station,* 1999, the canned, recorded sound of two lovers' rambling and conflicted dialogue emanates from speakers hung from a pair of real trees. These are leafless, lifeless things, wrapped in black tape as if bandaged – like a post-apocalyptic orchard bearing mechanical fruit. Similarly, the figures strolling along an unspoiled (natural) beach in *Sleep* are idealised and rendered unreal, like the 'perfect' (artificial) people of a fashion shoot or a perfume ad. In *Heyday,* the stiff artifice of the unmoving body

1 Krauss, Rosalind, 'Gestalt', in Krauss and Yve-Alain Bois, *Formless A User's Guide,* (New York: Zone Books), 1997, p. 90–91.

2 Bonami, Francesco, 'Ugo Rondinone: Grounding', *Parkett* 52, May 1998, Zurich, p. 108.

and the electric light of the gallery are contrasted with the movement and daylight of the 'real' world outside. An Arcadian wood is rendered in wholly unnatural, engraving-like images (*House of Leaves*, 1994, and similar). These are actually drawn from the artist's outdoor walks – 'unnatural' artefacts of his encounter with 'real' nature. Both nature and artificiality occupy a seamless world of 'Dream and Dramas', a phrase used in another of his rainbow signs: 'real' and 'unreal' are equally illusory, determined only by the way they are shaped by artists and poets in words and images.

As in *Sleep* and *Heyday*, figures are always alone in Rondinone's work: alone in the forest, alone in the fashion template, alone in the gallery. Isolated figures occupy vast wall-sized screens (*It's Late and the Wind Carries a Faint Sound ...,* 1999).[3] A man and, separately, a woman walk through a city (*Roundelay*, 2003). As with the isolated figures in the paintings of another 'romantic', Caspar David Friedrich, these lone figures are confronted with a beautiful yet potentially hostile setting. Perhaps Rondinone's most emblematic image of isolated figures occupying the 'base horizontal plane', are the clowns from *Where Do We Go From Here?*, 1996. Here the viewer is first led inside a giant plywood box/isolation chamber, then confronted by four wall-sized video projections of potbellied clowns lying lazily, provocatively on the floor. Are we being confronted with our own or the artist's 'pathetic indolence' – in making or receiving art, perhaps in responding effectively to the changing world around us? The strong verticality of the screens is contrasted with the reclining figures, which are behaving in no way as a clown should – that is, performing the 'stand-up' comedy act of a circus entertainer. This is a clown who landed on his bottom some time ago in a routine pratfall, and decided rebelliously to stay there forever, refusing to come up again for another laugh. (In the same way Rondinone also pointedly refuses to fulfil a few of the artist's traditional jobs, such as establishing a recognizable aesthetic 'style', or rendering our world more comprehensible to us.) This grounded clown is a foil to Italo Calvino's character Cosimo in the novel *The Baron in the Trees*, 1957, a young 18th-century nobleman who defies convention by literally climbing the family tree one evening never again to return down, wandering the earth forever – in defiance – from tree to tree. He too, in refusing the constrictions of human social behaviour, chooses never to walk upright again.

On one screen from *Where Do We Go From Here?* we see a clown asleep. Certainly this is not the first time that we, ever-patient art lovers, have been asked to watch a nearly motionless human sleep: Andy Warhol's 1963 masterpiece, also titled *Sleep*, fixed its 8-hour gaze (a more or less unmanned camera) upon a sleeping man. Whereas in Warhol's version the subject is seductive, in a state of 'natural' sleep, Rondinone's clown is wholly unerotic, performing sleep. A clown appeals at best only to children but here is rendered altogether grotesque, dehumanised behind garish make-up that includes more Rondinonesque striped rainbows in painted arches on his eyelids. Warhol is a recurring referent in Rondinone's work. *Heyday*, for example, with its picture window framing an ordinary street scene, requires that we do exactly what *Sleep* or *Empire*, among other Warhol films, had asked us to do: watch at length a real-time non-event – the unmoving Empire State Building, say – and thus glimpse the unmediated, unseen beauty of the world around us. With Warhol's eventless films as their precedent, Rondinone's gel-tinted windows literally behave like filmscreens. Moreover, like Warhol, Rondinone accumulates artefacts of uninflected reality – the

debris of everyday life – collected compulsively and unjudgmentally. In *Days Between Stations* (1993 – ongoing), Rondinone presents over 900 silent, 60-minute videos of his everyday life, just as Warhol had relentlessly taped or filmed everything around him. Rondinone's videos are kept boxed, exhibited on inclined shelves alongside a vast sequence of equally uneventful photographs. Like Warhol's analogous *Time Capsules* – identical cardboard boxes replete with the formlessness of life, from restaurant napkins to ticket stubs – Rondinone's obsessive accumulation is stacked in a highly orderly fashion. He imposes the illusion of vertical (human) order on the sprawling randomness of the everyday in an obsessive, grid-like archive of time and space.

Such contradictions – between order/disorder, form/formlessness, male/female, vertical/horizontal – are the recurring strains in Rondinone's otherwise disjointed work. For example, in drawings and text paintings such as *Lines Out to Silence,* 2005, written words are hung on the wall. Just as the human body in Rondinone's work refuses its 'proper' erect position, the text – usually belonging to the flat plane of a book – is forced upward to attach to a wall. Similarly, sound – usually formless and occupying space weightlessly – is given substance through its technological embodiment, speakers, in such works as the poetically titled *I Never Sleep. I've Never Slept At All. I've Never Had a Dream. All of That Could Be True*, 1999.

In an art-world family tree, Warhol and Rondinone would be distant cousins genealogically linked through the poet John Giorno. Briefly Warhol's lover, young Giorno was the isolated dreamer filmed in *Sleep;* Giorno also, on occasion, works with Ugo Rondinone today. One of Rondinone's carnivalesque signs, *Everyone Gets Lighter,* is taken from the title of a Giorno poem (Carnegie International, 2004). And, for his 2002 exhibition at Sadie Coles HQ, London, *cigarettesandwich,* Giorno recited at the opening his poem *there was a bad tree*. Often Rondinone – a poet himself – draws poets and poetry into his art this way. The title *I don't live here anymore* paraphrases a line borrowed from a poem by Baudelaire, 'Anywhere Out of the World' (1857): *'I think that I will be there where I am not'*. In fact, probably the best way to approach Rondinone's potentially baffling art is as you would a body of poetry: accepting the contrast between precision (the precise selection of words for a poet, the accuracy of form in Rondinone's art) with the vague, ethereal quality of the subject matter – broad themes such as equilibrium, isolation, hyperreality.

Another 'romantic' artist/poet who comes to mind is William Blake. Like Rondinone, he approached the turn of another century, 200 years ago, with a mix of curiosity and apprehension. They share such common themes as decaying love, dreams, arcadia and myth, seamlessly combining text and image. (Note the extreme attention that Rondinone always pays to his wordy, enigmatic titles, like the series of twenty-four light bulb sculptures entitled *First Hour of the Poem, Second Hour of the Poem,* and so forth.) Blake too was 'guided by voices', a visionary artist unique in the artistic climate of his day. Like Blake, Rondinone evokes an entire universe of his own fabrication, which responds to the complexity of his times and yet feels in touch with some existential pre-history. Both artist/poets are interested in great cycles of time and image, alluding to a distant, primal moment: Rondinone's cycle of primitivist masks, for instance, relate to the signs of the zodiac, under the title of 'Moonrise' (*Moonrise. West. January; Moonrise. West. February,* etc.). The image of a sleeping figure beneath an arching, celestial form above recurs in both Blake and Rondinone; compare Rondinone's installation of the round painting *No. 281 Siebenundzwanzigstermaizweitausendundzwei* swirling above the unmoving caveman/clown on the floor in *No How On,* 2002, with, among others, Blake's *Death of the Virgin Mary*, 1803. For both, the passive, sleeping figure is a cipher suggesting a vast, protective universe in flux, watching over an inert subject –

3 Full title: *It's late and the wind carries a faint sound as it moves through the trees. It could be anything. The jingling of little bells perhaps, or the tiny flickering out of tiny lives. I stroll down the sidewalk and close my eyes and open them and wait for my mind to go perfectly blank. Like a room no one has ever entered, a room without doors or windows. A place where nothing happens.* This is also the text on one of Rondinone's vast nylon flags titled *It's Late*, 1999.

the artist himself? Both combine a strange mix of melancholy and escapism, stretching beyond the concerns of the everyday and yet mired within it, tirelessly navigating unfamiliar worlds of their own making.

Pynchon, Warhol, Blake: a mixture of this motley crew of heretofore unrelated talents would, perhaps, yield an artistic temperament not unlike Rondinone's. We would have to add some peculiar quality of 'Swissness', defined by the late Harald Szeemann as 'a series of conditions that favour a loner's attitude'; [4] and Rondinone's peculiar, perverse pleasure in occupying this lonely universe on his own. 'In Rondinone's hyperreal world', writes critic Meghan Dailey, 'life is a melancholy path of futile searches and broken hearts on a rotting planet'. [5] In *Gravity's Rainbow,* Pynchon tells of a character named Nora, who 'has turned her face more than once to the Outer Radiance, and simply seen nothing there'. [6] At the heart of Ugo Rondinone's work there is this same kind of emptiness, this same void – whether the '0' we walk through to experience the 'empty', sound-filled space of *I'm Worried,* 2006, or the blank centre of his many target paintings, all pointing to what Rondinone has called the 'zero condition of the work'.

Recently, the art of this 'loner' seems intent on raising itself off the ground, so to speak, as if moving upwards – at times tentatively, at others in great bursts. In his 2001 installation *If There Were Anywhere but the Desert,* his recurring sleeping clown lies not beneath the pulsating skies of a round painting, but under a mirrored wall, criss-crossed by innumerable fragmenting lines, as if about to shatter. The wall may have been raised to the vertical, but is still on the verge of violent collapse. Other installations have grown (literally) more bold and erect: the heavy slanting walls in *Ultramarine,* 2000, and the giant, solid 'X' in *Lessness,* 2003, are inclined but stable, fixed between horizontal and vertical. Finally, occupying gallery installations since 2003 is a pylon-like black 'forest' called *All Those Doors,* a monumental *enfilade* that stands bolt upright, filling the space like the real forest of his photographic work *In the Sweet Years Remaining*, 1998. As Rondinone's work has lifted itself up, it seems to have grown more abstract: the standing position remains unavailable to the human figure, who at best is reflected ghost-like in its polished surface, and is constructed instead from inanimate minimalist forms. In Rondinone's recent installation also titled *Gravity's Rainbow,* 2004, Pynchon's rocket trail shoots straight up – its beam never returning to earth. The streaming colours pulsate ever upwards, as if the unseen vessel above is still sailing overheard – still climbing, still lonely, still screaming.

Alison Gingeras is a writer and Adjunct Curator at the Guggenheim Museum and was previously curator for contemporary art at the Centre Pompidou, Paris, from 1999–2004. She is a regular contributor to *Artforum, Tate Etc.* and *Parkett.*

David Thorp is a freelance curator and was formerly curator of Henry Moore Contemporary Projects from 2001–2004. He was active in the development of the contemporary art scene in East London and was Director of Chisenhale Gallery, London, and then Director of South London Gallery, 1992–2001.

Gilda Williams is a Lecturer in contemporary art at the Sotheby's Institute of Art, London. From 1994–2005 she was Editor and Commissioning Editor for Contemporary Art at Phaidon Press, and she is a regular contributor to *Tate Etc., Art Monthly* and *Parkett.*

4 Szeemann, Harald, *Visionäre Schweiz* (Visionary Switzerland), Kunsthaus Zurich, 1991, p. 7, as quoted in Daniel Kurjakovic, 'New Swiss Art', *Flash Art International,* no. 165, Summer 1992, p. 94.
5 Dailey, Meghan, 'Ugo Rondinone, Matthew Marks Gallery/Swiss Institute', *Artforum,* Summer 2002, p. 175.
6 Pynchon, Thomas, *Gravity's Rainbow* (New York: Picador), 1973, p. 150.

Biography & Bibliography

1964
Born in Brunnen, Switzerland.
Lives and works in New York.

1986–90
Studied Hochschule für Angewandte Kunst, Vienna.

SOLO EXHIBITIONS

2006
Galerie Almine Rech, Paris
Galerie Esther Schipper, Berlin
Ausstellungshalle zeitgenössische Kunst, Münster
Sadie Coles HQ, London, *my endless numbered days*
Whitechapel Gallery, London, *zero built a nest in my navel*

2005
ISR-Centro Culturale Svizzero di Milano, Milan, *clockwork for oracles*
Sommer Contemporary Art, Tel Aviv, *sunsetsunrise*

2004
Galleria Raucci/Santamaria, Naples, *sail me on a silver sun*
Matthew Marks Gallery, New York, *long gone sole*
Le Consortium, Dijon, *long nights short years*
Australian Centre for Contemporary Art, Melbourne, *clockwork for oracle*

2003
La Criée, Théâtre National de Bretagne, Galerie Art & Essai, Rennes
Galerie Hauser & Wirth & Presenhuber, Zurich, *moonrise*
Museum of Contemporary Art, Sydney, *our magic hour*
Galerie Almine Rech, Paris, *lessness*
Musée National d'Art Moderne, Centre Georges Pompidou, Paris, *roundelay*

2002
Centre for Contemporary Visual Arts, Brighton, *our magic hour*
Wurttembergischer Kunstverein Stuttgart, Stuttgart, *coming up for air*
Works on paper inc., Los Angeles, *1988*
Sadie Coles HQ, London, *cigarettesandwich*
Galerie Krobath Wimmer, Vienna, *the dancer and the dance*
Kunsthalle Wien, Vienna, *no how on*
Matthew Marks Gallery, New York, *a horse with no name*

2001
Galerie Schipper & Krome, Berlin, *slow graffiti*
FRAC Paca, Marseille
Palazzo delle Esposizioni, Rome, *kiss tomorrow goodbye*
Sommer Contemporary Art, Tel Aviv, *yesterdays dancer*
Herzliya Museum of Art, Herzliya, *dreams and dramas*
Galerie Almine Rech, Paris, *if there were anywhere but desert*

2000
P.S.1, New York, *so much water so close to home*
Matthew Marks Gallery, New York, *love invents us*
Sadie Coles HQ, London, *hell, yes!*
Mont-Blanc Boutique, New York, *if there were anywhere but dessert*
Galleria Raucci/Santamaria, Naples, *a doubleday and a pastime*

1999
Galerie für zeitgenössische Kunst Leipzig, *guided by voices*
Kunsthaus Glarus, *guided by voices*
Galerie Hauser & Wirth & Presenhuber, Zurich, *moonlighting*
Yves Saint-Laurent, New York, *light of fallen stars*
Schipper & Krome, Berlin, *in the sweet years remaining*

1998
Galerie Almine Rech, Paris, *the evening passes like any other*
Galerie João Graçà 1991, Lisbon, *in the sweet years remaining*
Galerie Krobath Wimmer, Vienna, *so much water so close to home*

1997
Galleria Bonomo, Rome, *moonlight and aspirin*
Galleria Raucci/Santamaria, Naples, *stillsmoking*
Le Consortium, Dijon, *where do we go from here?*
Cato Jans Der Raum, Hamburg, *tender places come from nothing*

1996
Centre d'Art Contemporain, Geneva, *heyday*
Migros Museum für Gegenwartskunst, Zurich, *dog days are over*
Le Case d'Arte, Milan

1995
Galerie Walcheturm, Zurich, *cry me a river*
ARC – Musée d'Art Moderne de la Ville de Paris, *Migrateurs*
Galerie Froment-Putman, Paris, *meantime*

1994
Galerie Six Friedrich, Munich
Galerie Daniel Buchholz, Cologne
Galerie Ballgasse, Vienna, *lightyears*
Centre d'Art Contemporain de Martigny

1992
Galerie Walcheturm, Zurich, *pastime*

1991
Galerie Martina Detterer, Frankfurt, *far away trains passing by*
Galerie Pinx, Vienna, *two stones in my pocket*
Galerie Walcheturm, Zurich, *i'm a tree*

1989
Galerie Pinx, Vienna

1987
Raum für aktuelle Schweizer Kunst, Lucerne

1986
Sec 52, Ricco Bilger, Zurich

1985
Galerie Marlene Frei, Zurich

GROUP EXHIBITIONS

2006
Galleria Civica, Modena, *Egomania*

2005
Chiba City Museum of Art, Chiba, *Contemporary Swiss Art*
Andrea Rosen Gallery, New York, *Looking at Words – The Formal Presence of
Text In Modern and Contemporary Works on Paper*
Kunstsammlung im Ständehaus, Dusseldorf, *Ambiance*
Hotel Sezz, Paris, *Chambres à part*
Galerie Analix Forever, Geneva, *Fragile*
Musée Cantonal des Beaux-Arts, Lausanne, *Private View – Collection Pierre Huber*
2nd Prague Biennale
Bunkier Stzuki, Krakow, *Swiss Video*
Atelier Augarten, Vienna, *Das Neue II*
Museo Extremeno e Iberoamericano, Badajoz, *Coleccion Helga de Alvear*
Cobra Museum of Modern Art, Amsterdam, *Swiss Made (The Art Of Falling Apart)
Collection Hauser & Wirth*
Museum of Contemporary Art, Chicago, *Universal Experience: Art, Life and the
Tourist's Eye*
Hayward Gallery, London, *Universal Experience: Art, Life and the Tourist's Eye*
Fotomuseum Winterthur, *Der Traum Vom Ich. Der Traum Von Der Welt*
Kunst-Werke, Berlin, *Zur Vorstellung des Terrors: Die RAF*

2004
James Cohan Gallery, New York, *The realm of the senses*
Galerie Loevenbruck, Paris, *La piste noire*
Museum Löffler, Kosice
Carnegie Museum of Art, Pittsburgh, *Carnegie International*
Louisiana Museum of Modern Art, Humlebaek, *Works And Days*
Centre for contemporary art, Waregem, Belgium, *Schöner Wohnen*
Guggenheim Gruppe Österreich, Vienna, *Nothing has changed*
Fundament, Tilburg, *Lustwarande 04*
P.S.1, New York, *Hard Light*
Musée des Beaux-Arts du Canada, Ottawa, *La Grande Parade. Portrait de
l'artiste en clown*
Cheim & Read, New York, *I Am The Walrus*
Sprengel Museum Hannover, Hanover, *Ugo Rondinone/Les Krims*

Centre d'art de Neuchâtel, Neuchâtel, *Lasko – Wallpainting en Suisse*
Domaine Pommery, Reims, cur. by Stéphanie Moisdon Trembley, *Genesis Sculpture*
Biblioteca Luis Angel Arango, Bogota, *Eden*
Galerie Almine Rech, Paris, *Sculptures Show*
Grand Palais, Paris, *La Grande Parade. Portrait de l'artiste en clown*

2003
Musée Cantonal des Beaux-Arts, Lausanne, *Le monde selon François Dubois*
Matthew Marks Gallery, New York, *Sculpture*
7e Biennale d'Art Contemporain de Lyon
Stiftung Binz 39, Zurich
Kunstpanorama, Lucerne
Magazin4 Vorarlberger Kunstverein, Bregenzer Kunstverein, Bregenz, *Love*
Villa Arson, Nice, *Lee 3 Tau Ceti Central Armory Show*
Museum für neue Kunst/ZKM, Karlsruhe, *The DaimlerChrysler Collection*
Moph cafe, Tokyo, *Tapas e video: videos by BDV*
Galerie Mirko Mayer, Cologne, *story faces*
La Galerie du petit château, Sceaux, *Carosseries, automobiles, art, architectures*
Grey Art Gallery, New York, *Not Neutral: Contemporary Swiss Photography*
Collection Lambert, Avignon, cur. by Eric Troncy, *Coollustre*
Fundació Joan Miró, Barcelona, *Psychodrome 04*
Alcala 31, Madrid, *Urban Diaries. Young artists from Switzerland*
Galerie Hauser & Wirth & Presenhuber, Zurich, *Breathing the Water*
Kunsthalle Zürich, Zurich, *Durchzug/Draft*

2002
Contemporary Arts Center, Cincinnati, *Loop: Back to the Beginning*
New Museum of Contemporary Art, New York, *Art Publishers Zurich*
CRAC Alsace, Altkirch, *bienvenue willkommen welcome@altkirch*
Grimaldi Forum, Monaco, *Jour de cirque*
The Museum of Modern Art, New York, *Drawing Now: Eight Propositions*
Museum of Modern Art Queens, Long Island City, *Drawing Now: Eight Propositions*
Halle au Poisson, Perpignan, *Je t'aime ... moi non plus*
Städtische Galerie Villingen Schwenningen, *I don't live here anymore*
Palazzo delle Papesse Centro d'Arte Contemporanea, Siena, *De Gustibus. Collezione privata italiana*
La Criée, Centre d'art contemporain, Rennes, *Campy, Vampy, Tacky*
Hallescher Kunstverein, Halle, *I don't live here anymore*
Swiss Institute, New York, *Lowland Lullaby*
Neuer Berliner Kunstverein, Berlin, *Zeitgenössische Fotokunst aus der Schweiz*
Fondation Sandretto (Guarene), Turin, *Self/In Material Conscience*
Sammlung Hauser & Wirth, St. Gallen, *The House of Fiction*
Fürstenberg Sammlungen at Donaueschingen, *Ahead of the 21st Century. The Pisces Collection*

2001
Liverpool Biennale
Galerie Krobath Wimmer, Vienna
Matthew Marks Gallery, New York, *Tenth Anniversary Exhibition*
Printemps de Septembre, Toulouse, *Fantastique*
Kunsthalle der Hypokulturstiftung, Munich, *Loop – Alles auf Anfang*
Musée d'art moderne, Buenos Aires, *Mouvements immobiles*
Musée d'art moderne et contemporain de Strasbourg, *Salons de musique*
Musée de la photographie, Mougins, France, *Surface lisse*
Netherlands Institut voor Mediakunst, Amsterdam, *dai, dai, dai, where do we go from here?*
Galerie der Stadt Sindelfingen, *Fingerspitzengefühl – der menschliche Körper in der Gegenwartskunst*
The Irish Museum of Modern Art, Dublin
Musée des Beaux-Arts de Montréal, *Gestes*
DaimlerChrysler Contemporary, Berlin, *Sammlung DaimlerChrysler. Neuerwerbungen/New Acquisitions*
Miami Art Museum, *Let's entertain*
Kunstmuseum Wolfsburg, *Let's Entertain*

2000
Musée National d'Art Moderne, Centre Georges Pompidou, Paris, *Let's Entertain*
Neues Kunstmuseum Luzern, Lucerne, *Landschaftsräume*
Location One, New York, *Life after the Squirrel*
Kunstpanorama, Lucerne, *Face à Face*
Centro d'Arte Contemporanea Ticino, Bellinzona, *Heart*
Podewil, Berliner Kunstveranstaltungs, cur. by Klara Wallner, Berlin, *come in and find out, vol. 4*
Portland Art Museum, Portland, *Let's Entertain*
Musée d'art moderne et contemporain, Mamco, Geneva, *Le jeu des 7 familles*
Villa Arson, Nice, *Une mise en scène du réel: artiste/acteur*

Fondazione Michetti, Francavilla al Mare, cur. by Gianni Romano, *Premio Michetti*
P.S.1, New York, *Volume: Bed of Sound*
Sommer Contemporary Art, Tel Aviv
Musée d'art contemporain de Bordeaux, cur. by Stéphanie Moisdon Trembley, *Présumé innocent*
Stedelijk Museum voor Actuele Kunst, Ghent, *Over the Edges*
Bluecoat Chambers, Liverpool, *Video Positive 2000 – The Other Side of Zero*
Walker Art Center, Minneapolis, *Let's Entertain*
KIAD, Canterbury, *Mécaniste*
KIASMA, Helsinki, *Under the Same Sky*
Museum Dhondt-Dhaenens, cur. by Hilde Teerlinck, *Living In The Real World*
Kunstsammlung Nordrhein-Westfalen, Dusseldorf, *Ich ist etwas anderes*

1999
Saatchi Gallery, London, *Eurovision*
Musée d'Art Moderne de la Ville de Paris, *L'autre sommeil*
Musée d'art moderne et contemporain de Strasbourg, *Sans réserve 1*
6th International Istanbul Biennial, cur. by Paolo Colombo, *The Passion And The Wave*
Kunstmuseum Bern, cur. by Christoph Doswald, *Missing Link*
Galerie Krinzinger im Benger Park, Bregenz, *D A CH*
FRAC Poitou-Charentes, Angoulême, cur. by Philippe Régnier, *trans-sphère*
Lofoten Arts Festival, Svolvær, *Spillerom*
Palazzo delle Papesse, Siena, *Le Repubbliche dell'arte*
Museum van Hedendaagse Kunst, Antwerp, *Trouble Spot. Painting*
1st Melbourne International Biennial, *Signs Of Life*
NGBK, Berlin, *Rosa für Jungs/Hellblau für Mädchen*
Espace des Arts, Chalon-sur-Saône, *XN99*

1998
Centre Culturel Suisse, Paris, cur. by Nicolas Trembley, *Dog Days Are Over*
Emily Tsingou Gallery, London, *Time After Time*
Kunsthalle Zürich, Zurich, *Auf der Spur – Kunst der 90er Jahre im Spiegel von Schweizer Sammlungen*
Galerie für zeitgenössische Kunst Leipzig, cur. by Eric Troncy, *Weather Everything*
1st Berlin Biennial, cur. by Nancy Spector, Klaus Biesenbach, Hans-Ulrich Obrist, *Berlin/Berlin*
Palazzo del Capitano, Cesena, *Libera mente*
Matthew Marks Gallery, New York (with Joseph Grigely and Millie Wilson)
Holderbank, *Kunstausstellung Holderbank*
Stedelijk Museum, Amsterdam, *From the Corner of the Eye*
Akademie der Künste, Berlin, cur. by Christoph Doswald, *Nonchalance Revisted. Junge Schweizer Kunst*
Art Club Berlin as guest in the Mies van der Rohe Pavilion, Barcelona, *Grenzenlos*
Villa Merkel, Esslingen, *4. Internationale Foto-Triennale*
Frankfurter Kunstverein, Frankfurt, *Freie Sicht aufs Mittelmeer*
Kunsthaus Zürich, Zurich, *Freie Sicht aufs Mittelmeer*
Galerie Walcheturm, Zurich, *Don't Look Now*
Université de Rennes, *Homo Zappiens Zappiens*
Centre d'Art Contemporain, Geneva, *Aids Worlds Altered States*

1997
Migros Museum für Gegenwartskunst, Zurich, *Hip*
Kunsthaus, Brünn, *Foto Relations*
Galerie Almine Rech, Paris, *Rear window*
Villa Merkel, Esslingen, *Fort! Da! Cooperations*
The Swiss Institute, New York, *Disaster and Recovery*
Cato Jans, Der Raum, Hamburg, *Why don't we do it in the road*
Shed im Eisenwerk, Frauenfeld, cur. by Harm Lux, *Diskland snowscape*
Hochschule für Bildende Künste, Ausstellungsprojekt der Klasse Armleder Braunschweig, Germany, *504*
Festival Atlantico, Lisbon
Galleria Nazionale d'Arte Moderna e Contemporanea, Rome (with Jessica Diamond)
Centro d'Arte Contemporanea Ticino, Bellinzona, *Transit*
Talmuseum, Engelberg, *Landschaft heute*
Galerie der Stadt Schwaz im Palais Enzenberg, Schwaz, Austria, *Ruhm und Ehre*
Le Magasin, Centre National d'Art Contemporain, Grenoble, cur. by Eric Troncy, *Dramatically Different*

1996
Centre PasquArt, Biel, cur. by Christoph Doswald, *Nonchalance*
Biennale São Paulo, *Where do we go from here?*
Kunsthalle Zürich, Zurich, cur. by Lionel Bovier, *YoungART Zürich*
Centre d'Art Neuchâtel, Neuchâtel, *Non! Pas comme ca!*
ICA, Philadelphia, *Conversation Pieces II*
Galerie Arndt & Partner, Berlin, *The Agression of Beauty*

Interims Kunsthalle, Berlin, *Macht der Verführung*
Attitude, Fribourg, *Cabines de bain*
2. Österreich.Triennale zur Fotografie, Neue Galerie und Künstlerhaus, Graz, *Radikale Bilder*
Kunsthalle Szombathely, *Radikale Bilder*
Collège Marcel Duchamp, Châteauroux, *Modèles corrigés*

1995
Bunker 4th floor, Berlin, *Files*
Memory/Cage Edition, Zurich, *The Pleasure of Merely Circulating*
Centre d'Art Contemporain, Geneva, *Livres d'artistes*
Mitterheinmuseum, Koblenz, *Lanschaft mit dem Blick der 90er Jahre*
Museum Schlossburg a. d. Saale, Berlin, *Landschaft der 90er Jahre*
Haus am Waldsee, Berlin, *Landschaft der 90er Jahre*
Zypressenstrasse 71, Zurich, cur. by Harm Lux, *Fields*
Kunsthalle, Bremen, *Kunstpreis der Böttcherstrasse in Bremen*
Ecole cantonale d'art de Lausanne, cur. by Lionel Bovier, *Entrée en matière*
Helmhaus, Zurich, *Oh Pain! Oh Life!*
Galerie Peter Kilchmann, Zurich, *Private Welten*

1994
Forde, Geneva, cur. by Lionel Bovier & Christophe Cherix, *Snow Job*
Kunsthalle Palazzo, Liestal (with A. Schnider, F. Valloton)
Galerie Walcheturm, Zurich, cur. by Ugo Rondinone, *Passing Through*
Raum Strohal, Vienna, cur. by Peter Weibel, *Lokalzeit – Wiener Material im Spiegel des Unbehagens*
Kunsthaus, Zurich, *Endstation Sehnsucht*
Kunstverein München, Munich, *Oh boy, it's a girl!*
Messepalast Wien, Vienna, *Oh boy, it's a girl!*
Steirischer Herbst, Graz, cur. by Paolo Bianchi
Fotohof Salzburg, Salzburg, *Suspension*
Fotoforum, Innsbruck, *Suspension*
Galerie im Taxispalais, Innsbruck

1993
Galerie Six Friedrich, Munich, *Papierarbeiten & einige Skulpturen*
Shedhalle, Zurich, *Changing I*
Frankfurter Kunstverein, Frankfurt, *Prospect 93*
Centre d'Art Contemporain Martigny, *Hellbound*
Shop, Zurich, cur. by Michelle Nicol, *Serial*
Mucsarnok, Salamon Torony, Visegard, *Donau*
Kunsthalle Wien, Vienna, *Die Sprache der Kunst*

1992
Frankfurter Kunstverein, Frankfurt, *Die Sprache der Kunst*
Kunstmuseum Luzern, Lucerne (with U. Fischer, C. di Gallo)
Centre Culturel Suisse, Paris, cur. by Bice Curiger & Hans Ulrich Obrist, *Oh! Cet écho!*

1991
Galerie B. & L. Polla-Analix, Geneva, cur. by Gianni Romano, *20 Fragile Pieces*
Cham, *Chamer Räume*
Nassauischer Kunstverein, Wiesbaden, *Über dem Röstigraben*

1990
Shedhalle, Zurich, *Stillstand Switches*

1989
Kunstmuseum Luzern, Lucerne
Kunsthalle Winterthur, *Igitur*
Kunstmuseum Luzern, Lucerne, *Weihnachtsausstellung*

1988
Shedhalle, Zurich, *Spiel der Spur*

1987
Seedamm Kulturzentrum, Pfäffikon

1986
Galerie M2, Vevey

1985
Kunstmuseum Luzern, Lucerne, *Weihnachstausstellung*
Shedhalle, Zurich, *Junge Schweizer* (with U. Frei, D. Zimmermann)

PROJECTS

2005
Kunst und Bau, Wohnsiedlung Werdwies, Zurich-Altstetten
New residence of the Swiss Embassy, Washington

2004
Showcases, Louis Vuitton, worldwide
LVMH Headquarters, Avenue Montaigne, Paris
Dior Homme, Fitting rooms, New York

AWARDS AND GRANTS

1998/99
Werkjahr P.S.1, New York, Bundesamt für Kultur, Bern

1998
Schweizer Plakat des Jahres 1998: *Eidgenössische Preise für freie Kunst 1998*

1997/98
Werkjahr New York der Stadt Zürich

1995
Eidgenössicher Preis für Freie Kunst

1994
Eidgenössicher Preis für Freie Kunst

1993
Kiefer-Hablitzel Stipendium

1991
Eidgenössicher Preis für Freie Kunst
Kiefer-Hablitzel Stipendium
Kantonales Werkjahr

EDITIONS

2006
Whitechapel Gallery, London

2004
Edition 5, Erstfeld

2002
Graphische Sammlung ETH Zurich
Art Investor, Munich
Contemporary Magazine, London

2001
Frankfurter Kunstverein, Frankfurt

1999
Kunsthaus Glarus, Glarus

1998
Parkett, No. 52, Zurich

1997
Portfolio, Galerie Walcheturm and Galerie Hauser & Wirth 2, Zurich

1997
Kölnischer Kunstverein, Cologne

1996
Memory/Cage Edition, Zurich

1992
Kunstmuseum Luzern, Lucerne

1991
Galerie Walcheturm, Zurich

OWN PUBLICATIONS

2002
Gerald Matt, Gaby Hartel, Laura Hoptman, Pierre-André Lienhard, *Ugo Rondinone. No How On*, Kunsthalle Wien, Vienna, 2002

2000
Ugo Rondinone, *Hell, Yes!*, Ink Tree Edition, Küsnacht, 2000
Ugo Rondinone, Scipio Schneider, 'I don't live here anymore (Fashion Pages designed by Ugo Rondinone),' in: *Flash Art*, vol. 33, no. 214, October, 2000, p. 65–69

1999
Beatrix Ruf, Jan Avgikos, Jan Winkelmann, *Ugo Rondinone Guided By Voices*, Kunsthaus Glarus, Galerie für Zeitgenössiche Kunst, Leipzig, Cantz Verlag, 1999
Ugo Rondinone, *1992 1993 1994 1995 1998*, self-published, Zurich, 1999

1996
Daniel Kurjakovic, Vittorio Santoro, Paolo Colombo, Rein Wolfs, Michelle Nicol, Hans-Ulrich Obrist, Lionel Bovier, *Heyday*, Memory/Cage Editions, Zurich, 1996
Swiss Federal Office of Culture (ed.), Bice Curiger, Pierre-André Lienhard, Christoph Doswald, Philippe Rénier, *Where do we go from here?*, Lars Müller, Baden, 1996

SELECTED BIBLIOGRAPHY

2005
Universal Experience: Art, Life and the Tourist's Eye, Museum of Contemporary Art Chicago, Distributed Art Publishers, Inc. New York, 2005, p. 207
Uta Grosenick, *ART NOW Vol. 2 – The new dictionary to 136 international contemporary artists*, Taschen Verlag, 2005, p. 448–451
Anne Keller, Beatrix Ruf, Stefan Kalmar (eds.), *Art at 30 St Mary Axe London*, Swiss Re, Zurich 2005, p. 89–95
Arlène Bonnant (ed.), *CAP Collection 2005*, Geneva 2005, p. 240–245
Yves Aupetitallot (ed.), *Private View, 1980–2000. Collection Pierre Huber*, Musée cantonal des Beaux-Arts de Lausanne, JRP|Ringier, Zurich 2005, p. 156–159
Antonio Caronia, *techne 05 – Art And Technology. The Infinite Image. Screens, Visions, Actions*, Milan 2005, p. 93–95
Giancarlo Politi, *Prague Biennale 2*, Milan 2005, p. 140–141
'Prague Biennial,' in: *Flash Art*, no. 243, July–September, 2005, p. 139
'Recenze Plus,' in: *Art & Antiques*, June–August, 2005, p. 70
Sabine B. Vogel, 'Prager Doppel No. 1,' in: *artnet.de*, June 3, 2005
'Zeventien Zwitsers exposeren in Cobra,' in: *Amstelveens Nieuwsblad*, June 1, 2005, p. 24
'Two biennals, one fracas,' in: *The Prague Post*, June, 2005
'Tendances du marché,' in: *Le Journal des Arts*, no. 217, June, 2005, p. 14
Sabine B. Vogel, 'Battling Biennials in Prague,' in: *www.artnet.com/Magazine/ news/artnews2/artnews5-19-05.asp*, May, 2005
T. M., 'Swiss Made,' in: *Kunstbeeld*, April 30, 2005, p. 7
Paola van de Velde, 'Familiecollectie Hauser & Wirth in Cobra Museum' in: *Telegraaf*, April 12, 2005, p. 15
Thomas Trummer, 'Ugo Rondinone,' in: *22 Interviews*, April, 2005, p. 158–165
'Swiss made,' in: *Amstelveens Nieuwsblad*, March 30, 2005, p. 7
Gregory Volk, 'Let's Get Metaphysical,' in: *Art in America*, March, 2005
Johanna Burton, 'Ohne Gleichen – Unter anderem zu Ugo Rondinone bei Matthew Marks Gallery, New York,' in: *Texte zur Kunst*, no. 57, March 2005, p. 210–213
James Trainer, '2004 Carnegie International,' in: *Frieze*, no. 88, January/February, 2005, p. 109
Merrily Kerr, '54th Carnegie International,' in: *Flash Art*, January/February, 2005, p. 51
Katy Siegel, 'The 2004 Carnegie International,' in: *Artforum*, January, 2005, p. 175
'Un Corso per Raucci e Santamaria,' in: *Flash Art*, January/February, 2005

2004
Juliana Engberg, *Rondinone: Clockwork for Oracle*, Australian Centre for Contemporary Art, Melbourne, 2004
Catherine Grenier (ed.), *Dépression et subversion. Les racines de l' avant-garde*, Centre Pompidou Paris, 2004, p. 135
Elisabeth Couturier, *L' art contemporain mode d' emploi*, Editions Filipacchi, 2004, p. 83
Hilde Teerlinck (ed.), *It is a small world*, Crac Alsace, 2004
La Grande Parade. Portrait de l' artiste en clown, *L' œil*, Hors Série, 2004, p. 19
Genesis Sculpture Experience Pommery # 1, Beaux Arts Magazine, 2004
Michelle Piranio, Franceso Bonami, *54th Carnegie International*, 2004–2005, p. 208–211
Julia Morton, 'Realm of the scences,' in: *New York Press*, no. 52, December 29 – January 4, 2004–2005
Jean Wainwright, 'The Carnegie International,' in: *Art Monthly*, December/January, 2004–2005, p. 39–40

Christopher Knight, 'A global cacophony. The Carnegie International exhibition's daunting task: probing what drives artists in time of dramatic change,' in: *Los Angeles Times*, December 5, 2004, p. 39
Andrea Bellini, 'New York Tales,' in: *Flash Art*, November/December, 2004, p. 106–108
Hans-Ulrich Obrist, 'Quand Cattelan recontre Rondinone,' in: *Vogue Homme*, Autumn/Winter, 2004–2005, p. 152–156
Richard Rhodes, 'The Ulimates,' in: *Canadian Art*, Winter, 2004, p. 54–58
Suzy Menkes, 'A spray of rainbows on Avenue Montaigne,' in: *International Herald Tribune*, November 23, 2004
Vanessa Friedman, 'Coming Soon. Nicole Kidman to Chanel No. 5,' in: *The New York Times*, November 10, 2004
Ken Johnson, 'Pittsburgh rounds up a globe full of work made in novel ways,' in: *The New York Times*, November 4, 2004
'Ugo Rondinone,' in: *New York Magazine*, November 1, 2004
'Long gone sole,' in: *Crash*, no. 31, Autumn, 2004, p. 51
'Matthew Marks Gallery,' in: *Time Out New York*, October 14–21, 2004
Linda Yablonsky, 'Ugo Rondinone,' in: *Art + Auction*, October, 2004, p. 44–48
'Ugo Rondinone – Moonrise,' in: *Tema Celeste*, no. 109, September/October, 2004, p. 76–81
Steve Dollar, 'Visual allusions juxtaposed in hard light,' in: *Newsday*, August 29, 2004
Lauren Cornell, 'Hard Light,' in: *Time Out New York*, August 5–12, 2004, p. 52
Ian Phillips, 'Couture Collection,' in: *Interior Design*, August 1, 2004
Nicolas Trembley, 'La passion créative,' in: *Numéro*, no. 55, August, 2004, p. 22–27
Justin Ortiz, 'New exhibits give ample opportunity to experience art in a new light,' in: *The Queens Courier*, No. 32, July 28 – August 3, 2004
Roberta Smith, 'Summertime at P.S.1,' in: *The New York Times*, July 16, 2004
Jane Harris, 'Truth teller, mischief maker: Artist as clown and vice versa,' in: *The Village Voice*, July 7–13, 2004
Barbara Pollack, 'I Am the Walrus,' in: *Time Out New York*, July 1–8, 2004
'Carnegie Artists announced,' in: *Art in America*, July, 2004, p. 55
Jan Avgikos, *I am the Walrus*, June 2004, New York
Roberta Smith, 'I am the Walrus,' in: *The New York Times*, June 25, 2004
Brigitte Ulmer, 'Vom Sammler zum Shopper,' in: *Facts*, June, 2004, p. 33–38
Guido Mingels, 'Sag mir, was Du hörst,' in: *Das Magazin*, no. 32, 2004, p. 20–24
Scott Rothkopf, 'Carnegie Haul,' in: *Artforum*, May, 2004, p. 75–78
'Lasko: un panorama du wall painting en Suisse,' in: *http://pourinfos.org/wap.php*, May, 2004
Sophie Bourquin, 'Lasko, la grotte aux images,' in: *http://www.impartial.ch/loisirs/ artsspectacles/expositions/2004/lasko.htm*, May, 2004
Olivier Michelon, 'Les souries amers du clown,' in: *Le Journal des Arts*, no. 190, April 2–15, 2004
Yann Popovic, 'L'art à la CHARNIÈRE,' in: *Le bien public*, no. 180, April 9–15, 2004
Nicolas Trembley, 'Moonlighting by Ugo Rondinone,' in: *Self Service Magazine*, Spring/Summer, 2004, p. 272–287
Damien Sausset, 'Le romantisme selon Ugo Rondinone,' in: *Connaissance des arts*, no. 614, March, 2004, p. 52–57
Roberta Smith, 'On Two Hudson River Piers, Emerging Talent, and Plenty of It,' in: *The New York Times*, March 12, 2004, p. 3
Robert Nelson, 'Sweet, but gloomy,' in: *The Age*, February 25, 2004, p. A3
Gabriella Coslovich, 'A couple of art lovers,' in: *The Age*, February 21, 2004, p. A2
Rose Mulready, 'The Ugo Show,' in: *Inpress Magazine*, February 4, 2004
Alison Barclay, 'Ugo's X factor,' in: *Herald Sun*, February 4, 2004, p. 42
'Cinq ans déjà,' in: *Numéro*, February, 2004, p. 245–246
Gabriella Coslovich, 'Welcome to my twilight zone,' in: *The Age*, January 30, 2004, p. A3

2003
Journey to now, John Kaldor Art Projects and Collection, Art Gallery of South Australia, Adelaide, 2003
Russell Storer, Elizabeth Ann MacGregor, *Ugo Rondinone Our Magic Hour*, Museum of Contemporary Art, Sydney, 2003
Avant – Après. 7e Biennale d'art contemporain, Lyon, Les Presses du réel, Dijon, 2003
Gaby Hartel, Christine van Assche, *Ugo Rondinone – Roundelay*, Musée National d'Art Moderne, Centre Georges Pompidou, Paris, 2003
LOVE, Magazin 4 Bregenzer Kunstverein, 2003, p. 68–71
Jean-Yves Jouannais, *L' Idotie – art, vie, politique – méthode*, Beaux Arts, Paris 2003, p. 94–95
Anne Pontégnie, 'Exposer encore,' in: *Après. 7e Biennale d'Art Contemporain de Lyon*, 2003, p. 286–287
Beatrix Ruf, *Durchzug/Draft, 20 Jahre Stiftung Binz39*, Zürich, 2003, p. 18, 39
'L'arte sui ponteggi,' in: *Flash Art*, December, 2003, p. 55
[TNB Théâtre National de Bretagne], 'Ugo Rondinone,' in: *http://www.t-n-b.fr/ festival/fiche.asp?mettreensceneid=84*, November, 2003
[Le Rennais], 'Quatre lieux – Ugo Rondinone,' in: *Le Rennais*, November, 2003, p. 16
Olivier Michelon, 'Une biennale taillée par le musée,' in: *Le Journal des Arts*, no. 179, October 24 – November 6, 2003, p. 11

Ken Johnson, 'Sculpture,' in: *The New York Times*, October 17, 2003, p. E40

Bethany Anne Pappalardo, 'Sculpture,' in: *ArtForum.com*, October 13, 2003

'Nuit Blanche: gare de Lyon, Tolbiac,' in: *Le Monde*, Aden, October 1–7, 2003

Kim Levin, 'Sculpture,' in: *The Village Voice*, October 1–7, 2003, p. c82

M. H., 'Von Mond und Masken,' in: *Schweizer Illustrierte*, no. 40, September 29, 2003, p. 70

C. H., 'Bodenlos,' in: *Sonntags Zeitung*, August 24, 2003, p. 55

F. W., 'Si vous n'aimez pas la mer. Si vous n'aimez pas la montagne,' in: *Sofa*, no. 22, Summer 2003

'Double mixte,' in: *Les Inrockuptibles*, Summer, 2003, p. 64

Markus, Boden, 'Ugo Rondinone,' in: *Artinvestor*, no. 2, 2003, p. 58–61

Peter Hill, 'Pick and mix,' in: *The Sydney Morning Herald*, July 13, 2003

Martha Schwendener, 'Not neutral: Contemporary Swiss Photography,' in: *Time Out New York*, July 3–10, 2003, p. 59

Nicoletta Gigli, 'Cobolli Citta d'arte Zurigo,' in: *Arte*, July, 2003, p. 98–105

Pascal Beausse, 'Collustre,' in: *Flash Art*, July – September, 2003, p. 57

N. E., 'Ugo Rondinone Roundelay,' in: *Modern Painters*, Summer, 2003, p. 121–122

Lyndall Crisp, 'Public minded private collector,' in: *The Australian Financial Review*, June 26, 2003

Chelsea Clark, 'Winter Blues,' in: *The Daily Telegraph*, June 25, 2003, p. 55

Martin Schwander, 'El mundo del arte suizo carece de sentimiento nacionalista,' in: *Arte*, 2003

Liam Gillick, 'Ugo Rondinone par Liam Gillick,' in: *Contemporary*, no. 58

B. R., 'Touché par la grace,' in: *Technikart*, no. 71, April, 2003

Elisabeth Lebovici, 'Rondinone, démarche à suivre. A Beaubourg, une installation vidéo mélancolique et cadencée,' in: *Libération*, March 7, 2003

B. T., 'Ugo Rondinone, Roundelay,' in: *Sofa*, no. 20, February/March, 2003

Urs Steiner, 'Okkulte Séance. Breathing The Water,' in: *Neue Zürcher Zeitung*, no. 50, March 1/2, 2003, p. 44

'Ugo Rondinone,' in: *Gazzetta ProLitteris*, January, 2003, p. 95

'Roundelay. Ugo Rondinone,' in: *Artforum*, March, 2003, p. 121

H. M., 'L'Artiste Ugo Rondinone,' in: *Madame Figaro*, April 18, 2003

Bénédicte Ramadi, 'Ugo Rondinone, sculptures sentimentales,' in: *L'oeil*, April, 2003

Eric Troncy, 'Le Trouble Clown,' in: *Beaux Arts magazine*, no. 227, April, 2003, p. 66–67

Nicolas Thély, 'Ugo Rondinone: Le flâneur et la flâneuse,' in: *Le Monde (Aden)*, no. 238, February 26 – March 4, 2003

Nicolas Trembley, 'La dérive des sentiments,' in: *Numéro*, no. 40, February, 2003

Frédéric Bonnet, 'Ugo Rondinone, l'homme aux cent visages,' in: *Vogue*, February, 2003

Daniel Kurjakovic, 'Arte actual en Suiza a la luz del dispositivo teatral,' in: *Lapiz*, no. 22, February/March, 2003, p. 86–89

Owen Drolet, 'Drawing Now: Eight Propositions,' in: *Flash Art*, no. 36, January/February, 2003, p. 56

Meret Ernst, 'Schaufenster der Szenemacher,' in: *Tages Anzeiger*, January 27, 2003

Ewa Hess, 'Er sammelt keine Kunst, er sammelt Künstler,' in: *Sonntags Zeitung*, January 26, 2003

Tim Griffin, 'Drawing Now,' in: *Artforum*, January, 2003, p. 135

2002

Campy Vampy Tacky, La Criée, Centre d'art contemporain, Rennes, 2002

Five years Louise. Cry me a river, Galerie Almine Rech, Paris, 2002

Hoptman Laura (ed.), *Drawing Now. Eight Propositions*, The Museum of Modern Art, New York, 2002, p. 26–29

Martin Schwander, *Urban Diaries – Young Swiss Art*, Comunidad de Madrid, 2002, p. 138–145

Grazia Quaroni, David Renaud, *Psychodrome*, Fundació Joan Miró, Barcelona, 2002, p. 26–30, 84–89

Zeitgenössische Fotokunst aus der Schweiz, Neuer Berliner Kunstverein, Berlin, 2002, p. 104–111

Padraig Timoney, 'Ugo Rondinone,' in: *Contemporary*, December, 2002, p. 44–47

'Ines Gebetsroither, Ellen Krystufek, Dita Pepe, Ugo Rondinone, Jutta Strohmier. Rollenspiel und Körperbilder,' in: *Eikon*, no. 39/40, 2002, p. 18–19

Christoph Kihm, 'Bienvenue Willkommen Welcome @ Altkirch,' in: *Art Press*, no. 285, December, 2002, p. 84

Andreas Jürgensen, 'Ugo Rondinone. Coming Up For Air,' in: *175 Jahre Württembergischer Kunstverein*, Stuttgart, 2002, p. 68–73

Günther Schehl, 'Blaue Blume oder endloser Himmel,' in: *Badisches Tagblatt*, December 12, 2002

Ute Thon, 'In glänzender Form,' in: *ART*, December, 2002, p. 103

Matthew Higgs, 'Matthew Higgs: Best of 2002,' in: *Artforum*, no. 41, December, 2002, p. 110–111

Holger Steinemann, 'Unter dem Hirschkäfer,' in: *Staatsanzeiger für Baden-Württemberg*, November 25, 2002

Ariella Budick, 'Drawing on history,' in: *News Day*, November 3, 2002

Jerry Saltz, 'Good on paper,' in: *The Village Voice*, October 30 – November 5, 2002

Silvia Dell'Orso, 'Opere d'arte sui ponteggi al posto della pubblicità,' in: *La Repubblica*, October 25, 2002

'L'arte è sui ponteggi Basta guardare in su,' in: *Il Corriere della sera*, October 23, 2002

Roberta Smith, 'Retreat from the wild shores of abstraction,' in: *The New York Times*, October 16, 2002, p. 33–38

Gilda Williams, 'Ugo Rondinone; Rachel Feinstein,' in: *Art Monthly*, October 2002, p. 37–39

'En Juillet,' in: *L'Alsace Le Pays (Version femina)*, no. 26, September 26, 2002

Rebecca Geldard, 'Ugo Rondinone at Sadie Coles HQ,' in *Time Out London*, September 25–October 2, 2002

Claudia Aigner, 'No How On,' in: *Wiener Zeitung*, September 17, 2002

Helen Sumpter, 'Ugo Rondinone: Cigarettensandwich,' in *Evening Standard*, September 6–12, 2002

Nicole Scheyerer, 'Kunst Kurz – Ugo Rondinone in der Kunsthalle und Galerie Krobath Wimmer,' in: *Falter*, no. 34/02, August 21, 2002

Claudia Spinelli, 'Es ist alles so schön sinnlos hier,' in: *Die Weltwoche*, August 8, 2002, p. 74

Florian Steininger, 'Ausgestellt in Wien – Galerie Krobath Wimmer,' in: *Die Presse*, July 24, 2002, p. 4

Jana Wisniewski, 'Labyrinth der Gefühle,' in: *Salzburger Nachrichten*, July 6, 2002

Eva Marz, 'Der Künstler wohnt hier nicht mehr,' in: *Süddeutsche Zeitung*, July 3, 2002, p. 151

Valérie Marchi, 'Quel cirque?,' in: *L'œil*, July – August, 2002, p. 76–83

Henriette Horny, 'Für Erhöhung der Dosis. Kunsthallen-Chef Matt über die MQ und die neue Schau,' in: *Kurier*, June 28, 2002

Almuth Spiegler, 'Wenn Clowns schlafen, tickt die Zeit anders,' in: *Die Presse*, June 28, 2002

Markus Mittringer, 'Fröhliche Lethargie,' in: *Der Standard*, June 28, 2002, p. 29

Rose-Maria Gropp, 'Wer bei der Kunst A sagt, muss auch B sagen: Die Art Basel,' in: *Frankfurter Allgemeine Zeitung*, no. 136, June 15, 2002, p. 63

Elfie Kreis, 'Ugo Rondinone,' in: *Kunstzeitung*, no. 70, June 2002, p. 11

Megan Dailey, 'Ugo Rondinone. Matthew Marks Gallery/Swiss Institute,' in: *Artforum*, Summer, 2002, p. 175

'Ugo Rondinone. I don't live here anymore,' in: *Frame*, Summer, 2002, p. 126

Michael Amy, 'Ugo Rondinone,' in: *Tema Celeste*, May/June, 2002, p. 88

Didier Le Bourgeant, 'Subversive confusion des genres,' in: *Têtu*, no. 18, May, 2002, p. 40

'Lowland Lullaby,' in: *The New Yorker*, April 22–29, 2002, p. 36

Judicaël Lavrador, 'Camping Creatures,' in: *Les Inrockuptibles*, no. 334, April 17–23, 2002, p. 87

'Ugo Rondinone with John Giorno and Urs Fischer,' in: *Village Voice*, April 16, 2002, p. 97

Ken Johnson, 'Ugo Rondinone: A Horse with No Name,' in: *The New York Times*, April 5, 2002

Eric Troncy, 'Le Transformiste,' in: *Numéro*, April, 2002, p. 208–213

Claudia Wahjudi, 'Zeitgenössische Fotokunst aus der Schweiz,' in: *Kunstforum International*, April/May, 2002, p. 303–305

'Confusions subversives,' in: *Mouvement*, no. 16, April/June, 2002

Sithara Atasoy, 'Kulinarischer Seidenspinner,' in: *Bolero*, April, 2002, p. 64

Gérard Pernon, 'Campy, Vampy, Tacky à la Criée,' in: *Ouest France*, March 26, 2002

'Ugo Rondinone,' in: *Time Out New York*, February 21–28, 2002

Yves Rosset, 'Gelobt, aber gut geschützt,' in: *Die Tageszeitung*, January 30, 2002, p. 16

Hans-Jörg Rother, 'Fahl ist das Blau des Himmels,' in: *Frankfurter Allgemeine Zeitung*, January 29, 2002

Michael Gurtner, '(Un)schöne neue Video-Welt,' in: *Berner Zeitung*, January 28, 2002

Marianne Mühlemann, 'Bewegte Bilder aus intimen Zonen,' in: *Der Bund*, no. 19, January 24, 2002, p. 21

Roland Schweizer, 'Die Liebe ist ein seltsames Spiel,' in: *Berner Zeitung*, January 24, 2002, p. 11

Nicola Kuhn, 'Heidi lebt nicht mehr,' in: *Der Tagesspiegel*, January 23, 2002

Ingeborg Ruthe, 'Leibesvisitation mit der Kamera,' in: *Berliner Zeitung*, January 16, 2002

Birgit Sonna, 'Endlos rotierende Tranquilizer. Hypo-Kunsthalle München: Loop – Alles auf Anfang,' in: *Frame*, no. 10, January/March, 2002, p. 124

Hans-Jürgen Hafner, 'Loop: Alles auf Anfang,' in: *Kunstforum International*, January – March, 2002, p. 350–351

2001

Pierre-André Lienhard (ed.), *vantage point*, Irish Museum of Modern Art, Dublin, 2001

Renate Wiehager (ed.), *Sammlung DaimlerChrysler. Neuerwerbungen/New Acquisitions*, Daimler Chrysler AG/Kunstbesitz, Berlin, 2001

Action, on tourne/Action, we're filming, Villa Arson, Nice, 2001, p. 91–93

Maria Grazia Tolomeo, *Ugo Rondinone. Kiss Tomorrow Goodbye*, Palazzo delle Esposizioni, Rome, 2001

Paul-Hervé Parsy (ed.), *Salons de Musique*, Musée d'Art Moderne et Contemporain, Strasbourg, 2001

Ugo Rondinone, Fonds régional d'art contemporain Provence-Alpes-Côte d'Azur, June/September, 2001

John Richardson, *Rencontres 5. Ugo Rondinone/John Richardson*, Almine Rech
 Editions/Editions Images Modernes, Paris, 2001
Marie Frédérique Hallin (ed.), *Théâtres du Fantastique*, Actes Sud, Nîmes, 2001,
 p. 98
'Munich, Loop – Alles auf Anfang,' in: *Art Press*, no. 247, p. 72–73
Anders Kold, '*Lige i øjet*,' in: *Louisiana Magasin*, Humlebaek, no. 3, October, 2001,
 p. 8–10
Sybille Kayser, 'Loop – Alles auf Anfang,' in: *Magazin für Medienkunst*, October 26,
 2001, Bayern2Radio
Eva Karcher, 'Hase und Igel. Wenn die Zeit ausrastet: die Münchner Ausstellung Loop –
 alles auf Anfang bindet Endlosschleifen,' in: *Der Tagesspiegel*, October 11, 2001
'Perspektive der Echtzeit.,' in: *In München*, no. 20, September 27–October 10, 2001, p. 22
Frank Frangenberg, 'Ugo Rondinone: Slow Graffiti,' in: *Kulturforum International*,
 no. 157, November/December, 2001, p. 279–280
Alexander Pühringer, 'Eine Ewigkeit – zwei Lächeln,' in: *Frame*, no. 9, November/
 December, 2001, p. 111
Anette Vestergaard, 'Her er jeg. Hvem er du?,' in: *Politiken*, November 11, 2001, p. 6
'Kiss tomorrow goodbye: artist Ugo Rondinone clowns around for pop,' in: *Pop*,
 Autumn/Winter, 2001, p. 240–247
Knut Ebeling, 'Das Geschäft des Gelächters,' in: *Der Tagesspiegel*, October 20, 2001
Bénédicte Ramade, 'Ugo Bosse,' in: *Technikart*, no. 55, September, 2001
Niklas Maak, 'Ausbruch aus der Tretmühle,' in: *Frankfurter Allgemeine Zeitung*,
 September 29, 2001
G., M. G., 'Ugo Rondinone, artiste de l'esthétisme,' in: *L'Hebdo Marseille*, no. 53,
 September 20–26, 2001
Géraldine Basset, 'Ugo Rondinone: Everyday Sunshine?,' in: *Ventilo*, September
 19–26, 2001, p. 21
Freia Oliv, 'Kritik an der Konsumgesellschaft: Loop – Alles auf Anfang, in der Münchner
 Hypo-Kunsthalle,' in: *Müncher Merkur*, no. 212, September 14, 2001, p. 19
K. U., 'Sisyphos Spielarten. Klaus Biesenbach kuratierte: Loop – Alles auf Anfang, in
 der Hypo-Kunsthalle,' in: *Berliner Zeitung*, September 18, 2001, p. 10
Els Roelandt, 'Let's get lost,' in: *Sint-Lukasgalerij*, no. 1, September, 2001, p. 8–9
'Gilles Barbier, Bruno Peinado, Ugo Rondinone,' in: *Le Monde (Aden)*, September 5–11,
 2001, p. 29
Philippe Régnier, 'Portrait à facette. Ugo Rondinone en vedette au Frac Paca,' in:
 Le Journal des Arts, no. 131, August 31–September 13, 2001, p. 10
Tatiana Reis, 'Guided by voices,' in: *lab02*, Summer, 2001, p. 87–89
Ugo Rondinone, *Moonlighting* [insert], in: *Black Diamond*, no. 3, Summer, 2001, p. 15
Monique Groot, 'Weinig geslaagde flirt in Montevideo,' in: *Noordhollands Dagblad*,
 June 20, 2001, p. 9
Jörg Becher, 'Künstler im Beauty-Contest,' in: *Bilanz*, June, 2001, p. 164–168
Patrice Joly, 'Marseille s'éveille,' in: *3301*, no. 2, June, 2001, p. 23–24
'Ugo Rondinone. Hell, Yes!,' in: *Tema Celeste*, May/June, 2001, p. 18
Arne Henderickxz, 'In The Media Mix,' in: *Tubelight*, no. 15, May/June, 2001, p. 5–16
Esma Moukhtar, 'De kaping als mediafenomeen,' in: *volkskrant*, May 30, 2001
Jennifer Tee, 'Kunstexplosie,' in: *BLUD*, April 30, 2001
'Works of Art. Vantage Point,' in: *IT Magazine*, April, 2001
Liesbet van Zoonen, 'Beelden die dichter bij de massamedia liggen, vind ik meteen
 mooi,' in: *Kunstblad*, no. 4, 2001
Mark Kostabi, *Conceptual Curiosity. Or: I won't steal your dealer, Ugo*
 [advertisement], in: *Flash Art*, vol. XXXIV, no. 217, March/April, 2001, p. 31
Ugo Rondinone, [insert], in: *Frame*, March/April 2001, p. 71–83
Beatrix Ruf, 'Ugo Rondinone's circles,' in: *Loop – Alles auf Anfang*, March, 2001,
 p. 38–47
Smadar Sheffi, 'Art,' in: *Ha'aretz*, March 30, 2001
Medb Ruane, 'Museum with its art in the right place. Despite massive underfunding,
 IMMA gets it right with Vantage Point,' in: *The Sunday Times*, March 25, 2001
S. S., 'Disappointment under the rainbow,' in: *Ha'aretz*, March 23, 2001
'Ugo Rondinone, If there were anything but dessert. L'image dans le miroir,' in:
 www.urbuz.com, March 21, 2001
Charlotte Hallé, 'Hot Iten,' in: *Ha'aretz*, March 9, 2001
'Ugo Rondinone,' in: *Le Monde (Aden)*, no. 153, February 28–March 6, 2001
Ken Johnson, 'West Side: The Armory Show on the Piers just keeps growing,' in:
 The New York Times, February 23, 2001, p. E33
Jean-Gabriel Périot, 'Expositions de la rue Louise Weiss,' in: *www.urbanpass.com*,
 February 6, 2001
Smadar Sheffi, in: *Ha'aretz*, February 2, 2001
Catherine Francblin, 'Ugo Rondinone' in: *Beaux Arts Magazine*, no. 201, February,
 2001, p. 31
Bénédicte Ramadi, 'Le cirque de Monsieur Rondinone,' in: *L'œil*, no. 523, February,
 2001, p. 107
Uzi Zur, in: *Ha'aretz*, January 26, 2001
Angelika Heinick, 'Die Geheimnisse der Rue Louise Weiss,' in: *Frankfurter Allgemeine
 Zeitung*, 2001
'Le 13 janvier. Allons à l'est dans le XIIIème,' in: *Connaissance des Arts*, no. 579,
 January, 2001

2000
Susan G. Davis, Walker Art Center, *Let's entertain: Life's guilty pleasures*,
 Minneapolis, 2000, p. 150–151
Foundation for Art & Creative Technology (FACT), *Video Positive 2000*, Liverpool,
 Bluecoat Chambers, 2000
On the frac track, FRAC Nord – Pas de Calais, Dunkerk, 2000, p. 19
come in and find out 4, Podewil Center for Contemporary Arts, Berlin, 2000, p. 17
Gianni Romano (ed.), *Premio Michetti, Europa/Differenti Prospettivi Nella Pittura*,
 Giancarlo Politi Editore, Francavilla al Mare, 2000, p. 142–143, p. 235
Gilda Williams, *Fresh Cream*, Phaidon Press, 2000, p. 514–519
Manami Fujimori, Yuko Hasewaga, *Very New Art 2000/100 Artists of the Year*,
 Bijutsu Shuppan-Sha, Tokyo, 2000, p. 198–199
Jari-Pekka Vanhala, *saman taivaan alla/under the same sky 3*, Kiasma Museum of
 Contemporary Art, Helsinki, 2000, p. 46–51
Nicolaus Schaffhausen, *Jahresgaben 00/01*, Frankfurter Kunstverein, Frankfurt, 2000
'Ich ist etwas anderes,' in: *Kunstsammlung Nordrhein-Westfalen Dumont*, Kunst-
 sammlung Nordrhein-Westfalen, Cologne, 2000
Présumés innocents. L'art contemporain et l'enfance, capc Musée d'art contemporain,
 Bordeaux, 2000, p. 133
*NB. New York/Berlin. Künstlerateliers der Eidgenossenschaft 98–99, Ugo Rondinone,
 Ignazio Bettua. Kunsthalle Palazzo Liestal*, Bundesamt für Kultur, Bern, 2000
Vicente Lucas, 'cimal: Arte internacional,' in: *Ediciones cimal internacional*, no. 52,
 Valencia, 2000
Museum Dhondt-Dhaenens, 'Living in the real world,' in: *Deurle*, 2000
'Daniel Buren, Ugo Rondinone,' *Documents sur l'art*, vol. 12, Dijon, 2000
Andreas Baur, Stephan Berg, 'Close Up: Oberfläche und Nahsicht in der Zeitgenös-
 sischen Bildenden Kunst und im Film,' in: *modo*, 2000, p. 128–133
Barry Schwabsky, 'Bridget Riley/Wojciech Fangor,' in: *Artforum*, special issue:
 'Best of 2000,' vol. XXXIX, no. 4, p. 140
James Meyer, 'Top Ten,' in: *Artforum*, special issue: 'Best of 2000,' vol. XXXIX,
 no. 4, p. 114–115
Jan Winkelmann, 'Über Ugo Rondinone,' in: *Artist Kunstmagazin*, no. 4,
 November 2000–January 2001, p. 44–49
Stefano Chiodi, 'Ugo Rondinone. Galleria Raucci/Santamaria, Naples,' in: *Tema
 Celeste*, October/December, 2000, p. 82
Peter Schjeldahl, 'The drawing board,' in: *The New Yorker*, November, 2000,
 p. 102–103
Sibylle Omlin, 'Face à face. Portraits im Kunstpanorama Luzern,' in: *Neue Zürcher
 Zeitung*, no. 237, October 11, 2000, p. 62
Christiane Meixner, 'Ohne Schirm im Regen stehen. Eine Ausstellung im Berliner
 Podewil zeigt aktuelle Möglichkeiten malerischer Tendenzen,' in: *Frankfurter
 Rundschau*, October 5, 2000
Maria Vogel, 'Das Verlangen hinter die Gesichter zu schauen. Eine Portrait-Ausstel-
 lung im Kunstpanorama Luzern,' in: *Willisauer Bote*, September 23, 2000, p. 11
Henrike Thomsen, 'Verkappte Wohnzimmer-Idylle in Pink und Pastell. Das Podewil
 zeigt neue Positionen der abstrakten Malerei,' in: *Berliner Zeitung*, no. 222,
 September 22, 2000
Kerstin Rottmann 'Die Festplatte ist voll. Die Schau "come in and find out, vol. 4"
 zeigt, wie auch die "hehre Malerei" Erlösung im Multimedialen sucht,' in: *Die Welt*,
 September 21, 2000
Christina Wendenburg, 'Egomanen unter sich. Allein die Wirkung zählt: Die Aus-
 stellung "come in and find out, vol. 4" im Podewil liefert einen höchst abstrakten
 Auftakt zum diesjährigen Berliner Kunstherbst,' in: *Berliner Morgenpost*,
 September 16, 2000
Bettina Karin Müller, 'Ohne Legitimation. "come in and find out, vol. 4" im Podewil
 widmet sich abstrakter Malerei,' in: *tip*, no. 19, 2000
'Alles so schön bunt,' in: *Prinz*, September, 2000
'Ciné Riviera. A la Villa Arson, "Action, on tourne" fait parler les murs,' in: *Technikart*,
 September, 2000
'Une mise en scène du réel: Artiste/Acteur,' in: *Le Monde (Aden)*, September, 2000
Matthew Debord, 'Ugo Rondinone,' in: *Artext*, August/October, 2000, p. 78
Jade Lindgaard, 'Séance de rattrapage,' in: *les Inrockuptibles*,
 August 29–September 4, 2000
Olivier Michelon, 'Plein écran. Le réel mis en scène à la villa Arson,' in: *Le Journal
 des Arts*, no. 109, August 25–September 7, 2000
Alain Dreyfus, 'Une mise en scène du réel se joue de nous. A Nice, une exposition
 collective entre vrai et faux,' in: *Libération*, August 24, 2000
'Une mise en scène du réel: Artiste/Acteur,' in: *Le Monde (Aden)*, August 17–24, 2000
Dorothea Strauss, 'Tuschlandschaften – FÜNFZEHNTERJULINEUNZEHNHUNDERT-
 NEUNUNDNEUNZIG von Ugo Rondinone,' in: *Kunst am Bau*, August, 2000, p. 12–13
Véronique Bouruet-Aubertot, 'Le Massacre des Innocents,' in: *Beaux Arts Magazine*,
 no. 159, August, 2000, p. 90–97
Filippo Romeo, 'Ugo Rondinone. Raucci & Santamaria,' in: *Flash Art*, vol. XXXIII,
 no. 223, Summer, 2000
Barry Schwabsky, 'Ugo Rondinone. Matthew Marks Gallery,' in: *Artforum*,
 vol. XXXVIII, no. 10, Summer, 2000, p. 183

Mariuccia Casadio, Alexia Silvagni, '26.05.2000. Ugo Rondinone. A Doubleday and a Pastime,' in: *L'Uomo Vogue,* no. 312, July/August, 2000

Lucia Prandi, 'Over The Edges: The Streetcorners of Ghent,' in: *Tema Celeste,* no. 81, July/September, 2000, p. 111

Christopher Phillips, 'Ugo Rondinone at Matthew Marks,' in: *Art in America,* vol. 88, June 6, 2000, p. 116–117

Edgar Schmitz, 'The self is something else. Art at the end of the 20th century,' in: *Contemporary Visual Arts,* June, 2000

Hans-Dieter Fronz, 'Von Oberfläche und Inhalt. Die Kunstvereine Freiburg und Baselland zeigen "Close up,"' in: *Südkurier,* June 15, 2000

Francesco Galdieri, 'Mostre/Da Raucci & Santamaria. La sperimentazione di Ugo Rondinone,' in: *Il Mattino,* June 13, 2000

Martin Engler, 'Monster im Oberstübchen. Nahsicht und Weltentwurf: "Close up" im Kunstverein Freiburg und im Kunsthaus Baselland,' in: *Frankfurter Allgemeine Zeitung,* June 10, 2000

Michael Krajewski, 'Ich ist etwas anderes,' in: *Kunst-Bulletin,* no. 5, May, 2000, p. 35

Christoph Doswald, 'Missing Link – Close the Gap!,' in: *Ediciones cimal internacional,* no. 52, 2000, p. 43–51

Claudia Pantellini, 'Die Kunst, die nichts als Oberfläche sein will,' in: *Dreilandzeitung,* May 25, 2000

Volker Baumeister, 'Hackfleisch und leere Versprechen. Gezeiten: Die Ausstellung "Close up" in Freiburg und Muttenz,' in: *Badische Zeitung,* May 24, 2000

Dietrich Roeschmann, 'Ich als Oberfläche. Schöner Schein und nichts dahinter? In Freiburg und Basel feiern 24 KünstlerInnen den Abschied von der Hierarchie von Inhalt und Hülle: das Ausstellungsprojekt "Close up,"' in: *Die Abendzeitung,* May 24, 2000

Christopher Phillips, 'Report from Istanbul/Band of Outsiders,' in: *Art in America,* vol. 88, no. 4, April, 2000, p. 70–75

Claudia Funk, 'Maskeraden und Mutationen,' in: *Stadtrevue,* April, 2000

Hubert Beck, 'Ich ist etwas anderes – Kunst,' in: *Anzag Magazin,* April, 2000

'Rondinone, Revey, Salami, Schär,' in: *Das Magazin,* no. 16, 2000

Matthias Macchler, 'Unterwegs mit Seidenfabrikant Andi Stutz (Photographien von Ugo Rondinone),' in: *Annabelle,* no. 8, April 14, 2000, p. 50–55

Timo Uusiniitty, 'Yllättäviä ilmestymisiä,' in: *Kymen Sanomat (kotka),* April 2, 2000

Nicola Kuhn, 'Gegen die Angst zu verschwinden. Eine Ausstellung in Düsseldorf fahndet nach der künstlerischen Identität,' in: *Der Tagesspiegel,* April 2, 2000

Diane Massey, 'Images over time,' in: *Daily Post,* March 31, 2000

Kim Levin, 'Ugo Rondinone. The Moonlightning,' in: *Village Voice,* vol. XLV, no. 12, March 28, 2000

Chris Arnot, 'Shooting stars,' in: *The Guardian,* March 23, 2000

Charlie Finch, 'Sensurrondinone,' in: http://www.artnet.com/magazine/features/finch/finch3-22-00.asp, March 23, 2000

Inge Rodenstock, 'Lippenstift und Regenbogen. Über die aufregende junge Schweizer Kunstszene,' in: *Wirtschaftswoche,* no. 13, March 23, 2000, p. 197

'Pick of the galleries – The biennial of the moving image,' in: *Independent on Sunday,* March 19, 2000

The Jerusalem Post, March 17, 2000

Thomas Wagner, 'Wo bist du, bbbbbbrrrrrruuuuuuccccccceeeeee? Das Subjekt verliert sich in der Selbstbeobachtung: "Ich ist etwas Anderes" in der Kunsthalle Nordrhein-Westfalen,' in: *Süddeutsche Zeitung,* March 9, 2000

David Hunt, 'Sixth International Istanbul Biennial,' in: *Artext,* no. 68, February/April, 2000

Geraldine Belmont, 'Ugo Rondinone. Hauser & Wirth & Presenhuber,' in: *Flash Art,* vol. XXXIII, no. 220, February/March, 2000

Line Helena Bak, 'Tom kulisse,' in: *Iyllandsposten,* February 28, 2000

Mette Sandbye, in: *Weekendavisen,* February 25, 2000

Roland Gross, 'Der Weg des Ichs ist das Ziel,' in: *Rheinische Post,* February 24, 2000

Thomas Kliemann, 'Denn es gibt keine Ferien vom Ich,' in: *General-anzeiger Bonn,* February 23, 2000

Andersen, Trine Rytter, 'Smuk og provokerende,' in: *Aarhur Stiftstiunde,* February 12, 2000

Gitte Orskou Madsen, 'Natur/kultur/tur/retur,' in: *Information,* February 10, 2000

'Streifen und Spiegel,' in: *Der Bund,* February 8, 2000

Robert Schiess, 'Irritierendes Spiel mit Räumen,' in: *Basellandschaft Zeitung,* February 3, 2000

Samuel Herzog, 'Melancholisch, malerisch – und etwas mager,' in: *Basler Zeitung,* February 2, 2000, p. 40

Katrin Luz, 'Schöne Hüllen, leere Körper, traurige Blicke,' in: *Frame,* January/February, 2000, p. 46

Cedar Lewisohn, 'Trans-Europe Express,' in: *Flash Art,* vol. XXXIII, no. 210, January/February, 2000, p. 47

Patricia Ellis, 'Ugo Rondinone,' in: *Inter Vista, the other art magazine,* vol. IV, no. 21, January/February, 2000, p. 6

Eric Troncy, 'Arts plastiques,' in: *Beaux Arts Magazine,* no. 188, January, 2000, p. 88

'review,' in: *Daily Telegraph,* January 19, 2000

William Packer, 'Same old ideas with no new flair,' in: *Financial Times,* January 18, 2000

Martin Coomer, 'Continental Drift. Saatchi's Mixed Bag of Euro-artists,' in: *Time Out London,* January 18, 2000

Peter Gut, 'Habe Mut! Havekosts Bilder in Leipzig,' in: *Frankfurter Allgemeine Zeitung,* January 14, 2000

Andrew Finkel, 'Istanbul Biennial,' in: *Artnews,* January, 2000, p. 175

1999

Katia Baudin, Veerle Van Durme (eds.), *Collection FRAC Nord – Pas de Calais, Een keuze,* Kortrijke BBL, 1999

Le Repubbliche dell'Arte, Schweiz. Suisse. Svizzera. Svizra, Palazzo delle Papesse, Contemporary Art Center, Siena, 1999

Angeline Scherf, Carlos Basualdo (eds.), *L'autre sommeil,* Musée d'Art Moderne de la Ville de Paris, 1999

Ariane Grigoteit, *Landschaften eines Jahrhunderts aus der Sammlung Deutsche Bank,* Frankfurt, 1999

'Neste Stopp, Kunstfestivalen i Lofoten,' in: *Kunstfestivalen i Lofoten,* 1999

Prix Conseillé, 1899–1999. 100 ans de Concours fédéral des Beaux-Arts, Zurich, Bundesamt für Kultur, Orell Füssli Publisher, 1999

6th Istanbul Biennial. The passion and the wave, Istanbul Foundation for Culture and Arts, Istanbul, 1999, p. 10–11, p. 182–185

Juliana Engberg, Shane Murray (eds.), *Signs of Life,* Melbourne International Biennial 1999, City of Melbourne, 1999

Rosa für Jungs/Hellblau für Mädchen, Neue Gesellschaft für Bildende Kunst, Berlin, 1999

Narcisse Tordoir, Luc Tuymans (eds.), *Trouble Spot. Painting,* Museum van Hedendaagse Kunst, Antwerpen, 1999

Beatrix Ruf (ed.), *Kunst bei Ringier 1995–1998,* Ringier AG, 1999

Sergio Risaliti, 'Siena,' in: *Periodico del palazzo delle Papesse,* 1999

Sabine Schmidt, 'Biennale Istanbul,' in: *Springerin. Heft für Gegenwartskunst,* no. 5/4, December 1999 – February 2000, p. 64–65

Thorsten Stecher, 'Die Zeit der Halbschatten,' in: *Die Weltwoche,* no. 52, December 30, 1999

Eva Karcher, 'Vakuum der Sehnsucht,' in: *Vogue,* no. 12, December, 1999, p. 96–97

Tim Sommer, 'Spiel mit Herztönen auf der Klaviatur der Installationen,' in: *LVZ,* December 27, 1999

Katja Uhlemann, 'Was von der Realität übrig bleibt,' in: *Freie Presse,* December 23, 1999

Ingeborg Wiensowski, 'Porträt Abenteur Installation,' in: *Spiegel Reporter,* no. 12, December, 1999, p. 138

C. J., 'Rondinone auf der ganzen Welt,' in: *Die Südostschweiz,* December 6, 1999, p. 5

Eva Hess, 'Er redet über vieles – bloss nicht über Kunst,' in: *SonntagsZeitung,* December 5, 1999, p. 63

Suzana Milevska, 'Istanbul Biennale,' in: *Springerin. Heft für Gegenwartskunst,* no. 5/4, December 1999 – February 2000, p. 64–65

Gilda Williams, '6th Istanbul Biennial,' in: *Art Monthly,* no. 232, December 1999 – January 2000, p. 26–27

Jan Verwoert, 'Ugo Rondinone. Dandy Pop,' in: *Flash Art,* December 1999 – January 2000, p. 60–61

Eleanor Heartney, 'Sixième Biennale Istanbul,' in: *Art Press,* no. 252, December, 1999, p. 70–72

Anna Helwing, 'Ugo Rondinone im Kunsthaus,' in: *Kunst-Bulletin,* no. 11, November, 1999

Samuel Herzog, 'Sechste Internationale Biennale,' in: *Kunst-Bulletin,* November, 1999, p. 35

Anne-Marie Michel, 'Ugo Rondinone,' in: *Art News,* November, 1999, p. 203

Niklaus Oberholzer, 'Ich hatte nie einen Traum,' in: *Neue Luzerner Zeitung,* no. 243, October 19, 1999

Joerg Bader, 'Aktuelle Eintragungen in ein Tagebuch des Zweifels. Das Erdbeben, die Leidenschaft und die Welle: Die sechste Internationale Biennale von Istanbul,' in: *Frankfurter Allgemeine Zeitung,* no. 235, p. 44

Joerg Bader, 'Die Biennale und das Beben,' in: *Berner Zeitung* [also in french translation in: *Le Temps*], October 1, 1999

Anders Kreuger, '6th Istanbul Biennial,' in: *Artelier,* 1999, p. 79–81

Matthew Gurrewitsch, 'In Istanbul, a Biennial Offers the Solace of Art,' in: *New York Times,* 2000

Gerhard Mack, 'Kunst verträgt sich nicht mit Gesellschaftskritik,' in: *Cash,* no. 38, September 24, 1999

Simon Maurer, 'Schweben am Fuss des Glärnisch,' in: *Tages-Anzeiger,* September 16, 1999

Eugen von Arb, 'Im Spiegelgarten der Kunst,' in: *Die Südostschweiz,* September 13, 1999, p. 3

'Zwei Vernissagen im Kunsthaus Glarus,' in: *Fridolin,* September 9, 1999, p. 27

P. D., 'Gegenwarts-Reflexion im Kunsthaus,' in: *Die Südostschweiz,* September 9, 1999, p. 7

Britta Polzer, 'Kunst,' in: *Annabelle,* September 3, 1999, p. 27

Heinrich Nicolaus, 'Papese: una finestra sulla Svizzera,' in: *La Voce del Campo,* no. 31, August 26, 1999, p. 6

Claudia Wahjudi, 'Rosa für Jungs, Hellblau für Mädchen,' in: *Kunstforum International,* no. 146, July/August, 1999, p. 344

Mariuccia Casadio, 'Moving Around,' in: *Vogue Italia,* June, 1999, p. 192–195

Gerhard Mack, Heinz Peter Schwerfel, 'Tour de Suisse,' in: *Art – Das Kunstmagazin,* June, 1999, p. 10–20

Lena Corner, 'Beauty and Beast,' in: *i-D magazine,* no. 186, May, 1999

'Xn99,' in: *Frieze,* no. 49, May, 1999

Claudia Senn, 'Meister der Melancholie,' in: *Bolero,* no. 9, 1999

Andrea Hilgenstock, 'Meine Geschichten passen gut zu Berlin,' in: *Die Welt,* March 3, 1999

Ulrich Müller, 'Lobgesang auf die Depression,' in: *Zitty,* February, 1999

Elfi Kreis, 'Bonjour Tristesse, bonjour Schneeschmelze,' in: *Der Tagesspiegel,* February 6, 1999

José Machado, 'Arco, para que te quero,' in: *Arte Ibérica,* February 21, 1999

Christoph Phillips, 'Art for an Unfinished City,' in: *Art in America,* January, 1999

Hans Steinegger, 'Ugo Rondinone im Kunsthaus Glarus,' in: *Einsiedler Anzeiger,* January 19, 1999

E. L., 'Des Suisses au mental fondu,' in: *Libération,* February 3, 1999

1998

Berlin/Berlin, Berlin Biennale für zeitgenössische Kunst e. V., Berlin, 1998

Martin van Nieuwenhuyzen, Leontine Coelewij (eds.), *From the Corner of the Eye,* Stedelijk Museum, Amsterdam, 1998

Kunst in der Provinzial, Provinzial Versicherungsanstalt, Schleswig-Holstein, 1998

Freie Sicht aufs Mittelmeer, Kunsthaus Zürich & Scalo, Zurich, 1998

Alice Rubbini, *Libera mente. La figurazione del sentimento,* Edizioni Charta, Milan, 1998

Xavier Douroux, Franck Gautherot, Eric Troncy (eds.), *Compilation. Une expérience de l'exposition,* Les Presses du Réel, Dijon, 1998

Eurovision, The Saatchi Gallery, London, & The Pale Green Press, London, 1998

Renate Wiehager (ed.), *4. Internationale Foto-Triennale Esslingen. Fotografie als Handlung,* Villa Merkel, Esslingen, 1998

Homo Zappiens Zappiens, Presses Universitaires de Rennes, 1998

Frank Wagner, *AIDS-Welten. Zwischen Resignation und Hoffnung,* AIDS Info Docu Schweiz, 1998

Altered States, Stichting Festival a/d Werf Utrecht, 1998

Katia Baudin, Benoît Dandre (eds.), *Un monde merveilleux. Kitsch et art contemporain,* Fonds Régional d'Art Contemporain Nord-Pas de Calais, 1998

Maria Smolenicka (ed.), *Foto Relations,* Kunsthaus der Stadt Brünn, 1998

Dramatically Different, Le Magasin, Centre National d'Art Contemporain de Grenoble, Grenoble, 1998

Jacqueline Burckhardt, Bice Curiger (eds.), 'Parkett – Karen Kilimnik, Malcolm Morley, Ugo Rondinone,' in: *Parkett,* vol. 52, 1998

The Art Collecting Activities at Swiss Re, Swiss Re, Zurich 1998

C. M., 'Ugo Rondinone,' in: *Expresso,* November 6, 1998

Elizabeth Janus, 'Ugo Rondinone,' in: *Artforum,* no. 3, November, 1998

Heinz Peter Schwerfel, 'Eine Sause in die Welt der Gefühle,' in: *Art,* November, 1998, p. 96

Jade Lindgaard, 'Jeux d'artifice,' in: *Les Inrockuptibles,* October 24, 1998

Gerhard Mack, 'Berliner Luft für kreative Gastarbeiter,' in: *Cash,* no. 39, September 25, 1998

Gabriele Hoffmann, 'Ans Alpenschleifen denkt niemand mehr,' in: *Die Tageszeitung,* August 30, 1998

Kim Levin, 'Voice,' in: *Village Voice,* August 11, 1998

Ralf Beil, 'Die Schweiz, jetzt alpfrei?,' in: *Kunst-Bulletin,* Zurich, no. 7/8, July/August, 1998

Hans-Peter von Däniken, 'Die feurigen Blicke der Betrachter(innen),' in: *Tages-Anzeiger,* July 24, 1998

Daniela Fabian, 'Auf dem Weg zum Ruhm,' in: *Schweizer Illustrierte,* no. 27, June 29, 1998

Mario Codognato, 'Ugo Rondinone,' in: *Artforum,* no. 10, 1998

Michelle Nicol, 'Fashionable Transgressions,' in: *Frieze,* no. 41, June/July/August, 1998

Padraig Timoney, 'Ugo Rondinone. Galleria Raucci/Santamaria, Naples,' in: *Frieze,* no. 41, June/July/August, 1998

Daniela Fabian, 'Von einem, der schläft, ist nichts zu erwarten,' in: *Schweizer Illustrierte,* no. 27, June 29, 1998

'Ugo Rondinone, Narzisstisches Spiel,' in: *Sonntagszeitung,* May 31, 1998

Sandra Smallenburg, 'Kunst als mooie droom,' in: *NCR Handelsblad,* May 27, 1998

Laura Cherubini, 'Ugo Rondinone. Bonomo. Raucci/Santamaria, Napoli,' in: *Flash Art,* April/May, 1998, p. 128–129

Hajo Schiff, 'Aus der Welt gefallene Räume,' in: *TAZ,* April 14, 1998

Gigiotto Del Vecchio, 'Ugo Rondinone,' in: *Segno,* March/April, 1998

Lubos Kolzacek, 'Svetoznami fotografove v Brne,' in: *Brünner Abendzeitung,* January 14, 1998

David Perreau, 'Dramatically Different,' in: *Omnibus,* no. 23, January, 1998, p. 18

1997

Hip, Museum für Gegenwartskunst Zürich, 1997

504, Ausstellungsprojekt der Klasse John Armleder, Zentrum für Kunst, Medien und Design, Hochschule für Bildende Künste Braunschweig, 1997

Christoph Doswald, Andreas Meyer (eds.), *Nonchalance,* Benteli Verlag, 1997, p. 130–137

Hans Ulrich Obrist, Georg Kargl (eds.), *EVN Sammlung Ankäufe 1995/96,* 1997

Aspekt: Landschaft, Tal Museum Engelberg, Diopter-Verlag, 1997

Renate Damsch-Wiehager (ed.), *Fort! Da! Cooperations. 20 internationale Künstler/innen im Dialog mit der Sammlung Gegenwartskunst der Staatsgalerie Stuttgart,* Cantz Verlag, 1997

Cabines de bain, attitudes, Geneva, 1997

Fenêtre sur Cour, Galerie Almine Rech, Paris, 1997

Stephan Berg, 'Nonchalant,' in: *Neue Bildende Kunst,* October/November, 1997

G. B., 'L'art contemporain en pleines formes, se montre au Magasin de Grenoble,' in: *Le Monde,* October 3, 1997

Christoph Doswald, 'Nonchalance: be good, be bad, just be,' in: *Document sur l'art,* no. 11, Fall/Winter, 1997/98

Silvia Ricci Lempen, 'A Bienne, l'art se mire dans son miroir,' in: *Journal de Genève et Gazette de Lausanne,* September 27, 1997

Laurent Wolf, 'Le Centre PasquART fait le portrait d'une génération d'artistes suisses,' in: *Le Nouveau Quotidien,* September 23, 1997

Annelise Zwez, 'Instant-Kultur im Centre Pasquart,' in: *Aargauer Zeitung,* September 20, 1997

Béatrice Schmidt, 'Was tut sich in der jungen Schweizer Kunst?,' in: *Der Bund,* September 19, 1997

Annelise Zwez, 'Medienkultur als Fundus für die Nonchalence akuteller Kunst,' in: *Mittelland-Zeitung,* Zurich, September 10, 1997

Simon Maurer, 'Das Sternenfirmament auf der Brust,' in: *Tages-Anzeiger,* September 1, 1997

Eric Troncy, 'Where do we go, Ugo?' in: *Art Press,* Paris, no. 227, September, 1997

Lionel Bovier, 'Ugo Rondinone … doesn't live here anymore,' in: *Flash Art,* no. 193, March/April, 1997

Doris Krumpl, 'Gelegenheit für lichte Momente,' in: *Der Standard,* March 6, 1997

Philippe Régnier, 'Les clowns tristes atteignent leurs cibles,' in: *Le journal des Arts,* no. 33, February, 1997

Jan Verwoert, 'Ugo Rondinone: tender places come from nothing,' in: *Springerin. Hefte für Gegenwartskunst,* no. 2, 1997

Mary Krienke, 'Ugo Rondinone – Centre d'Art Contemporain,' in: *ARTnews,* January 31, 1997

1996

Klara Wallner, *Macht der Verführung, Schönheit und Geheimnis in der aktuellen Kunst,* Wewerka Galerie, 1996

heyday, Centre d'Art Contemporain Genève & Migros Museum für Gegenwartskunst Zürich, 1996

Gerald Zeigermann, *You Talkin' to Me?* Institute of Contemporary Art, University of Pennsylvania, 1996

Kunst in der Provinzial, Provinzial Versicherungsanstalt, 1996

The Aggression of Beauty, Galerie Arndt & Partner, Berlin, 1996

Modèles corrigés, Collège Marcel Duchamp, Châteauroux, 1996

Werner Fenz, Reinhard Braun (eds.), *2. Österreichische Triennale zur Fotografie, Radikale Bilder,* Edition Camera Austria, Graz, 1996

Conversation Pieces II, ICA & University of Pennsylvania, 1996

Non! Pas comme ça, Centre d'Art Neuchâtel, 1996

John M. Armleder (ed.), *Never Say Never,* Offizin, 1996

Christoph Doswald, 'Oh dandy, oh dandy …' in: *CIMAL, Arte International,* no. 48, 1997

Françoise Jaunin, 'Ugo Rondinone au Brésil: Le spleen d'un dandy funambule,' in: *24heures,* November 14, 1996

Mary Krienke, 'Ugo Rondinone Centre d'Art Contemporain Genève,' in: *ARTnews special (The Cutting Edge),* 1996

Inès Katzenstein, 'Le fiest del arte brilla en San Pablo,' in: *El Cronista,* October 11, 1996

Maria Vogel, 'Augen, Ohren, Nase für Ungewohntes öffnen,' in: *Willisauer Bote,* October 17, 1996

Claudia Spinelli, 'Der Körper, das Spiel, der Kopf und der Clown,' in: *Basler Zeitung,* no. 233, October 5, 1996

'Ugo Rondinone,' in: *Bloc Notes,* Paris, no. 13, September–October, 1996

Gerhard Mack, 'Die Kunst der Langeweile. Der Zürcher Multimedia-Künstler Ugo Rondinone reitet auf einer Welle des Erfolgs,' in: *Cash,* no. 40, October 4, 1996

Brita Polzer, 'Das Gewöhnliche im Sog des Ausserordentlichen,' in: *Kunst-Bulletin,* no. 7/8, July–August, 1996

Rui Martins, 'Ugo Rondinone une monotonia e meditacao,' in: *Uterca-Feira,* August 8, 1996

Christoph Doswald, 'Konstatierender Gleichmut,' in: *Neue Bildende Kunst,* no. 3, June/July, 1996

'Die Enge – Der Diskurs – Die Kunst in der Schweiz,' in: *Neue Bildende Kunst,* no. 3, June/July, 1996

Nathalie Zeindler, 'Gigantisches aus den 90er Jahren,' in: *ERNST (Jugendbeilage des Tages-Anzeigers),* June 12, 1996

Christoph Doswald, 'Haarscharf neben der Realität,' in: *Facts,* no. 18, May, 1996

Jörg Schwerzmann, 'Alles neu macht der Mai – Kunst im Löwenbräu-Areal,' in: *Bolero,* Zurich, no. 5, May, 1996

Simon Maurer, 'Ugo Rondinone: Am Strassenrand,' in: *Tages-Anzeiger,* May 4/5, 1996

Véronique Zbinden, 'Ugo Rondinone, portrait de l'artiste en délicieux décadent,' in: *V Magazine,* no. 2, April 19–25, 1996

Hélène Tauvel-Dorsaz, 'Le rôle de l'art est de mettre le spectateur en face de lui-même,' in: *Journal de Genève et Gazette de Lausanne,* April 23, 1996

Annelise Zwez, 'Wird Kunst zum Jekami?,' in: *Solothurner Zeitung,* April 11, 1996

Emmanuel Grandjean, 'Non! Pas comme ça!,' in: *Kunst-Bulletin,* no. 4, April, 1996

Dorothée Janin, 'Ugo Rondinone, fauteur de troubles oculaires,' in: *Beaux Arts Magazine,* no. 144, April, 1996

Francoise Jaunin, 'Ugo Rondinone le caméléon joue ses jeux de rôle a Geneve,' in: *24 heures,* March 28, 1996

Jean-Christophe Aeschlimann, 'Le monde change. Vingt-huit jeunes artistes suisses en témoignent,' in: *Le Nouveau Quotidien,* March 18, 1996

J. D. F., 'Ugo Rondinone a brouillé les cartes,' in: *La Liberté,* February 19, 1996

Martin Imbach, 'Sandstrand und heilige Erde,' in: *Der Bund,* March 13, 1996

Laurence Chauvy, 'Ugo Rondinone – Centre d'Art Contemporain Genève,' in: *Journal de Genève,* February 2, 1996

Jean-Damien Fleury, 'Ugo Rondinone – Centre d'Art Contemporain Genève,' in: *Liberté de Fribourg,* February, 1996

Johanna Hofleitner, 'Ugo Rondinone, Musée d'Art Moderne de la Ville de Paris, Migrateur,' in: *ART+TEXT,* no. 53, 1996

Lionel Bovier, 'Ugo Rondinone sème le doute chez ses admirateurs,' in: *Tribune de Genève,* January 27/28, 1996

Philippe Régnier, 'Ugo Rondinone – Galerie Froment & Putman Paris,' in: *Bloc Notes,* no. 11, January/February, 1996

1995

Kunstpreis der Böttcherstrasse in Bremen, Kunsthalle Bremen & Kunstverein in Bremen, 1995

Daniel Kurjakovic, Vittorio Santoro (eds.), *The Pleasures of Merely Circulating,* Memory Cage Editions, 1995

Hans Ulrich Obrist (ed.), *Migrateurs,* Musée d'Art Moderne de la Ville de Paris, 1995

Kathrin Becker, Klara Wallner (eds.), *Landschaft mit dem Blick der 90er Jahre,* 1995

Die Preisträgerinnen und Preisträger des eidgenössischen Wettbewerbs für freie Kunst 1994, Bundesamt für Kultur & Musée d'Art et d'Histoire de la Ville de Neuchâtel, 1995

Preisträgerinnen und Preisträger des eidgenössischen Wettbewerbs für freie Kunst 1995, Bundesamt für Kultur & Kunsthaus Glarus, 1995

Philip Ursprung, 'Gegen die Modernist Correctness – Neues aus der Schweiz,' in: *Eikon,* no. 14/15, 1995

Martin Kraft, 'Wo der Computer den Gummibaum umsorgt,' in: *Tages-Anzeiger,* November 5, 1995

Thomas Wolff, 'Abziehbilder aus der Ich-Maschine,' in: *TAZ,* October 25, 1995

Detlef Wolff, 'Kandidaten für den Kunstpreis der Böttcherstrasse in der Kunsthalle Bremen,' in: *Weser Kurier,* October 14, 1995

Hans Rudolf Reust, 'Ugo Rondinone – Galerie Walcheturm,' in: *Artforum,* October, 1995

Christophe Cherix, 'Ugo Rondinone – Galerie Walcheturm,' in: *Flash Art,* Summer, 1995

Harm Lux, 'Flimben, wenn das Leben zum Film wird – Ugo Rondinones Blickwechsel in Zürich,' in: *Neue Bildende Kunst,* no. 3, June/August, 1995

Eva Karcher, 'Narziss und Fegefeuer,' in: *Art – Das Kunstmagazin,* no. 6, June, 1995

Michelle Nicol, René Ammann, 'Kunsthaus Schweiz,' in: *Das Magazin,* no. 24, June 17, 1995

Martin Kraft, 'Installation von Ugo Rondinone – Inszenierte Leere,' in: *Züri-Tipp,* May 10, 1995

Lionel Bovier, 'Endstation Sehnsucht – Kunsthaus Zürich,' in: *Flash Art,* no. 180, January/Feburary, 1995

1994

Hedwig Saxenhuber, Astrid Wege (eds.), *Oh Boy, It's a Girl,* Kunstverein München, 1994

Endstation Sehnsucht, Kunsthaus Zürich & Cantz Verlag, 1994

Andreas Züst, *Ugo Rondinone 1988 (Kinderbuchzeichnungen),* 1994

Lokalzeit – Wiener Material im Spiegel des Unbehagens, Raum Strohal, 1994

Justin Hoffmann, 'Aktuell in Münchner Galerien,' in: *Süddeutsche Zeitung,* no. 260, November 11, 1994

Ludmila Vachtova, 'Bettgeschichten für Verlorene – Endstation Sehnsucht im Kunsthaus Zürich: Langsamer Selbstmord?,' in: *Die Weltwoche,* no. 28, July 14, 1994

Nadine Olonetzky, 'Grosse Emotionen abgekühlt – Endstation Sehnsucht – Ausstellung im Kunsthaus Zürich,' in: *Tages-Anzeiger,* July 2, 1994

Nadine Olonetzky, 'Endstation Sehnsucht – Cooler Umgang mit Wünschen,' in: *Züri-Tipp,* July 1, 1994

Yvonne Volkart, 'Passing through – Walcheturm Zürich,' in: *Flash Art,* May/June, 1994

Angelika Kirchenrath-Affentranger, 'Ich-Erfahrungen – Gruppenausstellung: Passing through in Zürich,' in: *Neue Zürcher Zeitung,* January 25, 1994

Ursula Eggenberger, 'Gefühlskunst der 90er – Passing through,' in: *Züri-Tipp,* January 21, 1994

Sigmar Gassert, 'Damals, heute, morgen – Rondinone, Schnyder und Vallotton nebeneinander in Liestal,' in: *Basler Zeitung,* January 7, 1994

Annemarie Monteil, 'Kunsthalle Palazzo in Liestal: Ugo Rondinone, Albrecht Schnyder, Félix Vallotton,' in: *Basler Zeitung,* January 4, 1994

1993

Salamon Torony Visegrad (ed.), *Donau,* Mucsarnok Visegrad, 1993

Die Sprache der Kunst, Kunsthalle Wien & Cantz Verlag, 1993

Peter Weiermair (ed.), *Prospect 93, Eine internationale Ausstellung aktueller Kunst,* Frankfurter Kunstverein und Schirn Kunsthalle Frankfurt, 1993

Ugo Rondinone, Albrecht Schnider, Félix Valloton, Kunsthalle Palazzo Liestal & Schwabe & Co Publisher, 1993

Robert Schiess, 'Drei Künstler und die Kunstgeschichte – Ugo Rondinone, Albrecht Schnyder und Félix Vallotton in der Kunsthalle Palazzo,' in: *Basellandschaftliche Zeitung,* December 11, 1993

Johanna Hofleitner, 'Augen-Blick doch! Bilder Psychedelik,' in: *Kurier,* April 30, 1993

Daniel Kurjakovic, 'Ugo Rondinone, Wie wir uns zu Subjekten verfestigen und uns wieder abhanden kommen …,' in: *Artis,* March, 1993

Christoph Schenker, 'Ugo Rondinone, Galerie Walcheturm Zürich,' in: *Flash Art,* no. 168, January/February, 1993

1992

Gianni Romano, *Twenty Fragile Pieces,* Art Studio Edizioni, 1992

Bice Curiger, Hans Ulrich Obrist (eds.), *Oh! Cet écho!,* Centre Culturel Suisse, 1992

Die Stipendiaten des eidgenössischen Kunststipendiums 1991, Bundesamt für Kultur/Kunstmuseum Solothurn, 1992

'Aids und Innerschweizer Künstler,' in: *Professionnelle,* December 11, 1992

Gerhard Mack, 'Luzern: Zwei Ausstellungen im Kunstmuseum – Ethik und Aesthetik im Zeitalter von AIDS,' in: *Kunstbulletin,* no. 11, November, 1992

N. O., 'Katalog nach Ausstellung, Luzerner Museum,' in: *Luzerner Zeitung,* no. 274, November 24, 1992

Matthias Frehner, 'Zielscheiben, die treffen,' in: *Neue Zürcher Zeitung,* October 10/11, 1992

Maria Vogel, 'Junge Innerschweizer und Kunst und Aids,' in: *WB Woche,* October 10/11, 1992

C. J., 'Zur letzten Seite,' in: *Stehplatz,* no. 5, October 5, 1992

Urs Bugmann, 'Das Ich sieht sich in seinen Bezügen zu andern,' in: *Luzerner Neue Nachrichten,* October 2, 1992

Niklaus Oberholzer, 'Neben – und Miteinander – Vier Künstlerinnen und Künstler aus der Innerschweiz im Kunstmuseum Luzern,' in: *Luzerner Zeitung,* October 2, 1992

Daniel Kurjakovic, 'New Swiss Art,' in: *Flash Art,* June, 1992

Caroline Kesser, 'Genuss und Reflexion,' in: *Tages-Anzeiger,* May, 1992

Elisabeth Claus, 'Ugo Rondinone, Galerie M. Detterer Frankfurt,' in: *ZYMA,* no. 2, March/April, 1992

D. Baer-Bogenschütz, 'Künstliches Paradies,' in: *Frankfurter Rundschau,* January 21, 1992

1991

Harm Lux, Philip Ursprung, *Stillstand Switches,* Shedhalle Zurich, 1991

Chamer Räume, Kunst an Ort, Forum Junge Kunst Zug, 1991, p. 137–144

Vincenzo Berardi, 'Ugo Rondinone, Galerie Pinx Vienna,' in: *Artis,* September, 1991

D. Baer-Bogenschütz, '13 junge Schweizer Künstler in Wiesbaden,' in: *Kunstbulletin,* Zurich, no. 4, April, 1991

1990

Weihnachtsausstellung Innerschweizer Künstler 1990, Kunstmuseum Luzern, 1990

Spiel der Spur, The Poetry of Chance, Shedhalle Zürich & Buchhandlung Walther König, 1990, p. 53–55, p. 74–75

1989

Christoph Schenker, *Igitur,* Kunsthalle Winterthur, 1989

Hedwig Saxenhuber, 'Auf der Jagd nach der Kunst von morgen,' in: *Der Standard,* October, 1989

Melencolia, Galerie Grita Insam, Vienna, 1989

Imprint

This publication was realized on occasion of the exhibition
Ugo Rondinone – zero built a nest in my navel,
at the Whitechapel Gallery, London, January 24th – March 26th, 2006

The exhibition is presented in collaboration with
The Henry Moore Foundation

CURATED BY
David Thorp

ORGANISED BY
Andrea Tarsia, Head of Exhibitions and Projects, Whitechapel Gallery
Candy Stobbs, Senior Exhibitions Organiser, Whitechapel Gallery

LENDERS
Galerie Eva Presenhuber, Zurich
Sadie Coles HQ, London
Matthew Marks Gallery, New York
Libra Art Collection

WITH SUPPORT FROM

The Henry Moore Foundation

**STANLEY THOMAS
JOHNSON FOUNDATION**

FONDATION NESTLÉ POUR L'ART

Supported by Presence Switzerland

PR●HELVETIA
■ Γ
Arts Council of Switzerland

Galerie Eva Presenhuber, Zurich, Sadie Coles HQ, London,
Matthew Marks Gallery, New York, Galerie Almine Rech, Paris,
Galerie Esther Schipper, Berlin, Galleria Raucci/Santamaria, Naples

WITH KIND ASSISTANCE FROM THE EXHIBITION CIRCLE
Shane Akeroyd
And those who wish to remain anonymous

TOWER HAMLETS

Publication

EDITOR
Andrea Tarsia

DESIGNER
Scipio Schneider
with thanks to Claudia Roethlisberger

EDITING AND PROOFREADING
Andrea Tarsia, Candy Stobbs, JRP|Ringier

COVER
Ugo Rondinone

PHOTO CREDITS
All images courtesy of the artist and Galerie Eva Presenhuber, Zurich

COLOUR SEPARATING
Daniel Möhrle

PRINTING
Druckerei UHL GmbH & Co. KG

TYPEFACE
Montype Grotesk

PUBLISHED BY
JRP|Ringier
Letzigraben 134
CH – 8047 Zurich
T +41 (0)43 311 27 50
F +41 (0)43 311 27 51
info@jrp-ringier.com
www.jrp-ringier.com

CO-EDITION WITH

Whitechapel

80–82 Whitechapel High Street
London E1 7QX, UK
T +44 (0)20 7522 7888
F +44 (0)20 7377 1685
info@whitechapel.org
www.whitechapel.org

JRP|Ringier books are available internationally at selected
bookstores and the following distribution partners:

Switzerland
Buch 2000, AVA Verlagsauslieferung AG, Centralweg 16,
CH – 8910 Affoltern a. A., buch2000@ava.ch, www.ava.ch

France
Les Presses du réel, 16 rue Quentin, F – 21000 Dijon,
info@lespressesdureel.com, www.lespressesdureel.com

Germany and Austria
Vice Versa Vertrieb, Immanuelkirchstrasse 12, D – 10405 Berlin,
info@vice-versa-vertrieb.de, www.vice-versa-vertrieb.de

UK
Cornerhouse, 70 Oxford Street, Manchester M1 5NH,
info@cornerhouse.org, www.cornerhouse.org

USA
D.A.P./Distributed Art Publishers, l55 Sixth Avenue, 2nd Floor,
New York, NY 10013, dap@dapinc.com, www.artbook.com

Other countries
IDEA Books, Nieuwe Herengracht 11, 1011 RK Amsterdam,
idea@ideabooks.nl, www. ideabooks.nl

ISBN 3-905701-52-9
ISBN 0-85488-145-X (UK only)